Caravaggio

Vittorio Sgarbi

Caravaggio

On the cover
Penitent Magdalene
(detail)
Rome, Galleria Doria Pamphilj
© ADP - license by Fratelli
Alinari

Design
Marcello Francone

Editorial coordination
Franco Ambrosio

Editing
Tanja Beilin

Layout
Elita Fiorentino

Translations
Alta L. Price

ISBN-10: 88-7624-859-5
ISBN-13: 978-88-7624-859-7

Distributed in North America
by Rizzoli International
Publications, Inc.,
300 Park Avenue South,
New York, NY 10010.
Distributed elsewhere in the
world by Thames and Hudson
Ltd., 181a High Holborn,
London WC1V 7QX, United
Kingdom.

First published in Italy in 2007
by Skira Editore S.p.A.
Palazzo Casati Stampa
via Torino 61
20123 Milano
Italy
www.skira.net

Printed and bound in Italy.
First edition

Contents

Caravaggio: Life and Work

Without a doubt, given the current state of research and after worthy examination of the documents, the greatest Lombard painter of the seventeenth century begins to exist, in art, only upon his arrival in Rome. Before that Caravaggio is just a name in the documents patiently studied by Mia Cinotti and Giacomo Berra, who agree, with a slight margin of error, on the painter's date of birth — which more likely occurred in Milan than in Caravaggio — September 29, 1571. His parents were Fermo Merisi, administrator, architect, and superintendent in the house of Francesco Sforza da Caravaggio, and Lucia Aratori, a woman from a well-to-do family with property near Caravaggio. Michelangelo is the first of four children. Of the second, Giovanni Battista, the date and place of birth — on November 21, 1572, in Milan — are known. In the legal proceedings of the family he is always recorded as being a year younger than his older brother. In the baptismal records of the parish of Santa Maria della Passerella, where Fermo lived, there is a gap of four years, until October 20, 1571, just over nine months after the wedding of Michelangelo's parents. September 29 is the feast day of Saint Michael Archangel; many historians conclude that this coincides with the painter's date of birth. As for the location, there are no elements that prove one hypothesis over the other, between Milan and Caravaggio, but, while the other children of Fermo Merisi are documented as being born in Milan, it is worth noting that all the sources that give us precious news of the painter, from Mancini to Baglione, Bellori, and Von Sandrart, state that he was born in Caravaggio. Berra concludes: "From all of the various goings-on that have emerged in relation to the Merisi and Aratori families, it is nevertheless evident that, beyond the real birthplace of the painter, Michelangelo was utterly a citizen of Caravaggio inasmuch as, aside from passing his infancy and youth in the village of Caravaggio, he was also a member of a local family that had ample economic interests and deep ties to 7

said village. At the same time, he was decidedly Milanese as far as his artistic formation is concerned." The very young Caravaggio probably fortified his spirituality in the sanctuary of Santa Maria della Fontana in Caravaggio, observing pilgrims, cripples, the diseased and poor, and perhaps was a manual assistant to the architect Pellegrino Pellegrini, also known as Tibaldi, and grew close to the "masters of masonry who usually build the Madonna," Bartolomeo Merisi and Fermo Degani. Bartolomeo was Caravaggio's uncle, whose son Giulio was learning the trade, but from the start cousin Michelangelo preferred the "ars pingendi" to the "art of masonry," as is recorded in a document of 1585. Considering this, Caravaggio's mother, who was widowed in 1577, placed him in the studio of Simone Peterzano, as early as April 1584: "In primis convenerunt… quod dictus Michael Angelus teneatur stare et habitare cum dicto domino Simone, ad discendum artem pictoris et hoc per annos quator proxime futuros die hodie Inceptos." More than the Lombard tradition, Simone Peterzano kept the Venetian tradition alive in Milan, with explicit echoes of his master declared in the signatures on his paintings: "Titiani alumnus." But Caravaggio's curiosity about the Lombard painting tradition certainly came from Peterzano, who was from Bergamo, and spanned from Campi, Lorenzo Lotto, and Moroni — painters from Cremona working in Bergamo — to Savoldo and Moretto, who worked in Brescia, as Longhi has noted. These circles must have occupied his formative years, in which we don't know what Caravaggio did, even if Mancini seems to reasonably comfort us about his dedication: "In his infancy, from four to six years, he studied in Milan with diligence, even if, from time to time, he committed some extravagance due to his hot nature and large spirit." The meticulous Berra can only confirm that Michelangelo remained in Milan, and in Peterzano's studio, until at least March 1585; according to Robb the apprenticeship lasted until 1588. There are no traces of the work he did in those years. One can agree with Berra in his recognition that Giovan Paolo Lomazzo's *Trattato dell'arte della pittura*, hot off the press in 1584, had a definite theoretical influence on Peterzano and Caravaggio himself.

Peterzano's teaching probably didn't differ much from the one outlined by Bernardino Campi in his small treatise titled *Parere sopra la pittura*: "One must teach them to portray from life;" and he likely organised travel for study to Venice, and had a familiarity with the Lombard masters practicing in Milan at the church of San Paolo in Converso, and in particular works such as the *Beheading of Saint John the Baptist* and *Visit of Saint Catherine to the Prison* by Antonio Campi, an absolutely original work completed in 1583. These suppositions were first suggested by the critical intuition of Longhi. We know from the documents that, after his apprenticeship with Peterzano, Michelangelo is again a resident of the village
of Caravaggio, and is busy selling real estate with contracts drawn

up at various dates — September 25, 1589; June 20, 1590; March 21, 1591; April 1, 1591. But already by November 28 of this latest year Caravaggio appears as a resident of Milan, and the contract that mentions him was drawn up for a house in the parish of San Michele alla Chiusa in Porta Ticinese, not far from where Giuseppe Arcimboldo was residing after his return from the court of Prague in 1587. Arcimboldo stayed in Milan until 1593, the year of his death. Berra, opportunely, differs from Longhi, — who considers Arcimboldo "passably stupid" — and imagines that a twenty-year-old Caravaggio visited the studio of the famous artist who, albeit with the most extravagant assemblages in the spirit of the *Wunderkammer*, had shown a minutely detailed and almost scientific naturalism, even if it were aimed at the marvellous. Still in Caravaggio on July 1, 1592, we can imagine him soon thereafter on his way to Rome as, reasonably, Mancini reconstructs it: "Afterwards he went on to Rome, at the age of about twenty [...] with little money." Bellori suggests a variation on that: "Fleeing Milan on account of some discord, he reaches Venice, where he delighted in the colouring of Giorgione and took it as a guide for imitation." We know for certain that upon arriving in Rome he found Costanza Colonna, Marquise of Caravaggio, who had arrived by sea that same summer. We know of the ties binding Costanza Colonna and her husband Francesco Sforza to Caravaggio's family, and in particular his maternal grandfather, Giovanni Giacomo Aratori. News of the marquise's departure for Rome must certainly have reached Caravaggio. Berra hypothesizes that his aunt, Margherita, also followed the marquise. As we have no record of Caravaggio's first Roman address, it is likely that Costanza, conscious of the young man's qualities and merits, protected him and gave him a place to stay. One of the most reliable contemporary sources, Giulio Mancini, strongly supports this hypothesis by recording his first arrangement in Rome at the house of Pandolfo Pucci, master of Camilla Peretti's house; Peretti was the sister of Pope Sixtus V, and related to the Colonna. Mancini writes: "He went on to Rome at the age of approximately twenty years, where, not being very moneyed, he stayed with Signor Pandolfo Pucci da Recanati, Benefiziato of San Pietro, where it was partly convenient for him to go, and performed other tasks less suited to his lineage, and virtue, and what is worse, he passed the evenings with a salad that served as his dinner, and dessert [...] and after that he always called his host Monsignor Salad." In Mancini's notes we find records of the first work now attributed to Caravaggio: "In the time that day permitted he made some copies of devotional works that are at Recanati and for himself to sell; the cherub who cries after being bitten by a lizard that he holds in his hand, which caused him, upon selling it — being encouraged that he could live on his own — to depart from that lacking master or Patron." Thus we begin to delineate the central objective of Caravaggio's quest, right from the first tries.

His was a realism that was phenomenological in a way it had never been before. The *Boy Bitten by a Lizard* was known in two versions: the one formerly in the Korda collection, now at the National Gallery in London, and the harder one, in the Longhi Foundation. These works must fall around 1593, together with "that cherub who peeled an apple with a knife," of which there are many known versions, none authenticated; all are insufficient for the quality of Caravaggio. From Mancini we know that the painter's activity must have been prolific ("and afterwards he made many paintings for the Prior that brought them to Seville, his homeland"). Mancini's synthesis is effective in informing us (as recounted to him), "that he was at the house of Cavalier Giuseppe," referring to D'Arpino, "and after that at the house of Monsignor Fantino Patrignani, who gave him the comfort of a room, where he made many paintings, and in particular a gypsy who reads the palm of a young man, the Madonna fleeing to Egypt, the penitent Magdalene, a St John Evangelist, and others." Mancini's observations are surprisingly punctual; he lists some of the paintings of Caravaggio's early, limpid, classic mature work, where he has not yet turned to the strong effects of chiaroscuro and artificial lighting. Thus we see *The Fortune Teller* as one of the début works of the new Caravaggesque taste, with the full volumes of the two figures cut out against an indistinct background, in the version at the Pinacoteca Capitolina, from the collection of Cardinal Del Monte and — more demanding because of its layers of light on the background wall — in the version at the Louvre. Results like this, for a twenty-three-year-old painter, are certainly surprising, as they have an inventive strength that doesn't seem to derive from any earlier experience, and for the disarmed naturalness, more than naturalism, with which Caravaggio presents his characters. To explain the candour of the youth in the feathered hat, with echoes of the literary figure in Giorgione's work (used to make him appear lesser in comparison), there are no models of any sort, not even the doubtlessly useful experience with Cavalier D'Arpino. Caravaggio immediately begins to speak a new language, as if there were nothing before him, with no need to cite other artists, and with a liberty — even iconographic liberty — that no one else had allowed himself before. There remain the moods of his sources, and the masters that he had observed, in particular Lorenzo Lotto, Moretto, Savoldo, and also Moroni's way of making volumes felt in space. But everything is light, vague, dreamy, and precisely in the works listed by Mancini one sees miracles of freshness and naturalness that neither the cultured Renaissance nor the artificial mannerism could conceive of. There could be no more eloquent painted examples than *The Fortune Teller*, the *Bacchus* of the Uffizi, the *Boy with a Basket of Fruit*, and the so-called *Sick Bacchus* of Galleria Borghese, among the very earliest of Caravaggio's known works, done after he had been in the studio of Cavalier D'Arpino. We can trust his peer and

competitor Baglione, who informs us, in a sufficiently circumstantiated manner, of Caravaggio's movements: "And from the beginning he settled himself with a Sicilian painter, who with coarse works ran a studio. He then went to stay in the household of Cavalier Giuseppe Cesari D'Arpino for a few months. Thence he tried to stay on his own, and made some small paintings portrayed from the mirror. The first was a Bacchus with a few different bunches of grapes, made with great diligence, but slightly dry in manner." The reference to the *Sick Bacchus* of Galleria Borghese, a plausible self-portrait, is evident. But that is not all that Baglione wants to say in referring to the "little paintings of himself portrayed in a mirror." As Longhi further explains, "use of the mirror wasn't unknown in sixteenth-century painting, in two distinct acceptations: first, that which facilitated the execution of a famous artist's own effigy, thereby perhaps offering a pretext for an added 'culterana' of alterations produced by the mirror, as in the famous example of Parmigianino; second, and more rarely, to prove oneself as the noted 'paragon' in comparison with sculpture, succeeding in showing in one single painting many views of the same figure, as in the nude that Vasari attributed to Giorgione, and in the so-called Gastone di Foix by Savoldo. Even if that quest, in the hands of Savoldo, was not wanting in visual subtleties, the goal remained that of an intellectual acuteness. It has nothing, that is, in common with Caravaggio's decision to portray things from a mirror without it appearing in the painting; as if, for the naturalist Caravaggio, the new method were a pledge of a more intense certainty." Beginning with the still life paintings, this is extraordinarily evident in the *Boy with a Basket of Fruit*, the many cited paintings of Bacchus, and the admirable *Basket of Fruit* of the Pinacoteca Ambrosiana. From these first-fruits, from these offerings worked out in many compositions or isolated in small format, Caravaggio moves toward more elaborate compositions, in those early intense Roman years so rich in curiosities and experiences. It is useful to cross the accounts of Baglione and Mancini. Imagine Caravaggio around 1595 painting the two versions of *The Fortune Teller*, of the Musei Capitolini and the Louvre, next to which, for stylistic affinity, *The Cardsharps* now at the Kimbell Art Museum in Fort Worth and the *Saint Francis of Assisi in Ecstasy* of the Wadsworth Atheneum of Hartford line up. A masterpiece that presupposes neither a before nor an after, be it in the history of art or the history of an artist, is the *Magdalene* in the Galleria Doria Pamphilj, a composition so simple and absolute that it foreshadows, with unequalled naturalness, the works of Orazio Gentileschi and Vermeer. The *Rest on the Flight into Egypt* is from the same period, also now at the Pamphilj, and has the fantastical markings of a dream (the angel intervenes in the lives of humans and asks Saint Joseph to hold the score, in order to play and produce the ecstasy of his celestial music). In Rome Caravaggio starts out with three works of such nov-

elty and inventive quality that he was immediately sought after, at such a young age, by the great families of Roman collectors. Von Sandrart's intuition is immediately clear: "He introduces the straightforward imitation of nature and life [...] and to that end he kept before his eyes, in his room, the object he intended to portray, until he was able to faithfully reproduce it in his work: and in order to succeed in expressing in a complete manner the relief and natural separations, he was careful to make use of places sometimes dark or other rooms without lighting, that received a little light from high up, in a way such that the shadows appeared more vigorous, so as to obtain a stronger relief." A series of masterpieces like those completed in the first years of his stay in Rome couldn't have fallen into a void. Certainly the novelty and discomfort of such original ideas must have initially disconcerted people, such that Caravaggio "found no way to sell them, or give them away, and to that sad end he reduced himself to a penniless state, and most terribly dressed, such that a few gentlemen of the profession, out of charity, went to uplift him." But during that period, at San Luigi dei Francesi, Caravaggio met a painting dealer, a certain Maestro Valentino who "saw to giving some of them away." And in this way, for bringing such prodigious works to broader attention, he came to know Cardinal Del Monte, "who, to enjoy himself, and having a large part of the paintings, took him into his house, and having part and provisions, raised his spirits, and credit, and painted for the cardinal a music [scene] of a few youths portrayed quite well from life." This painting, recorded in the cardinal's inventory February 21, 1627, is identified with *The Musicians*, now at the Metropolitan Museum of Art in New York, almost universally recognised as a work of Caravaggio's hand, despite the frightening conditions of conservation, and perfectly concords — in the languid expression on the face of the young man strumming the instrument — with *The Lute Player* at the Hermitage in Saint Petersburg, the sole attributed version, of which there are many copies of lesser quality improperly judged originals. The quality of the painting is such that, in the later version placing the human figure next to a still life, it seems to exemplify, almost like a caption, Vincenzo Giustiniani's consideration that "he put such handwork into making a good painting of flowers, just as of figures," to bring out the admiration of the envious Baglione: "A youth, who played the lute, who lived, and it all appears true, with a carafe of flowers full of water, that within one excellently discovers the reflection of a window, with other echoes of the room inside the water, and above the flowers there was a vivid dew, portrayed with every exquisite diligence." Baglione then leaves the conclusion to Caravaggio: "And this [he said] was the best piece ever done." In this climate, with the precedent set by the *Boy Bitten by a Lizard*, Caravaggio also paints for Cardinal Del Monte the roundel

12 *Medusa*, "with a most frightful hair of vipers." The cardinal saw to

it that it was sent as a gift to Ferdinando, Grand Duke of Tuscany. It cannot be excluded that this is a deformed self-portrait, datable to around 1596. In these years we can also situate some of the works not recorded in the historic sources, but cited in the inventories which reappeared in recent times. Such is the case with the mural painting of *Jupiter, Neptune, and Pluto* in the casino of Cardinal Del Monte (now villa Boncompagni Ludovisi), commissioned on November 26, 1596, and likely painted the following year. From the same period, with a compositional maturity and surprising luminosity, is the *Saint Catherine of Alexandria* now in the Thyssen collection, with an extraordinary sculptural relief accentuated by the idea of bracing the saint with a true-to-life wheel (Bellori observed, "Saint Catherine kneeling and braced against the wheel"), a highly elegant image with which the paintings of *Martha and Mary Magdalene*, now in Detroit, and the celebrated *Judith and Holofernes*, formerly in the Coppi collection, and now at Palazzo Barberini, in Rome, concord. We are between 1597 and 1598. Only now can one imagine the machination-laden, late-mannerist invention of the *Conversion of Saul* in the Odescalchi collection, with the romantic view out over a sunset landscape felt with the nostalgia of his homeland on the Padanian plains. The raking light of the sunset comes close to that found in the *Conversion of Saul* and the *Saint Francis of Assisi in Ecstasy* of Hartford, with its opening onto a landscape striped with the last light of day and the soft, plump angel, which recalls that of Saul with a more consistent sculptural relief due to the wooden support (the only case in all the painter's œuvre). The Uffizi's *Sacrifice of Isaac* could also belong to this same period, painted for Maffeo Barberini, who later became Pope Urban VIII, convincingly, but not in concordance, set by Longhi in the painter's very first years in Rome, with a clear connection to Brescian painting in the landscape. Only later, moving toward the full maturity shown in the Contarelli chapel in San Luigi dei Francesi, can we place important paintings of religious subjects like *Christ Crowned with Thorns* now in Vienna (1599), the *David and Goliath* at the Prado, the *Supper at Emmaus* at the National Gallery of London (1598–1599) and *The Incredulity of Saint Thomas* in Potsdam; these last two paintings, along with *Saint John the Baptist* now in the Pinacoteca Capitolina, were painted for Ciriaco Mattei. At this stage of the painter's maturity came his first large public project, the decoration of the Contarelli chapel, in San Luigi dei Francesi. We are straddling two centuries, between 1599 and 1600. The revolution is complete, and if the *Saint Matthew and the Angel* above the chapel's altar, in its insolent realism and the vivid contrast between the rustic figure of the saint and the very elegant, feminine figure of the angel, seems to perfectly concord with the dramatic realism of the Potsdam painting, the two lateral scenes with the *Calling of Saint Matthew* and the *Martyrdom*, in the agitation of the numerous characters, pave the way for a new vision, a theatri- 13

Cardinal Contarelli's will. For these delays "the soul of the deceased is defrauded the suffrage that is its due." On July 12, 1597 the informers of the Duke of Urbino communicate that, at the pope's behest, Contarelli's inheritance has been transferred from the Crescenzi executors to the offices of Saint Peter's. The responsibility for the works' delays is attributed to Cavalier D'Arpino. It is from this failure that, two years later, charge of the two lateral paintings for the Contarelli chapel is given to Caravaggio, as substitute for Cavalier D'Arpino, who returns the advances received.

In this new commission, which Baglione obtained through Giustiniani, in this passing of the project from one painter to the other, from one century to another, a new vision of the world is affirmed, as Von Sandrart saw so well: "This Caravaggio was the first among the Italians to distance himself, in the studio, from the old traditional manners [...] he held in contempt all that which had not been done from nature, calling them bagatelles and children's games, implying that nothing could be called good if it weren't as similar as possible to nature." The interior of the *Calling of Saint Matthew*, with the formidable idea of the window from which no light enters, but that the space is lit by a ray of light from some other source, indicates in an eloquent way the transfer of the miracle into the physical and psychological space of daily life. Christ arrives, and finds a group of people, 'his' Matthew among them, stolidly bent on playing the game according to the outline that Caravaggio himself introduced with the group of *The Cardsharps*. This is the unforeseen sense of divine presence, which changes the life of one of those men, and redeems it in the "poetic conception of a dissolute theme of life that all of a sudden changes by the force of a destiny that intervenes" (Longhi). Here the game is certainly played until the very end, and the great *telero* is the first slice of life of modern painting, so new that even Caravaggio doesn't manage to keep pace with himself in the involved and neo-mannerist scene of the Saint's martyrdom, in which the unity of action is subordinate to the multiplication of points of view in a stellar composition. Caravaggio later seeks to mask this *empasse* with formidable effects of raking light, from the highly sculptural back of the witness in the lower right corner, to the damask dress of one of the knights seen from behind. The evident contradiction and pictorial jump between the two canvases, while certified as being concluded along with the balance on July 4, 1600, even cause Longhi's judgement to vacillate, and he is embarrassed to mistake the version that is now destroyed for the altarpiece: "These meditations of Caravaggio's make one understand that he conceived of himself here on a level rather different from the youthful *Saint Matthew* 'that he had made earlier for that altar in San Luigi' and where the saint had been mistaken for a crude illiterate. Now he knew that Matthew was a publican, an exchange agent, a bearer of taxes and customs. And also that in these places one exchanges mon-

ey and, where the exchange is done, the game is easily initiated, nothing prevents the scene of the *Calling* from deciding on a moment's notice that something (the light) or someone (Christ) comes to take Matthew and his companions from a poker game." This painter begins to stir up marvels in all Europe, to the point where Karel van Mander, as early as 1603, but informed by Floris Claesz van Dyck in 1601, writes: "At Rome there is a certain Michel Angelo da Caravaggio who does marvellous things [...] with his work he has already reached a great fame, and created a name for himself [...] he is one of those who don't make much of the work of any master. His motto is that they are nothing but bagatelles, infantile and mendacious things, and that it matters not what one paints or by whom it is painted, when it is not done and portrayed from nature, and that there is nothing good or better than to follow nature. He traces not a single line without doing so directly from the live model." Hence the legend is also born: "Now, he is a mixture of grain and chaff; indeed he does not consecrate himself continuously to laziness, but when he has worked for a couple of weeks, he wanders round for a month or two with a sword at his side and a servant behind him, and goes from one ball game to the next, very inclined to duel and get into fights, such that it is rare that one is able to frequent him." But it is precisely in those years that Caravaggio carries out the most fortunate works. On September 24, 1600 he begins two pictures for the chapel of monsignor Tiberio Cerasi, the pope's treasurer, in Santa Maria del Popolo, and already by November 10 he receives the balance. Once again in the *Conversion of Saint Paul* Caravaggio creates a scene of reality never seen before, even a bona fide new point of view.

The saint is below the horse, in a revolution of the vision, with the horse as protagonist, an absolute overturning of order to which people were accustomed, even in a subject so frequently portrayed in sixteenth-century painting (for example, in a masterpiece by Moretto, which certainly Caravaggio could have seen in the church of Santa Maria in San Celso in Milan). The Caravaggio of those years is the one described by Van Mander. On November 19, 1600 Girolamo Stampa da Montepulciano quarrels with Caravaggio, at the house of Del Monte, for having assaulted him with a club and affronted him with sword, to the point of mangling his mantle. In February 1601 he makes peace with Fabio Canonico, whom he had hurt; on November 10 he received the balance for the two canvases of the Cerasi chapel. On January 9, 1602 he is already at work to replace the painting above the Pietà altarpiece of Santa Maria in Vallicella, the most classic of his modern works, with the reflection of the most authoritative and beloved sources, Michelangelo's *Pietà* in the Vatican, from which he takes the abandoned arm of Christ, and Raphael's Baglioni *Deposition*, almost one hundred years apart. An

homage to Michelangelo appears also on the face of Nicodemus, with

his elbow pressed against us, while the three expressions on the faces of the women seem a distant homage to the mourning polychrome terracotta figures certainly seen by Caravaggio in his trips through Padania. Thus, between demanding, inventive works and brawls, the life and fame of Caravaggio move ahead. On August 28, 1603 Giovanni Baglione issues a lawsuit with the governor of Rome against the architect Onorio Longhi, and the painters Caravaggio, Orazio Gentileschi, and Filippo Trisegni, for having distributed two slanderous poems of which Caravaggio had received copies from the pupil Tommaso Salini, called Mao. According to Baglione the quarrelling parties acted out of envy, after he had completed a *Resurrection* for the Chiesa del Gesù. Caravaggio, he sustained, wanted to win the commission. The trial continued on September 12 with the questioning of Trisegni and Gentileschi. The former confirmed that he had copied the poems and given them to Mao Salini to inform him of the wickedness circulating about him and Baglione. The trial is, for us, the precious pretext for hearing the voice of Caravaggio, who was arrested on September 11 and questioned on the 13. If the transcription is faithful, beyond the character, we can also get to know Caravaggio's tastes, the painters that he considers "valent'huomini" (worthy men) Zuccari, Cavalier D'Arpino, Pomarancio, Annibale Carracci, and Tempesta. "Valent'huomo" for Caravaggio is one who knows "how to paint well and imitate natural things well." The transcription of Caravaggio's questioning, aside from being extremely lively, is also powerful — the expression of a strong character. Let's listen to it: "I was taken the other day in piazza Navona, but I know not the cause and occasion. My practice is that of a painter. I believe that I know almost all the painters of Rome, and beginning with the 'valent'huomini', I know Giuseppe, Carraccio, Zucchero, Pomarancio, Gentileschi, Prospero, Gio Andrea, Gismondo and Giorgio Todesco, Tempesta, and others. Almost all of the painters I have named above are my friends, but they are not all 'valent'huomini'. That word 'valent'huomo,' for me, means that one knows how to do well, that is, knows how to do his art well, such that in painting 'valent'huomo' is one who knows how to paint well and imitate natural things well. Of those I named above, neither Gioseffe, Gio Baglione, Gentileschi, nor Giorgio Todesco are my friends, as they do not speak to me; all the others speak and converse with me. Of the painters I named above and as good painters [there is] Gioseffe, Zucchero, Pomarancio, and Annibale Carraccio, and the others I do not consider 'valent'huomini'. 'Valent'huomini' are those who understand painting, and will judge as good painters those who I have judged good and bad; but those who are bad painters, and ignorant, will judge as good painters those who are ignorant as they are. I do not know that any painter lauded and held as a good painter any one of those painters whom I do not see as good painters [...]. I know nothing of the existence of a good painter who lauded Gio-

vanni Baglione as a good painter. I have seen nearly all the works of Gio Baglione, that is, those in the Grand Chapel of Madonna dell'Orto, at St Gio Laterano, and most recently the Resurrection of Christ at the Chiesa del Gesù. I do not like that painting of the Resurrection at Gesù because it is clumsy and I see it as the worst that anyone has ever made or deemed painting; I have not heard it praised by any painter, and of all the many painters I have spoken to, not one liked it. If it weren't praised by someone who is always with him [Baglione], who they call guardian angel, who was there when the work was discovered to praise it, who they call Mao […]. It might be that he likes it and daubs on it yet, but I have never seen any work of this Mao […]. With Honorio Longo I have never spoken about Baglione's painting of the Resurrection, and it is more than three years now that Gentilesco does not speak to me […]. Signor, no, I do not enjoy composing verses, neither in the vulgate nor in Latin. I have never heard, in rhyme or in prose, in vulgate or in Latin, or of any sort, any in which mention was made of Giovanni Baglione." Good works are layered atop the gossip and bad actions. In the questioning of Gentileschi, who was also summoned, one learns that for six or eight months he had no longer had any relations with Caravaggio, since he had loaned him "a Capuchin cloak and a pair of wings," clues that could lead either to the Hartford *Saint Francis* or two separate works, a *Saint Francis Preaching* and the admirable *Amor Victorious* now in Berlin, an insolently pagan work. Caravaggio remains imprisoned at Tor di Nona through September 25. Later on, still regarding the lawsuit of Baglione and Mao Salini, Caravaggio's friend Onorio Longhi is also arrested. Other documents indicate that in 1604, on January 2, Caravaggio was at Tolentino to paint a picture for the main altar of the Capuchin church. But shortly afterward Pietro da Fusaccia, a waiter at the Osteria del Moro, presents a lawsuit against Caravaggio, who had thrown a plate of artichokes in his face, wounding his left cheek, and had threatened him with a sword. On September 6 the large *Deposition* is completed and hung in the Pietà chapel of Santa Maria in Vallicella; but shortly afterward, on October 19 and 20, the painter is again in the Tor di Nona prison for having thrown rocks and insults at the cops in via dei Greci. On November 18 there are further problems with the police, for carrying arms: at five in the morning Caravaggio is stopped at the Chiavica del Bufalo; armed with sword and dagger he shows his license. The official maintains that he replied with a "good night, sir," and in return received an insult; once again Caravaggio returns to the Tor di Nona prison. There are further misunderstandings with the police on May 28, 1605, as Caravaggio no longer has a license to bear arms, and his dagger and sword are sequestered. On July 20 Caravaggio is again in the Tor di Nona prison, for having affronted a certain Laura and her daughter Isabella. In an extraordinary escalation of events, in continuous chiaroscuro, in a double life not

grave bloodshed that happened in Campo Marzio between two bands of four people after a game. Caravaggio, head of the first band, had murdered Ranuccio Tomassoni da Terni; then, wounded himself, he fled. The episode is confirmed in a letter of the ambassador of the Este family, Masetti, who sent Caravaggio — who remained at large — the order to complete the Madonna for the Duke of Modena. Later on Masetti learns that Caravaggio is in hiding at Paliano, in the feudal lands of Prince Marzio Colonna, where he perhaps painted the *Supper in Emmaus* (now at Brera), the most extreme testimony of his period in Rome. In the first days of 1607, Caravaggio shows up in Naples where, as early as January 9, he receives the balance for the altarpiece of the *Seven Acts of Mercy* for the Pio Monte. This is one of his most complex works: in a single space, in the illusion of a unified action, different situations and moments coexist as on a Neapolitan street corner, and they seem to be made uniform by a single light source. They are at once concepts (the works of Mercy) and fragments of life from prison to death, under the beneficent care of the merciful Virgin sustained by a group of large-winged angels. Caravaggio has outdone himself, as if in a theatrical performance, giving it royal dress and playing out concepts of strong symbolic and theological value. Between February 17 and April 28 of that year the painter-assassin, probably accompanied by remorse, has the fate of seeing his work, which had been refused by the priests of Santa Maria della Scala, bought for 280 scudi by Pieter Paul Rubens for the Duke of Mantua, and exhibited for a week in Rome, "to satisfy the university of painters," while the painter himself is still at large. During a sequestration in the studio of Cavalier D'Arpino two of Caravaggio's paintings are also confiscated, early works he left there during his years in Rome: *Sick Bacchus* and the *Boy with a Basket of Fruit*. On May 4 Cavalier D'Arpino gives his collection to the Camera Apostolica, in exchange for his freedom, and the two Caravaggio paintings are also passed to Cardinal Borghese. The Este family ambassador again requests the restitution of the advance paid for the unfinished Madonna in Modena, and foresees the probable remission, "absolution of the painter because the stated homicide was an accident and even he was wounded." Again for the Duke of Mantua, on the 15 and 25 of September, an agent in Naples, Ottavio Gentili, and the Flemish painter Pourbus suggest the possibility of buying "something good" by Caravaggio. The *Madonna of the Rosary* and *Judith and Holofernes* are, in fact, for sale. Antonio Ernesto Denunzio's recent studies suggest linking these pictorial undertakings to the purchases of the Count of Benavente, viceroy of Naples from 1603 to 1610. Indeed, in his collection were Caravaggio's *Crucifixion of Saint Andrew*, now in Cleveland, a *Saint Jerome with the Symbols of his Martyrdom*, lost, and a *Washing of the Feet* of which we have no record. To these we can probably add the *Madonna of the Rosary*, even if the reasons why he would have so rapidly ridded him-

self of this work are unclear. In June 1607 Caravaggio leaves Naples to take refuge in Malta. Perhaps he sought protection in order to gain papal pardon. He embarked on a sailing ship of the Order [of the Knights of Malta], not on a private or commercial trade ship. He was certainly protected by Grand Master Alof de Wignacourt, who had for some time been seeking a painter, even of lesser fame, to take to the island. The voyage, as Sciberras suggests, must have been adventurous, because in those same days seven enemy vessels had been spotted off the coast of Gozo. Because of this, during the voyage from Sicily to Malta, all men aboard the ships had to be prepared for combat. Caravaggio soon found himself the centre of attention of protectors and patrons, including Francesco dell'Antella and Ippolito Malaspina, for whom he painted *Sleeping Cupid* and *Saint Jerome Writing*. Antonio Martelli is likely the *Knight of Malta* now at Palazzo Pitti. During his stay in Malta Caravaggio met Francesco di Lorena, who commissioned the *Annunciation* for the main church of Nancy. Meanwhile Caravaggio's fame on the island grew, and Wignacourt realised what luck he'd had. He knew how sought after the artist was with princes and cardinals in Italy, and wanted a portrait, in armour and with a page, for himself. Thus began the process of binding Caravaggio to Malta by knighting him. Obtaining two papal dispensations in order to grant the investiture of Knight of Magisterial Obedience to a man responsible for homicide, Wignacourt wagered that Caravaggio would be unable to leave Malta, once knighted, without his consent. The procedure was quick, and Caravaggio was already thinking of the advantages of returning to Rome with his new rank: "A fugitive convicted of homicide who triumphantly returned to the papal city as a Knight of the Order of Malta, armed and dressed in a black suit with the eight-pointed white cross proudly displayed" (Sciberras). On July 14, 1608, with a bull signed by Wignacourt, Caravaggio received the investiture of Knight of Magisterial Obedience, a "Knight of Grace," since the title of "Knight of Justice" was reserved for the high aristocracy. In the silence and meditation of those days Caravaggio conceives of his most complex and extraordinary work, the *Beheading of Saint John the Baptist*. That supporting, sharing world, gathered in the atrium of a noble mansion, that had been introduced in the theatrical *Madonna of the Rosary* — where poor and rich, saints and preachers all lived together in an overcrowding of space in order to enjoy the benefits of the divine presence — here squeezes into a sombre courtyard before a prison, where the macabre ritual of the beheading is carried out, to which the two mourning, humiliated women are witness, while from the jail window curious prisoners look on. Caravaggio begins to leave empty space, just as he will soon do in the *Burial of Saint Lucy*, another sombre, terrible violence. The large, silent, pained painting, with the signature written in the blood from the saint's head, seems to call forth other difficult moments. Things 21

precipitate; as a knight he had to constrain himself to a measured, prudent conduct, nor was he allowed to frequent taverns, inns, to move amid prostitutes and gamblers, and share the desperate life of the streets anymore. And, being unable to contain himself at length, he found himself on the night of August 18, 1608 at La Valletta, again at the centre of a fight. The incident happened at the house of Brother Prospero Coppini, organist of the church where Caravaggio's masterpiece was hung. Seven knights, all Italian, were involved, and Count Giovanni Roero was fatally wounded. The first to be identified were Caravaggio and Brother Giovanni Pietro de Ponte, a deacon in the conventual church; both were imprisoned at Forte Sant'Angelo merely two days from the feast day of the beheading of Saint John the Baptist, which perhaps coincided with the public presentation of Caravaggio's work. After being imprisoned for the entire month of September, on October 6 Caravaggio escaped and fled the island. Aside from his grave guilt, with his escape Caravaggio had gone against the statutes of the Order, and in particular the requisites of honour and discipline. On December 1 he was stripped of the suit and, *in absentia*, expulsed from the Order. The circumstances of his flight are mysterious, but he was certainly helped to quickly reach Sicily. Sciberras concludes: "The ceremony of Caravaggio and de Ponte's expulsion was held the first of December, 1608, in the oratory, ironically, in front of the *Beheading of Saint John the Baptist* and in the presence of the Venerable Counsel, which many of Caravaggio's protectors took part in. The first to be expulsed *tanquam membrum putridum foetidum* and unanimously banished *in absentia* from the Order was Brother Michelangelo Merisi da Caravaggio." Upon arrival in Sicily — we do not know how worried he was about being pursued following his flight — we find him in Syracuse. It appears he was so absentminded as to behave like a tourist, visiting the antiquities of the city and baptising the most famous quarry the "Ear of Dionysus:" "Moved by that unique genius of his for imitating the things of nature," he reveals how the ancient tyrant "by wanting to make a vessel that served to make things heard," had it built to resemble an ear. But this absentminded attitude is incongruous with the dramatic intensity with which he interpreted the burial of Saint Lucy, with the macabre ritual of the two monstrous executioners who prepare the grave for the saint before a group of mourners. Among them is an old woman who raises her hands to her head, repeating the analogous gesture of one of the two women in the *Beheading of Saint John the Baptist*. By now Caravaggio has entered into an extreme, sombre, visionary dimension, and the imprint of the quarry on his memory reproduces itself in the large empty space of the upper canvas. And that emptiness is still in his eyes when, in the church of the Padri Crociferi in Messina, for the Lazzari chapel, on June 10, 1609, he leaves the *Raising of Lazarus*. The gesture of the hand of Christ returns, not because of a call from life,

but from a call from death, and waves in front of the incredulous eyes of brutalised men, just as it had only ten years before (though it seems a much longer time) in the *Calling of Saint Matthew*. Here the hand of Lazarus replies from the realm of death, regaining life in the arms of the desperate people in gestures of pain and pity. Caravaggio cuts the painting with an ideal horizontal line that divides the empty from the full, and with a vertical line separates the group of mourning humanity from that of mechanical, brutal humanity, which only the presence of Christ can bring back, through surprise, to the light. Later on the senate of Messina will request an *Adoration of the Shepherds*: yet again a monument of humble, poor Christianity, with the Virgin and Child on the ground and, in front of them, lined up and kneeling, the shepherds. The humble objects of the work — the group, carpenter's plane, and breadbasket, that still life of the poor, as Longhi defined it — are resplendent. The straws of hay laid out to warm the ground shine. In Palermo Caravaggio leaves, in the Oratory of San Lorenzo, a more elaborate, refined work; again the *Nativity*: Saint Lawrence, in the Dalmatic that foreshadows Zurbarán, the shepherd seen from behind with hair of tow, the angel that announces of God's glory. A neat composition, with separate parts, without the dramatic and poetic unity of the other Sicilian paintings, it is perhaps the announcement of a palingenesis, of a new, more structured idea of form. It is difficult to prove it better after the thirty-five years since the work's disappearance. After this last try we find Caravaggio on his way back, in Naples, in the summer of 1609. Bellori recounts that, having stopped at the Locanda del Cerriglio, taken by a few armed men, he was abused and received a facial wound. The news appears already in Baglione, who refers to a famously epic Knight of Justice who had followed him to Naples; "and then, being recently reached by him, was so wounded to the face, that one could almost no longer recognise him for the blows." The news, spread by the informers of the Duke of Urbino, was greatly amplified on October 24: "One hears from Naples that the famous painter Caravaggio has been killed, and others say disfigured." In all, his is a life without peace. Nevertheless, even in these extreme hours, there is no dearth of high thoughts and meditations on life and death, through the pain and mortification of the faces of the two women in *Salome with the Head of Saint John the Baptist* in the Royal Palace of Madrid. In the sombre thoughts of the second Neapolitan sojourn the *Salome* in the National Gallery of London was also born. And his idea of himself, like an anticipation of psychoanalysis, is in the head of Goliath in the young, mournful, melancholic *David* of the Galleria Borghese. That face of Goliath, sealed in the last scream, is the face of Caravaggio at that moment. It is from the same period as the London *Salome* with "the rogue who thrusts his arm toward us, almost coming out of the picture itself, in identical fashion to that famous *David* of Galleria Borghese," as 23

Longhi observes, concluding: "And even of this it is permissible to ask oneself if it isn't one of the paintings of his last days in Naples, together with the *Saint John the Baptist* under the sprig of grapevine (also at the Galleria Borghese), where the legs, so boldly polished and stiffened by the shadow, find no match but the *Lazarus* of Messina." Indeed, nothing precludes the possibility that the two pieces were sold through commerce from the South and that Cardinal Scipione bought them after Caravaggio's death. Into the mystery of those feverish circles the simple, brutal *Denial of Saint Peter* now at the Metropolitan Museum of New York also falls, in which, with unsurpassed strength, Ribera and Velázquez are foreshadowed — true shadow and light and symbolic shadow and light. Toward the end, already on the side of death, is the *Martyrdom of Saint Ursula*, which re-emerged after the exhibition of 1951 and was discussed at length, until the correct authorship was recognised by Ferdinando Bologna, and confirmed by Mina Gregori. There is a record of the painting in a letter dated May 11, 1610 addressed to Marcantonio Doria by Lanfranco Massa, his procurator at Naples: "I had thought to send you the painting of Saint Ursula this week, but, to be sure of sending it well dried, I set it yesterday in the sun, which most rapidly made the paint become dry; I want once again to go to said Caravaggio to get his opinion of how one must do in order that it doesn't spoil." There are in this painting, then, the extreme thoughts of Caravaggio, who, in the last months of life, declining his compositions "in an extremely pathetic and dismal way," needed to express torments and melancholies, believing to the very end in painting, even in the consummation of form and colour in shivers of nocturnal light. These late works speak of his thought, and his biographers — those closest to him, such as Mancini, and even those who didn't respect him, like Baglione — speak with infinite pity of his last days of life. He had rediscovered hope, he could believe: "Setting himself in a felucca with a few belongings, in order to come to Rome, returning by order of Cardinal Gonzaga, who negotiated his remission with Pope Paul V. As he arrived on the beach, he was in exchange taken prisoner, and placed in jail, where, held for two days and then released, he no longer found the felucca, such that he set himself into a great fury, and as a desperate man roamed that beach under the scourge of the blazing July sun to see if he could spot the vessel that held his belongings in the sea. Finally arriving at a place on the beach he went to bed with a malignant fever; without human help after a few days he died badly, just as he had lived badly" (Baglione).

We find a variation on this in Bellori, farther from the facts of those last hours, and perhaps of a Romantic leaning towards fiction, underlining the disappointment for not having reached the greatly desired Rome when his pardon had been granted: "Where, as soon as was possible for him, he boarded a felucca, full of most

acerbic pain, and sent himself off to Rome, having already, through the intercession of Cardinal Gonzaga, obtained from the pope his liberation. Coming from the beach, the Spanish guard, attended by another knight, arrested him in exchange, and held him in prison. And though he was finally left free, he no longer saw his felucca that carried his things with it. Thus struck miserably with anguish, and with grief running along the seaside in the greatest heat of the summer sun, arrived at Porto Ercole, and abandoned himself, and surprised by a malignant fever, he died in a few days [...] thus Caravaggio was reduced at the close of his life, and his bones on a deserted beach, and at the hour when at Rome his return was awaited, arrived the unexpected message of his death," solitary and desperate, on July 18, 1610.

Karel van Mander, *Het Leuven Der Moderne oft dees-tijtsche doorluchtige Italiensche Schilders*, Haarlem 1603, fol. 191 r.

G. Mancini, *Considerazioni sulla pittura*, critical edition edited by A. Marucchi and L. Salerno, Rome 1956–1957, I, p. 223.

L. Salerno, D.T. Kinkead, W.H. Wilson, "Poesia e simboli nel Caravaggio," in *Palatino*, 2, 1966, pp. 106–117.

L. Spezzaferro, "La cultura del cardinal Del Monte e il primo tempo del Caravaggio", in *Storia dell'Arte*, 1971, nos. 9–10, pp. 57–92.

M. Cinotti, *Caravaggio*, Bergamo 1973.

L. Spezzaferro, "La pala dei Palafrenieri," in *Atti del colloquio sul tema Caravaggio e i Caravaggeschi*, Rome 1974, pp. 125–138.

L. Spezzaferro, "Caravaggio rifiutato? 1. Il problema della prima versione del 'San Matteo,'" in *Ricerche di Storia dell'Arte*, 1980, no. 10, pp. 49–64.

V. Pacelli, in *Caravaggio. Le Sette Opere di Misericordia*, Salerno 1984.

L'Incredulità del Caravaggio e l'esperienza delle "cose naturali," Turin 1992.

S. Corradini, *Caravaggio: materiali per un processo*, with a foreword by M. Marini, Rome 1993.

E. Fumagalli, "Precoci citazioni di opere del Caravaggio in alcuni documenti inediti," in *Paragone*, 44, 1994, pp. 101–117.

V. Pacelli, *L'ultimo Caravaggio: dalla Maddalena a mezza figura ai due san Giovanni (1606–1610)*, Todi 1994.

Z. Wazbinski, *Il cardinale Francesco Maria del Monte 1549–1626*, Florence 1994.

G. Baglione, *Le vite de' Pittori, Scultori et Architetti. Dal Pontificato di Gregorio XIII del 1572 in fino a' tempi di Papa Urbino Ottavo nel 1642*, edited by J. Hess and H. Röttingen, Vatican City 1995, I, pp. 136, 137.

C. Belloni, *Cesare Crispolti: documenti per una biografia*, in *Michelangelo Merisi da Caravaggio: la vita e le opere attraverso i documenti*, acts of the international study convention, Rome, 5–6 October 1995.

M. Maccherini, "Caravaggio nel carteggio famigliare di Giulio Mancini," in *Prospettiva*, 86, 1997, pp. 71–92.

S. Corradini and M. Marini, "The Earliest Account of Caravaggio in Rome", in *The Burlington Magazine*, 140, 1998, pp. 25–28.

L. Spezzaferro, "Nuove riflessioni sulla pala dei Palafrenieri," in *La Madonna dei Palafrenieri del Caravaggio. Vicende, interpretazioni, restauro*, Venice 1998, pp. 51–60.

Idem, "All'alba del seicento. Caravaggio e Annibale Carracci", in *La Storia dei giubilei*, edited by A. Zuccari, Florence 1999, III, pp. 180–195.

"Roma, la città del papa. Vita civile e religiosa dal giubileo di Bonifacio VIII al giubileo di papa Wojtyla," in *Storia d'Italia*, 16 Annals, edited by L. Fiorani and A Prosperi, Turin 2000.

F. Rossi, "Caravaggio e le armi. Immagine descrittiva, valore segnino e valenza simbolica," in *Caravaggio. La luce nella pittura lombarda*, exhibition catalogue, Bergamo (Accademia Carrara di Belle Arti), edited by F. Rossi, Milan 2000, pp. 77–88.

L. Spezzaferro, "Caravaggio," in *L'Idea del Bello. Viaggio per Roma nel seicento con*

Giovan Pietro Bellori, exhibition catalogue (Palazzo delle Esposizioni), edited by E. Borea and C. Gasparri, Rome 2000, II, pp. 271–274 (and the relevant catalogue description pages).

R. Vodret, "I primi anni romani di Caravaggio: nuovi documenti su Lorenzo Siciliano, alias "fratello Lorenzo pittore", alias Lorenzo Carlo," in *Studi di storia dell'arte in onore di Denis Mahon*, edited by M.G. Bernardini, S. Danesi Squarzina, C. Strinati, Milan 2000, pp. 53–56.

"La Cappella Cerasi e il Caravaggio," in *Caravaggio, Carracci, Maderno. La Cappella Cerasi in S. Maria del Popolo a Roma*, edited by L. Spezzaferro, M.G. Bernardini, C. Strinati, A.M. Tantillo, Milan 2001, pp. 9–34.

A. Cirenei, "Conflitti artistici, rivalità cardinalizie e patronage a Roma fra Cinque e Seicento. Il caso del processo criminale contro Cavalier d'Arpino," in *La nobiltà romana in età moderna. Profili istituzionali e pratiche sociali*, edited by M.A. Visceglia, Rome 2001, pp. 255–306.

L. Sickel, "Remarks on the Patronage of Caravaggio's Entombment of Christ," in *The Burlington Magazine*, 143, 2001, pp. 426–429.

Sulle orme del Caravaggio: tra Roma e la Sicilia, (Palermo, Palazzo Ziino, 2001), edited by V. Abbate and G. Barbera, Venice 2001.

G. Berra, Il giovane Michelangelo Merisi da Caravaggio: la sua famiglia e la scelta dell'"ars pingendi'," in *Paragone*, 53, 2002, nos. 41–42, pp. 40–128.

"Caravaggios 'Früchtekorb': das früheste Stilleben?," in *Zeitschrift für Kunstgeschichte*, 65, 2002, pp. 1–23.

V. Farina, *Giovan Carlo Doria promotore delle arti a Genova nel primo Seicento*, Florence 2002.

G. Floridi, "La morte e la sepoltura di Caravaggio a Porto Ercole e la sua appartenenza all'Ordine di Malta," in *Strenna dei Romanisti*, 63, 2002, pp. 245–253.

M. Maccherini, "Novità sulle Considerazioni di Giulio Mancini," in *Caravaggio nel IV centenario della Cappella Contarelli*, acts of the international study convention, Rome 24–26 May 2001, edited by C. Volpi, Città del Castello 2002, pp. 123–128.

H. Röttgen, *Il Cavalier Giuseppe Cesari D'Arpino: un grande pittore nello splendore della fama e nell'incostanza della fortuna*, Rome 2002.

K. Sciberras, "'Frater Michael Angelus in tumultu': the Cause of Caravaggio's Imprisonment in Malta," in *The Burlington Magazine*, 144, 2002, pp. 229–232.

P. Sohn, "Caravaggio's Deaths," in *The Art Bulletin*, 84, 2002, pp. 449–468.

L. Spezzaferro, "Caravaggio accettato. Dal rifiuto al mercato," in *Caravaggio nel IV centenario della Cappella Contarelli*, acts of the international study convention, Rome 24–26 May 2001, edited by C. Volpi, Città di Castello 2002, pp. 23–50.

La natura morta italiana da Caravaggio al Settecento, exhibition catalogue (Munich–Florence), edited by M. Gregori, Milan 2002–2003.

S. Macioce, *Michelangelo Merisi da Caravaggio. Fonti e documenti 1532–1724*, Rome 2003.

G.L. Masetti Zannini, *Hermes Cavalletti bolognese, ragioniere generale della Chiesa e la sua cappella con il quadro del Caravaggio*, "Atti e memorie. Deputazione di Storia Patria per le Province di Romagna," N.S. 54, 2003, pp. 153–166.

L. Sickel, *Caravaggios Rom. Annäherungen an ein dissonantes Milieu*, Berlin 2003, in part. pp. 50–88.

Caravaggio: l'ultimo periodo 1606–1610, (Naples, Museo Nazionale di Capodimonte, 2004–2005), edited by N. Spinosa, Naples 2004.

M. Maccherini, "Ritratto di Giulio Mancini," in *Bernini dai Borghese ai Barberini: la cultura a Roma intorno agli anni venti*, acts of the convention Rome 1999, edited by O. Bonfait and A. Coliva, Rome 2004, pp. 47–57.

L. Spezzaferro, "La Medusa del Caravaggio," in *Caravaggio: la Medusa. Lo splendore degli scudi da parata del Cinquecento*, exhibition catalogue, (Milan, Museo Bagatti Valsecchi), Cinisello Balsamo 2004, pp. 19 and following pages.

R. Vodret, "I 'doppi' di Caravaggio: le due versioni del S. Francesco in meditazione," in "Storia dell'Arte," 8, 2004, no. 108, pp. 45–78.

G. Berra, *Il giovane Caravaggio in Lombardia: ricerche documentarie sui Merisi, gli Aratori e I Marchesi di Caravaggio*, Florence 2005.

Vittorio Sgarbi

Being and Time in Caravaggio

That Michelangelo Merisi, called Caravaggio, was in reality two people is something that appears (and has appeared) evident to those who have juxtaposed a few episodes of his disorderly and adventurous life with the works known up until now, in their coherent and orderly development. The life and works of an artist always end up resembling one another; but in Caravaggio there is a playful spirit, a pleasure in jest, and a lack of measure in his life that are not mirrored even in the most open-minded work, which is instead explained by a radical renewal of the thought to which all intemperance is foreign. In Caravaggio a sophisticated, cultured intellectual capable of creating an ideal shift in the course of history lives alongside the quarrelsome, overbearing — in a word, cursed — protagonist of an adventure novel, just as romantic interpretation would have had it. On the other hand, his irregularity certainly cannot be traced back to the spirit of the age, as a way of being that today seems extravagant but that was instead quite common in that difficult and violent epoch, which approximately coincides with that of the 'bravi' of Manzoni's don Rodrigo. Caravaggio's behaviours didn't fail to appear singular even to his contemporaries, considering above all the traditional role of the artist. The true greatness of Caravaggio lies in his having shown the other side of reality, which is, in the end, the authentic one. But these are external elements, psychological reflections that pass from life to art. It is, in any case, excessive — in order to realise a formal revolution, and especially in this case a revolution of ideas — to fight with everyone, confront lawsuits, provoke cops, kill, get hurt, escape: all things quite distant from the slow and difficult concentration of painting, of the work that, in few artists as much as in Caravaggio, seems the fruit of an extraordinary dedication and coherence. And yet a large part of Caravaggio's ideas rest on his conception of life, and are a consequence that doesn't impair the autonomy of his aesthetic. Frequenting the streets was, 27

for Caravaggio, a sort of metaphor for the flight from the 'ivory tower' represented by the studio. It was a way of always being in direct contact with the things that cast reflections on the work of art, if not in the phase of execution, in the moment of concentration; this is a typically modern behaviour, of which in our own century, in various manifestations, a man like Pier Paolo Pasolini was testimony to. Even for him, certainly, a direct relationship between the experiences of life and the ultimate, fundamental experience of a work of art didn't exist. This, nevertheless, be it in a creative or theoretical manifestation, found its profound reasons in Caravaggio's passions, desires, encounters, violence, and even death (or its foreshadowing) — reasons experienced in the confrontation with reality. It is evident, reading direct sources and testimonies, including that of Caravaggio himself at the trial of 1603, when he was accused of defamation by Giovanni Baglione, that above all what pressured Caravaggio, after all else, was precisely his painting, his engagement and efforts as an artist. Life offers thousands of chances that he, out of voracity, doesn't want to miss; but he also knows when it is time to reflect on things, return to the canvas, to transport to it all the dense, terrible, and passionate reality that he has encountered. There must be nothing in art that isn't in life; and if life momentarily seems richer and more open to art, this, in time, will remain alone to speak to us, and must gather within itself at least part of the glimmers, sweetness, thoughts, and human experiences that are lost forever. Art must be a mirror of reality. Because of this, that which seems like violence, adventure, desecration, and wretchedness in the human vicissitudes of Caravaggio is instead a total immersion in existence, lived in order to gather the flame of vitality bursting forth in absolute immediacy. And it is singular that it all recomposes itself not only in the formal measure of art, but also in the moral measure, in a profoundly humane and Christian truth, in the works. How can one who has committed murder give examples of virtue — of authentic, profound, and absolute morality? Caravaggio was able to. After Giotto and Masaccio it fell to him to bring us ever closer to the truth of things, a painful truth, made up of the humble and poor rather than the rich and powerful, of the most beautiful youths and desperate elderly folk, of mourning and crushed women, of Magdalenes and Narcissuses. Caravaggio must have never been truly happy. Born in 1571, probably in Milan, to a family originally from Caravaggio, from which the painter took his name, he entered as an adolescent into the workshop of Simone Peterzano, where he remained for four years, through 1588. It cannot be excluded that in those years, as Peterzano declared himself a student of Titian, Caravaggio may have visited Venice, to then leave in the early nineties for Rome. The old sources, such as Mancini, Baglione, and Bellori, are in relative agreement in giving us news about his formation, indicating the *Boy Bitten by a Lizard*, *Boy Peeling Fruit*, the *Sick Bac-*

the other a bit sickly, with a sallow complexion and ashen lips, and yet another, chubby, with puffy cheeks, marked eyebrows, and pitch black eyes. Even in this choice there is a complacency, not a desecration of the myth, but of the need to make understood the fact that every ideal is set in reality and can find a concrete representation that is intimately anticlassical or anti-humanistic. These aestheticising cross-dressings of his, coloured with homosexual morbidity, recall those of Baron Von Gloeden, who attributed the nude bodies of Sicilian boys bruised by misery to his dream of Greek beauty. Caravaggio anticipates, by four centuries, the photographs of the licentious baron; but in Caravaggio there is no vice, because that which must be faithfully respected is reality. The fruit is just like the fruit that in a little while will go bad, and Bacchus is that boy, not another, because there is no difference between people and things. As Caravaggio said to the Marquise Giustiniani, "it took such handwork to make a good painting of flowers as of figures." Here is why, for the first time, a complete painting can appear to us, enough unto itself, dense with human 'values,' no less than an historic or religious subject; the famous *Basket of Fruit* of the Pinacoteca Ambrosiana was the first example of still life as an autonomous genre not because you couldn't judge other similar baskets that appeared in more ample compositions the same, but because here the 'genre' surpasses itself and the painting represents absolute values that lie not only in a possible allegorical interpretation, but in a total restitution of the real, which is the same regardless of what subject is represented. Caravaggio's phrase means not only a technical fact and moral indifference for the theme, but also a visual equivalence and a display of mental aptitude toward things. The truth of the fruit is the same truth of man. This is why the *Basket* of the Ambrosiana is so important, this is why it is not just a still life, but is a manifesto of modern thought, the testimony of the Copernican revolution's completion even in painting. Having reached this point, Caravaggio no longer has anything to learn from Cavalier D'Arpino, and we find him in close relations with the grotesque painter Prospero Orsi, around 1595. It was perhaps his friend or, as Baglione would have it, master Valentino, a painting dealer at San Luigi dei Francesi, to introduce Caravaggio to his first protector, Cardinal Francesco Maria Del Monte, a highly cultured, powerful man and immediately impassioned collector of the artist's works. It is this rapport that permits, more than many authoritative critiques have wanted to admit, the connection to Giorgione. Indeed, even translating them into his modern lingo, the themes Caravaggio dealt with in this period are clearly inspired by his patron, and correspond to the tastes of the humanistic circle in genre painting: *The Fortune Teller*, *The Cardsharps*, the *Lute Player*, the *Concert of Youths*, up to the explicit neo-Veneto retakes such as the *Rest on the Flight into Egypt* and the *Magdalene*. This last work, despite its great elegance, is already quite dis-

imitator of nature, and admiring his works as miracles they followed him in a race, stripping models and raising lights; and without waiting any longer in studio, or for lessons, each easily found, in the squares and on the streets, their teacher and example, in copying natural things." Now we witness the development of his very first ideas; here the figures are painted with the same objectivity as flowers and fruit are painted, and the historical and allegorical episode of the *Calling of Saint Matthew* becomes a gathering of gamblers at an inn. Caravaggio seems to prescribe himself a norm from which he will no longer deviate in the future — the norm, that is, of not representing anything by the light of day, but rather in a room lit by lamplight, capable of outlining strong chiaroscuros. Even the scenes set in the open, such as *Saint Francis of Assisi in Ecstasy* or the various versions of *Saint John the Baptist* are lit with a strong artificial light. But above all in Caravaggio the theatrical spirit is very much alive: the two large canvases with the *Calling* and *Martyrdom of Saint Matthew*, and also the two versions of *Saint Matthew and the Angel*, were set on a stage with only a few essential elements useful for defining the room and atmosphere: a window, a table, two chairs for the inn, or a column and altar for a church, a wobbling stool for the studio of the saint-come-evangelist. And it is always a question of original sceneries; in the *Calling* the characters are in vintage costume, and of various ages. While they play they are surprised by a sudden event. The two pilgrims enter from the doorway without announcement, and with them a sudden light arrives. The pilgrims are dressed in clothes without age, walking barefoot, and they have mussed hair and large, knotted hands. The younger one raises his arm, almost with indolence, making his trembling hand shine in the shadow; he wants to point to one of the gamblers, and intensely fixes him in his stare. Matthew's stupor and curiosity are mirrored in the glance of his young friend. Two other gamblers don't realise a thing; a third suddenly turns, marking his legs and pointing his hand on the corner of the stool, intensely attracted. The dialogue of the two protagonists' hands strongly suggests theatrical mime, but is also a very essential way of communicating, of being halfway between the quotidian and the symbolic. Caravaggio succeeds in keeping the two levels — the literal and moral meanings — perfectly autonomous and perfectly communicating. When he moves on to the episode of Martyrdom, a few compositional complications, echoes of a mannerist setup, seem to make the passage between the two levels more difficult, perhaps precisely in order to achieve a scenographic accentuation. The synthesis of the previous episode risks being fragmented into many single episodes that in naturalistic relief alternate between an heroic gestural emphasis, as in the case of the young brute in the centre, and virtuoso acrobatics, as in the case of the angel who leans out from the cloud to extend his palm to the saint, who with perfect synchronicity offers his

tal energy overthrows any human identity, and the sole one whose face is visible shows a mask with wrinkles cut into the thick skin with short, very dense hair. This is a true martyrdom; we feel the weight of the wood of the cross, we read the pain in Peter's face, and once again everything happens in a moment, there's no time to lose. Extraordinary monuments of action, these two paintings seem a declaration of war against Annibale Carracci — who was hired for the *Assunta* of the main altar in the same chapel — and the vision of another world without time, while that of Caravaggio is both of his time and of all time, an obscure allegory of violence. To prove how radical his dissention was, Caravaggio had even given a second version, probably more extremist than both of the other paintings that had been requested on panel, and certainly more extremist than one in particular, the *Conversion of Saint Paul*, the primitive version of which is in the Odescalchi collection. It is a marvellous and complicated machine, where the action multiplies itself into many episodes, with a conception of space that is still mannerist. One has reason to marvel at the fact that the two final versions of the paintings were accepted without discussion and censure, those same censures that Caravaggio had to undergo for his *Saint Matthew and the Angel*. But here the strength of the happenings is translated in such essential terms that it seems it is directly witnessed, as if there could be nothing but what happened in this way. I think this sensation must have also reached the patron, monsignor Tiberio Cerasi, like the acceptance of something ineluctable. As Longhi confirms, in the *Crucifixion* "things happen with a blameless evidence, where each tends to his own work." By now the truth of a moment had been taken in, and here Caravaggio is confronting with the same spirit the *Supper in Emmaus*, the *Sacrifice of Isaac*, and for Vincenzo Giustiniani an *Amor Victorious* whose spread wings don't suffice to weaken the irresistible sexual charge, stronger than art, whose instruments remain abandoned on the ground. We're in 1603, the year in which the vital exuberance of the artist brings him to court and jail, as art doesn't have it all. The painter Giovanni Baglione had sued him, and Orazio Gentileschi and Onorio Longhi along with him, for some slanderous poems that supposedly were dictated out of envy for a work by Baglione himself. Caravaggio would supposedly have written the composition, whose first verse reads: "Gioan Baghagha you don't know an ah." Before the trial takes place Caravaggio ends up in jail for having wounded Flavio Canonico, a sergeant at Castel Sant'Angelo. Called from the prison to take the stand, he leaves us (you can see the philological importance of the lawsuits handed down to us surviving in judicial records!) the only direct testimony of his word and thought, expressed in a rather strange occasion, but on subjects that directly address the arts and his relationships with his artist contemporaries. In the painter's deposition we read the proud declaration of his own artistic profes-

34

in daily fights, quarrels, and lawsuits. Here he is again, on the 19 and 20 of October 1604, in the jails of Tor di Nona for having insulted and thrown stones at the cops in via dei Greci. More insults and more incarcerations occur on November 18, when Caravaggio is stopped at Chiavica del Bufalo for an arms patrol check. After showing his license, the artist can't resist insulting the official who disturbed him; and once again he is sent to the Tor di Nona prisons. More fights in 1605, more jail time and lawsuits. The notary Pasqualone da Accumulo claims his head was wounded when struck by a sword after fighting over a certain Lena "who is Michelangelo's woman." This time Caravaggio prefers to flee to Genoa. He returns on August 26 , but already by September 1 Prudenzia Bruna, the woman from whom the painter had been renting a room, accuses him of breaking a window shutter by throwing stones to vindicate the sequestration of his belongings in return for the rent that hadn't been paid for at least six months. On October 24 the painter is wounded: he refuses to speak to the notary of the "criminals" who struck him on the throat and left ear, obstinately claiming that he hurt himself by falling on his own sword. This sword really becomes a symbol, a metaphor of uncontrollable action, opposed to the brush that Caravaggio seems never to have abandoned. He is equally fond of both his sword and brush. Between the end of 1605 and the beginning of 1606 he sends out the *Madonna* for the altar of Sant'Anna dei Palafrenieri in Saint Peter's. After two days the altarpiece is transferred elsewhere. This is yet another rejection, despite the subject, which was more respectful of ecclesiastic iconography than others, with the Son who pushes on the foot of the Madonna to help her crush the head of the serpent. The face of Saint Anne is wrinkled and marked as the living symbol of poverty, misery, and the spirit of the disinherited, and even if the composition is above condemnation it seems opportune, in any case, to avoid making it too evident. Caravaggio is misunderstood, and here he repeats himself again in the *Madonna di Loreto* for the church of Sant'Agostino, painting an apparition to two ragged farmers with filthy feet, "nothing but a man and woman of the people, among the most torn up of pilgrims who, having reached the end of their long walk, have the good fortune of immediately encountering the Virgin, while, leaving the house and pausing for a moment at their intention, she leans against the old doorpost." Here the commoners become protagonists of the action, even here where action isn't necessary, where there is no need for the superfluous. Caravaggesque anti-humanism is to be understood as a central and extremist manifestation of Lombard anti-humanism on par with that of Moroni and Manzoni. The heroes are the humble ones, in a perspective that doesn't want to know of the problems of beautiful souls, that is the refusal of art as evasion, art that is a direct take on the problems of reality. While Car-

avaggio seems to understand the most authentic motives of Chris-

tianity in his radical vision of humanity and the most humble ranks, his works distance themselves inexorably from traditional schemes. Right after the 'accident' of the *Madonna dei Palafrenieri*, the *Death of the Virgin* for the church of Santa Maria della Scala is refused for having the painter's having represented "the Madonna with scarce decorum, swollen, and with uncovered legs," a poor drowned woman, around whom — with an intensity not seen since Nicolò dell'Arca's *Compianto* — the neighbourhood folk who have just taken her from the river gather to mourn. The light enters suddenly into the room animated by the large suspended red tent, lights the heads of the desperate old people, and rests on the lifeless face and abandoned hand of the Madonna, stopping on the neck of the woman reclining in the foreground. The scene is grave and solemn, the pain essential and absolute, and death is without appeal and without hope. Such a sublime and dramatic grandeur, misunderstood by thea "good Fathers" of the church of Santa Maria della Scala, was fully understood by Rubens, who in 1607 bought the painting for the Duke of Mantua.

Meanwhile, the painter — who step by step moved forward to reach the deepest truths of existence, and at the same touched the abysses of abjection — is involved in the umpteenth brawl. Two gangs face one another, each with four men: the head of the first, Caravaggio, kills Ranuccio Tomassoni, from Terni, and, though wounded, flees. He stays hidden for some time at Paliano, thanks to the protection of Prince Marzio Colonna. He will never again see Rome. In 1607 he reaches Naples, while in Rome the local painters, excited not only by his rich legacy of ideas but now also by his mythic stature, witness the week-long exhibition, curated by Rubens himself, of the *Death of the Virgin*, which is about to be packaged up with the greatest care for shipping to Mantua. Naples is his second Rome, and here he immediately finds new and perhaps even more motivated followers. With the great excitation about work that so markedly distinguishes him — almost a fever lucidly controlled by the intellect through an implacable development — he paints the *Seven Acts of Mercy*, a masterpiece in which the most desperate vision of an elementary humanity lives alongside a faithful didactic representation of the moral precepts of the Catholic Church. The same intensity of the *Death of the Virgin* passes through this theatrical machine, a work so full of concepts and behavioural norms brought together in an improbable unity of action. High up the embrace of the angels, between whose wings we catch a glimpse of the Virgin as if from a balcony, is another ingenious machination of a great director, and is also a sign of bursting vitality. A new classicism, more inspired than in Rome, seems to characterise the Neapolitan Caravaggio, and we see it in the *Madonna of the Rosary*, with the large red curtain gathered round the fluted column, with a rhythm Poussin would have liked because it recomposes the dis-

ordered rhythm of the curtain in the *Death of the Virgin*. In both cases it is a question of theatrical devices used to imbue the composition with a formal rhythm. In the *Madonna of the Rosary* it is still a dogma, revealed with a limpidness that pays homage to Lorenzo Lotto and his own hand in the *Madonna di Loreto*. Classicism reaches its most extreme consequences in the *Flagellation* for the church of San Domenico Maggiore, where the essential and dynamic rhythm of the *Martyrdom of Saint Peter* and the *Deposition of Christ* returns. Here again evil and good are together, on the same level, as inseparable expressions of life. In 1608, while awaiting absolution "because the homicide in question was an accident, and even he was badly wounded," he departs for Malta, where he is welcomed among the Knights of Grace (since he wasn't a noble, as nobles were Knights of Justice). It is the 14 of July. The contradiction that marks Caravaggio's existence now leads him to make his most epic, grandiose, modern, and essential painting, a synthesis of ten years' research, expressionism, and classicism, in a drama composed in a balanced way within a large space that is absolute theatre, absolute Shakespearean tragedy. It is the *Beheading of Saint John the Baptist*, which Longhi defined "the greatest painting of the century." Here everything is still, solemn, definitive.

After the almost physical clamour of passionate life that burst forth from the Neapolitan altarpieces, here Caravaggio's drama is distilled in a motionless space, without depth and without echoes. There is proof that the *Beheading* was famous at the time and that its admirers (including Bellori) undertook the long and uncomfortable trip to Malta just to see it: but one must wonder what role such a mercilessly austere painting could have within an environment like that of Italy, which was already dominated by baroque spirituality. The only person able to understand it was perhaps the other disillusioned, introverted genius of the seventeenth century — Rembrandt.

In just a few weeks he paints other works, like the *Portrait of Grand Master Wignacourt in Armour with a Page*, *Saint Jerome Writing* (an extreme maturation of the *Saint Matthew with the Angel*), and *Sleeping Cupid*. But a few days suffice for Caravaggio to find himself involved in some ugly doings. On October 6 he flees from the jail of the Maltese Order, where he had been most likely locked up for affronting a Knight of Justice, which costs him expulsion from the Order into which he had just been admitted. He is no longer even on the island, because we find him in Syracuse, where, almost like a carefree tourist, he visits the Greek antiquities and in front of the most famous quarry nonchalantly comes up with the lucky definition we now know it by. He called it the "Ear of Dionysus," attributing the intention of "wanting to make a vessel that served to make things heard" to the ancient tyrant. His vision of art remains very pure, and in the large space of the *Burial of Saint Lucy*, for the

eponymous church, he repeats and redoubles the drama of the *Beheading of Saint John the Baptist*, with a potency that is concentrated in an animal-like way in the two figures of the executioners in the close foreground before the inanimate body, like that of the swollen Virgin, of Saint Lucy. Standing behind her, dispersed in the void, are the mourners, contrasting, in their disoriented, pained faces, with the almost monstrous head, with neither neck nor human expression, of the executioner, victim of his own bestiality. From Syracuse Caravaggio goes to Messina, where he leaves another tragic masterpiece, the *Raising of Lazarus*, in which, at an almost unbearable degree of pain, the ancient formal elegances are forever lost, even if citations of distant thoughts live on, as in the hand of Lazarus trembling in the light. And another most pure masterpiece, in a perfect space, where everything is reduced to the most extreme, humble truth, is the *Adoration of the Shepherds*, also at Messina, for the Capuchin church. The four-post tent, planted on the earthen floor, contains all humanity in the pleasant warmth of a few strands of hay. In the foreground we see what Longhi defined a "still life of the poor," with tablecloth, a loaf of bread, and a carpenter's plane. Having reached Palermo en route back to Rome, he paints an *Adoration of the Shepherds in the presence of Saint Lawrence and Saint Francis* for the Oratory of San Lorenzo, in which he presents himself again with some justly pictorial elegances in a more studied composition, as if he has achieved a new serenity after the major, total, and desperate tests of the previous years. Caravaggio returns to Naples in the summer of 1609, just in time to be intercepted at the door of the Locanda del Cerriglio by the men of his Maltese rival, who beat him past the point of recognition. The painter stays in Naples for about ten months, and paints yet more works without pausing to catch his breath, including *Salome with the Head of Saint John the Baptist*; *David with the Head of Goliath*, in which is hidden his own devastated and terrible *Self-Portrait*; a *San Giovannino*, extreme incarnation of the youthful little Bacchus depictions; and an *Annunciation* (now at Nancy) of simplified elegance and an already baroque spatial layout. But by now Caravaggio has exhausted his own Neapolitan experience and feels within the urge, push, and restless desire to return to Rome, in hopes of a grace that had been announced from various directions. He makes the voyage by sea, in a felucca pointed in the direction of Port'Ercole, where he is to await readmission to Rome. Upon disembarking he is mistaken for someone else, interrogated, and left by the Spanish police, who confiscate the few goods he'd brought with him. Desperate and alone, the painter walks the deserted, malarial beach in search of the boat that has already left. Here he is caught by a malignant fever, "and without human help after a few days he died badly, just as he had lived badly." It was July 18, 1610; at the end of that very month Caravaggio would have obtained Papal pardon.

Vittorio Sgarbi

Interpretations: from Federico Borromeo to Ferdinando Bologna

Despite the fact that the fire lit by him blazed throughout Europe, Caravaggio never received due recognition, even from the earliest, most sensitive, intelligent interpreter of baroque painting, Giovan Pietro Bellori. Little more than fifty years after his death the judgement passed on him is as precise as it is implacable. His originality is recognised: "Caravaggio was without doubt suited to painting, come a time that, nature being made little use of, people depicted practical and mannered figures, and were more satisfied by the sense of vagueness than that of truth. Therefore, removing every little beauty and vanity from colour, he reinvigorated the tints, and gave back to these blood and incarnation, reminding painters of imitation." Straightaway Bellori notes a limitation: "One doesn't find, though, that he uses cinnabars or azures in his figures […] and even if once in a while he had made use of them, he weakened them, saying it was the poison of the tints. I won't speak of turquoise, clear air and sky, which he never coloured in the histories, but rather always used a field, and a black background; and the black in the flesh limited the strength of the lamp to very few parts;" and worse: "Caravaggio appreciated no one but himself, calling himself the faithful, sole imitator of nature. He was missing many — and the best — parts, because in him were neither creativity, decorum, drawing, nor any science whatsoever of painting, while if the model were removed from his sight his hand and ingenuity remained empty." But Bellori must have been aware of the contagion Caravaggio's painting had inspired. He observes, without hiding his reprobation, in the name of order and harmony, that "many were smitten with his manner, and willingly embraced it, because study and hard work facilitated the tendency to copy nature, following vulgar bodies without beauty. The grandeur of art was thus subjected to Caravaggio, everyone took license, and the depreciation of beautiful things followed. All authority of antiquity was gone, as was Raphael's, where 41

for the comfort of the models, and to portray a head from nature, leaving behind the use of histories, which are the property and duty of painters, they gave themselves over to half-length figures that before then were not much in use. Then began the imitation of vile things, seeking out filth and deformities, as some anxiously did; if these [painters] are to paint some armour, they select the most rusted one; if a vase, they do not do it in its entirety, but foully, and broken. They dress in tights, trousers, and large hats, and thus in imitating bodies they stop and focus all their study on the wrinkles, and the defects of the skin and its surroundings; they form knotty fingers, with members changed by malady. Because of these modes Caravaggio encountered displeasures, as his paintings were taken down from altars." The conclusion, which will guide critics for the following two and a half centuries, is still more severe: "As some herbs produce healthful medications or pernicious poisons, so Caravaggio, even if he were in part suited to it, was nevertheless harmful, and set head-over-heels every ornament, and fine habit of painting. And painters, truly distracted by imitation of nature, had need of someone to set them back on the righteous path; but as one so easily flees one extreme only to run into the other, thus they distanced themselves from the correct manner, and for having followed nature too much they moved utterly far from painting, and remained in error, and in the dark, until Annibale Carracci came to illuminate their minds and return beauty to imitation." It is possible to imitate from nature even subjects that aren't low and vulgar or, even worse, vulgarising lofty subjects; "such modes of Caravaggio agreed with his physiognomy, and aspect. He was of a dark colour, and had dark eyes, black eyelashes and hair; and he naturally succeeded in being the same in his painting." But Bellori recognises that even Caravaggio had initially tread this path: "The first manner, sweet and pure of colouring, was the best, being advanced in this to the highest merit, and proven himself, with great lauds, an optimal Lombard colourer." Here, even for Bellori (1672), we have arrived at the point. "But he then went on to the other dark (manner), drawn to it by his own temperament, as in his habits he was still turbid, and contentious." Finally we come to the moral judgement — or rather prejudgement — of the person: "We will not fail to note the modes of his comportment and dress, using drapes and noble velvets to adorn himself; but then, when he dressed himself in an outfit, he never took it off, until the point where it was falling into rags;" and the legend of the damned one, of the bohemian: "He was most negligent in cleaning himself; for many years he ate his meals over the canvas of a portrait, using it as napkin and tablecloth morning and night." These anecdotes are useful annotations for the (negative) legend. But the formula worked: "Many were those who imitated his manner in natural colouring, thus called Naturalists." This is a perfidious epitaph as well as a consecration — albeit a contro-

versial one. Naturalism originates from Caravaggio — a painting of truth, even too crude, too tragic, without the comfort of the ancient if not pretextuous, used. The figure of Caravaggio is constructed in contrast with all that is classic. Félibien ups the ante: "The painter must, above all, concern himself with rendering his own works pleasing: but this is precisely what Caravaggio has never done. Please consider, if you will, what great talent he possessed. He painted with a knowledge of colours and light more knowledgeable than that of any other painter."

But by now the path is set, and in order to fully recognise the greatness and influence of Caravaggio one must await Longhi. Unlike Raphael and Michelangelo, who had a studio and school, Caravaggio had no followers. From his energy autonomous, original figures are generated that could not exist without him, but which do not imitate or replicate him; they understand the method and call to reality, to nature. Without him there wouldn't have been — at least in the way in which they were revealed — Rubens, Velázquez, and Vermeer. They follow new, unpredictable paths. Caravaggio is a fever, a virus, but those who follow him cannot copy; they can, if anything, extend, enlarge, and recognise the method, and very distinct personalities come out of this, from Gentileschi to Vouet, Stomer, Mattia Preti. Jusepe de Ribera can be called completely Caravaggesque, in his first phase, as can Artemisia Gentileschi — a woman, no less.

Frequenting the streets, Caravaggio invents photography. In the interior of a dark workshop the light of a reflector falls on a group suddenly torn from counting money by an unforeseen change — the arrival of two pilgrims, who instead of asking for assistance have come to propose some news, some new business. "You, precisely you," the person who has just arrived seems to indicate with his hand in midair, both mysterious and sure of himself. We are there, witnesses of this offer that cannot be refused. Caravaggio represents the 'decisive moment,' in which reality is composed before us to give us back its profound meaning. Caravaggio sees it first, as no one ever has. This intuition renders him indispensable to any artist in Rome. Suddenly reality shows its true face without being prefabricated or domesticated. In this real absolute Caravaggio prefigures photography and revolutionises a vision that doesn't represent an idea or world order, but rather shows the world as it is, how it sets itself before our eyes. This contradiction is completely foreign to any metaphysical conception, and contrasts, above all in the religious subjects, with the prescriptions of the Counter-Reformation: "For these modes Caravaggio encountered displeasures, as his paintings were taken down from altars." The clumsy attempt at explaining Caravaggio's poetics through a privileged relationship with Cardinal Borromeo is unfounded. The truth is that the cardinal certainly had some knowledge of the young painter, but in the report he 43

leaves us, newly illustrated and written from the correct point of view, by Ferdinando Bologna, one understands the infinite abyss that separates their visions, with a distance more moral than aesthetic. Federico recognises the wholly immanent character of Caravaggio's experience — no transcendent perspective, and a substantial correspondence between life and work. "In the order of human things scientific men have made observations, finding themselves in a certain exquisite correspondence and proportion, of which they speak thus: as is the condition of the earth, such are the fruits and the crops […] and as are human bodies, such should be, naturally speaking and for the most part, the condition of ability; and finally, as is the condition of their talent, such is the condition of their compositions." This is the premise for describing, without indicating a name, a painter that has all the characteristics of Caravaggio: "In my days I have known a painter at Rome who was of filthy habits, and always went about with torn rags for dress, and unbelievable foulness, and one continuously saw him among the youths of the courtly people's kitchens. This painter never did anything else, as he was good at his art, than represent the innkeepers and gamblers, or the gypsies that read hands, or the swindlers, and the porters, and the disgraceful, who at night slept in the public squares; and he was the most content man in the world, when he had painted an inn, and within it those who ate and drank. This proceeded from his customs, which resembled his works." In the end, beyond the captious attempts at transmuting the truth about Caravaggio into an evangelical perspective, this is the judgement passed on the artist, normalised just a few years after his death — so it is in Baglione, Agucchi, and Bellori. The principle is that, an artist's "habits resemble his works;" and that "contaminated men mustn't deal with divine things, having rendered themselves unfit for such ministry; […] full of vices and guilt as they are, one cannot see how they can infuse in [their] images the piety and religion that they do not possess." These reflections are the most faithful mirror of the conception of Caravaggio, precisely because of their negative characterisation, for their unwillingness to recognise his spirituality, which moves best where he feels evil, sin, disease, and death. He who is of "filthy habits" and is "contaminated" cannot paint Good. Bologna responding to those — in particular the obstinate Calvesi — who confute the words of Federico in reference to Caravaggio, gives us the probative answer. In the notes written in his own hand and recorded above, Borromeo had written: "Narrating the likes of Michel Angelo Caravaggio: in illo apparebat l'osteria, la crapula, nihil venusti: per lo contrario Rafaelo." This sets Caravaggio *versus* Raphael, the real against the ideal. This independence from religious precepts, this secular, agnostic vision allows Caravaggio to paint the world without prejudices, and to seek out the truth in things. Yet a profile of the painter

that corresponds to the bad mood of Borromeo, motivated by an

indestructible Christian conviction, is clear in the testimony of Luca, barber of the late Marco Romano, who was interrogated in the tribunal on July 11, 1597: "This painter is a horrid youth, twenty or twenty-five years of age, with a bit of black beard, chubby, with large eyelashes and black eyes, who dresses in black, in a rather unorganised fashion, as he wore a pair of slightly torn black stockings, and as he wore his voluminous hair long in front." If this setting is the one so punctually reconstructed in Bologna's interpretation, whose observations are again elaborated in the essay for the Neapolitan exhibition *Caravaggio: l'ultimo tempo*, the tight evolution of his style fully confirms it. Even the progressive dimming of the light, so evident between the first and second versions of the *Supper in Emmaus*, in a grinding up of colour that seems to rarefy itself, renouncing all preciousness, into an admirable simplicity of execution, projects Caravaggio toward night, toward death. When he arrives at Sicilian works the mystical process seems to be complete. It is a bona fide journey to the end of night. The *Burial of Saint Lucy*, *Raising of Lazarus*, and *Adoration of the Shepherds* all emerge from a closed environment in which no light enters, be they quarries, sepulchres, or thatched-roof huts. Those flashes and shivers that had crossed through the works up to these years are extinguished, as if to signal that the season of hope is over. Above the heads of those gathered in the *Burial of Saint Lucy* — though from no sign are we made aware that she is a saint, but that she is wholly entrusted to earth and death — is a large empty space in which the lightless quarries are hinted at. It is difficult to imagine, before Caravaggio, before this period, such vast, indistinct spaces, negative space prevailing over positive space, vibrations of darkness. Having tried out closed, oppressive space in the *Burial*, Caravaggio doubles it in the *Raising of Lazarus*, even more indistinctly. That darkness, unlike that of the *Burial*, generates a light that is no longer physical. It seems to be called by — and symbolically coincide with — life: from the gesture of Christ that points to Lazarus and revives him with light; the hand that opens to the newfound existence; all the way to that which puts death at a distance. The process completes itself in this ideal triptych, in the Nativity, with the Madonna seated on the ground, upon which the shepherds seem to precipitate into the humble wooden hut, between adoration and prayer, warmed by ox and donkey. The obstinate closure to any external light heightens the interior luminosity of the protagonists, who generate light. The painting seems to want to express the equivalent of the mystical experience of Saint John of the Cross: "The higher I climbed / the more my sight grew dim, / and the most bitter conquest / was a work of darkness; / but in the amorous fury I blindly hurled myself forth / to such height, to such height / that I reached the prey. / The more I brushed up against the summit / of this exalted furor, the more I felt / low, surrendered, overpowered.

The descriptions have been revised
and the bibliography updated by
Vittorio Sgarbi and Paola Caretta.
The bibliography for the descriptions refers
to the monograph by Maurizio Marini,
Caravaggio 'pictor praestantissimus'
(Rome 2001), with concordances, updates,
and underlining.

Description writers
P.B. (Piero Boccardo)
B.C. (Benedetta Calzavara)
A.C. (Alberto Cottino)
G.D. (Giulia Davì)
C.D.F. (Clario Di Fabio)
A.L. (Antonella Lippo)
K.S. (Keith Sciberras)
V.S. (Vittorio Sgarbi)

The Masterpieces

1
Self-Portrait as Bacchus

Oil on canvas, 67 × 53 cm
Rome, Galleria Borghese

Against a uniform brown background a youth crowned with ivy — with his right shoulder and part of his back bared, and a light-tempered white tunic with a mauve band knotted round the waist — turns toward us with ashen, bloodless lips and a slightly gaunt face. In his hand he holds a bunch of white grapes, which he seems to lift to his face. Another bunch of grapes, this time red, and two peaches are laid on the stone tabletop. This is an enigmatic and melancholic image, of a fresh, vital, and 'quotidian' naturalism, and yet also laden with cultured classicism and rich with symbolic references. More than a god, Bacchus appears in reality a simple boy, of precarious physical complexion, just as many that could be seen at that time in the city streets, which the slightly theatrical and artificial *mise en scène* of the crown of ivy and the tunic seems to render a little embarrassed. This is probably a self-portrait, and one of disconcerting frankness inasmuch as it doesn't hide the problems, torments, and anxieties of the young artist.

"Another little painting with a young fellow with a Garland of ivy round him, and a bunch of grapes in hand, without a frame;" this is how the work was described for the first time, as number 54 on the list of paintings sequestered by Pope Paul V Borghese from Cavalier D'Arpino in 1607, to then reappear continuously, with various attributions (Carracci, Tiarini), in the many inventories of the Borghese household. According to Baglione (1642) this is the first painting done by Caravaggio as an independent painter: "He then went to stay in the household of Cavalier Giuseppe Cesari D'Arpino for a few months. Thence he tried to stay on his own, and made some small paintings portrayed from the mirror. The first was a Bacchus with a few different bunches of grapes, made with great diligence, but slightly dry in manner." We must, then, be around 1592–1593: the outlines and echoes of Lombardy, his home, and his adolescence clearly come to the surface. Mina Gregori in particular has underlined how the very structure of the image depends on the *Sibilla Persica* painted by Simone Peterzano in the Certosa di Garegnano; but one mustn't forget that certain passages, such as the intense facial mimicry, go back to Leonardo. Gregori also (1984) rightly notes that these half-length figures, which also seem to evoke "the Giorgionesque poetic aura," fit within a current that was typical of those years in Northern Italy (practiced also by Annibale Carracci) "of 'comic' and didactic poetry, whose level corresponded, with regard to history painting, to that of comedy — and the didactic genre of classical poetics — with regard to tragedy." The extreme naturalism, wholly Lombard, with which Merisi portrays himself in the mirror is probably totally new to the Roman scene. And yet here we see an interest in the ancient world that seems completely Roman, and even a reflection on the works of Michelangelo (I refer to the small satyr in the lower portion of the *Bacchus* executed for Cardinal Riario).

Numerous, often contradictory, interpretations have been given of this painting: from that of Röttgen (1969; 1974), which proposes a psychological reading, reflecting on the symbolism of the ivy (followed also by Marini 1987; 2001), to that of Frommel, who in 1971 re-read from a homoerotic viewpoint all Caravaggio's early half-length figures, to that of Calvesi (1990, in particular pages 224–228), which favours a Christological interpretation in the vein of an *Imitatio Christi*. In this case the still life would assume symbolic meanings, with the green and red grapes representing the death and resurrection, the sour apples representing sin, and the table representing the stone covering of the sepulchre.

A.C.

Bibliography: Marini 1987; Cottino 1995–1996, p. 102 (with bibliography); Marini 2001, *passim* (with bibliography).

48

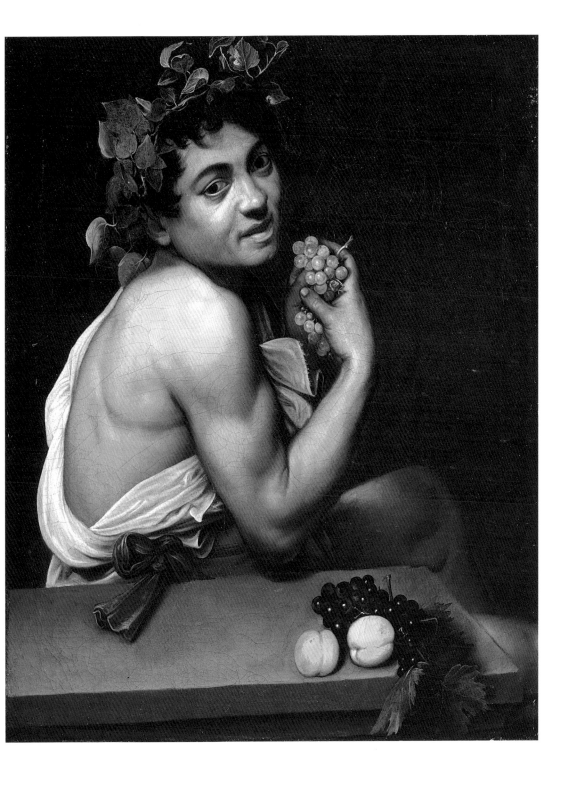

2
Boy with a Basket of Fruit

Oil on canvas, 70 × 67 cm
Rome, Galleria Borghese

This scene appears to be simple, quotidian. The protagonist is a boy, seen in a slight three-quarter view, in half-length and from a very close position, with bare shoulder and a light leaning of the head to our left, which accentuates the nonchalant — I'd even say confidential — relaxed nature of the pose, as if the youth were taking a step, and coming toward the viewer while holding a large basket filled to the brim with fruit in his hands.

Probably completed just after the *Self-Portrait as Bacchus* (we are therefore around 1593–1594), with respect to which this shows rapid progress in the mastering of pictorial means, even this canvas is among those sequestered in 1607 from Cavalier D'Arpino (as number 66: "A painting of a youth who holds a Basket of fruits in hand, without frame.") and shares the same history.

In 1985 Mina Gregori correctly brought to view the young painter's ability in underlining the spatial scansion through light: indeed, the diagonal of the body jumps out in the shoulder and large white spot of the tunic inundated with light, outlined against the dark of the wall, while the slightly rumpled mass of dark curls is cut out against the illuminated part of the background; the left cheek slides into a penumbra played out in infinite gradations of reflected light, which lights up the left eye with a sudden flash. But the real protagonist, the focal point upon which the painter is concentrated and to which he asks us to pay attention, is the basket filled with fruit, the first of many painted by Caravaggio throughout his career. The mimesis with which the fruits and rustic texture of the wicker basket are shown is worthy of a Flemish painter, not without Leonardesque echoes, filtered perhaps through Vincenzo Campi, as Hibbard (1983) already suggested, nor should one exclude a naturalistic re-elaboration of Arcimboldo's compositions of fruit.

Just as for the young *Bacchus*, numerous interpretations have also been formulated for this work. If Gregori (1985) notes in particular the relationship with the naturalistic half-length figures of Northern Italy in the tradition of the Veneto, above all Giorgionesque (and Caravaggio's rapid technique, done directly from life, is here to testify to that), and is tempted to consider that "the subject corresponds probably solely to that which it appears, a young [fruit] seller who offers his goods, exhibiting them in a basket mixed in with the still-fresh leaves of the fruit whose verity is exalted by the admirable brilliance of the colours." That is indubitably true, and yet a few leaves that are beginning to yellow and lose their vitality, some fruits that have opened because they are overripe, and the youth-freshness relationship of the fruit (in both cases of brief duration) seem too explicit to not think of a meaning, even metaphorical, of *vanitas* (in contrast with the eternity of life offered by [religious] faith), in homage perhaps to the words of Cardinal Ottavio Parravicino, who saw in some of Merisi's works a meaning "in that middle ground between the devout and the profane," which, according to Calvesi (1990, p. 196), adapts itself well to these early works. It is likely, then, that works of this type, wholly new to the Roman scene, could have been interpreted from a religious viewpoint. Recently, Gregori (2002) suggested an interesting connection with a passage from the *Icon* of Philostratus (which could have been known to Merisi), which speaks of a young man with refined clothing "left open so as not to hide his splendour."
A.C.

Bibliography: Hibbard 1983; Calvesi 1990; Cottino 1995–1996, p. 104 (with bibliography); Coliva in Bergamo 2000, pp. 190–102 (with bibliography); Laureati 2001, p. 71, no. 17; Marini 2001, pp. 375–176 (with bibliography); Ebert-Schifferer 2002, pp. 1–23; Gregori 2002, p. 23.

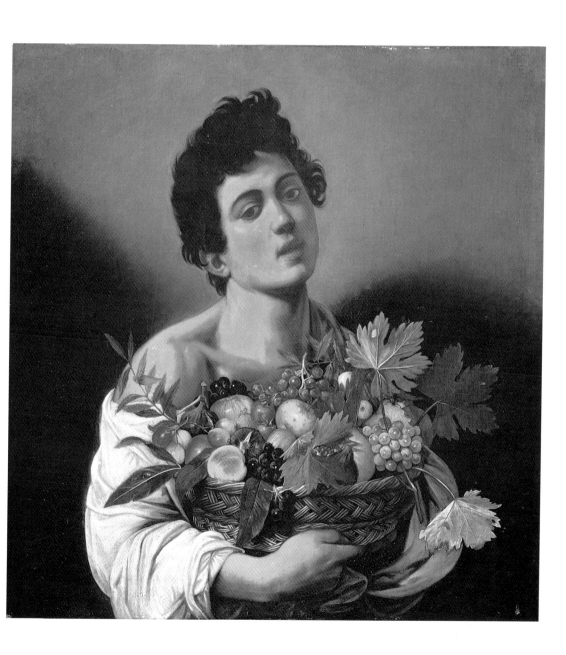

3

Saint Francis of Assisi in Ecstasy

Oil on canvas, 92.5 × 127.8 cm
Hartford, Wadsworth Atheneum

In a rapidly approaching night, but with a sky still lit by the suggestive, luminous iridescence of the sunset, Saint Francis is at the height of mystic ecstasy in which the mystery of the stigmata descends upon him (with a significant rejection of the traditional iconography). He is almost fully laying down in a field described in great detail, lovingly supported by a young angel, who with a gesture of moving spontaneity seems to want to loosen the cord around his waist. To the left, in partial shadow, one glimpses brother Leo; in the distance is a fire around which some shepherds are seated. The scene is one of great simplicity, but also of a strong and complex spiritual intensity, inasmuch as we are witnessing a miraculous, inexplicable act, beyond human comprehension. Heaven and earth seem to unite in a hymn to the mightiness of creation, and of God, which can be known only through ecstasy, as Maurizio Marini (1987 and 2001) rightly argued. With respect to the very earliest works (*Bacchus* and *Boy with a Basket of Fruit*) the scene here seems to lose in immediacy but gain in *dignitas* and spiritual depth; Francis is seen as an *alter Christus*, the ecstasy is seen as physical suffering but spiritual beatitude, and an emblem of the agony and Passion of Jesus. This is the first painting of an openly religious subject by Merisi. Here the transcendent — aside from physical and rational — conception of light begins, and becomes the true protagonist of the Christian message, the light of God, and cleaves through the darkness to rest on the two sacred figures. As Mina Gregori (1985) rightly pointed out, this scene also rightly recalls the writings of Saint Francis de Sales, this light possesses a "double meaning, natural and spiritual." The painting, approximately datable to 1594 (the figure of the angel with the very white tunic is comparable to the *Boy with a Basket of Fruit* and with the Eros of *The Musicians* in New York, but the tone of the landscape's description and the light register still owe a lot to Savoldo) belonged to Cardinal Francesco Maria Del Monte (it is also quite possible that the very choice of saint echoed the name of the work's patron), in whose inventory it is recorded in 1627. An old copy of the painting is in the Museo Civico of Udine, and is probably the one cited by Ottavio Costa in 1606 as a work to be given to abbot Ruggero Tritonio (who in his turn described it in 1607).

A.C.

Bibliography: Gregori 1985, pp. 224–227; Marini 1987, pp. 369–372 (with bibliography); idem 2001, *passim* (with bibliography).

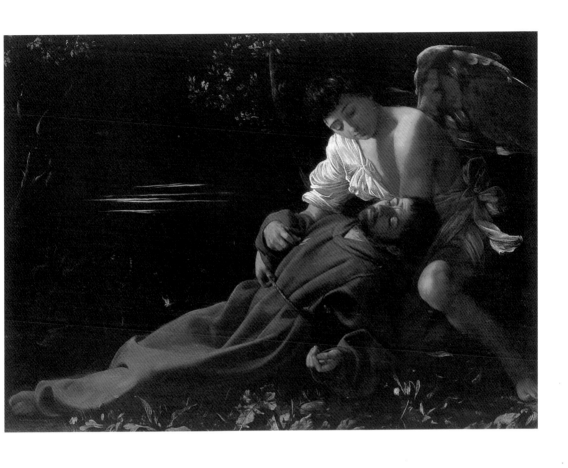

4
The Fortune Teller

Oil on canvas, 116 × 152 cm
Rome, Pinacoteca Capitolina

This work is an admirable example of 'psychological counterpoint' between the malicious, adulterous winking of the young gypsy and the naïve boldness of the boy with plumed hat, bewitched by her gaze upon his eyes to the point where he doesn't realise the impalpable gesture with which, while she reads his palm, she steals his ring. The light lays lightly on the young face of the woman, exploring her pink skin with very subtle glazes, leaving her eyes in a mysterious half-shadow, lighting up the bright white shirt and charming turban, and underlining the chubby and slightly stolid face of the boy and his beautiful ochre coloured dress coat. "All the same the little gypsy shows her cleverness with a false laugh in taking the ring from the youth, and he his simplicity and libidinous affection towards the charm of the little gypsy who tells his fortune and takes his ring;" thus Giulio Mancini in 1620 describes this subject by Caravaggio, known in two authenticated versions — this one at the Capitolina, former property of Cardinal Del Monte and datable to around 1594–1595, and the one at the Louvre, with a provenance from the Pamphilj family and executed slightly later (Mancini refers to the latter; see the relevant description). Mancini fully understands the psychological register that the young Merisi succeeds in giving to the event, which is played out fully in the 'libido' of the youth for the 'charm' of the young woman, who de facto, by the ordinary daily life, in the agitation of common people's life found on every lane of Rome, becomes an almost universal emblem of the perpetual game of senses between woman and man, an eternal trickery since the betrayal narrated in Genesis. Caravaggio knows how to bring to the surface, in her face, in that smile that only appears to be sincere, the 'deceit' that melts all the youth's diffidence. "Però fia di mestier, scaltre et viziate / Giovani mie, zitelle mie, mie putte / Appuntar bene gli orecchi / a succhiellar per tutto, e dietro ad essi / l'ugna e le dita, e lavorar segrete: / E svegliata la lingua / Ir trattenendo stupidi e merlotti: / E con ciance allettargli, / Con isguardi incantargli, / E colle man parlargli." ["But being of the trade, cunning and licentious / My young ladies, my maidens, my little cherubs / Cock up your ears / to suck up everything, and behind these / the fingernails and fingers, and secret working: / And having awoken the tongue / catching the attention of stupid people and simpletons: / And with chit-chat alluring them, / With glances enchanting them, / And with the hands speaking to them."] Thus Michelangelo Buonarroti the younger writes in his Fiera (1619) about gypsies, and it almost seems as though he has this painting in mind. Gaspare Murtola, who really did see the painting (we don't know if it was this one or the one at the Louvre), composed a noted madrigal in its honour, Per una cingara del medesimo, in which he plays upon the concept of magic between she who effectively practised it — the gypsy — and he who, painting her, magically brought her to life: "Non so qual sia più maga / O la donna, che fingi / O tu che la dipingi / Di rapir quella è vaga / Coi dolci incanti suoi / Il core e'l sangue a noi. / Tu dipinta, che appare / Fai, che viva si veda. / Fai, che viva e spirante altri la creda." ["I don't know which is more the magician / The woman who feigns / Or you who paint her / She is keen to capture / With her sweet charms / The heart and blood from us. / You, make she who appears painted / Make it such that she is seen alive. / Make it such that others believe her alive and breathing."] The characterisation of the scene and the particular clarity given to the gesture make the relationship with the types and situations of the Commedia dell'arte plausible (Gregori 1985, 1991), just as in The Cardsharps of Fort Worth. The theme of trickery, in any case, can also be interpreted as a modern transcription of the parable of the Prodigal Son (Marini), an hypothesis that can also be extended to The Cardsharps.
A.C.

Bibliography: Gregori 1991 (with bibliography); Langdon 2001, pp. 44 and following; Marini 2001, passim (with bibliography); Moffitt 2002, pp. 129–156.

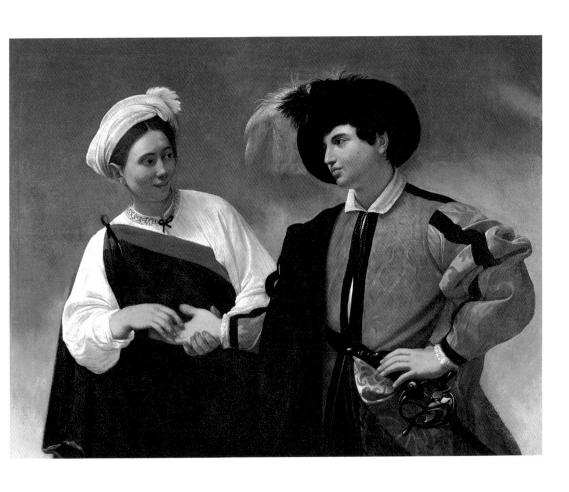

5

Rest on the Flight into Egypt

Oil on canvas (Tablecloth of Flanders linen), 135.5 × 166.5 cm
Rome, Galleria Doria Pamphilj

The Holy Family allows itself a little rest on the edge of the forest, toward sundown in early autumn near a glade on the banks of a river, tired out by the voyage that is to lead far from Herod and his terrible intentions. The Madonna (probably the same red-haired model from the painting of the *Penitent Magdalene* in the same gallery), dressed in a magnificent fire-red mantle, has fallen asleep tenderly hugging the Child and resting her own face on his; to the left Saint Joseph has sat down on their sack of supplies after setting the bottle of wine safely on the ground. A violin-playing angel has miraculously materialised, while Joseph himself holds the musical score for him: it is a eulogy to the Virgin, but also the harmony that seals an exceptionally lyric and contemplative atmosphere. From behind the plant the donkey looks on with an attentive eye. Caravaggio scrupulously describes the place chosen for rest by the Holy Family, with plants, leaves, rocks, and the cool water in the background, with a 'Venetian' chromatic strength one could say, as Longhi (1951) already noted, pointing out the echoes of Lorenzo Lotto and underlining with intelligent wit that in a subject like this "no painter of the day would have omitted the citation of the Eastern flora of palms and date trees. But here there are only the small oaks of the Roman countryside, the white poplars beyond the river under an already cold sky, and the succulent or spiny grasses amid the crumbles of red bricks near the furnaces." The angel, seen from behind with an immaculate, fluttering, light-drenched tunic, has "Apollonian" forms (Calvesi) and the luminous candour of classical statuary — even if the face, with a rebellious tuft of hair, insists on formal traits found in the other early paintings of Merisi — contrasts in general with the dense naturalism of Joseph's face, with its rougher, more carved-out lines, furrowed by deep wrinkles, with evident baldness. One notes how the painter captures with a truly acute eye the very human and involuntary gesture of the feet of the tired old man, with one brushing the other, as if to warm up, moved by a shiver.

As Trinchieri Camiz (1983) demonstrated, the *incipit* of the score is the beginning of the motet "Quam pulchra es et quam decora, charissima in deliciis," from the *Song of Songs*, by the early sixteenth-century musician Noel Baldewijn. Both Calvesi (1971; 1990) and Maurizio Marini insist upon the relationship of the subject of this work with the *Song of Songs*, and Marini in particular (1973–1974; 1987; 2001) glimpses here a "complex allegorical organism in which multiple cultural elements are intertwined with a biblical substrate (from a messianic viewpoint) that doesn't remove itself from the inclination of the Counter-Reformation [...] the whole is imbued with a sense of redemption, in an air of elegiacal stasis (sleep, metaphor of death, is another symbol of salvation, connected as it is to the death and resurrection of Christ and the parallel redemption of the Virgin) and constitutes, to the extreme, an hyperbolic syncretism of Old and New Testament." The work, completed by Caravaggio during his first years in Rome, when he lived with monsignor Fantin Petrignani (around 1595), is recorded in 1611 in the inventory of the collection of Olimpia Aldobrandini senior, sister of Cardinal Pietro and wife of Giovan Francesco Aldobrandini: it is possible that the patron was Pietro, who was also known for his interests in the field of music, or more probably Olimpia herself, who also owned the painting of Martha and Magdalene (Testa 2000).

A.C.

Bibliography: Calvesi 1971; Trinchieri Camiz 1983; Marini 1987, pp. 393–395 (with bibliography); Calvesi 1990; Testa 2000, pp. 129–154; Marini 2001, *passim* (with bibliography).

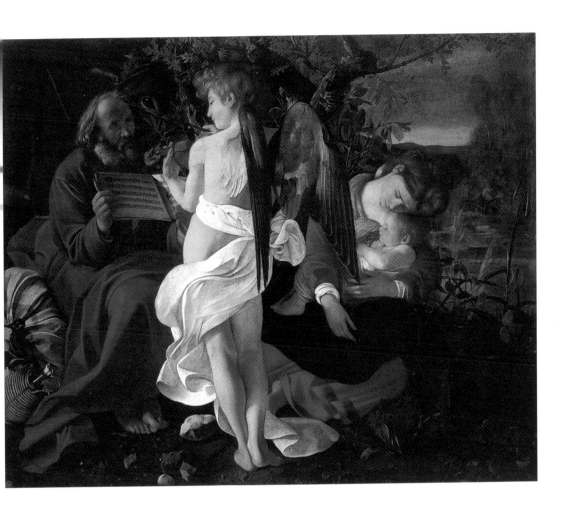

6
Penitent Magdalene

Oil on canvas, 123 × 98.3 cm
Rome, Galleria Doria Pamphilj

The young woman of the long, red locks of hair loosened and a little mussed over her shoulders cries, seated on a straw-bottomed chair, her arms folded in her lap. Alone. Her head is bent and a tear slowly slides down her nose. The room, with undefined outlines, is empty, immersed in a strange penumbra cut into the upper right by a blade of light, but the light also inundates her, her luxurious dress, her white, elegantly embroidered blouse, the jewels thrown to the floor, and the glass vase full of ointment. It is Magdalene, caught in the miraculous effort of conversion, of the abandon of "excess ornaments, excessive pomp, the pilgrims' fashions," as San Carlo Borromeo said a few years before in the *Predica ai milanesi*. Giacomo Lubrano would later write of Magdalene, "I lived in sacrilege. Have I lived, if I killed my life with sin? In pieces of vain, wicked mirror, where I feigned being beautiful, when the soulless body stank. I looked upon myself, always in tears, until there remains no shadow of reason in me." Suddenly, the moral fables of the young Merisi, painted interpretations of the subjects of the *Commedia dell'arte*, played out between nature and symbol in expressions, gestures, and colour, transform themselves in the interiorised, very human investigation of the moral and physical drama of conversion and penitence, rendered comprehensible and credible, even 'close,' by the impassioned naturalism with which the figure is painted. With respect to the mannerist models with which the saint had been interpreted up to that point, this is an extreme naturalism. This is a contemporary, seventeenth-century Magdalene (Longhi defined her a "poor, betrayed *Ciociarella*" [poor woman from the rural area south of Rome]), and the miracle of the conversion happens, as will soon happen also in the *Saint Matthew*, in the present time. From now on Caravaggio will appear to us as an ever more sincere and inspired singer of the Sacred, translated into a language of striking empathy with the viewer. The ray that cuts the darkness of the room is a tangible testimony of the presence, or rather proximity, of God — the light of salvation countering the darkness of sin (Calvesi 1990, p. 207), just as it will be a few years later in the *Calling of Saint Matthew* in San Luigi dei Francesi. Light is the true foundation of this very sophisticated painting of suffering, and assumes here, perhaps for the first time in Caravaggio's painting, a double role, sustaining not only the symbolic meaning, but also the naturalism, in the pointed description of every detail of the protagonist's figure in the moment in which, penitent for her sins, she decides to change her life.

We don't know for whom the painting, datable to around the crucial year of 1595, was done, perhaps for Olimpia Aldobrandini senior or for Cardinal Pietro Aldobrandini, her brother. In the *Inventario del Guardaroba di Pietro*, in 1626, there is a "painting in large format with a Magdalene, with gilt frame," (Testa 2001). From this family the painting went to the Pamphilj, in whose palazzo it is attentively described by Bellori in 1672.
A.C.

Bibliography: Marini 1987, pp. 390–392 (with bibliography); Calvesi 1990, *passim*; Marini 2001, *passim* (with bibliography); Testa 2001, pp. 129–154.

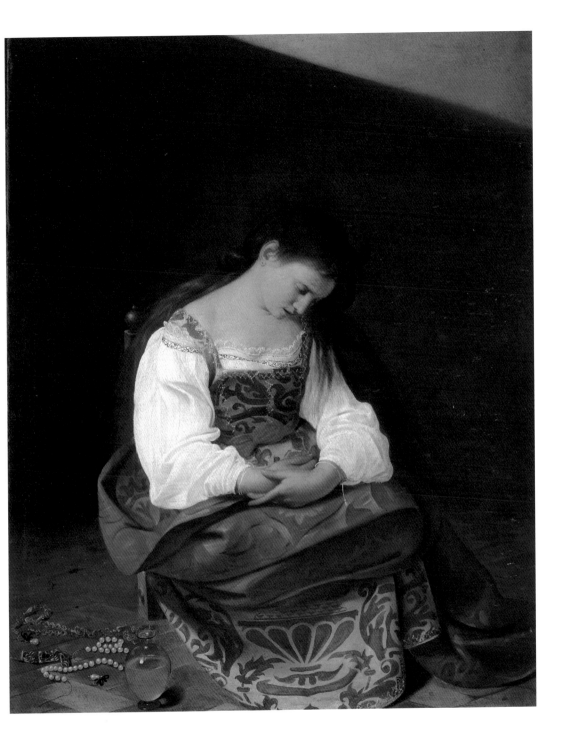

7

The Musicians

Oil on canvas, 92 × 118.5 cm
New York, Metropolitan Museum of Art

This painting has a mysterious and fascinating subject: at the centre of the composition is a youth with lute in hand, eyes fixed on some distant point, and a half-open mouth, concentrated and rapt; to the right is a boy seen from behind reading a musical score, with a white tunic leaving his left shoulder and part of his back bare; while from the background the face of a curly-haired boy emerges, horn in hand, who looks at the viewer. At the far left one glimpses a very young boy with wings and quiver, who is identified as Amor/Eros, bent to pick a bunch of white grapes.

The painting was done around 1595, without a doubt in the cultured musical climate of Cardinal Del Monte's circle, in whose inventory (1627) it is clearly recorded, and cited by Baglione in 1642, who underlines how the painter portrayed his models from life ("he came to know Cardinal Del Monte, who, to amuse himself greatly with painting, took him into his house, and being part and parcel took heart and credit and painted for the Cardinal a Music of a few youths, portrayed from nature, very well"). This is the first painting by Caravaggio with more than two figures, but the scene presents a spatiality that is rather compressed and resolved with some difficulty, which probably indicates also an early meditation by the artist on Roman bas-reliefs — the fronts of sarcophagi in particular — not only from an archaeological point of view, but also from a strictly compositional one. In this sense I agree with Macioce (2000): even the figure of Eros who cuts a bunch of grapes seems to recall the representations of the cupid-angel-vintner of late antiquity, just as can be found in the sarcophagus of Giunio Basso, according to Calvesi's (1990) suggestions. Caravaggio succeeds in combining these ancient elements with the usual, very attentive naturalism in rendering the physical individuality of the characters, an inheritance of his Lombard and Giorgionesque background. As Gregori rightly pointed out in 1985, an interest in perspectival rendering of musical instruments appears clear here, and will find a decisive maturation in *The Lute Player* of the Hermitage. The presence of Amor/Eros, as well as classical tunics and mantles (note the great spot of colour made by the red mantle of the lute player in the centre, which grabs the viewer's attention), suggests an allegorical theme in order to 'universalise' a subject that is otherwise too pedestrian.

The fairly compromised state of conservation prevents a reading of the musical scores, which in the time of Cardinal Del Monte must have been possible (as can still be done with works like *The Lute Player* of the Hermitage and the *Rest on the Flight into Egypt* of the Doria-Pamphilj), but which probably reinforced the music-love nexus that seems to fully emerge from this scene (again see Macioce 2000).

A.C.

Bibliography: Gregori 1985, pp. 228–235; Marini 1987, pp. 374–377 (with bibliography); Calvesi 1990, p. 219; Macioce 2000, pp. 198–201; Marini 2001, *passim* (with bibliography); Vodret, Strinati 2001, p. 93.

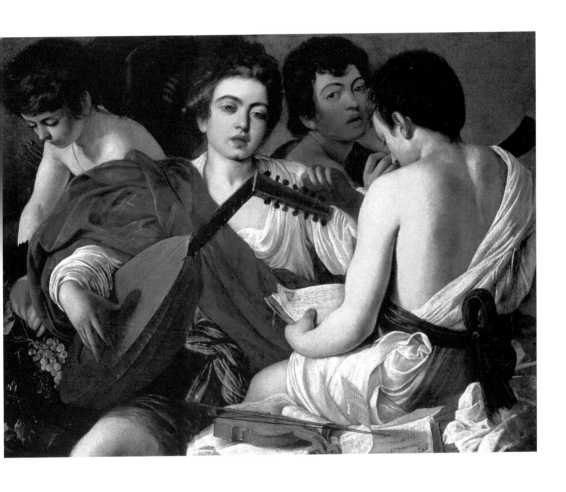

8

The Lute Player

Oil on canvas, 94 × 119 cm
St Petersburg, Hermitage Museum

Yet another half-length figure of a young man, with a white classicising tunic and ribbon in his hair, seated at a table while playing the lute, with a slightly effeminate, inspired, concentrated face and partially opened mouth, perhaps caught at the moment in which he is beginning the song. A glass carafe filled with flowers is on the left, all around are some fruits casually spread about, while in the centre is a musical score (that Franca Trinchieri Camiz, in an important 1983 study, identified as the bass-clef transcription of a madrigal by the sixteenth-century composer Jacob Arcadelt, of which one can read the *incipit* "Voi sapete ch'io v'amo") next to which, in perfect perspective, a violin is painted. In a later study (1988) the same researcher proposed identifying the youth as the Spanish castrato Pedro Montoya, singer at the Sistine Chapel between 1592 and 1600, which could justify the apparent androgyny of the effigy in his face and dress.

The atmosphere is one of highly lyric intensity, and perhaps also melancholy, since Caravaggio painted half-length figures also of musicians for Cardinal Del Monte, around 1595: Baglione (1642), in fact, recalls that he "painted for the Cardinal [...] a youth, who played the lute, and alive and true it all appeared, with a carafe of flowers, filled with water [...] And this was the most beautiful piece that he ever painted." In any case, it is certain that this painting was composed for Vincenzo Giustiniani. And Maurizio Marini (1987) is perhaps right on the mark, hypothesising a close cultural relationship between Giustiniani, Del Monte, and Caravaggio that would have given rise to this work, and, per-

haps, to another version now in the collection of the cardinal (for the most recent proposal, see Gregori 2003), suggesting also a possible reading as a *vanitas* (as seems acceptable also for other early half-length figures by Merisi), intertwined perhaps with a concept of Harmony, as derived from an epigram by Silos dedicated to this painting. Vincenzo Giustiniani, after all, did have a deep personal interest in the field of music (Baldriga 2001). The old, envious Baglione is correct to insist on the unparalleled liveliness of this figure. Caravaggio reached such an expressive maturity that it permitted him to capture the ambiguity of a facial expression in all its subtlety, through very soft modulations (up to the lit contrast of the neck and left cheek), with misty eyes just barely touched by slight dark shadows underneath, or the fleshy red lips. With respect to *The Musicians* of New York, the spatial scansion appears resolved with a greater sureness, demonstrated also by the foreshortening of the musical instruments. The carafe with flowers to the left, executed with exceptional optical perspicuity, refers perhaps to a lost work by Merisi of the same subject, painted for Cardinal Del Monte.
A.C.

Bibliography: Trinchieri Camiz, Ziino 1983, pp. 67–90; Marini 1987, pp. 399–402; Baldriga in Rome 2001, pp. 274–276 (with complete bibliography); Marini 2001, *passim*; Gregori 2003, p. 139.

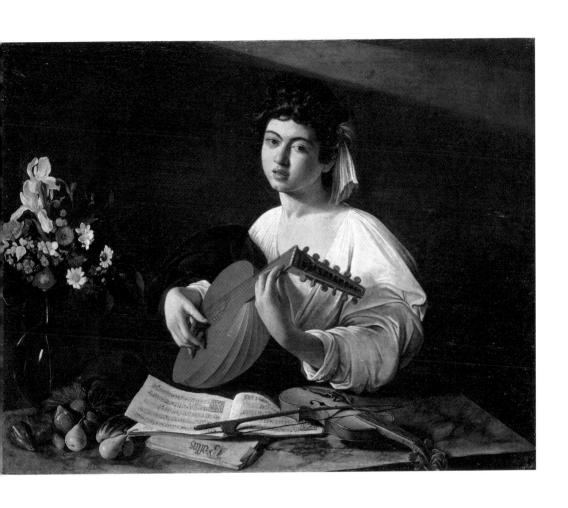

9

The Cardsharps

Oil on canvas, 91.5 × 128.2 cm
Fort Worth, Kimbell Art Museum

"He depicted a simple youth with playing cards in hand, and it is a head well portrayed from life in dark clothing, and, encountering him, a fraudulent youth turns to him in profile, leaning with one hand on the game table, and with the other sneaking a false playing card from his belt, while the third, close to the youth, looks at the points of the playing cards, and with three fingers of his hand signals them to his companion, who, in leaning over the little table, exposes his back to the light, in a yellow dress coat striped with black bands, and the colour of the imitation is not false. These are the first brushstrokes of Michele in that crisp manner of Giorgione, with tempered darks." Thus the biographer Giovan Pietro Bellori describes, in 1672, with extreme attention, this painting by Caravaggio, when it was property of the Barberini. In reality the canvas, datable to around 1595, had an extremely complex history, with fiction-like plot twists: initially belonging to Cardinal Del Monte, even if it isn't certain whether it was commissioned by him or rather purchased later on, and from there passed on to the Barberini; after the division of that collection (1812), it was passed to the Colonna di Sciarra in their palazzo in via del Corso; but the economic ruin of don Maffeo Barberini Colonna di Sciarra caused the dispersion of his part of the collection and the exportation of this and other paintings in the last decade of the nineteenth century. After that all traces of it were lost, until it reappeared in Switzerland in the nineteen-eighties and was acquired by the museum of Fort Worth (Texas) (for complete historical details see Gregori 1991). Since the seventeenth century it has been considered one of the most important paintings by Merisi because of the novelty of the scene, never before seen in Italy (Hibbard noted this in 1983), executed with a complex perspective, played out in a double diagonal that fixes the emotionally crucial element of the trick at the expense of the naïve youth, and which goes beyond the simple genre scene. Rather, it is charged with symbolic details and twists

that in the times of the Counter-Reformation must have been read in a moral sense, as well as from a formal point of view, as Bellori himself pointed out. Indeed, in the construction of the scene, in the strength of the colour, and in the unusually descriptive naturalism — which is not an end in itself, but necessary for the comprehension of the meaning (the youth from a well-to-do family wears a sober, elegant dark suit, the two accomplices, on the other hand, faded and worn dress, indicating a different social extraction) — echoes from a 'modern' point of view of certain allegories out of Giorgione or early Titian appear clear, just as do the Lombard works of Altobello Melone, Savoldo, or even Lorenzo Lotto, as Gregori well pointed out — a type of culture that Caravaggio must have assimilated in his hometown and that, evidently, he considered the true roots of his own naturalistic vision. But it is above all the poetics of the affections, or rather the bona fide 'theatre of the passions' to define the scene: the contrast of expressions, the naïve trust of the fooled youth with extended facial details, the quick move of the cardsharp, who with great dexterity is about to toss the false card onto the table, with wrinkled forehead, a coaxing grin on his face, and the hand-sign of his accomplice, clearly establish the roles of 'good' and 'bad,' who have justly brought to mind the situations of *Commedia dell'arte*, analogous to *The Fortune Teller* (Gregori 1985 and 1991). In the comedies of this street-theatre the theme of deceit in the most varied forms was one of the most common, and the close relationship with these explains the importance of gesture attributed to these paintings, for the comprehension of the subject and its moral implications.
A.C.

Bibliography: Hibbard 1983; Gregori 1991, pp. 96–102, 191–192; Langdon 2001, pp. 44 and following; Marini 2001, *passim* (with complete bibliography).

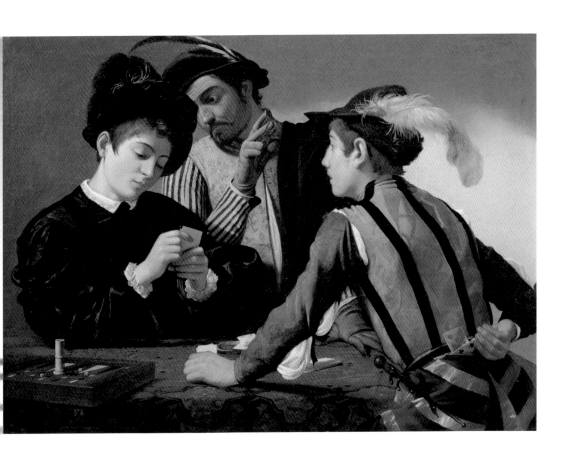

10
The Fortune Teller

Oil on canvas, 99 × 131 cm
Paris, Musée du Louvre

This is a version by Caravaggios' hand done later than the painting of the Pinacoteca Capitolina. Having belonged to the Pamphilj, the painting was donated in 1665, together with other works, to King Louis XIV by Prince Camillo Doria Pamphilj through Gianlorenzo Bernini. Long stored at Versailles, the painting has been in the Louvre since Napoleonic times. It is possible that it could be the one cited by Mancini (1620) as belonging to Alessandro Vittrici.

The composition and meaning of the scene (deceit, subterfuge, the danger posed to men when they give in to their senses, but also the parable of the Prodigal Son, transported into modern times according to an acceptable religious reading suggested, among others, by Marini) are analogous to those of the painting at the Musei Capitolini. From a formal point of view, however, Caravaggio here has applied some meaningful variations, above all in the position of the two heads and the gypsy's torso, seen at less of an angle and therefore appearing more rigid. And vice versa, as Marini noted (1987; 2001), the light here plays a greater role, even in bringing into relief the play of the hands, the most crucial point of the painting. Having almost completely eliminated all motion from the figures, Caravaggio expresses himself on a more complex level, exclusively psychological and symbolic, less 'charged' and immediate. The physiognomies of the protagonists also vary: the gypsy has a chubbier face, a less accentuated smile, and a less malicious expression. In judging the work one must consider, in any case, the poor state of conservation and the retouched areas that mar the surface.
A.C.

Bibliography: Gregori 1991 (with bibliography); Langdon 2001, pp. 44 and following; Marini 2001, *passim* (with bibliography); Moffitt 2002, pp. 129–156.

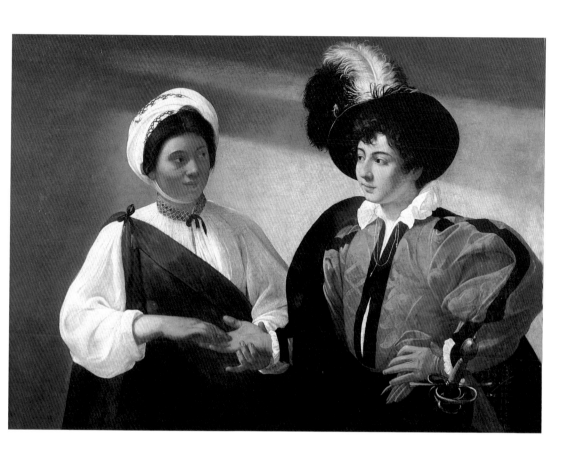

11
Bacchus

Oil on canvas (Tablecloth of Flanders linen), 98 × 85 cm
Florence, Galleria degli Uffizi

This is a masterpiece of formal refinement, subtlety, psychological ambiguity, embarrassing naturalism, and classic nostalgias in a crossed dissolution, and requires viewer involvement. It is also an extraordinarily 'epidermic' painting, sustained by the supremely analytical quality of the light. Young Bacchus, partially reclined, in ancient fashion, on a sort of triclinium (but the same sack-cushion of Saint Joseph in the Doria *Rest on the Flight into Egypt* makes an appearance here), adolescent, with slightly flaccid white skin and classically dressed in a white tunic, which he seems to want to open, loosening the knot of his belt with his right hand, fixes the beholder with his eyes, to whom he offers a glass of wine. Before him on the table, which marks the foreground plane, is a bowl full of fruit, some of which are clearly rotting, and to the left a carafe of wine. Another admirable still life is the crown of grapes and vine tendrils atop his hair, autumn coloured.

With this painting, datable to 1595–1596, the period of Caravaggiesque half-length figures commissioned or stimulated by the prominent personage of Cardinal Del Monte is practically concluded: from the Cardinal it may have been given early on to the Grand Duke of Tuscany Ferdinando I de'Medici, in whose collections at villa Artimino it is documented as early as 1609, and where it is still found in 1738 (Fumagalli 1998). After that all traces of it were lost, and it was rediscovered only in 1916 by Matteo Marangoni in a storage room of the Uffizi, in a precarious state of conservation.

The painter's gaze flows over the large, luminous patch of the youth's skin and defines, with attentive and passionate naturalism, details absolutely unusual in previous paintings: the dirty fingernails, the wine in the carafe that still has some bubbles from being just recently poured, or moved in little concentric waves in the glass, which is slightly tipped toward the viewer. The calyx and carafe, with their luminous reflections and the transparencies of the glass, are Leonardesque touches, but also Brescian (the overripe fruit). "The imitation of the natural given, based on colour, light, illusionism, and in the optical, experimental, and empirical values that were dear to the painter" (Fumagalli 1998) doesn't succeed in completely masking the cultured relationship with classical sculpture, which becomes emphatic here: in particular, Merisi seems to have the figures of Antinoo, the favourite of Hadrian (Moir 1982) in mind, from which he could also derive a certain ambiguous and decadent character of the representation. Maurizio Calvesi (1971; 1990) interprets the pagan image from a Christian viewpoint — which he sees in all the early work of the painter — with the identification of Bacchus-Christ, as ancient as Christianity itself, and wine-Eucharist, an acuteness that is perfectly compatible with the figure of Cardinal Del Monte and a society permeated by the precepts of the Counter-Reformation. One mustn't forget that Bacchus-Dionysus, again according to Neoplatonic philosophy, was considered a precursor of Christ. This would obviously explain the gesture of toasting or offering the glass as well. In this sense "the *Bacchus* would then become a paraphrase of 'salvation' in the death of sin, in a Counter-Reformational sense, of a suitable context for underlining the monitions of a prince of the Church to someone as powerful as the Medici" (Marini 1987; 2001).
A.C.

Bibliography: Marini 1987, pp. 397–399 (with bibliography); Calvesi 1990, *passim*; Fumagalli 1998, p. 88; Marini 2001, pp. 412–414 (with bibliography).

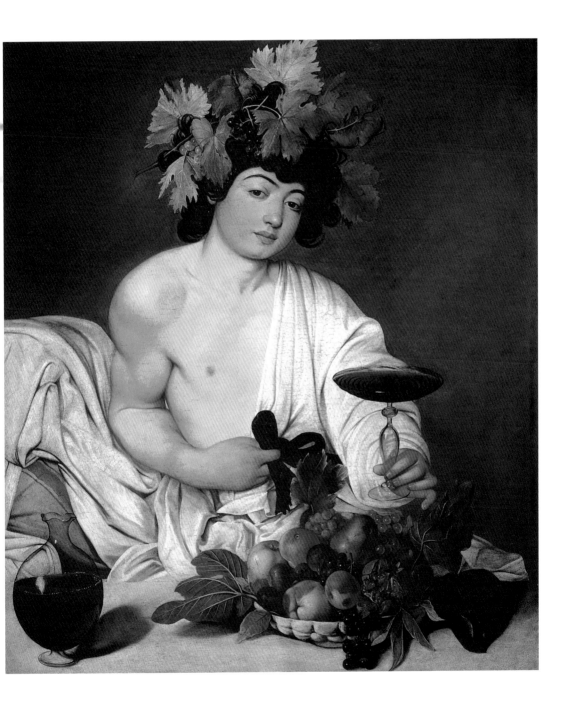

12
Boy Bitten by a Lizard

Oil on canvas, 66 × 49.5 cm
London, National Gallery

The earliest record we have of this work is in the "considerations on painting" by Giulio Mancini, written about ten years after Caravaggio's death, when the painter was already a legend. The indications are quite precise. The work is mentioned in the beginning of Caravaggio's stay in Rome, "at approximately twenty years of age, when the painter of little money" was with Pandolfo Pucci da Recanati, for whom he painted, "to be sold [...] a cherub who cries after having been bitten by a lizard which he holds in his hand." Mancini himself tells us that Caravaggio managed to sell the painting and leave Pucci ("which caused him, upon selling it — being encouraged that he could live on his own — to depart from that lacking master or Patron."). But it is Baglione (1642) who observes the contrast on which he bases the composition: "That head seemed to truly be shrieking, and the whole was worked with a great diligence." Of the known versions, throughout the years two have, for the most part, been judged authentic: the one now in England purchased by Doctor Jones, bishop of Kildare, given to the Viscount of Harcourt, where Borenius discovered it in 1925, and later sold on June 11, 1948 at Chrisitie's and bought by Vincent Korda, with whose name it is recorded, before passing (1986) into its actual home; and the one found by Longhi, first in the d'Atri collection in Paris, then in Rome, and now in the Longhi Foundation. The almost contemporaneous appearance of the two versions is reflected in their alternating changes in the critical opinion of them: for the authentication of the work in London: Borenius, Pevsner, Zahn, Berenson, Voss, Venturi, Baumgart, Jullian, Cinotti, and Marini; for the Longhi version, in addition to Longhi himself: Baroni, Hinks, Mahon, Friedländer, Berne-Joffroy, Spear, Frommel, and Nicolson. For the authentication of both of them: Ottino della Chiesa, Moir, Spike, and Gregori. To Gregori we owe the opportune connection of the capricious spirit of the work regarding the deformation of the face with the drawing of Sofonisba Anguissola with a young woman and baby who cries because of a crab bite. Evidently this is a representation influenced by scientifically minded research on psychophysical reactions that, in Lombardy, perfect upon Leonardo's reflection on nature. It is interesting to observe that another precedent of expressive deformation, of grimace, lies in the details of the two little cupids in the painting of *Cupid Drawing his Bow* by Parmigianino, now in Vienna. It is difficult, on the other hand, to agree upon the interpretation forwarded by Calvesi, who sees in this work a *vanitas* with a capricious reference to the *Portrait of a Youth* by Lotto at the Accademia in Venice, or to the *Portrait of a Man* of the Galleria Borghese, glimpsing a small skull emerging from the rose petals. No allegory, no psychological research, no metaphor: simply a scientific observation of the reactions to a lizard bite. The formidable naturalism of the flowers, fruit, and glass bottle in which a window of the room is reflected with effective virtuosity correspond with the grimace. In the comparison of the two versions, the observations of Marini regarding the transparency of the London painting and the greater precision of the focal point with respect to the Longhi Foundation's version, which is denser and heavier, are perfectly justifiable.
V.S.

Bibliography: Cinotti, Dell'Acqua 1983; Rodeschini Galati in Bergamo 2000, pp. 188–189; Marini 2001, *passim*; Spezzaferro 2001, pp. 23–50; Gregori in Monaco 2003, pp. 131–133.

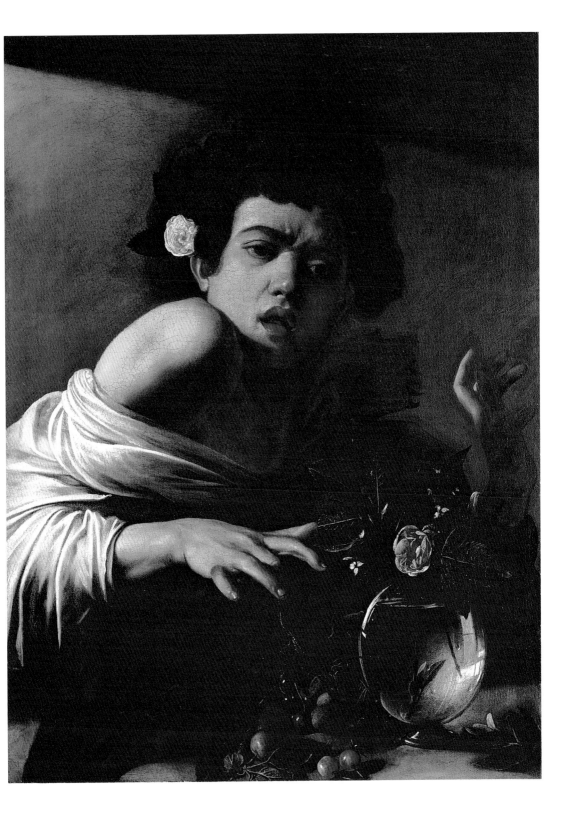

13

Boy Bitten by a Lizard

Oil on canvas, 65.8 × 52.3 cm
Florence, Fondazione di Studi di Storia dell'Arte Roberto Longhi

See the previous description.

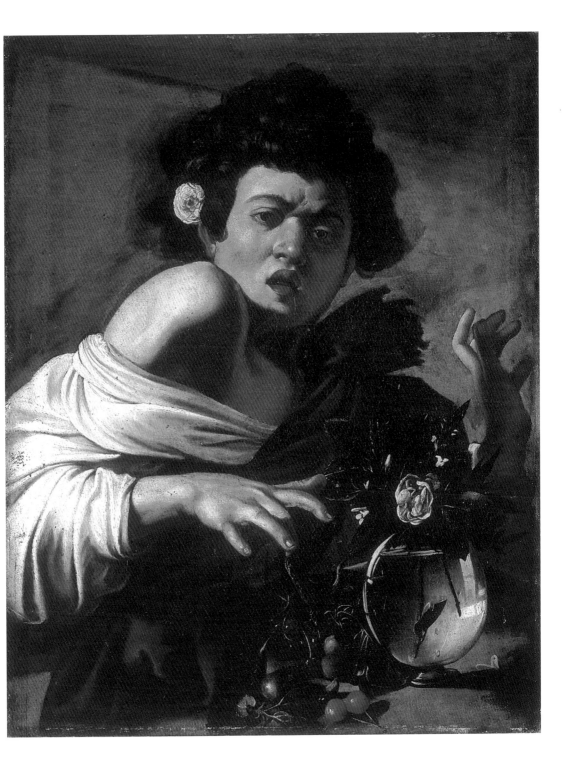

14
Basket of Fruit

Oil on canvas, 31 × 47 cm
Milan, Pinacoteca Ambrosiana

This work is the culmination of all the early experiences of the painter: the Lombard-Giorgionesque origin of 'portraying from nature,' or painting from life with models (in this case, courageously, a humble, isolated basket of fruit, which for the first time assumes the dignity of an artistic subject, as though it were a figure), the Flemish tradition, but also the Leonardesque tradition of calligraphic attention to detail, that the young Merisi must have known quite well from a childhood spent observing the *Last Supper* and frequenting Arcimboldo's studio, and the wholly Roman — classical — tradition of the trophy of fruit that probably derives from a familiarity with Hellenistic mosaics that reproduced the so-called *xenia*, the gifts for guests, and the *emblemata*, not to mention paleo-Christian works. The particular spatial articulation, with the basket emerging three-dimensionally from a light, uniform, abstracting background, which illusionistically sticks out from the table's edge with a significant razor's-edge of shadow, recalls the typical scansion of Roman bas-reliefs, with the image that comes toward the viewer rather than moving with gradations into greater depth, combined naturally with the perspective skills carried by every good sixteenth-century painter. The suspicion is that young Merisi, in Rome, focussed not only on the study of antiquity, but also to the interpretation of ancient things in the line of Raphael and his school (for example, the close relationship between naturalism and classicism present in the verdant floral festoons of the *Loggia of Psyche*).

The light is exceptionally analytical, capable of underlining in an illusionistic manner all the minor details, not only the forms, but also the material consistency of every object and surface, from the artisanal line of the intertwining vines, to the powdering on the grapes. A simple basket set atop a table had never been seen before in painting. This is the first bona fide autonomous Italian still life not connected to any figure (as in the *Boy with a Basket of Fruit*, of which this is evidently a development, and

therefore from a later period, or in the *Bacchus* of the Uffizi), a very sensational outcome in the Rome of the late sixteenth century, a true revolutionary manifesto because it opens "a new and prioritised relationship with nature, based on experience and the verification of the senses" (Gregori 2003, p. 26), part of a larger movement of ideas that in Giordano Bruno and Galileo find their main supporters, without, naturally, letting this prejudice one or more possible symbolic meanings or the fundamental tie to antiquity.

Property of Cardinal Federico Borromeo, this famous painting, which appears simple but is extremely meditated and executed with an unparalleled technique, is concentrated on the humility and simplicity of the fruit, exulting those characteristics of *vanitas* already underlined à propos of the *Boy with a Basket of Fruit*: the leaves are visibly drying out, the apple in the centre presents a visible wormhole, and that which at first glance seems fresh and vital in reality is quickly consumed. The principle of death is implicit within life itself, and the bitter proof is to be read in a Christian sense: youth, and all of human existence, ends too quickly, just as fruit and flowers don't last more than an instant. The religious reading by Calvesi (1990) underlines how in the writings of Amedeo di Losanna the golden basket full of fruits symbolises Jesus, but it mustn't be forgotten that the Christ-vine and Christ-grape identification, directly incorporated from Holy Scripture, goes back to the very earliest years of Christianity in figurative art (Calvesi also cites the later apse mosaic in San Clemente, from the thirteenth century). For the reasons above, it is probable that the date of the work, set by many art historians between 1594 and 1595, should be set later to 1595–1596.

A.C.

Bibliography: Marini 1987, pp. 367–369 (with bibliography); Calvesi 1990; Marini 2001, *passim* (with bibliography); Gregori 2003, pp. 26 and following.

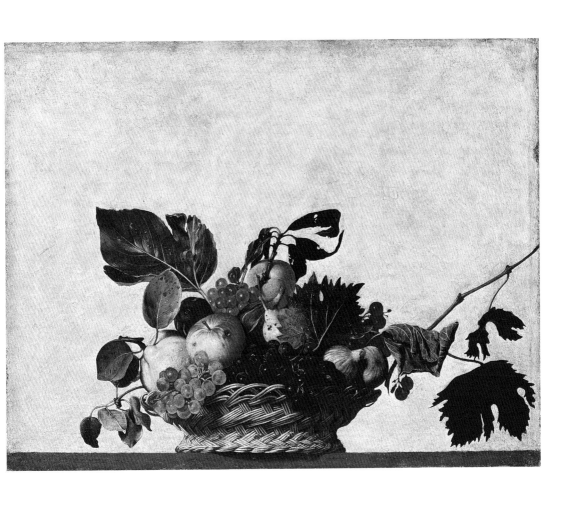

15

Sacrifice of Isaac

Oil on canvas, 104 × 135 cm
Florence, Galleria degli Uffizi

Could this *Sacrifice of Isaac* really be the work described by Bellori? "For Cardinal Maffeo Barberini, who later became Pope Urban VIII, Pontifex Maximus, in addition to his portrait, he painted the *Sacrifice of Abraham*, who holds a knife to the throat of his son, who screams and falls." If this description is faithful, even in its synthesis, the sole point that finds confirmation here is that of the "son who screams." As for the rest, the knife isn't held to his throat, and Isaac isn't falling, but is bent and forced over by his father, who would have already struck him if the angel hadn't stopped his hand. The dialogue between the young, Apollonian, imperative Angel and the diffident, surprised Abraham, who doesn't give up his grip, causing Isaac's grimace, is admirable. As always Caravaggio favours the decisive moment: an instant later would have been too late. But here the sacrifice isn't in the act of being committed, as in *Judith and Holofernes*; it is on the cusp of happening, but it isn't God's will. On the other hand, the notes of Maffeo Barberini, published by Aronberg Lavin, refer to four payments, between 1603 and 1604, to Michelangelo da Caravaggio for an unspecified painting. The indications in the inventories and Bellori's citation have established a connection, generally accepted, with the *Sacrifice of Isaac* now in the Uffizi, whose external history doesn't necessarily correspond to that of the Barberini painting. At least two incongruities remain: that Bellori's description doesn't correspond with the iconography of the painting, as we have observed, and the chronological tie of the document to 1603, when Caravaggio's stylistic evolution indicates a different vision. It seems evident that the painting can't be too far from the *Rest on the Flight into Egypt* of the Doria Pamphilj and the *Conversion of Saul* of the Odescalchi collection, with which it shares an opening onto the landscape done wholly within the traditions of the Veneto and Savoldo, to be understood in a moment of continued lively suggestion in Northern Italian painting. On the other hand, Mina Gregori also emphasises the connection with the Odescalchi *Conversion* that, contrary to Longhi's hypothesis, she determines isn't an early work. The *Sacrifice of Isaac* was given to the Uffizi in 1917 by John Fairfax Murray and was published for the first time by Marangoni, who connected it to Bellori's description. Recognitions by Voss and Longhi soon follow, and conveniently judge it an early work, as it doesn't seem right to doubt because of the excessive documentary trustworthiness. "The stylistic anachronism of the various sources," already observed by Marangoni, created some reservations among critics (Cinotti), but Gregori believes she can concord with the dating suggested by the documents published by Lavin. In reality the doubts brought forward by the Odescalchi *Conversion* remain even for the *Sacrifice*, which nevertheless exhibits a greater internal coherence and a stronger unity of action. The *Sacrifice* would seem to be the first work in which Caravaggio realises a full formal synthesis. And it might be opportune to reconsider the possibility of dating the work to around 1595–1596.
V.S.

Bibliography: Kallab 1906–1907, 26, pp. 272–292; Marangoni 1922; 1953; Voss 1925; Kirsta 1928; Zahn 1928; Longhi 1928–1929, 1, pp. 17–33; 5–6, pp. 258–320, reissued in Longhi 1968, IV; Venturi 1930 in *Enciclopedia italiana*, VIII, pp. 942–944; Schudt 1942; Berenson 1951 and reissue; Longhi 1951, no. 15, March, pp. 3–17; Venturi 1951; Longhi 1952; Mahon 1952, no. 25, January, pp. 20–31; Hinks 1953; Mahon 1953, pp. 212–220; Baumgart 1955; Friedländer 1955; Berne-Joffroy 1959; Jullian 1961; Bottari 1966; Aronberg Lavin 1967; Longhi 1968, cf. 1952, Rome-Dresden; Cinotti 1971; Marini 1974; Moir 1976; idem 1982; Hibbard 1983; Gregori 1985; Marini 2001, *passim*.

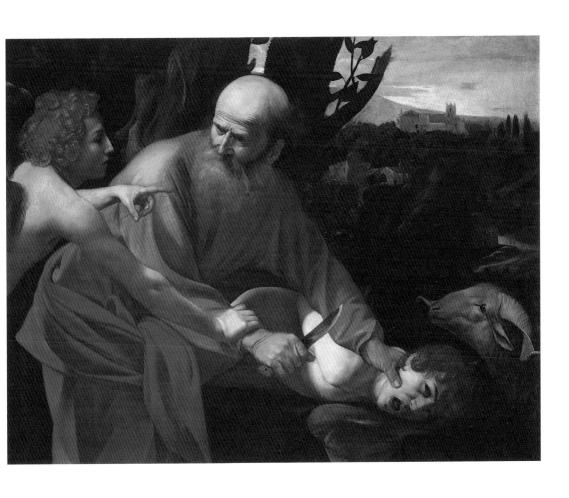

16
Medusa

Oil on canvas mounted on poplar shield, diameter 55.5 cm
Florence, Galleria degli Uffizi

Medusa's drama has just reached its culmination. Perseus, who doesn't appear here, took advantage of the reflective shield Athena gave him and cut off the Gorgon's head. In reality the head is still shaken by its last spasm of life, while blood gushes copiously from the wound (from which Pegasus will be born), her muscles contract, and her mouth gapes open in a cry of pain — but also of incredulity, because it seemed impossible that anyone could go so far. It is a chilling scream that seems to expand in concentric circles and bounce back in lugubrious echoes. Her eyes are the same, those very vivid and dangerous eyes of when she was still alive, still animated by the last, disquieting flash of light, such that they seem to bulge out of their sockets. The serpents move as though they've gone crazy. The scene, of such shattering, palpable, extremely close violence as has never been seen before in painting, is perceived in a sort of 'suspended animation,' in that moment of passage between life and death. The poor, damned soul (for which the courtisan Fillide Melandroni, immortalised in a portrait painted by Merisi, may have posed) is a bearer of pain but also a victim of her own power, reduced to a mask, a tragic emblem like those of classical theatre that were so well known to someone as familiar with antiquities as Caravaggio was (a point already made by Wittkower in 1958). In this sense, perhaps, there could be a hint of the celebrated drawing by Michelangelo, now in the Uffizi, with a screaming figure, known as the *Damned Soul*, which Merisi probably knew quite well, just as he must have known Leonardo's preparatory sketch for the *Battle of Anghiari*, now in Budapest, with an old man yelling, or some copy of the cartoon. It must be remembered that Leonardo himself had painted a *Medusa's Head*. Medusa petrifies those who look at her directly, but not Perseus, who catches only her image reflected in the shield; Caravaggio, then, sets this representation up based on the "sense of sight." Additionally, to the reciprocity of 'seeing' and being seen the artifice of the reflection is uniquely opposed, and must therefore be considered a separate entity from the "real body" (Marini 2000). This is a masterpiece, then, of meditation on the problem of refraction and convex mirrors, and perhaps paralleled Galileo's study of the same themes. Giovan Battista Marino, in the poetic composition *La testa di Medusa in una rotella di Michelagnolo da Caravaggio nella Galeria del Gran Duca di Toscana*, writes: "Hor qua i nemici fian che freddi marmi / Non divengan repente / In mirando, Signor, nel vostro scudo / Quel Fier Gorgone, e crudo, / Cui fanno orribilmente / Volumi viperini / Squallida pompa, e spaventosa à crini? / Ma che? Poco fra l'armi / A voi fia d'huopo il formidabil mostro. / Ché la vera Medusa è il valor vostro." ("Now, here, enemies are as cold marble / Do they not become suddenly caught / In looking, Sir, into thy shield / That fierce, crude Gorgon / Horribly made up of / Viperous volumes / Squalid pomp, and frightful locks? / What? Few are the arms / Necessary to thee against the formidable monster. / Because the true Medusa is thine own valour.") (This was published in 1620, but was probably composed in 1601; see Giambattista Marino, *La Galeria*, edited by M. Pieri and A. Ruffino, Trent 2005, p. 39.) He uses Caravaggio's masterpiece to encomiastic ends with regard to the Grand Duke Ferdinando de' Medici, to whom Cardinal Del Monte, who commissioned the work, gave it around 1598 (Baglione 1642). An epigram by Gasparo Murtola (1603) about this work is also known; according to Marini (2000), it refers to another version.

A.C.

Bibliography: Marini 1987, pp. 403–405 (with bibliography); Marini in Bergamo 2000, pp. 482–483; Marini 2001, *passim* (with complete bibliography); *Caravaggio: la Medusa...* 2004.

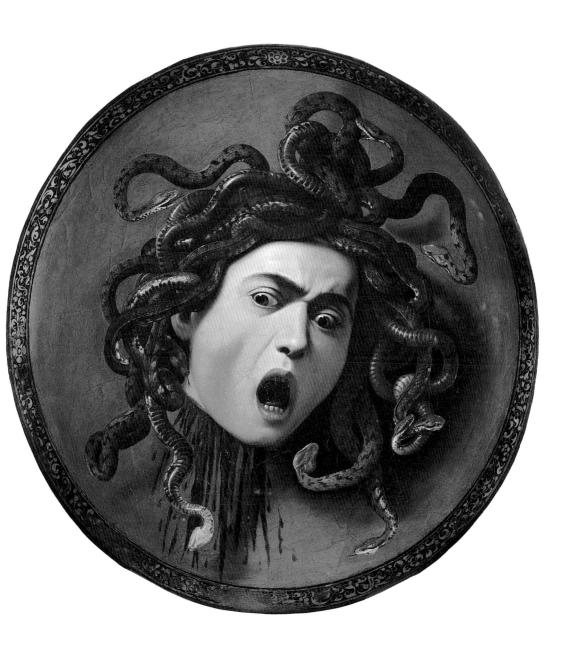

17

Portrait of Maffeo Barberini

Oil on canvas, 124 × 90 cm
Florence, private collection

The relationship between Caravaggio and monsignor Maffeo Barberini, who became cardinal on September 11, 1606, after Merisi's flight from Rome, is documented by Bellori (1672, p. 208). "For Cardinal Maffeo Barberini, who later became Pope Urban VIII, Pontifex Maximus, in addition to his portrait, he painted the *Sacrifice of Abraham*." The mention in Bellori was made in connection to a portrait in the Corsini collection, attributed to Caravaggio by Lionello Venturi in 1912 (pp. 1–2). It was Longhi (1943, pp. 37–38) who first published the portrait of Maffeo Barberini in a private Florentine collection as an authentic work. The new attribution proposed by Longhi was met with unanimous agreement despite the lively debate among critics who recanted their opinions on the originality of the painting in the collection of the Corsini princes of Florence. In the inventory of December 8, 1608 two portraits are recorded, both still in Palazzo Salviati, which according to Lavin are hypothetically referring to this work and the Corsini one. The Maffeo identified by Longhi holds a scroll in his left hand and is portrayed with a scroll-carrying case leaning against the arm of the chair. From these details one can only suppose that the painting in question is connected to Barberini's nomination to become cleric of the Camera Apostolica on March 16, 1598. The position became effective the following year, on March 20, 1599. These indications offer important dates regarding the chronology of this work. Marini (2001) dates the painting to around 1598, and such dating is acceptable both in relation to Barberini's age — who it seems was in his thirties — and the work's style. Longhi sees in Maffeo the beginning or a new phase of Caravaggio's style, in which he "invigorates the darks." The painter focusses on depicting the white folds in the shirt, and through a play of light reflections underlines the knuckles and ball of the thumb on the left hand. As with the portrait of Fillide, one would agree with Frommel (1996, p. 25) in saying that this isn't a psychological portrait, but he certainly renders the life and reality of the sitter immediately recognisable, beyond a mere physiognomic truth and natural colouring. Baumgart also posed the question of whether or not the work, for certain stylistic aspects, might have been done in a period during which the Barberini weren't yet collecting Caravaggio's works. This is a portrait done in the same early years as the portrait of the courtesan Fillide (1599). Because of the differences in composition, the canvas recognised by Longhi as the original (1968, p. 14) is certainly a later work than the other, and according to Aronberg Lavin (1967, p. 470) must date back to 1598, the date in which Maffeo Barberini was nominated cleric of the Camera Apostolica. The few documents found of this work, which attest to the Barberini's commission, date back to 1603–1604. The two paintings found are very different in their composition; the one in a private collection presents greater affinities with the one of Fillide, done more or less in the same period (Marini 1981, pp. 418 and following), thus confirming that Caravaggio held beautiful forms and characteristics and a spontaneity of expression very dear, much more so than deeply penetrating the expression (Frommel 1996, p. 27).

A.L.

Bibliography: Bellori 1672; Venturi 1912; Schudt 1942; Mahon 1953; Berenson 1954; Friedländer 1955; Wagner 1958; Jullian 1961; Wilson 1966; Aronberg Lavin 1967; Panofsky, Soergel 1967–1968; Longhi 1968; Marini 1981; Dell'Acqua, Cinotti 1971; Moir 1982; Calvesi 1990; Frommel 1996, pp. 18–41; Gregori 2001; Marini 2001, *passim*; Volpi (ed.) 2001; Macioce 2003.

18

The Conversion of Saul

Oil on panel, 237 × 189 cm
Rome, Odescalchi collection

This work is prevalently known as a first version of one of the two canvases painted for the Cerasi chapel in Santa Maria del Popolo, as recorded in reliable biographic sources such as Mancini and Baglione. The painting is recorded as early as 1701 in the testament of Francesco Maria Baldi, in Genoa, and is later cited in numerous guides of that city. Only at the beginning of the twentieth century does it return to Rome, to its present collection. Its luck with the critics arrives fairly late, and not through the pen of a connoisseur; Giulio Carlo Argan was the first to publish it in 1943, with a relatively late proposed date of 1606. Later on, in 1947, like Morassi, he recognises its authenticity after seeing the original in the exhibition *Pittura del Seicento in Liguria*. The slow but definite acceptance it received removes none of the clamorous debate, such as the disagreement regarding the painting's chronology. If, on the one hand, the execution of many details perfectly corresponds with that of his early mature years, around 1600–1601, the composition, on the other hand, seems to belong to an older formal, still mannerist model. Argan himself, in a second publication, proposed an earlier date, around 1588. This is difficult to believe, as it would mean the work came from a fifteen-year old boy following a theme much larger than himself. For Longhi, more logically, it could fall between 1590–1592, an idea confirmed by the reflection on sixteenth-century Lombard painting evident here. It closes one era and opens another, whose profoundly different characteristics will be publicly declared, as if in a manifesto, in the version on canvas painted for the Cerasi chapel. It is unlikely that such a mental revolution could occur in a short time, without trauma, difficult encounters, and reflections. This explains the necessity, for Longhi, in establishing the work's authenticity, and of an early date, with no relationship to the Cerasi chapel version, as Venturi also observed. The critics' disorientation, even in the impossibility of their refusing the authentication, continues in the most recent studies, in particular those of Marini, Moir, and Gregori, all of whom are oriented toward the impossible date of his earliest maturity, 1600. The documents are of some comfort; the Odescalchi *Conversion* would be a mistaken version that was rejected by the patron, who wanted a simpler, more orderly composition, instead of such a tumultuous, uncoordinated masterpiece. From these criticisms and observations a new interpretation would soon emerge. But *Natura non facit saltus*, and from a vision as tormented as that of the Odescalchi *Conversion* one cannot pass, without trauma, to the post-Copernican vision of the Cerasi chapel version, with its perfect, ordered, complete synthesis, so plastic in its absolute realism. The fideistic adherence to Marini, Moir, and Gregori's documents is easy but perhaps not obligatory, as it seems to preclude the possibility that Caravaggio had worked, in different times and with more variations, with the theme of Saint Paul's fall. The contention remains one of stylistic evolution, as Mahon observed and Gregory timidly warned, but we cannot agree with the disarmed resignation of the art historians who favour corresponding external dates over the clarity of the forms. In reality the *horror vacui* that makes the rhythm of the Odescalchi *Conversion* so anxious and perturbed turns into a measured harmony of essential elements in the revolutionary Cerasi *Conversion of Saint Paul*. From an open work to a closed work — from Manner to Nature.

V.S.

Bibliography: Argan 1943, p. 40; Longhi 1943, p. 101; Argan 1948, p. 74; Longhi 1951, p. 19; Berenson 1951 and reissue; Mahon 1951, pp. 227, 234; Venturi 1951–1963; Mahon 1952, pp. 118–119; Longhi 1968; Röttgen 1969; Calvesi 1971, pub. 1972; Dell'Acqua, Cinotti 1971; Marini 1973–1974, pp. 156–157, 385–386; Moir 1976, pp. 119, 160–161, note 283; Marini 1980, p. 38, no. 38; Marini 1981, p. 367, note 10; Moir 1982, p. 104; Gregori 1985, pp. 39, 41, fig. 10; Calvesi 1986, pp. 42–44; Marini 1989, pp. 190–191, 447–449; Marini 2001, *passim*; Sgarbi 2004.

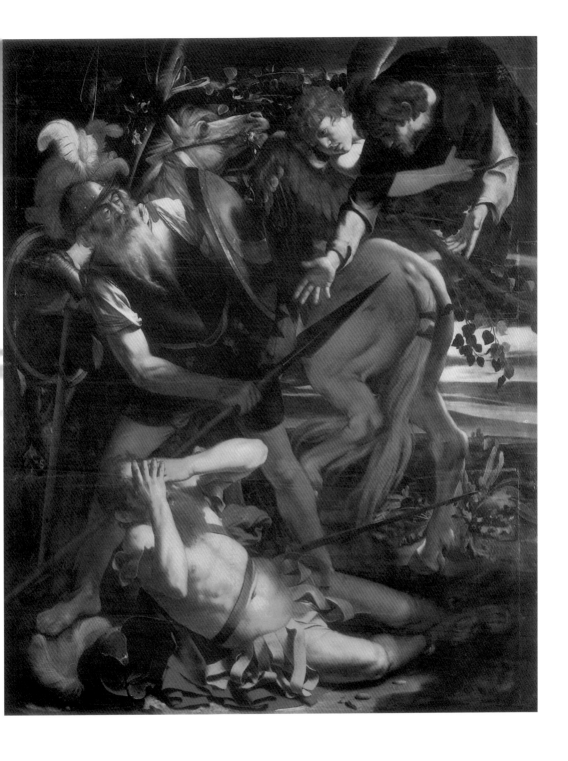

19

Saint Catherine of Alexandria

Oil on canvas, 173 × 133 cm
Madrid, Museo Thyssen-Bornemisza

Cardinal Francesco Maria Del Monte commissions Caravaggio to portray Saint Catherine, or rather that saint who, along with Magdalene in the 1621 testament, is named as the one who intercedes on the cardinal's behalf (Wazbinski 1994, p. 635). There are several documents that attest to the presence of this painting in the cardinal's collection. The first, published in Frommel (1973, p. 23) presents the inventory of goods compiled upon the death of the cardinal's nephew, Uguccione, main heir to the collection (1626). Later documents studied by Kirwin (1971, p. 55) attest to the sale of those goods carried out by the sole remaining heir, Alessandro, who, in order to pay the creditors of his uncle the cardinal, sold the most prestigious pieces, including eight paintings by Caravaggio (May 7, 1628). The possible purchaser of at least two of the works, *Saint Catherine* and *The Cardsharps*, was identified as Cardinal Antonio Barberini, since the two paintings are recorded in his inventory of April 1644 (Aronberg Lavin, 1975, p. 167). The *Saint Catherine*, of unquestionable quality, was at the centre of other debates regarding its attribution; Longhi himself, who in 1916 attributed it to Orazio Gentileschi, in his later studies confirms with certainty that it is a work of Caravaggio's hand. Merit for its attribution to Merisi is due to Matteo Marangoni, on the occasion of a 1922 Florentine exhibit. The work's authenticity is now unanimously agreed upon.
Even with regard to the work's date art historians' hypotheses seem to converge in the years around 1597 to 1599. Mahon is the first to mention a date in that period, followed by Hinks (1953, pp. 55–56), Arslan (1959, pp. 201–202), and Röttgen (1974, p. 64), who also indicates a precise moment — immediately preceding the paintings on the lateral walls of the Contarelli chapel, therefore prior to 1599 — an opinion shared by Cinotti (1971, pp. 97–98). Studies by Frommel (1971, p. 17), Salerno (1960, pp. 21–28), and Marini (1980, p. 28) instead suggest a chronology more closely tied with that of works like the *Portrait of Fillide*, *Martha and Magdalene*, and *Judith*. As Frommel suggests (1996, p. 25), Merisi "was finding the path to a truly grand style." After some experiences with half-length group paintings he had returned to the lone figure offering a plastic, monumental interpretation, in which the levels are clearly defined by the angle of lighting, which seems to structure the objects. The questions critics have most debated remain those surrounding who was the model for the saint and the profane nature of the painting despite the presence of the canonical attributes (the wheel, sword, martyr's palm frond, and, strangely, the halo, which appears here for the first time in Caravaggio's entire œuvre.

As for the model, the most credited hypothesis, supported by Voss (1923, pp. 80–81), and followed by Longhi and Mahon, would seem to be the same as for the (now destroyed) Berlin portrait of the courtesan Fillide, as well as for *Martha and Magdalene* and *Judith*. These choices could also be read, as Cinotti suggests, in light of a particular attention to the human aspect with respect to the dominant theme of holiness. The absolutely unmentioned and resolute aspect of the composition remains that of the wheel, which is transformed from an instrument of torture into a support upon which to lean, described by Bellori (1672, p. 204) as a painting of "Saint Catherine Kneeling against a Wheel."
A.L.

Bibliography: Bellori 1672; Marangoni 1922; Voss 1923; Schudt 1942; Longhi 1952; Hinks 1953; Mahon 1953; Friedländer 1955; Arslan 1959; Frommel 1971; Kirwin 1971; Röttgen 1974; Aronberg Lavin 1975; Cinotti, Dell'Acqua 1983; Calvesi 1990; Corradini 1993; Wazbinski 1994; Marini 2001, *passim*; Macioce 2003.

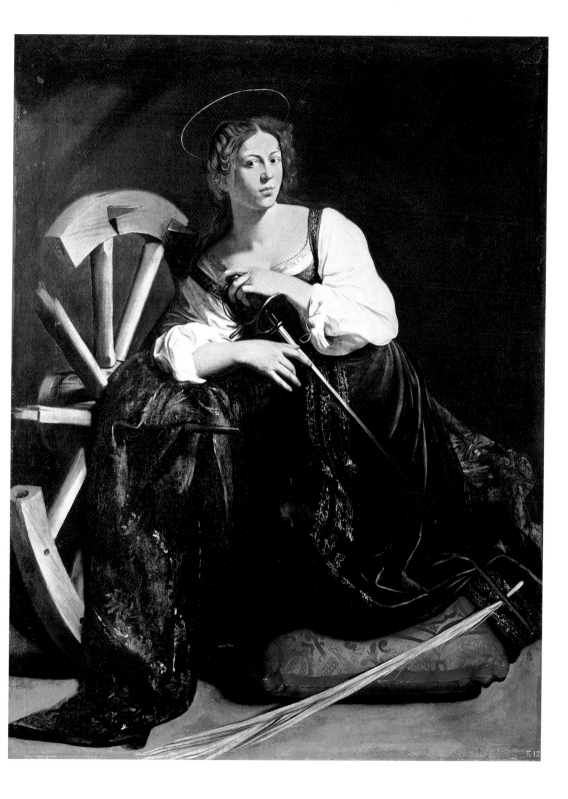

20

Portrait of the Courtesan Fillide

Oil on canvas, 66 × 53 cm
Formerly in Berlin, Kaiser Friedrich Museum

This painting was destroyed in 1945, during the bombardment of Berlin. It had been purchased in 1815 from the Giustiniani collection, in whose 1638 inventory, published by Salerno (1960, pp. 135–136), it was listed as a "Portrait of a courtesan named Fillide," an authentic Caravaggio (Dell'Acqua, Cinotti, 1971, f. 102, no. 12). There is no disagreement on its date and authenticity, but the clearest point of contention is the courtesan's identity.

From her testament, dated October 8, 1614, we find that Fillide was the owner of a portrait executed by Merisi — a work that was hers for only a little while longer, according to Frommel (1996, p. 25) — and that the portrait was given to her lover Giulio Strozzi that same year. The date of the portrait's completion falls approximately around 1598–1599, according to Corradini (1993, pp. 111) and Frommel (1996, p. 29), because of its stylistic similarity to paintings like *Saint Catherine* and the *Portrait of Maffeo Barberini*. Marini (2002), maintains that the courtesan Fillide Pelandroni, born in Siena in 1581, was nineteen or twenty years old when she posed for Caravaggio. When facing the theme of the portrait the artist, rather than concentrate his attention on physiognomic or realistic details, focuses instead on subtle metaphorical allusions such as the orange blossoms, which could end up in contrast with the trade of courtesan Fillide (Cinotti 1971, p. 97). Marini underlines the painting's subtle erotic pull, which could also be read as a testimony of the current fashion in women's clothing. The dress with bodice and shoulder straps paired with a puffy-sleeved shirt is analogous to that of the Doria *Magdalene* and *Saint Catherine*, and the dangly earrings are those of the *Magdalene* and *Judith* as well (Cinotti, Dell'Acqua 1983, p. 411). Calvesi (1990, p. 207), despite the Giustiniani inventory's citation of a courtesan, forcefully proposes a different, religious interpretation. The so-called courtesan of Berlin makes a gesture similar to that made by the Detroit *Magdalene*, inasmuch as her right hand rests a bouquet of flowers at her breast. If the interpretation offered for the *Magdalene* was that of a 'mystic marriage' with Christ, it must be doubted that the painting is of a courtesan. The girl of the Berlin painting, even if much flashier than the Magdalene or Saint Catherine, has attributes that recall the bride of the *Song of Songs*. Other hypotheses have also been considered; Voss (1923), followed by other art historians, suggested the name of Caterina Campani, wife of Onorio Longhi, a friend of the painter. In any case, many documents have been found that attest to the presence of noted Fillide, Caravaggio's lover, in Rome (Macioce 2003, p. 97).
A.L.

Bibliography: Bellori 1672; Marangoni 1922; Voss 1923, p. 81; Schudt 1942; Longhi 1951; Venturi 1951; Salerno 1960; Cinotti 1971; Frommel 1971; Röttgen 1974; Marini 1980; Cinotti, Dell'Acqua 1983; Calvesi 1990; Corradini 1993; Frommel 1996; Marini 2001, *passim*; Spike 2001; Marini 2002, p. 239; Danesi Squarzina 2003; Macioce 2003.

21
Judith and Holofernes

Oil on canvas, 145 × 195 cm
Rome, Galleria Nazionale d'Arte Antica, Palazzo Barberini

This work appeared in a *coup de théâtre* at the Caravaggio exhibition at Palazzo Reale in Milan in 1951, inspiring admiration, discord, and debate. Pico Cellini, the wise and curious restorer who had seen it in Rome in the collection of Vincenzo Coppi, brought it to the attention of Roberto Longhi, the critic who enthusiastically studied it. The last owner claimed that it had been in his family since 1640, through the marriage of Matilde de' Cinque Quintili to Giannuzzi Savelli in the early twentieth century, who gave birth to Paolina, Coppi's mother. Only recently has Costa Restagno (2004) clarified, through very rigorous study of the documents, the complete history of the painting. The first mention (to date) of the work goes back to the 1632 testament of Ottavio Costa, a patrician from Albenga born in 1554 in Castello di Conscente who lived most of his life in Rome, where he had moved in 1576. Extremely attached to his own goods and wealth, and therefore to works of art as well, in his 1632 testament he declares the 'inalienability' of "all the paintings of Caravaggio, particularly the Judith [...]," an inalienability that he defined in his final testament, dated 18 January 1639, as a prohibition of the "alienation and distraction of all my paintings of whatever quality and value, and in particular of those works found in Rome by Caravaggio, Giuseppino, and Guido [...]" In the attached inventory, taken just after Costa's death, there is a record of "a large painting with the image of Judith made by Michelangelo Caravaggio, with frame and taffeta covering intact." Sortly thereafter, in 1642, Baglione correctly records "a Judith who cuts off the head of Holofernes, painted for the Costa," thus indicating it belonged not to Ottavio, who had just died, but rather to the family in general. Indeed, despite repeated testaments, Ottavio's daughter-in-law Maria Cattaneo kept the inherited goods at the residence in Rome. Here they were punctually registered in the 1685 testament and 1688 post-mortem inventory. For a detailed history of the paint-ing's path see the studies of Costa Restagno. Suffice to say that, against the will of Ottavio, the goods were never moved to Albenga, and remained in the capital city, passed on to nearby family branches. Upon the death of the last owners, the Origo family, the goods were given to the Congregation of the 'Operai della Divina Pietà' in Rome, who in 1846 decided to sell them at auction. In 1854 Marquis Antonio de' Cinque Quintili purchased thirty-four paintings that had been left unsold after the 1846 auction. Among the paintings was the "Judith who cuts off the Head of Holofernes, original work by Caravaggio."

Reappearing, after four centuries, in the 1951 exhibition, the painting was accepted virtually without reservation (to Mezio's objections, Longhi replied, "it will not take long for the work to become a stable part of the great Lombard's authenticated œuvre"). Critics also agree on dating the work to 1598–1599, around the period of the *Martyrdom of Saint Matthew* in the Contarelli chapel in San Luigi dei Francesi.

Caravaggio's growing realism is shown in a lucid, crystalline form in this work, almost in a declination of the taste for "plastic values" coherently defined beginning with the Thyssen-Bornemisza *Saint Catherine* and Detroit *Martha and Magdalene*, in which the figures of the young women appear similar to the determined Judith so pained by the horror of the bloody act. The work was purchased by the State in 1971. During the 1999 restoration the letters C.O.C. on the original canvas were discovered, interpreted as the initials of "Comes Octavius Costa," which, as Costa Restagno pointed out, Ottavio also used in his silverware.

V.S.

Bibliography: Spezzaferro 1974, pp. 579–586; Spezzaferro 1975, pp. 103–118; Marini 2001, *passim*; Costa Restagno 2004; Costa Restagno in Genoa 2004, p. 430.

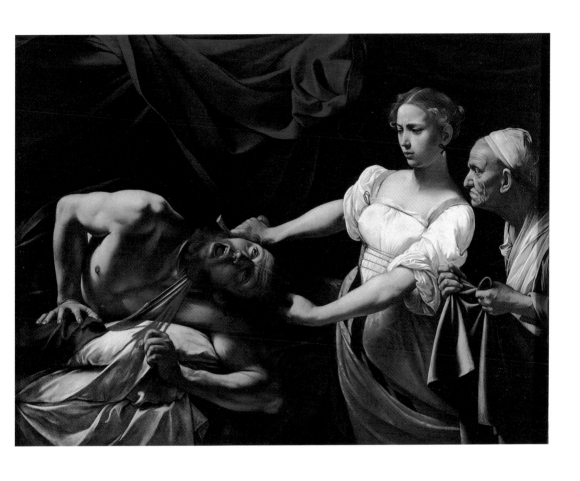

Christ Crowned with Thorns

Oil on canvas, 127 × 165.5 cm
Vienna, Kunsthistorisches Museum

The discovery of a document attesting to this painting's provenance from the Giustiniani family gave the definitive proof of its authenticity, discounting the many uncertainties that accompanied its rediscovery. The painting is recorded among the canvases purchased in Rome in 1810 by Ludwig von Lebzeltern (1774–1854), imperial ambassador to the Vatican and passionate art collector. *Christ Crowned with Thorns* was destined, together with other paintings (by Albani, Lanfanco, and Mengs) to end up in the collection of Francis I, Emperor of Austria from 1804 on. It was only in 1816, however, that the paintings left Rome for Vienna. On April 16, 1816, in the *Journal-Protocoll* of the imperial gallery, there is an annotation of the painting's arrival. The documents are doubly interesting, as they attest to the Giustiniani provenance of *Christ Crowned with Thorns* and Albani's *Christ and the Samaritan Woman*, both still in Vienna, and because they underline the already known economic difficulties of the Giustiniani family.
Christ Crowned with Thorns was nevertheless already known thanks to its having been registered in the Giustiniani inventories and descriptions offered by Bellori (1672, p. 222, 1976 edition) and Silos (1673, p. 88). In 1638 the painting is recorded in the post-mortem inventory of Marquis Vincenzo, as well as in Bellori. Even if the Roman biographer sets this painting before *Amor Victorious*, dated around 1601–1602, and claims it was painted following the request of Vincenzo, such information must be considered with some reservations. It is interesting to note how in both paintings the same armour appears, similar to the one the painter used for the Dublin *Taking of Christ*, which differs only in the addition of a broad gilt border, and again for the later *Crucifixion of Saint Andrew*, in which the armed man seems to be the same on from the Viennese *Christ Crowned*. But the almost universally accepted opinion regarding Caravaggio's use of drawings or models throughout his entire career, even many years apart, doesn't allow for the use of such references in support of a timeline of the works. It is instead necessary to consider stylistic traits, but not even these can always provide an agreed upon date. If one were to rely solely upon a visual impression, a painting like the *Death of the Virgin*, an "incunabulum of his great meditations in Sicily and Malta," to use Strinati's words (1998), would seem to come after the *Madonna dei Palafrenieri*. The documents, on the other hand, have proven the exact opposite. In the case of this painting, the dating vacillates between 1598 and 1599 according to Marini (2001), who sets it in close relationship with the Costa *Judith and Holofernes*, and 1606–1607 according to Gregori (1985) who, while not excluding her hypothesis (1992) that placed it in his Roman period, situates the painting in relationship to his first Neapolitan works, supposing that the canvas could have been purchased by the Giustiniani family in Naples. Prohaska favours setting the painting in his Roman period, specifically around 1601–1602, after the Contarelli chapel in San Luigi dei Francesi, because of the new way in which the light bathes the figures. It would seem logical that Merisi was directly commissioned by Vincenzo to do the painting (the two canes crossing above Christ's head seem to allude to a V), and that it was envisioned as a painting to be hung above a doorway. It is more difficult, on the other hand, given the complete absence of Neapolitan works in Vincenzo's inventory, to believe that the Giustiniani family could have purchased the painting during a later trip to Naples. The presence of a "Crowning with thorns of Our Lord, half-length figures done in the natural hand of Michel'Angelo da Caravaggio 400" in 1688 among the goods of Giovanni Vandeneyden in Naples doesn't constitute a valid proof. Vandeneyden is also recorded as owning Merisi's *Flagellation* and *Taking of Christ*, copies that were more likely by the hand of some Caravaggesque Neapolitan painter.
V.S.

Bibliography: Marini 2001, pp. 429–430 (and preceding bibliography); Prohaska 2001.

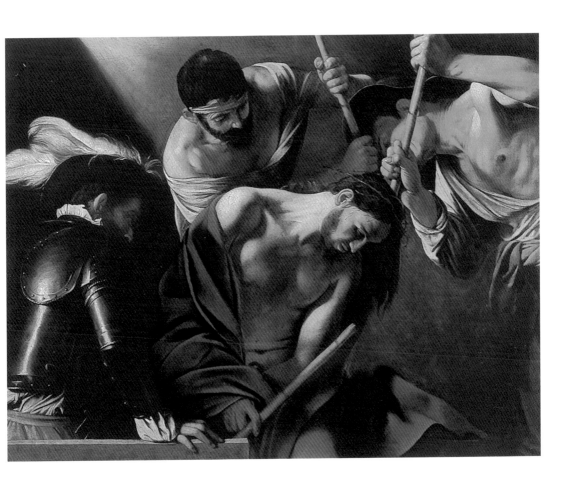

23
Martha and Mary Magdalene

Oil on canvas, 100 × 134.5 cm
Detroit, Institute of Arts

On August 6, 1606 Genoan financier Ottavio Costa wrote in his testament that he wanted his friend, abbot Ruggero Tritonio of Udine, secretary of Cardinal Montalto, to inherit a painting of his own choice between the Hartsford *Saint Francis* and the Detroit *Magdalene*. The document, discovered by Spezzaferro (1974, pp. 579–586), doesn't record the painter's name, but in Tritonio's testament, dated October 25, 1607, one learns that there was a *Saint Francis* by Caravaggio — a gift from Costa — in his collection. Tritonio's choice fell on the more mystical painting, representing Saint Francis receiving the stigmata, "probably now in the Museo Civico of Udine, modelled on the prototype by C. in Hartford and, at the time, belonging to Cardinal Del Monte" (Marini 1987, p. 408). The painting Tritonio did not choose, probably also a copy from the original by Caravaggio, went to his friend, colleague, and executor of his will, Giovanni Enriquez de Herrera, though it doesn't appear in the inventory of goods compiled upon his death, on March 1, 1610, to go to his son Diego (Spezzaferro 1974; Macioce 2003, p. 205). The recent contributions of Testa and Cappelletti (1990, p. 241) revealed a record of the painting in the inventory dated May 25, 1606, regarding the belongings of Olimpia Aldobrandini senior. "A painting of St M. Magdalene and Martha as the latter converts the former, with a frame of gold," is mentioned. The painting is always recorded without the artist's name in other inventories of Olimpia's belongings, in 1611, 1615, 1626, and 1634 (Macioce 2003, pp. 341–343; 352, 357). Only in 1638 does it appear with the correct attribution, and is again recorded in the inventories of Olimpia Aldobrandini junior in 1646, 1662, 1682, and 1769 (Testa 1990, pp. 241, 244, note 108). Through 1769 it remains in the Aldobrandini household, according to another inventory. The painting carries nineteenth-century seals and contemporary inscriptions, which lead to the belief that it was purchased by the Panzani family of bankers, and remained theirs until the end of the nineteenth century (Spezzaferro 1974, pp. 582–583).

Following a series of sales and acquisitions, in 1973 the painting arrived in Detroit. Numerous extant copies confirm the great interest it inspired in early seventeenth-century Rome, but there is no trace of this painting in the biographers' summaries. In 1943 Longhi was the first art historian to note a connection to the model for *Saint Catherine* and the female figures of Titian and Palma il Vecchio or, to stay in the vein of Caravaggio's work, that of the courtesan Fillide.

This painting's identification as a conversion of Magdalene is due to Cummings (1974, pp. 563–564), who thus returned the true meaning to the painting. It certainly isn't Martha's reprobation of Magdalene, but is rather the sinner's conversion; the moment in which divine light illuminates her, and Magdalene symbolically abandons her jewels. The orange blossom the woman holds with her hand to her heart, or rather to her breast, and the wedding ring on her left ring finger are symbols, as Cummings hints at, of her mystical marriage to Christ. Gregori (1985, p. 250) interprets the mirror held by Magdalene as an allusion to the *vanitas* of terrestrial things. The dark, convex mirror with the reflection of the square peg, symbol of wisdom, represents contemplative life (Testa 2001, p. 133). Frommel (1996, p. 25) also maintains that the subject of this painting is the conversion, her leaving the shadow of sin, which is ideal for Caravaggio's paintings of light and shadow. A similar hypothesis is taken up again by Calvesi (1990, p. 340) who underlines, as in other depictions of Magdalene, the relationship with the description of the bride in the *Song of Songs*.

A.L.

Bibliography: Fiocco 1917; Voss 1923; Longhi 1952; Mahon 1952; Frommel 1971; Cummings 1974, pp. 563–564, 572–578; Spezzaferro 1974; Cummings 1975; Spezzaferro 1975; Cinotti 1983; Cinotti, Dell'Acqua 1983; Marini 1987; Calvesi 1990; Gregori in Firenze-Roma 1992; Frommel 1996; *La luce del vero* 2000; Marini 2001, *passim*; Testa 2001, pp. 133, 150, note 36; Macioce 2003.

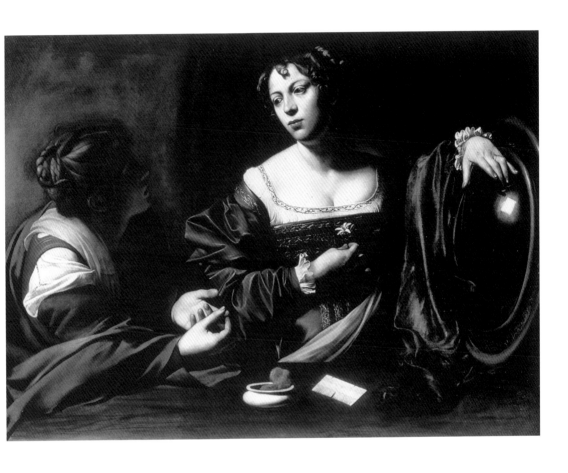

24
Jupiter, Neptune, and Pluto

Oil mural painting, 300 × 180 cm
Rome, Villa del Monte (formerly Casino dell'Aurora)

Referring to Caravaggio, Bellori (1612, p. 215) writes that "the Jupiter, Neptune, and Pluto of the Ludovisi Gardens near Porta Pinciana [are by his hand], in the villa of Cardinal Del Monte, who, being a scientist of chemical medications, adorned the little room of his distillery with it, affiliating these gods to the elements with the globe of the world between them." It is an oil colour wall painting, as "Michele had never touched a fresco brush." Merisi used the oil colours to bind the pictorial layers (Lapucci 1992, p. 32). The work, after other attributions, was recognised by Zandri (1969, pp. 338–343) and studied by Spezzaferro (1971). The proposed dating falls between 1597 and 1600, presuming Del Monte's purchase of the villa (26 November 1596) as the earliest possible date; in September 1597 however, he ceded it to Pietro Aldobrandini, and came back into ownership only in 1599, hence the first versions of the paintings in the Contarelli chapel must have been done after this painting. On September 20, 1597 Del Monte refers to the room as a source of satisfaction. It is logical to believe, then, along with Marini, that on that date the room and its decoration must have been completed. The painting wasn't initially considered a Caravaggio, and Longhi had called Bellori's record "foolish." Indeed, Del Monte's relationship to alchemy seems unthinkable. Zandri's analysis identified the three deities with the elements air, water, and earth. The apparent absence of fire is justified by the hints of a solar circle. According to Frommel (1996, p. 22) this painting represented for Caravaggio a mode of rivalling the Carracci, who shortly before had decorated a little room in Palazzo Farnese. The literary source, according to Frommel, can be found in the passage of the *Illiad* that recounts the battle between the Titans and the sons of Cronus, who, as victors, divided the world: Zeus reigned over heaven and earth, Poseidon over the sea, and Hades over the underworld. Gregori (1996, pp. 106–120) also maintains that the three deities are depicted in the moment in which they are dividing the universe. There are at least three veins of iconographic investigation supported by art historians. Frommel's reading appears clearly mythological. The writings of Zandri, and in particular those of Cole Wallach (1974–1975, pp. 101 and following), continue in the tracks of an astrological, alchemical conception according to which the Homeric account of the division of the cosmos should correspond to the cosmic separations in Genesis. Calvesi (1990, pp. 173 and following) further deepened the meanings of the alchemical decoration, which is an allegory of the process of material transmutation through various states until reaching the philosopher's stone. Bellori, in speaking of chemical medications, could be referring to hermetic alchemy, since the philosopher's stone is often defined as an elixir or medicine. The three deities represent the transitions of the material from one element to another. The passage from one phase to another is suggested with an irreverence in the figures' attitudes that is entirely Caravaggio. It might be noted that he had no experience in painting figures in movement *di sotto in su* (from bottom up). As Gregori confirms (1996, p. 118), "The uncommon knowledge of perspective that Merisi possessed is also demonstrated in the illusionistic artifices he so often used." Caravaggio received no more commissions for ceiling decorations or mythological scenes, but his masterful conception of space remains. *A.L.*

Bibliography: Bellori 1672; Jullian 1961; Longhi 1968; Zandri 1969; Calvesi 1971; Dell'Acqua, Cinotti 1971; Frommel 1971; Spezzaferro 1971; Marini 1974; Röttgen 1974; Cole Wallach 1974–1975; Marini 1980; Cinotti, Dell'Acqua 1983; Calvesi 1990; Frommel 1996, p. 22; Gregori 1996; Marini 2001, *passim*; Berra 2005.

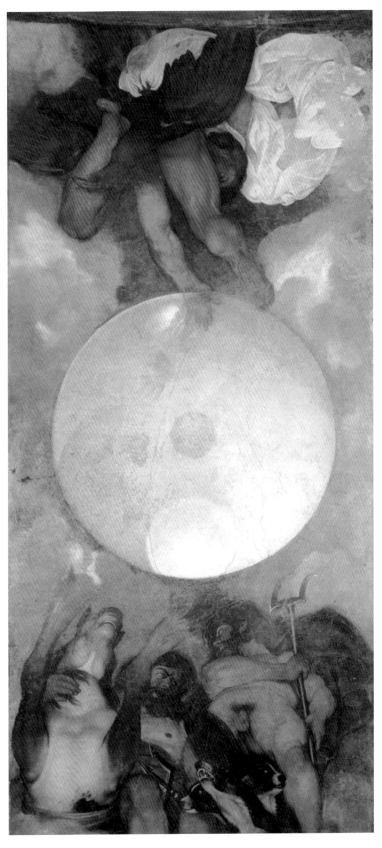

25
The Calling of Saints Peter and Andrew

Oil on canvas, 132 × 163 cm
London, Hampton Court Palace, Royal Gallery Collection

A 1782 etching in lamp black, etched and printed by John Murphy and part of the royal collections of Windsor, has a caption stating that it was done after Caravaggio's original. The painting had been purchased by King Charles I in 1637. Numerous copies are known, but the Hampton court version has been confirmed authentic ever since the first guide to the gallery was written by Ernest Law (1898, p. 105), despite the fact that it inspired quite a bit of perplexity in light of its state of conservation. Marini, who first maintained it was a copy of an original (1973–1974, p. 128), feels that the conditions of the painting are an obstacle to recognising its authenticity. A confusion has grown round the painting also on account of its mention in Celio (1620, p. 134), who recalls having seen it in the Mattei household — "that [painting] of Emmaus" — but in reality he refers to the *Supper in Emmaus*. Such disagreement has caused doubts as to the paintings authenticity. Even if the painting has sometimes been mentioned as *On the Way to Emmaus*. It was Longhi (1943, p. 39) who first interpreted the subject as *The Calling of Saints Peter and Andrew* (Matthew IV, 18:20), with an approximated date of 1595. Wagner (1958, p. 230), on the other hand, is in complete dissent regarding the painting's authenticity, claiming it is a pastiche executed in the style of Caravaggio after his death. Voss (1924, p. 443) noted the painting as a copy of an *On the Way to Emmaus*. The 1639 gallery inventory mentions it as *Three Disciples Returning from Fishing*; it is instead registered as *Peter, James, and John* in the Green-

wich inventory of 1639. "Three Fishermen by Michel Angelo Caravaggio," on the other hand, are recorded in the Commonwealth inventory of 1640. According to Voss, Scudt, and Friedländer, it is an *On the Way to Emmaus*. The presence of fish in Peter's right hand alludes to the fisherman's trade in the evangelical sense, while the scene in the calling of Andrew seems to recall that of the *Calling of Saint Matthew* (Cinotti 1973, p. 559). In this painting also, just as in the *Supper in Emmaus*, Christ is young and beardless and, in addition to recalling a Leonardesque sensibility (Longhi 1952, p. 31), it makes one think of the eternal youth of the *Ecclesia triumphans* in contrast to the two mature apostles, emblems of the *Ecclesia militans* (Marini 1987, p. 412). The canvas was purchased from William Frizell by Charles I in 1637, and appears in the Van der Doort catalogue of 1639 (Cinotti 1983, p. 559). Cast out by the puritan government in 1651, it was recovered after restoration in 1660, in 1665 was in Whitehall, and later on in Windsor (Levey 1964, pp. 69–70).

A.L.

Bibliography: Celio 1620; Baglione 1642; Law 1898; Voss 1924; Isarlov 1935; Longhi 1943; Hinks 1953; Friedländer 1954; Wagner 1958; Longhi 1960; Levey 1964; Moir 1967; Cinotti 1971; Levey 1971; Nicolson 1974; Cinotti 1983; Marini 1987; idem 2001, *passim*.

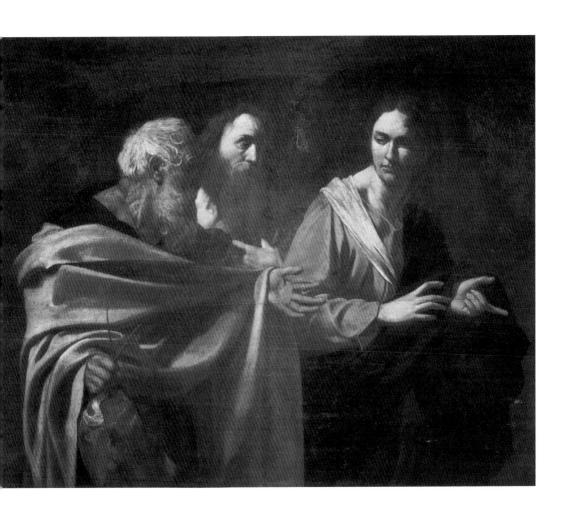

26
Doubting Thomas

Oil on canvas, 107 × 146 cm
Potsdam, Sanssouci, Bildergalerie

The travel diary of Bizoni, secretary to Marquise Giustiniani, is the oldest literary reference (dated 1606) to mention this painting, referring to a Genoan copy owned by Orazio del Negro. The first inventory that records its ownership is precisely that of Marquise Giustiniani in 1638, in which the dimensions are indicated and coincide with the Potsdam version. Throughout its long peregrinations the painting landed in Paris, and was purchased by the King of Prussia in 1815, and had even been considered lost.

The question of its authenticity has been debated at great length. Voss (1923) first writes of the work, based on references from literary sources. For the 1951 exhibition in Milan Longhi had wanted to present a painting of the same subject from the Museo Nazionale in Messina by Alonso Rodriguez, attributing it to Caravaggio. A dense correspondence on this debate between Venturi and Longhi follows, and the issue is resolved only with Salerno's 1960 rediscovery of the Giustiniani inventory (Danesi Squarzina 2003, pp. 54–57). This document, dated 1638, which is in itself quite scrupulous in distinguishing copies from originals, has an annotation that the painting in question is the work of Caravaggio's hand. One of the sources that first cites the work is Von Sandrart (1675). Even Baglione (1642, p. 138) describes it in minute detail: "Saint Thomas then touched the ribs of the Saviour with his finger," but he considers it part of the collection of Ciriaco Mattei. One must wonder whether the painting mentioned by Baglione could be an authentic replica, if it is the same original that previously belonged to the Mattei family and was added before 1606 to the Giustiniani collection, or if that is a mistake. There is no trace, in reality, of such a replica, as it isn't mentioned in any of the Mattei family inventories (Frommel 1971). The *Doubting Thomas* certainly remains one of Caravaggio's most copied paintings; Moir (1976) provides an extended catalogue of such copies. Approximately twenty-two are known, of which at least five are in Spain, two are in private collections in Madrid, and the others in the church of St María la Mayor de Toro, the church of St Francisco in Valencia, and the church of St Justo in Granada. Regarding these Malvasia writes of how cardinal Giustiniani encouraged copies of the painting to be made in Bologna and Genoa, with the goal of exemplifying Caravaggiesque realism (Dempsey 2001, p. 195).

The date of this work ranges from 1599 to 1601–1602. The first hypothesis, supported by Mahon (1952) and Voss (1958), is based on a stylistic affinity with the *Supper in Emmaus*, to which this painting was considered a pendant. Because of its similarities to the canvases of the Contarelli chapel (1599–1600, 1602) it has also been supposed that the *Doubting Thomas* was painted between 1601 and 1602.

The figures are closed within an ideal elliptical space. Lionello Venturi (1951) defined the work "a compositional marvel;" the theme is from the Gospel of John (XX, 24:29), and the gesture of the finger plunging into the slit, which arose in Northern Europe and is portrayed in such a raw, realistic way, is an act of faith passing through doubt and human inadequacy.

A.L.

Bibliography: Baglione 1642; Bellori 1672; Von Sandrart 1675; Malvasia 1678; Voss 1923; Longhi 1928–1929; Schudt 1942, p. 26; Venturi 1951; Mahon 1952; Friedländer 1955, p. 161; Salerno 1960; Longhi 1968; Cinotti 1971; Gregori 1972; Marini 1974; Röttgen 1974; Marini 1980; Moir 1982; Cinotti, Dell'Acqua 1983; Bologna 1992; Marini 2001, *passim*; Danesi Squarzina 2003.

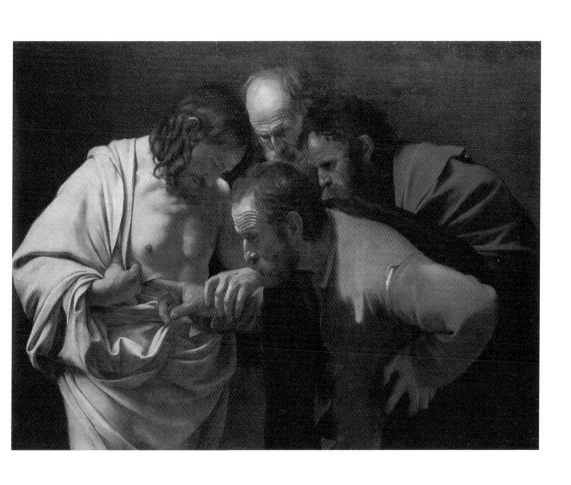

27
Saint Matthew and the Angel

Oil on canvas, 223 × 183 cm
Formerly in Berlin, Kaiser Friedrich Museum

Unfortunately destroyed in a fire in 1945, this painting of *Saint Matthew and the Angel* is the first version of the altarpiece commissioned from Caravaggio in early 1602 for the Contarelli chapel, in San Luigi dei Francesi in Rome, after the remarkable success of *The Calling* and *The Martyrdom of Saint Matthew* — the paintings on the same chapel's lateral walls. According to Bellori this painting was rejected because the saint had neither the decorum nor demeanour of a saint.

Sitting with crossed legs and bare feet in the foreground, rudely turned toward the public and directly above the altar, Saint Matthew is attentive but confused as a young angel — with a great, almost erotic sensual energy — guides his hand while he is writing the Gospel. The angel is painted very close to the old saint, and it almost seems as though the evangelist is illiterate. A beautiful transparent veil reveals a large part of the body of the sweet-faced boy, so harmonious in his sinuous pose and the attractive, feminine delicacy of his movements. In this work, perhaps deliberately, Caravaggio shows scarce consideration for traditional religious decorum.

The origin of Matthew's pose probably derives from Raphael's preparatory drawing for the fresco *Jupiter and Cupid* in Villa Farnesina; in 1602 Cherubino Alberti, a friend of Caravaggio, made an etching of the fresco. He took up Raphael's creation and used it with realistic aims to outline the pose of a bald model with knotted-up eyebrows, seated in his study on a Savonarola chair, the presence of which is significant because one of Matthew's extortionist colleagues sits on the very same chair in the *Calling*. Above all, in the context of the chapel, the seat reinforced in many ways the representation of the saint's conversion and his response to the call of Christ. Nevertheless, strangely, the saint's physiognomy (or look) is quite different from that portrayed in the lateral paintings. The open book and the act of writing (in Hebrew) are inundated with light, as is the face of the angel while he receives divine inspiration; significantly, Matthew's face is in shadow. In the second version, executed after the first was rejected, Caravaggio corrected the iconography, creating a more conservative, respectful, even classical painting. Until the discovery of the contract for this commission (Röttgen 1965), Bellori and other art historians took the idea that the altarpiece predated the lateral paintings for granted, and even gave it a date toward the end of the fifteen-nineties. In reality, the sculptural setup and solidity of modelling are particular to the paintings between 1599 and 1600; the loss of the painting denies us of a fundamental work from the artist's Roman period.

As sanctioned in the February 7, 1602 original contract, Caravaggio presumably delivered the painting by Pentecost of the same year. The artist received payment for the chapel altarpiece on September 22, 1602, but it isn't entirely clear whether the payment was for the painting in question or the second version, which is still *in situ*. The rejected first version was immediately purchased by Marquis Vincenzo Giustiniani. At a certain point the dimensions of the painting were reduced, probably in order to better fit it within the context of a private collection. It was sold together with the rest of the Giustiniani collection in Paris in 1812, and purchased by the Kaiser Friedrich Museum in 1815. The painting was destroyed during the bombing of Berlin in 1945.
K.S.

Bibliography: Jullian 1961, pp. 103–104; Röttgen 1964, p. 220; idem 1965 (1974 edition), pp. 47–68, 75, 102–127; Ottino della Chiesa 1967, no. 44A; Kitson 1969, no. 41 A; Röttgen 1969 (1974 edition), pp. 89–92; Cinotti, Dell'Acqua 1971, pp. 32–33, 112–113, 152–153; Lavin 1974; Moir 1976, p. 90, no. 19; Nicolson 1979, p. 33; Cinotti 1983, no. 3; Hibbard 1983, pp. 144, 183–191, 302–304; Marini 1989, pp. 455–458, no. 48; Bologna 1992, pp. 306–308; Gregori 1994, p. 149, no. 39; Christiansen in *Come dipingeva...* 1996, pp. 7–9; Pupillo in Macioce 1996, pp. 148–166; Puglisi 1998, no. 38; Marini 2001, no. 53; Spike 2001, no. 27; Corradini in Volpi 2001; Zuccari in Volpi 2001.

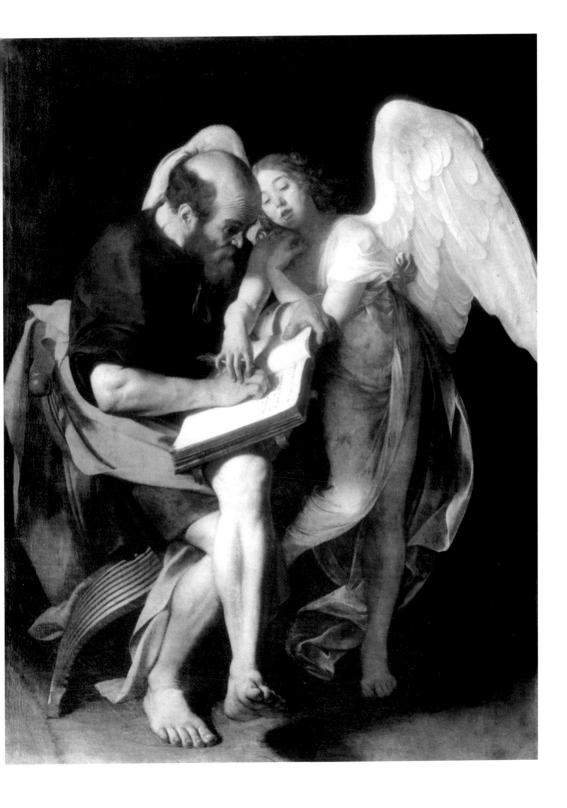

28

The Calling of Saint Matthew

Oil on canvas, 322 × 340 cm
Rome, church of San Luigi dei Francesi

As if in a still of a daily news event, Caravaggio's Saint Matthew is distracted by the light of divine salvation while intent on gambling with his friends, probably with dice. "If, then, Caravaggio might also have felt supported by the ambiguity with which the word 'telonio' — the tax room — was occasionally used to indicate a gambling room, is a question to pose to all those who know for sure how to reconstruct the history of that linguistic use. And it would be worth the trouble of looking into it" (Longhi 1968, p. 24). In reality *The Calling of Saint Matthew*, next to the other two canvases of the Contarelli chapel completed by Caravaggio in Rome, is among the most documented works in the history of art; but the many documents refer, for the most part, to the drawn-out question of a financial contention between the Crescenzi, executors of the testament of cardinal Cointrel (founder of the chapel), and the congregation of San Luigi. From the documents it is clear that the Crescenzi were probably not interested in the completion of the chapel's decoration as they were in the actual congregation. Support for this comes also from a reading of the contract, dated July 23, 1599 and rediscovered by Röttgen in 1964 (pp. 49–50), in which Caravaggio is dedicated to painting the two pictures on the lateral walls of the chapel. "The painter is to finish the two works within year's end, as written in this document, or, in the case that as of said date they remain incomplete, will finish them for a total of 400 scudi, of which he has received 50 in advance." (Macioce 2003, p. 77). For the first time, with respect to the mass of documents narrating the Contarelli chapel's history, the name of Merisi appears, but the painter would seem to be almost forced upon the Crescenzi by someone merely identified as father Berlighiero from the Fabbrica di San Pietro. The more recent studies of Pupillo (1996, pp. 148–165) and additional documentary findings confirm how the existing relationships between the Contarelli and the Crescenzi families was so close as to inspire doubt regarding a possible dispute, even regarding the selection of an artist such as Caravaggio.

The theme shown here is the one Contarelli had already established for Muziano, and the directions were to represent Jesus passing by on the road with his disciples and calling the tax collector Matthew, but Caravaggio with his way of painting, renders the scene absolutely new, and, because of a few details, enigmatic. Christ enters the scene as if a passage had mysteriously opened; Peter is at his side — a clear allusion to the Church — and repeats the gesture of pointing to Matthew. Radiography has shown that the figure of Peter was added, almost as if to reinforce the theme of holy Grace. Aside from a stylistic analysis of the individual characters that populate the scene, according to Marangoni (1922, p. 794) the absolute protagonist is once again the light that models form and space, and according to Calvesi (1990, p. 311) its symbolic use as an "Augustinian mould."
A.L.

Bibliography: Bellori 1672; Marangoni 1922; Schudt 1942; Venturi 1952; Mahon 1953; Berenson 1954; Friedländer 1955; Wagner 1958; Jullian 1961; Longhi 1968; Marini 1974, 1984; Moir 1982; Cinotti, Dell'Acqua 1983; Calvesi 1990; Pupillo 1996; Gregori 2001; Marini 2001, *passim*; Volpi (ed.) 2001; Macioce 2003; Puglisi 2003; Berne-Joffroy 2005.

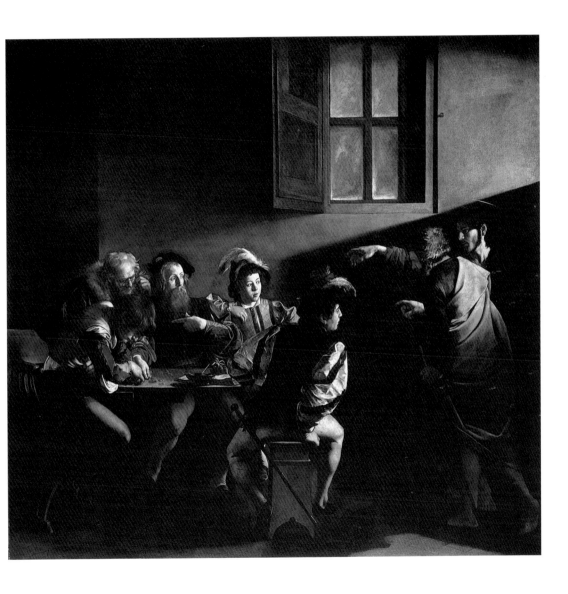

The Martyrdom of Saint Matthew

Oil on canvas, 323 × 343 cm
Rome, church of San Luigi dei Francesi

The Martyrdom of Saint Matthew was the very first canvas to be sketched out for the lateral walls of the Contarelli chapel. Radiography has exposed the first layout of the painting, conceived as "a symbolic composition, rather than a dramatic one," inasmuch as it represents not "the act of killing, but *just* the threat" (Venturi 1952, p. 38). The only biographical mention to record the re-facing of the *Martyrdom* is in Bellori (1672, pp. 205–206): "On the other side is the martyrdom of the saint himself, dressed in sacerdotal robes and laid atop a counter; and the rogue approaching him brandishes a sword to wound him [...] The composition and masses, however, were insufficient for an historical painting; thus he redid it twice over." The contract for the painting's execution is the same as for *The Calling of Saint Matthew*. Merisi's hire is inevitably intertwined with the drawn-out events surrounding the Contarelli chapel. On July 23, 1599, for the first time, the name of "Mich[el] Angelus Marisius de Caravagio" appears, to whom the completion of the chapel's sides was entrusted, according to the plan set out between Virgilio Crescenzi, will executor of Contarelli, and the painter Cavalier D'Arpino, to whom the project had originally be entrusted, but who failed to complete the work (Macioce 2003, p. 77). In the *Martyrdom* the tragic event is depicted almost as a crime from the daily newspaper in which all the emotional reactions of the witnesses are emphasised through the brilliant play of volumes and gestures, thanks to the plasticity of the bodies and contrast between light and shadow. As often happens in Caravaggio's painting, the precise moment before the drama unfolds is depicted — the moment in which the most tension and pathos is let loose. The central framing of the scene brings to light not only the initial phase of the tragic event, but also the moment linking the human element to the divine element, embodied by the angel swooping down and extending the palm frond of martyrdom. À propos of this detail, Calvesi pointed out how the text *De Pictura Sacra* by Federico Borromeo, from whose devotional dictates Caravaggio seems to have taken inspiration, recommends that artists do not forget to represent a palm in scenes of martyrdom.

Moir's description (1982, p. 94) is minutely detailed and effective: "He [Caravaggio] pivoted the action on the executioner, placed in the centre, portraying him in the crucial moment in which he catches Saint Matthew laid out defenceless on the ground. While the saint raises his right hand, invoking pardon for his own executioner, the angel's hands bring down the martyr's palm, and the other figures spread out, frightened, in all directions." Gregori (2000, p. 30) focuses on the value of the light, maintaining that "in the darkness of the martyrdom the light comes from a source outside the scene, and the presence of the little candle on the altar has the sole purpose of indicating, through the displacement of the flame, the supernatural arrival of the angel. Both the episodes described in the lateral canvases document the passage from the transparent style of the early works to a new, luministically opposed vision."
A.L.

Bibliography: Bellori 1672; Schudt 1942; Venturi 1952; Mahon 1953; Berenson 1954; Friedländer 1955; Wagner 1958; Jullian 1961; Wilson 1966; Longhi 1968; Dell'Acqua, Cinotti 1971; Marini 1974; Moir 1982; Marini 1984; Calvesi 1990; Macioce (ed.) 1996; Gregori 2000; Marini 2001, *passim*; Volpi (ed.) 2001; Macioce 2003; Puglisi 2003.

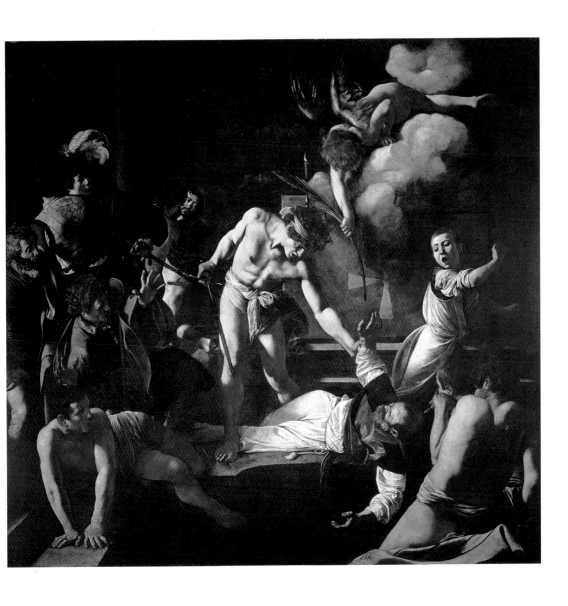

Saint Matthew and the Angel

Oil on canvas, 296.5 × 195 cm
Rome, church of San Luigi dei Francesi

"Caravaggio, in order to ingratiate himself with the priests of San Luigi dei Francesi, repainted Saint Matthew. The second version is still above the altar, and he resorted to slim proportions, a serpentine pose, and the angel who descends from the heavens; he avoided any social incongruities, but wasn't true to himself, and the work of art was merely mediocre" (Venturi 1951, reissued 1963, pp. 51–52). This critical opinion brings into focus a known problem in the works of Caravaggio, once again torn between realistic method and the need to bring back to the work a greater spirit of transcendence. The first version of the *Saint Matthew* was rejected, as always, for reasons of 'decorum,' presumably in connection with iconographic innovations including the evangelist's pose, as he was depicted as an illiterate in direct contact with the divine, represented by the angel. Its rejection is reported by Baglione, and is more amply described in Bellori. The painter was forced to quickly make a second version, the payment for which is documented on September 22, 1602, rediscovered by Röttgen (1965, pp. 55, 56). February 1603 has sometimes been the preferred date of the work's delivery, when for the second time the carpenter was paid for framing it (Papi 1992, p. 80). In the second version, Longhi (1968, no. 48) confirms that Caravaggio conceives — just as in the first version — "at least angels can fly […] the angel could give his explications from on high." In the second version one notes a more quiet meditation on the dialogue between the human and the divine, a result, according to Longhi, of the painter's return to a serene classicism. The saint is also described through little yet significant details, such as the folds of his robe which Gregori (1985, p. 43) defines as "long and sharp, clearly derived from the plastic solutions found in classical sculpture." The Saint Matthew of the second, definitive version has assumed the look of a sage, far removed from the rustic and stolid expression of the face in the first version, and he turns to the angel without any excessive look of wonder. With regard to the chronology, a date between 1600 and 1601 is fairly agreed upon, not only by virtue of the document attesting to its payment. According to Calvesi (1990, p. 308) another reason, related to the statue by Cobaert that Caravaggio's painting would substitute, must exist. In place of the altarpiece planned for by the late cardinal Contarelli, Crescenzi, as executor of his last will and testament, had hired Cobaert to carve a statue of Matthew and the angel. Even though incomplete, the sculptural group was placed on the altar between January 8 and 12, 1602; but this try-out made Giacomo Crescenzi decide to relieve Cobaert of the responsibility. The contract, releasing the sculptor from the duty of completing the angel that was still missing, is dated January 30, 1602. Probably the effect of the whole was unsatisfying, and the new rector Francesco Contarelli didn't much appreciate the statue (Macioce 2003, p. 108). In the meantime Caravaggio had completed the first version of *Saint Matthew*, which was nevertheless the wrong size to fit the available space. The artist's second *Saint Matthew* is, in fact, 64 centimetres shorter and 6 centimetres narrower. The definitive layout responds, therefore, to the need for a certain balance of proportion between the lateral paintings and the one above the altar. The main reasons for the refusal of the first version, Calvesi confirms (1990, p. 310) could, then, be ones of size. And given that the painting had to be redone anyway, it was seen as an opportunity to radically emend the work's iconography for the many reasons debated at length.

A.L.

Bibliography: Bellori 1672; Schudt 1942; Hess 1951; Venturi 1951; Mahon 1953; Berenson 1954; Friedländer 1955; Wagner 1958; Jullian 1961; Röttgen 1965; Wilson 1966; Longhi 1968; Dell'Acqua, Cinotti 1971; Marini 1974, 1984; Moir 1982; Gregori 1985; Calvesi 1990; Papi in Florence-Rome 1992; Gregori 2001; Marini 2001, *passim*; Volpi (ed.) 2001; Macioce 2003; Puglisi 2003; Berne-Joffroy (reissue) 2005.

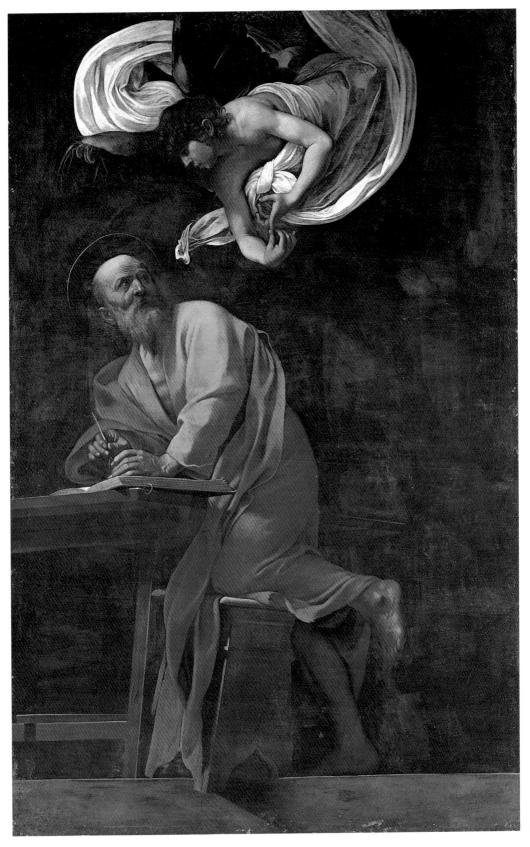

Supper in Emmaus

Oil on canvas, 141 × 196.2 cm
London, National Gallery

The theme of the supper in Emmaus, which illustrates the moment in which the disciples recognise the resurrected Christ as he blesses and breaks the bread, is only related in the Gospel according to Luke (XXIV, 30:31). For Ciriaco Mattei Caravaggio paints a work with "Our Lord in *fractione panis* [breaking the bread];" thus it is recorded in Mattei's accounting books. The document, dated January 7, 1602, confirms payment through "monsignor Romolo Rizivene" for the painting now identified as the London *Supper in Emmaus*. This document is illuminating also with regard to the type of relationship that existed between the painter and Ciriaco Mattei, who normally only bought his works through banks, and commissioned another two works from him: the *Saint John the Baptist* in the Musei Capitolini in Rome, and the *Taking of Christ* in Dublin (Macioce 2003, p. 106). The first certain mention of the canvas appears in the inventory of Villa Borghese by Manilli in 1650. It later appears in Scannelli (1657, p. 51), who refers to the "tremendous naturalness" of the painting, and Bellori (1672, p. 211) offers a singular description. "In the supper in Emmaus, aside from the rustic forms of the two Apostles and the Lord depicted as a youth without beard, the innkeeper looks on with a cap on his head, and on the table there is a plate of grapes, figs, pomegranates out of Season" (it is thought, in fact, that the supper in Emmaus took place just after the Easter period). Bellori additionally incorrectly reports how the painting was executed for cardinal Borghese, but if that were true, its date would have to be shifted to 1605, when a relationship between the cardinal and Caravaggio is recorded; a stylistic analysis of the work precludes such a hypothesis.

The authenticity of this painting, one of Caravaggio's most famous, on the other hand, is without doubt. As for its date, art historian's hypotheses agree upon the early sixteen-hundreds, based also on a comparison with the lateral paintings of the Contarelli chapel, in which the gestures and foreshortening that involve the viewer are not as strong as they are in the Cerasi canvases (1600–1601). In this painted scene the moment of benediction and the institution of the Eucharistic sacrament are juxtaposed with the moment of the apostles' recognition of Christ, made evident by the strongly foreshortened gesture of the pilgrim on the right. The innovative element, as usually occurs in Caravaggio's paintings, this time lies in the beardless image of Christ. According to Lavin (2000, p. 19) the Christ without a beard could have been inspired by some ancient sarcophagi or, according to Kinkead (1966, p. 114), by the Michelangelo of *The Last Judgement*. For Longhi (1968, p. 19) the "beardless, oval Christ is an almost ironic memory of Leonardo's supper, seen during his years in Milan," while Calvesi interprets the figure's youth as a signal of the eternal life that Christ gives to the faithful, and the figure's androgyny as an hermetic symbol of the unity of opposites. Also in the London *Supper* are the bread, water, and wine that Christ blesses, but also a roasted chicken and a basket of fruit and grapes — allusions to the resurrection.

The still life of such neat, clear Lombard ancestry (Longhi 1928–1929, p. 273) constitutes not only a symbolic element, but also stabilises within the whole composition a layer of depth that fully involves the viewer.

A.L.

Bibliography: Celio 1638; Manilli 1650; Scannelli 1657; Bellori 1672; Marangoni 1922; Longhi 1928–1929, p. 273; Kinkead 1966; Longhi 1968, p. 19; Calvesi 1971, nos. 9/10; Levey 1971; Cinotti, Dell'Acqua 1983; Gregori 1985, pp. 271–276; Calvesi 1990; Cappelletti, Testa 1994; Gilbert 1995; Lavin 2000; Marini 2001, *passim*; Spike 2001; Gregori, Bayer (eds.) 2004.

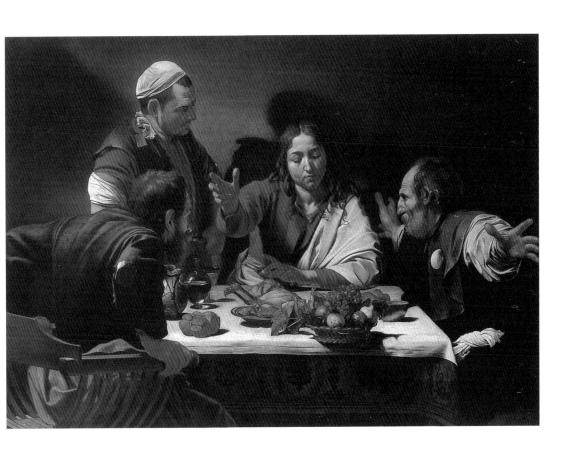

32
Crucifixion of Saint Peter

Oil on canvas, 230 × 175 cm
Rome, church of Santa Maria del Popolo

"Rome is flourishing in painting, more than it ever has in previous times; much anticipated are the two paintings that Caravaggio is creating for the Chapel of the late Monsignor Ceraseo, Treasurer." This is the proclamation given in a notice dated June 2, 1601 (Spezzaferro, Mignosi Tantillo 2001, p. 111). This document confirms the fact that Caravaggio is still painting the second version of the canvases for the Cerasi chapel in Santa Maria del Popolo.

Payment was made in November 1601. Then, on the left side of the chapel, a second version of the canvas portraying the crucifixion of Saint Peter is to be installed. For the first version Caravaggio had received yet another rejection.

The iconography adopted here is rare, and the event is reduced to its essence: the three executioners are busy lifting the enormous cross, to which the saint has been nailed in order to be crucified upside-down, according to his own wishes as described in the *Acts of the Apostles* (XXXVII, 8, 2). The paradox later told is that the tortured man becomes the recorder of his own martyrdom.

In this case once again an element of absolute innovation is noticeable, given to the scene by Caravaggio's determination to reduce the episode to a situation that adheres to daily reality. The art historical testimony that most fully expresses this atypical condition of Saint Peter's martyrdom is by Longhi (1943, pp. 36–37), with this effective passage: "Above those brown rocks that will be (along with that light in his eyes) the last memory of the martyr [...] the impassible painter circles the efforts of the servants (whose gesture, it must be recognised, is that of labourers who struggle, rather than that of executioners who become crueller out of need) [...] And he captures the saint from up close — perhaps some good, well-known model from via Margutta who, already affixed to the cross, looks at us calmly, as conscious as a modern secular hero."

Critics' and historians' observations also bring to light the complexity of the structure and the original (theatrical) direction of the light. Once again we see a light of redemption irradiating from Peter, symbol of the Church, which blinds and inundates the executioners. Gregori interprets the light as an element that allows Caravaggio to represent the scene as an ordinary event, which is in harmony with the "stoic resignation of the saint" (Gregori 2001).

The two canvases complement one another in both iconographic language and schema. For Marini (1974, p. 32) the schema in the *Crucifixion* is radial, and intervenes in order to lift the cross and the saint upward; in the *Conversion* the mass of light that is the horse bursts forth over the open figure of Paul, projected diagonally outward.

A.L.

Bibliography: Mancini 1619–1621; Baglione 1642; Bellori 1672; Voss 1920; Longhi 1928–1929; Longhi 1943; Berenson 1951; Longhi 1951; Mahon 1951; Venturi 1951; Jullian 1961; Marini 1973–1974; Gregori 1985; Calvesi 1986; *La luce del vero* 2000; Volpi (ed.) 2000; Gregori 2001, p. 51; Marini 2001, *passim*; Spezzaferro, Mignosi Tantillo 2001, p. 111; Macioce 2003; *Caravaggio l'ultimo tempo*, 2004; Berra 2005; Berne-Joffroy (reissue) 2005.

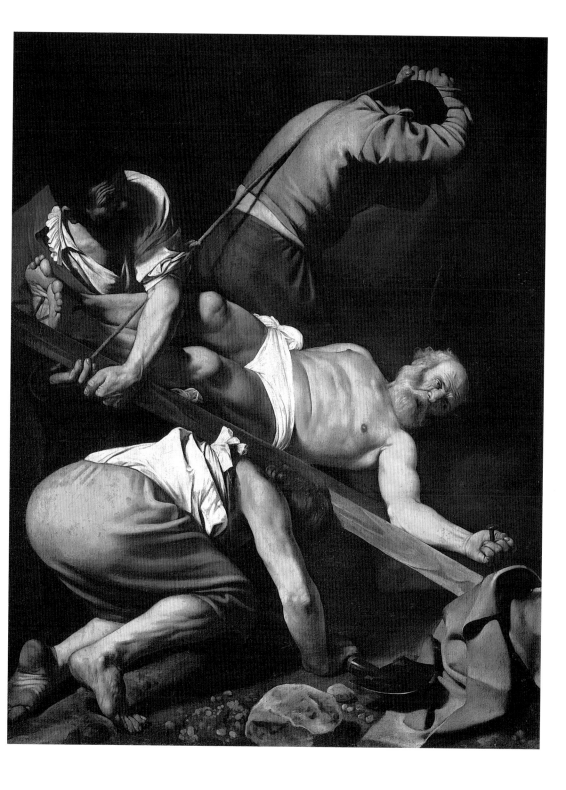

33
Conversion of Saint Paul

Oil on canvas, 230 × 175 cm
Rome, church of Santa Maria del Popolo

The commission issued on September 24, 1600 by monsignor Tiberio Cerasi to Caravaggio called for two lateral paintings for the church of Santa Maria del Popolo, one representing the *Conversion of Saint Paul* and the other representing the *Crucifixion of Saint Peter*, both of which were executed in two versions. The first two paintings on cypress panel were rejected for reasons of decorum. Baglione provides an ample report regarding the two versions. The 1600 contract, in which the commission is given to Caravaggio, also established the dimensions (ten palms high by eight palms wide), the deadline of eight months from the contract's signing for completing and delivering the works, and the compensation of 400 scudi, of which fifty had been paid in advance. The date in question, then, would be May 24, 1601, but the canvases were delivered after November 10, 1601, the date of payment on the balance, when they were recorded once again in the painter's studio. Such a delay is understandable both because of the refusal of the first two works and because of the events surrounding the death of the patron, which happened in May of the same year. In the document regarding the payment given to Caravaggio we also find that the total sum was 300 scudi, 100 less than the amount originally agreed upon (Macioce 2003).
It would be the Ospedale della Consolazione to eventually inherit and pay for the canvases through its chamberlain Giovan Battista Alberini (Marini 1984).
In the definitive version of the *Conversion of Saint Paul*, the absolute novelty is provided by the introduction of a horse that takes up over half of the painting, seen from behind and diagonally, almost as if greater attention were given to the horse rather than the knight-saint — this is also the most surprising iconographic aspect of the painting. The first version featured the presence of a very visible Christ in the foreground; in the second try, Caravaggio seems instead to want to radically twist and distort the composition. Historians and critics have wondered what the reasons for such a change might have been. In the final version the image of Christ was indeed less prominent, symbolically substituted by the beam of light that blinds Paul, bucked from the horse. If, on the one hand, this image agrees with the story in the *Acts of the Apostles* (IX, 1:8 and XXII, 6:12), it also, on the other hand, resolves the difficulty — visible also in other works by Caravaggio — of representing Christ as a celestial figure rather than a human one.
The entire work, then, depends on the role of the light: for Friedländer (1955) it is an expression of all that is natural, and for Calvesi (1986, p. 44) it is the light of divine grace descending on the sinner. Even the setting in which the painting is destined to be placed would justify such an interpretation, inasmuch as the church of Santa Maria del Popolo is run by the Augustines, and it must be remembered that for Saint Augustine knowledge is the light of grace.
A.L.

Bibliography: Mancini 1619–1621; Baglione 1642; Bellori 1672; Marangoni 1922; Voss 1923; Longhi 1928–1929; Berenson 1951; Mahon 1951; Friedländer 1955; Jullian 1961; Röttgen 1969; Cinotti 1971; Marini 1973–1974; Cinotti, Dell'Acqua 1983; Marini 1984, pp. 446–447; Gregori 1985; Calvesi 1986; Macioce (ed.) 1996; Gregori in *La luce del vero* 2000; Marini 2001, *passim*; Macioce 2003, p. 106; Berra (reissue) 2005.

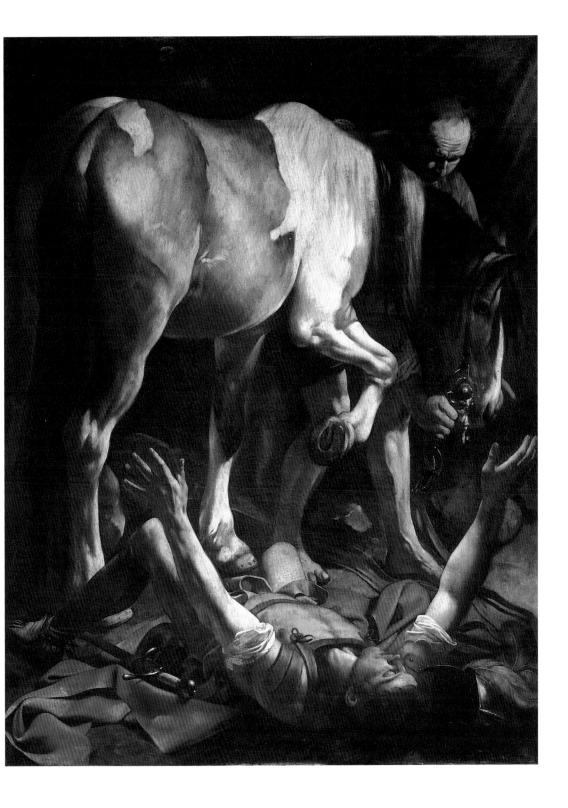

113

34
David and Goliath

Oil on canvas, 110 × 91 cm
Madrid, Museo del Prado

The young David contemplates decapitated Goliath — a theme that recurs throughout Caravaggio's œuvre, but in this case without an explicit autobiographical aspect (Marini 1981, p. 178). David is an adolescent who, through supernatural intervention, succeeds in defeating evil, and the club with which he confronted the giant hints at the cross. One could see it as a prefiguration of Christ. A document dated May 11, 1635 in the archives of the Royal Palace in Madrid led Marini to suppose that among the four paintings confiscated from Gian Battista Crescenzi, the record of which is generally informative, the *David and Goliath* and *Salome* could be recognised; both paintings are now in Madrid. Although documents have indicated a different origin for the latter painting (Madrid-Bilbao 2000), for *David and Goliath* the hypothesis remains open. Marini also (1996, pp. 135–142) pointed out a document rediscovered by Corradini, on January 26, 1643, the testament in which abbot Galeotto Uffreducci mentions various paintings in his collection that he bequeaths to his friends. To the "most Illustrious Monsignor Rospiglioso" he leaves a David by Caravaggio. Uffreducci is among the friends of Cardinal Del Monte, young Caravaggio's first patron, in the Marche region. Monsignor Rospiglioso will then become Pope Clement IX, who was politically very fond of the Spanish; hence it is understandable why the painting would have come to a Spanish collection. The painting is mentioned in the inventory of the Buen Retiro (1794) and in the inventory manuscript of the Prado written in 1849. The theme dealt with here is from the book of Samuel (Book I, XVII, 49–54) of the Old Testament. Many historians have seen similarities in the solution Caravaggio adopted to the stance of the figure in *Amor Victorious* or the Capitoline *Saint John the Baptist*. Regardless of some hypotheses that doubt the work's attribution to Merisi, Longhi (1951, p. 21) and Pérez-Sánchez (1970, p. 122) agree on its authenticity and date it to 1599–1600; Marini (1974, p. 149) includes it in the context of preparatory research done for the Saint Matthew cycle (1601–1602). A reading of the radiographic investigations brings to light how Caravaggio also modified Goliath's head. Gregori (1992, p. 22) affirms that "the first version, underneath, undeniably confirms the authenticity of the work, because of the choice of the expression of horror, which corresponds — just as in the Holofernes of *Judith* and in the *Medusa* — to the psychophysical reaction that occurs at the moment of death. In the final version the giant's head appears composed at a later time, and is no longer represented at the height of the action."
A.L.

Bibliography: Venturi 1927; Longhi 1943; Berenson 1951; Longhi 1951; Mahon 1952; Hinks 1953; Battisti 1955; Jullian 1961; Pérez-Sánchez 1970; Cinotti 1971; Spear 1971; Marini 1974; Moir 1976; Marini 1981; Cinotti, Dell'Acqua 1983; Gregori 1992; Marini 1996; Marini 2001, *passim*; Macioce 2003; *Caravaggio e il suo ambiente* 2004.

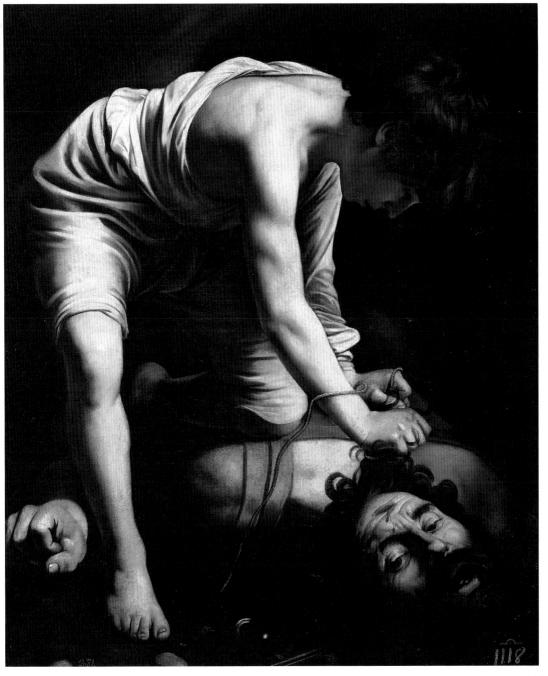

35
Amor Victorious

Oil on canvas, 156 × 113 cm
Berlin, Staatliche Museen Preussischer Kulturbesitz, Gemäldegalerie

Gaspare Murtola (1603, madrigals 468–473) dedicated six madrigals to Caravaggio, confirming the great interest the painter's works inspired among the poets who followed Marini. The first three make references to the *Amor Victorious*, which was probably realised for Marquis Vincenzo Giustiniani (Von Sandrart 1675, p. 182). The painting remained in Giustiniani's collections until 1815, when it was then sold to the King of Prussia, who in turn donated it to the Museums of Berlin. In the 1638 inventory this work appears as "Laughing Love in the act of disparaging the world he keeps below him, with various instruments, crowns, sceptres, and armours, widely known also as the Cupid of Caravaggio" (Danesi Squarzina 2003, p. 96). This painting foreshadows Vincenzo Giustiniani's theories on music, and in his *Lettera sulla pittura al signor Teodoro Amideni* (1620, in Longhi 1951, pp. 49–50), referring to Caravaggio he writes: "He put such handwork into making a good painting of flowers, just as of figures" (Squarzina 2001, pp. 282–286). The complexity of the allegorical meanings dealt with here has inspired various critical reflections. Above all others, the reference to Virgil's topos *Omnia vincit amor* (Friedländer 1955, p. 182 and following), suggested by jurisconsult Marzio Milesi in his 1610 distich (Cinotti 1971, p. 162, F 93). It is clear how in this case a negative connotation is given to the laughing Amor, victor of all the arts — music, poetry, mathematics, and the military arts. The interpretation offered by Murtola's rhymes is, on the other hand, the exact opposite, inasmuch as within love we find the allegory of a true noble's virtue, likely a reference to Vincenzo (whose name shares the same etymology as the verb *vincere*). Love, then, isn't the derisive conqueror of the arts, but rather raises himself up high with the material instruments of his Virtue. This isn't a profane Love who triumphs over the attributes of sacred Love, but is to the contrary a work analogous to Agostino Carracci's engraving *Omnia vincit amor*. Love's laugh isn't one of desecration, but one indicating joy and hilarity, while the cuirass is a symbol of virtue. This interpretation is also supported by a comparison — which Giustiniani certainly desired — with Baglione's painting that portrays divine Love ruling over profane Love, as is written in a document dated September 14, 1603, in which Gentileschi's questioning in the Baglione trial is transcribed. The document carries precise indications both of the locations of the paintings Vincenzo Giustiniani commissioned from Baglione and Caravaggio, as well as details of how Gentileschi loaned Merisi a Capuchin robe and a pair of wings (Cinotti, Dell'Acqua 1983, fig. 54). This reference to the props Merisi borrowed from Gentileschi additionally clarifies Caravaggio's technique of portraying things from life.
A.L.

Bibliography: Murtola 1603; Giustiniani 1620; Von Sandrart 1675; Schudt 1942; Berenson 1951; Longhi 1951; Venturi 1951; Longhi 1952; Hinks 1953; Hess 1954; Wagner 1958; Salerno 1966; Calvesi 1971; Dell'Acqua, Cinotti 1971, p. 162; Frommel 1971; Spear 1971; Brandi 1972; Marini 1974; Röttgen 1974; Cinotti 1975; Nicolson 1979; Fulco 1980; Marini 1981; Cinotti, Dell'Acqua 1983; Pacelli 1989–1990; Calvesi 1990; Maccherini 1997; Danesi Squarzina (ed.) 2001; Marini 2001, *passim*; Danesi Squarzina 2003; Macioce 2003.

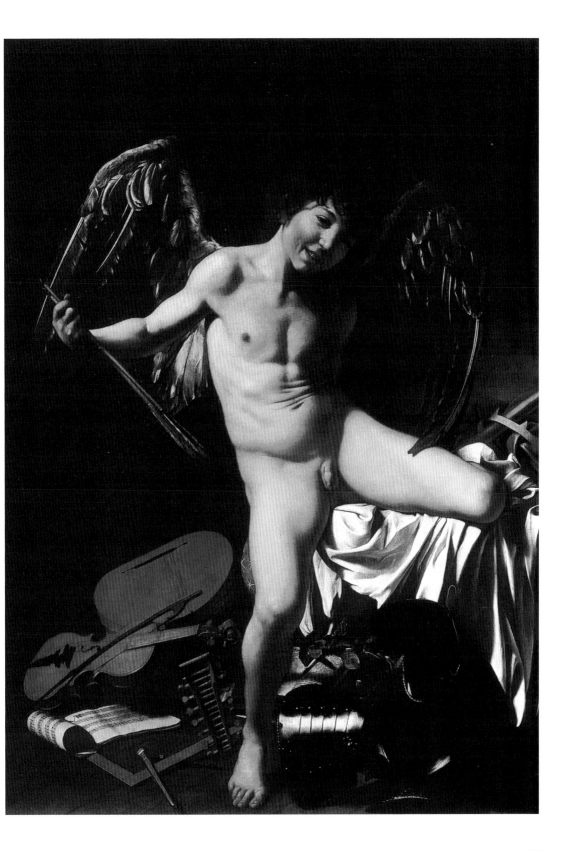

36
The Taking of Christ

Oil on canvas, 133.5 × 169.5 cm
Dublin, National Gallery of Ireland

This work was painted by the end of 1602 for Ciriaco Mattei, whose family Caravaggio was staying with at the time. Sources confirm that the painting remained in Palazzo Mattei until the end of the eighteenth century, when, because of its nocturnal setting, it was attributed to Gherardo delle Notti (Gerrit van Honthorst). The painting left Palazzo Mattei in 1802 when it was purchased by William Hamilton Nisbet, a relative of the famed Lord Elgin who went down in history for removing the Parthenon marbles. In 1921, upon the death of the last Hamilton kin, part of their collection — including the former Mattei *Taking of Christ* — was sold at auction in Edinburgh (Benedetti 2004, pp. 15–22). From there the painting passed (under undocumented circumstances) into the collection of Irishwoman Mary Lea-Wilson, who bequeathed it to the community of Saint Ignatius on Leeson Street in Dublin. The painting stayed there for approximately seventy more years, until Sergio Benedetti, called by the current rector of the community to appraise the work in its possession, recognised it as the former Mattei *Taking of Christ* by Caravaggio, thanks to the precise description of it given by Bellori in 1672. The restoration carried out by the National Gallery in Dublin, to whom the painting was later generously entrusted, brought back to light the original pictorial surface, confirming Benedetti's intuition.
As early as 1626 there is a record of a copy made by a certain Giovanni d'Attilio for Asdrubale Mattei, and it is likely that the many low quality copies circulating already in the fifteenth century were made from that copy. Roberto Longhi (1943) identified one in a private collection in Florence and included it in the 1951 Caravaggio exhibition at Palazzo Reale in Milan. In the following years many other copies were published — some of scarce value, and others of higher quality, such as the one now in the Museum of Western and Eastern Art in Odessa — but the debate surrounding the identification of the original Caravaggio ceased upon the discovery of the one in Ireland.

Like other works Caravaggio created during this period for private patrons, this painting has a closed structure, with several three-quarter-length figures. The episode is very precisely directed. The frame of the composition is extremely close-up, in order to increase its dramatic impact, and a warm, intense light glows in the otherwise dark scene, illuminating the group against the dark background. In the painting two consecutive moments of the same drama coexist: the betrayal and the capture. On the left, the figures of Christ and Judas seem as though suspended in a still image, a moment before the kiss. Christ, aware and resigned, abandons his entwined hands in his lap, already a near prisoner; Judas leans toward him, and with his hand grabs and holds him fast. Around them the scene flows convulsively: on the left Saint John flees in desperation, and in the foreground the soldiers gather threateningly round.
On the right, in the dark, holding up a lamp that lights the scene, the painter himself curiously observes, as Roberto Longhi first noted (Longhi 1960, pp. 23–26). This hypothesis is confirmed by the recovery of the *Martyrdom of Saint Ursula*, where the same face appears. For the other figures, Sergio Benedetti offers a series of comparisons with other paintings by Caravaggio from the same period and with works that could have inspired him, such as the *Saint Peter Martyr* altarpiece by Moretto, an engraving by Albrecht Dürer, and also the bas-relief of a sarcophagus now in the Vatican Museum (Benedetti 2004, pp. 31–32).
B.C.

Bibliography: Longhi 1943, pp. 5–63; idem 1951; idem 1960, pp. 23–36; Marini 2001, *passim*; Benedetti 2004 (with bibliography).

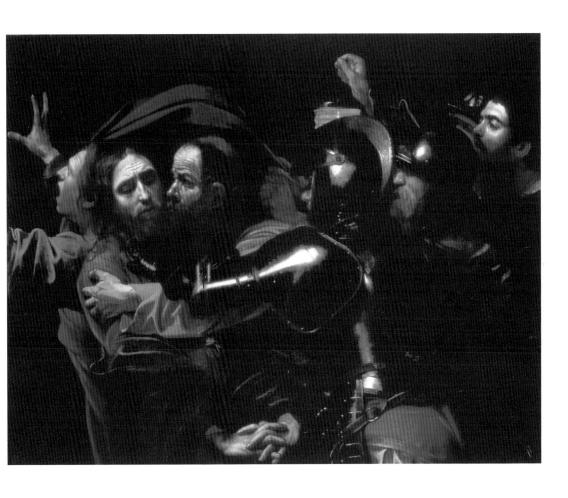

37

Saint John the Baptist

Oil on canvas, 129 × 95 cm
Rome, Musei Capitolini, Pinacoteca

The *San Giovannino* (or *Little Saint John,* as this work is also known) in the Musei Capitolini shows a nearly Dionysian, very lively exuberance, and perfectly pairs with *Amor Victorious* (Calvesi 1990, p. 242). Its history can be reconstructed through the literary sources in Scannelli, Bellori, and Baglione, as well as the source documents of Cardinal Del Monte, Mattei, and Pio's respective inventories. Denis Mahon brought the work to light again in 1953, recognising it in the studio of the mayor of Rome. A restoration and subsequent exhibition in the Pinacoteca Capitolina followed, as well as another exhibition in London in 1955. Since then the critical debate has principally dealt with the ties between the painting and its copies, above all the one in Rome's Galleria Doria Pamphilj — the only truly important replica that inspired some doubt as to which of the two was the original. The Capitoline *Baptist* is generally agreed upon as the authentic Caravaggio, and its moves from one collection to another are sufficiently well documented. The first written mention of it dates back to a record of two payments in 1602 noted by Cappelletti, Testa (1990, p. 77; 1994 pp. 137–141, nos. 33 and 49), paid to Caravaggio on June 26, and December 5, 1602 by Ciriaco Mattei for an unspecified painting, but which is very likely this *Saint John the Baptist*. Another citation, in the 1616 inventory guardaroba of Giovan Battista Mattei, Ciriaco's first-born son, places the painting in relationship with the name of the patron's son. Giovan Battista himself, in his two testaments dated January 21, 1623 and June 5, 1624, sees to the bequest of the painting of Saint John the Baptist to Cardinal Del Monte (Panofsky, Soergel 1967–1968, p. 188). In 1627 it appears again in the postmortem inventory of the cardinal's belongings.

On May 5, 1628 the painting was put up for sale by the cardinal's nephew Alessandro in order to pay off Del Monte's creditors. The *Saint John* is identified here with the term *Coridone*, from the Greek, indicating a shepherd from the works of Theocritus. The work is later documented in the inventories of Pio di Savoia through 1777 (Macioce 2003, pp. 460–461).

The questions surrounding the work's interpretation remain open. On the one hand, critics have emphasised the difficulty of reconciling the image painted by Caravaggio with a religious subject. Not only the youth's nudity and pose, but also the absence of the traditional iconographic attributes, have all caused art historians such as Marini, Cinotti, and Gregori to favour a secular reading. Calvesi, on the other hand (1990, p. 224), affirms, "we stand before that divine Love that is Jesus himself signified by Aries."

In reference to the camel pelt, Calvesi underlines how this is one of the saint's attributes, which also appears in the Kansas City *Saint John*. "Of a tonality between brown and blonde, the pelt is situated between a white garment, above, and a red mantle, below [...] These colourations perhaps have a symbology: the white could suggest purity and candour, and the red could suggest love, faith, or spilled blood."

A.L.

Bibliography: Celio 1620; Baglione 1642; Scannelli 1657; Bellori 1664; Mahon 1953; Salerno 1956; Panofsky, Soergel 1967–1968; Kirwin 1971; Marini 1974; Cinotti 1983; Hibbard 1983; Gregori 1985; Marini 1987; Calvesi 1990; Cappelletti, Testa 1990; Tittoni 1990; Bologna 1992; Gregori (ed.) 1992; Cappelletti, Testa 1994; *Caravaggio e la collezione Mattei* 1995; Marini 2001, *passim*; Macioce 2003.

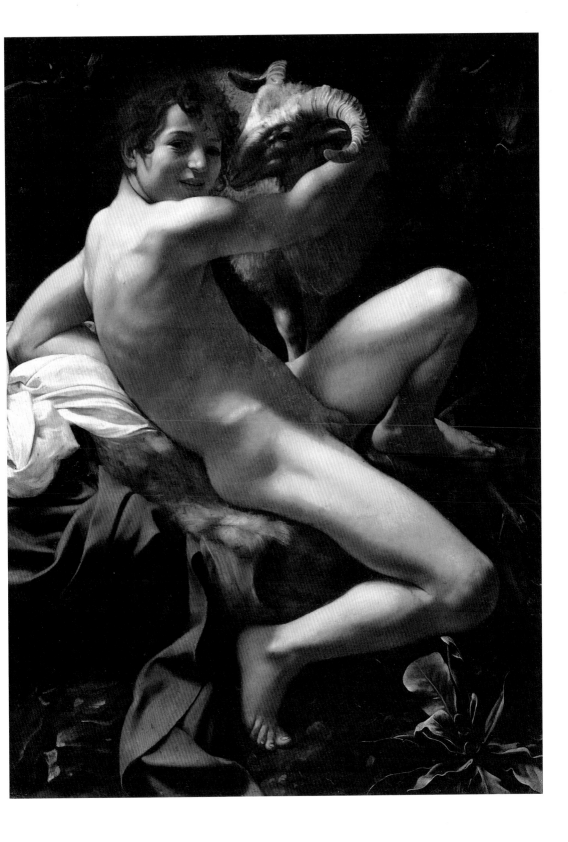

38
Saint John the Baptist

Oil on canvas, 173 × 133 cm
Kansas City, The Nelson-Atkins Museum of Art,
Chichester-Constable collection

The Genoan banker Ottavio Costa was an important figure in the circle of Caravaggio's relations and patrons. A letter of credit from Costa and his bank, dated April 26, 1592, to cardinal Federico Borromeo confirms this fact. The document, published for the first time by Cinotti in the pages of *Corriere della Sera*, attests to the role of the financier who, in addition to being a collector of Caravaggio's works, also took care of the financing and shipping of works to cardinal Borromeo (Macioce 2003, p. 45).

In the inventory of goods in the Roman palazzo of Ottavio Costa, dated January 18–24, 1639, along with other originals by Caravaggio (*Judith, Saint Francis of Assisi in Ecstasy,* and *The Cardsharps*) "another painting with the image of St John the Baptist in the desert" is listed, and can be no other than the Kansas City *Saint John the Baptist*.

Only two copies of this work exist, but it is important to reconstruct their histories. The first is in the Museo Nazionale di Capodimonte in Naples, and came either from Bartolomeo Manfredi or Orazio Riminaldi (Cinotti, Dell'Acqua 1983, p. 444). The second is now in the church of Sant'Alessandro in Conscente, a possession of the Costa family in Albenga. The rediscovery of this Genoan copy further confirms the connection between the Kansas City original and Ottavio Costa. There is no reference to the painting in the literary sources. The painting, purchased in Malta, appears in England in the collection of Lord James Ashton of Forfar and from there, through marriages and acquisitions, in 1952 it entered the Thomas Agnew and Sons gallery in London, until it was moved to the present collection. Critics and art historians generally accept its authenticity, but the question of its date of execution is more debated. Longhi (1943, pp. 14–15) was the first to publish this painting as the original, identifying the version in Naples as a later copy, and proposes an approximate date of 1598–1599. Berenson (1951, p. 33) and Marini (1975, pp. 160–161) suggest a date

of 1600, and the latter has established a stylistic comparability with the Capitoline *Baptist, Narcissus,* and *Conversion of Saul.* According to Mahon (1952, p. 19, note 25) this version is later than the Corsini *Baptist,* and therefore datable to approximately 1602–1604. Hibbard (1983, pp. 191–193) and Gregori (1985, pp. 300–303) place it later still, to 1604–1605. Maria Cristina Terzaghi (see *Il Sole 24 ore,* October 30, 2005, p. 45) found a receipt from Caravaggio that probably refers to this *Saint John the Baptist* in the Origo collection of the Siena government archives: "On this day of 21 March 1602. I, Michel Angelo Marrisi, have received more than twenty schudi from the illustrious Ottavio Costa on good account for a picture that I am painting for him; this day of 21 March 1602. I, Michel'Angelo Marrisi." Because this speaks of an account ("on good account") for a work perhaps already under way ("that I am painting for him"), we can reasonably conclude that the painting was completed between 1602 and 1603. Even in this case the complex spatial construction is of great interest (Marini 1974, p. 387). Mina Gregori points out the simplification of iconography that has led to the omission of the symbolic lamb, while the cloaked figure's pose recalls classical sculpture. It is also important, in discussing this work, that we see the same technique Caravaggio used on other occasions — a practice of using a sort of engraving as a substitute for preparatory drawings, which included incising lines directly into the fresh paint.
A.L.

Bibliography: Mancini 1619–1621; Baglione 1625; Bellori 1672; Longhi 1943; Berenson 1951; Longhi 1951; Venturi 1951; Mahon 1952; Friedländer 1955; Röttgen 1969; Frommel 1971; Marini 1974; Spezzaferro 1974; Calvesi 1975; Cinotti in *Corriere della Sera*, February 2, 1975; Nicolson 1979; Marini 1980; Moir 1982; Cinotti, Dell'Acqua 1983; Hibbard 1983; Gregori 1985; Calvesi 1990; Gregori (ed.) 1992; Gregori 2000; Marini 2001, *passim*; Macioce 2003.

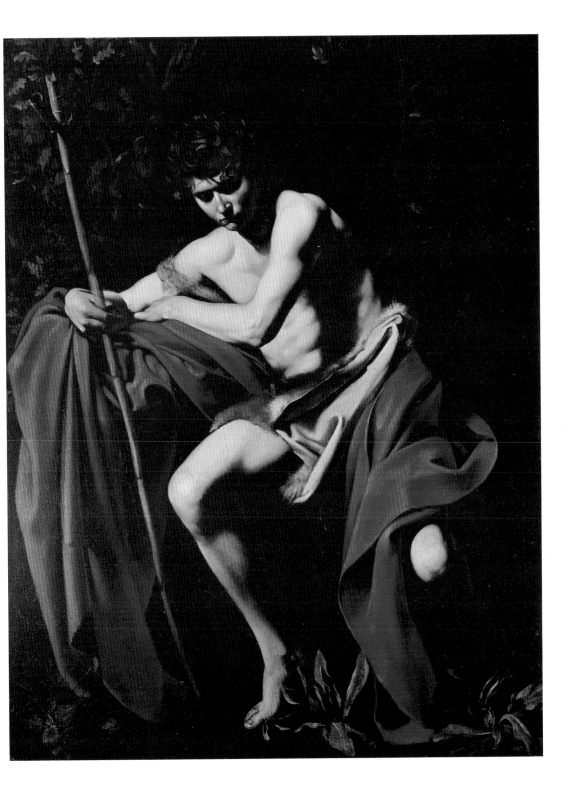

39
Deposition of Christ in the Sepulchre

Oil on canvas, 300 × 203 cm
Vatican City, Pinacoteca Vaticana

Pietro Vittrici was hired to complete the decoration for the family chapel in Santa Maria di Vallicella, in the 'Chiesa nova,' following the enlargement of the nave and development of the two smaller aisles. By June 13, 1577 he had gained the privilege of having his own chapel dedicated to the Pietà, and after his death (March 26, 1600) his nephew Girolamo assumes responsibility for it. Architect Gio. Batta Guerra completed the chapel — whose building had been approved and supported by Pope Clement VIII — on January 15, 1602. The commission for the altarpiece must therefore have been given to Caravaggio in February 1602, upon the completion of Guerra's work. In a note dated September 1, 1604, the painting is recorded as being *in situ*, if one considers it in the context of the earlier painting completed for the same chapel: "Please give the painting of the Pietà with its wooden ornament to the nephew of Signor Piero Vittrice, as he had requested a new painting by Caravaggio which has no need of the aforementioned wooden ornament." Mancini, Baglione, and Scannelli all saw the painting. Bellori gives an admirable description of it: "Certainly among the best works that have come from Caravaggio's brush, one must justly esteem the Deposition of Christ in the Chiesa Nova de' Padri dell'Oratorio." Napoleon had the painting moved to Paris in 1797, and it was returned in 1815 and placed in the Pinacoteca Vaticana. Before the verification of all documents, Kallab dated the work to 1595. Longhi (1913) opportunely set the work beside the canvases in Santa Maria del Popolo, and was followed by Pevsner, Friedländer, Berne-Joffroy, and Marini, who see it as being much closer to the second version of *Saint Matthew and the Angel* in the Contarelli chapel of San Luigi dei Francesi. Mancinelli pushes the date to the extreme limit of 1604. Of the innumerable interpretations that mention the devotional precepts and prescribed iconography of Saint Philip Neri, and accepting even the most peculiar Oratorian themes, one cannot easily accept Moir's suggestion of a competition with the *Pietà* by Michelangelo, even in the clear citation of the abandoned arm of Christ. Hibbart broadens the references to the *Burial of Christ* by Raphael in the Galleria Borghese and the sarcophagus with the *Carrying of Meleagro's Body* in the Musei Capitolini. Gregori still sees in the painter's mature work the "Lombard echoes of Savoldo, Calisto Piazza, and Peterzano."

The admirable fan-like unfolding of the composition — from the sepulchre's rim brushed by Christ's hand, to Cleophe, with her arms raised high and an elbow nearly pressing against the viewer — emphasises the theatrical setup and acted-out expression in a very personal reinterpretation of the *Mourning of Christ* in polichromed terracottas that were widespread in the Padanian area.
V.S.

Bibliography: Marini 2001, pp. 471–473.

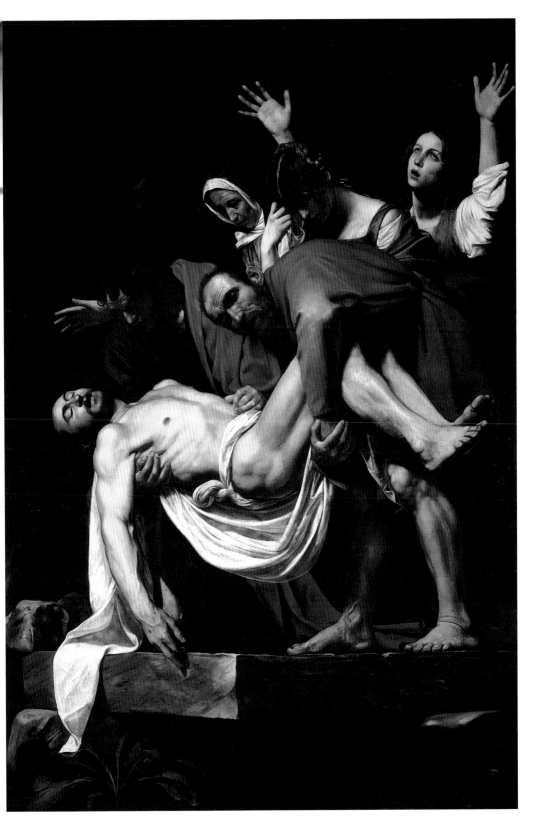

40

Christ in the Olive Garden

Oil on canvas, 154 × 222 cm
Formerly in Berlin, Kaiser Friedrich Museum

"A large painting formatted to hang above a doorway with Christ in the garden and the sleeping apostles […] by Michelangelo da Caravaggio." This description of the painting appears in the inventory of Marquis Giustiniani dated 1638 and published by Salerno in 1960; already cited in the post-mortem inventory of cardinal Benedetto Giustiniani in 1621, it appears again in a 1791 list as a painting "representing St Peter, St James, and St John sleeping, with Christ who wakes them, by Michel'Angelo Caravaggio" (Danesi Squarzina 2003, p. 389). In 1815 the work the Giustiniani inventories refer to was moved to the Kaiser Friedrich Museum in Berlin. It was destroyed in 1945, while in one of the wartime storage rooms of the Berlin museums (Norris 1952), following the fire in which the *Portrait of the Courtesan Fillide* and the first version of *Saint Matthew and the Angel* — both of which came from the collection of Marquis Vincenzo Giustiniani — were lost. A lively critical debate has developed regarding the work's authenticity. A few reservations have been mentioned, beginning with Marangoni. For most art historians and critics — Voss, Mahon, Salerno, Marini, Moir, Cinotti — the work is an authentic Caravaggio, but for many the fundamental problem is clearly associated with the fact that judgement of the work can only be based on photographs. The hypotheses are therefore based on a comparative study of general inventory descriptions and photographic reproductions, considering the absence of literary sources. Regarding the work's date, proposals range from the period of the Vatican *Deposition* (1602–1603 according to Cinotti) and the last paintings completed in Rome (1605–1606) according to Mahon. The subject is from the Gospels of Matthew (XXVI, 38:43) and Mark (XIV, 32:40). According to Marangoni (1922) the typically Caravaggesque element lies in the expressive strength of the fist upon which one of the apostles rests his head. "There are no divine interventions" (Moir 1976, p. 130), and therein one finds Caravaggio's creative exceptionality, inasmuch as everything is so terrestrial. One of the apostles, lost deeply in sleep, and for precisely this same 'human substance,' recalls the *Saint Francis in Meditation* in Cremona (Papi 1992, p. 291).

A lunar light falls upon the figures and exalts their faces and clothing, but it also seems to relegate the sleeping apostles to a state of psychological incommunicability.

A.L.

Bibliography: Silos 1673; Marangoni 1922; Voss 1924; Schudt 1942; Mahon 1952; Berne-Joffroy 1959; Salerno 1960; Jullian 1961; Marini 1973–1974; Moir 1976; Cinotti, Dell'Acqua 1983; Papi in Florence-Rome 1992; Gregori 1996; Marini 2001, *passim*.

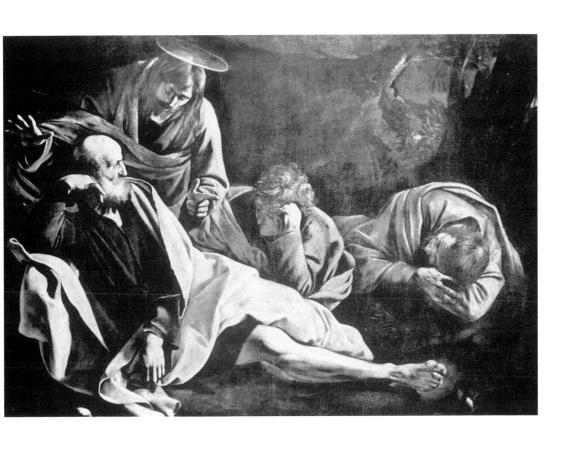

41

Madonna di Loreto (Madonna of the Pilgrims)

Oil on canvas, 260 × 150 cm
Rome, church of Sant'Agostino, Cavalletti chapel

Among the highest and most classical works by Caravaggio, the *Madonna di Loreto* is still above the altar in the chapel of the Cavalletti family, originally from Bologna (as recorded in the documents made known by Lopresti in 1922). It is recorded even in the oldest sources, Mancini and Baglione: "In the first chapel of the church of Sant'Agostino, on the left-hand side was a Madonna di Loreto portrayed from nature with two pilgrims, one with muddy feet, and the other with a dirty, worn cap, and for the lightness of certain parts which a good painting must have, there was a great commotion." The extraordinary realism of the Virgin's apparition at the door of her home is based on a classical statuary conception, which led Berenson to see the Virgin as "the most attractive, and at the same time most regal of all Caravaggio's figures to come to us," and Longhi compares the Virgin's head to Irene of Cephisodotus. The painting's iconography is analysed in depth in Zuccari (Madrid-Bilbao 1999), and also in the well-known documentary research done by Pupillo (2001).

While Mancini, Celio, and Baglione recognise a representation of the Madonna di Loreto in this painting, and thereby emphasise its subject, so clearly expressed by the wishes in the testament of the 'patron' Ermete Cavalletti, the painting's later success is attributed to it's definition as "Madonna of the Pilgrims," due to the powerful presence of the two travellers kneeling at the Virgin's feet. The Madonna is the incarnation of the Catholic Church who welcomes the repentant, offering the possibility of forgiveness of their sins (the pilgrimage represents a terrestrial, practicable route for reaching salvation). But she is a woman, profoundly of this earth, the human representation of a prototype that is all too often idealised. Paraphrasing the words of Bellori, Caravaggio took a woman (perhaps Lena?), and "faked" her (represented her) as "ma-donna;" to make her recognisable he had to dress her in blue and red and add a halo. In representation of the Santa Casa di Loreto, on the other hand, only the little stair, the marble threshold, and the brick wall that coats the entire interior of the home in Loreto, remain — hidden elements in what the people could have more easily recognised as a Roman house, and which some believe is a house on via de' Prefetti.

Zuccari proposes that within the kneeling figures Ermete Cavalletti can be recognised, accompanied by his mother or some other family member. Cavalletti's participation in the confraternity of the Pilgrims' Trinity and the role he played in preparing the 1602 pilgrimage are well known.

Because of stylistic traits and documentary evidence one could claim that the work was painted between 1604 and 1605. But on March 2, 1606, in fact, the altarpiece — which had previously decorated the chapel dedicated to Mary Magdalene — was donated to cardinal Scipione Borghese by the Augustine Fathers. It would be reasonable to conclude that on that date Merisi's painting had already been displayed on the altar, where it still is today. Ermete Cavalletti, the 'iconographic' patron of Caravaggio, died in 1602, leaving his brother-in-law Girolamo de' Rossi, Domenico de' Cavalieri and, indirectly, his wife Orinzia de' Rossi as executors of his will.

There are numerous known copies of this work, both in Italy and abroad. Along with the recent notes about copies in Sicily (Marini, in Palermo 2001) it is also worth remembering the one mentioned in the 1637 inventory of the Duke of Alcalá, as well as a painting registered in 1648 in the collection of Tomás Mañara in Seville (Brown, Kagan 1987; they believe it is the same one as that recorded in the 1637 inventory). A copy now in Madrid, in the Museo Lázaro Galdiano, is noted in the inventory of Gaspar Enríquez de Ribera in 1674.

V.S.

Bibliography: Brown, Kagan 1987, pp. 231–255; Treffers 1996, pp. 213–226; Zuccari in Madrid-Bilbao 199, pp. 63–73; Marini 2001, *passim*; Marini in Palermo 2001, p. 124; Pupillo in Palermo 2001; Masetti Zannini 2003 (2004), pp. 153–166.

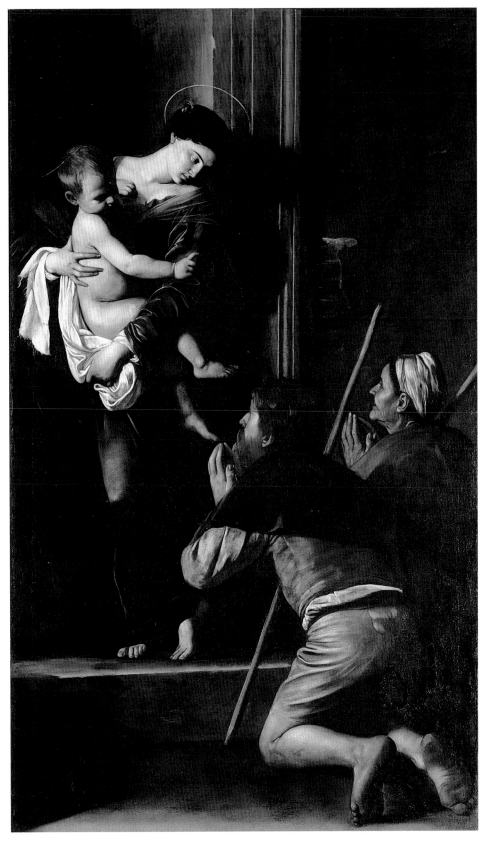

Ecce Homo

Oil on canvas, 128 × 103 cm
Genoa, Palazzo Bianco, Musei di Strada Nuova

Up until now no precise records regarding the ancient origins of this painting have been found; rediscovered in the gallery storage of Palazzo Bianco with no indications of its provenance, only in 1921 was it recorded in the inventory as a copy by Lionello Spada. In 1953 Roberto Longhi recognised it as an original Caravaggio, and the following year he published it; there is no proof in support of his hypothesis tracing it back to the "concorso Massimi." There are indications pointing toward the possibility — glimpsed by Gregori (1991) and later re-examined (Puija, in *Domenico Fetti* 1996) — that the work was begun in Rome and completed in Genoa during the summer of 1605. This is the same summer that critics almost unanimously agree, also on a stylistic basis, that Caravaggio stayed with Marcantonio Doria for a few weeks, or, perhaps more credibly, with another branch of the same family, Andrea II, Prince of Melfi, husband of the Roman Giovanna Colonna, whose family's connections to the artist are well known (cf. Calvesi 1990, pp. 125–126; Boccardo 2004, p. 36). The numerous *pentimenti* (sketched, erased, and redrawn lines) revealed by radiographic inspection (Gregori 1991; Bonavera, Di Fabio 2003) in the hands of the last figure and the head and other parts of Christ support the hypothesis of a rapid execution followed by later revisions and corrections.

With one major exception (Bologna 1992), after the presentations by Gregori, Cinotti, and Marini, supported by the opinions of other art historians (Hibbard, Bonsanti, Previtali, Christiansen, Calvesi, and Contini), specialists no longer doubt the authenticity of the Palazzo Bianco *Ecce Homo*. Regardless of the revelations inferred long ago regarding the way in which the painting was done and a certain heaviness due to a restoration by Cellini in 1953–1954, after very recent work (Bonavera, Di Fabio 2003) the canvas is in a better state of conservation than expected, and has such quality and appeal that its influence on the painters active in Genoa at the time is completely justifiable. To their eyes it was incredible for the choices of lighting — charged with clear symbolic value — in the contrast between the luminous clarity of the Nazarene's body and the extreme darkness of Pilate — and for the presence of a Christ whose posture, reduced by an attitude of suffering yet absolute resignation, and even in its pure and Apollonian beauty, presents itself as a true *Agnus Dei*. The composition is enriched by recollections of Caravaggio's formative experience in Lombardy during the Counter-Reformation with artists like Moroni and those of Brescia. The viewer is involved in the cruel sacrifice being prepared here, whose purple mantle is both symbol and harbinger; it is a necessary holocaust in the providential plot, but one also desired and completed within the frame of history, and the viewer identifies with the crowd of historic witnesses, and, relegated to the negative role of 'judge,' the spectators decree the martyrdom of the Righteous one, in which not even the Roman attorney had detected guilt. The painting works, therefore, as a devotional image, but also as an episode of figurative, moralising theatre capable, by virtue of its realism, of the compositional concentration and choices in lighting that induce the viewer — who remains on this side of the painted parapet but whose empathy is drawn into the scene by Pilate's stare, wonderfully worked hands (Contini, 2003, p. 112, captures quite well the suggestive effect of "a vibrating spatial density"), and the words "Ecce Homo!" that he is declaring — to confess his sins and repent.

P.B., C.D.F.

Bibliography: Longhi 1954; Cinotti 1983, p. 47 (with preceding bibliography); Gregori in *Michelangelo Merisi* 1991, pp. 148–261; Bologna 1992, p. 88; Pesenti 1992, pp. 109–110; Puija in *Domenico Fetti* 1996, pp. 79–80; Di Fabio in *Van Dyck* 1997, pp. 156–157; König 1997, pp. 82–84; Bona Castellotti 1998, p. 92, note 68; Vannugli 1998, p. 7; Di Fabio in Bergamo 2000, pp. 212–213; Di Fabio 2001, pp. 99, 101, 105, and notes 39, 53, 54; Marini 2001, *passim*; Bonavera, Di Fabio in Contini 2003, pp. 110–113.

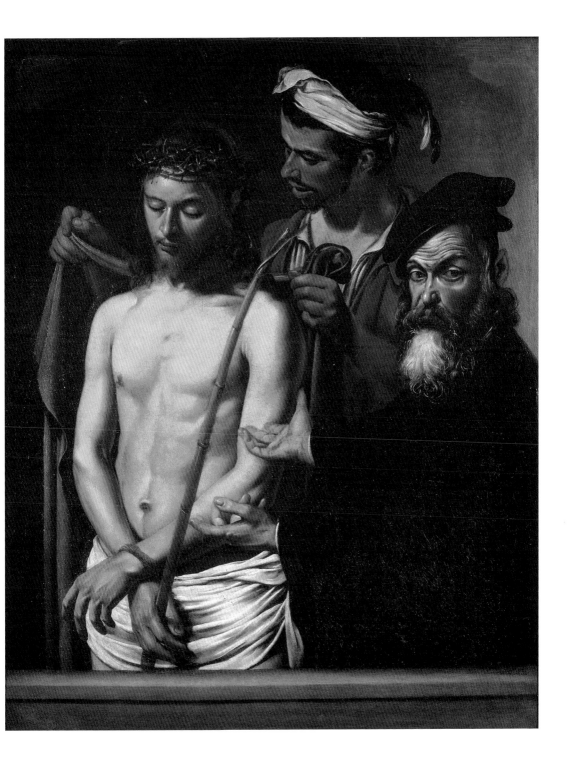

43
Madonna dei Palafrenieri

Oil on canvas, 292 × 211 cm
Rome, Galleria Borghese

While this work is accompanied by a large body of rather detailed documents, there still is no clear idea of the real development of events surrounding it. In 1998 Calvesi Coliva, Spezzaferro, and Strinati returned to closely studying it, offering hypotheses that were in many ways parallel, and agreed on considering this work one of the two certain refusals the artist received (the other, nearly contemporaneous one was the Carmelite nuns' refusal of the *Death of the Virgin* for Santa Maria della Scala).

From the documents it seems that on April 14, 1606 a carpenter was paid for "having set the panels in the altar of St Anna in San Pietro Novo." Logically, after having set the panels, the carpenter would have also had to install the canvas. But this is far from being proven or provable, even if the church brothers do refer to a painting that was "put in the new altar of San Pietro" (May 19). One certain fact is that two days later, on April 16, the painting was taken down and moved to the church of Sant'Anna, bordering the Vatican walls. In the document an explicit reference to the two lackeys needed to move a work of such large dimension is included. For installing the work above the altar, however, only one carpenter is mentioned, with no other servants. On April 8 Caravaggio declared himself pleased with the painted work, which must therefore have been finished by then, and perhaps already in San Pietro (March 13).

Cincinelli is responsible for the recovery of the documents in the confraternity archives of Sant'Anna dei Palafrenieri, from which we learn of the payments made to Caravaggio, from December 1, 1605 to May 19, 1606, for a total of 75 scudi. Already by April 8 there was a receipt signed by Caravaggio to the confraternity deacon: "I, Michel'Ang.O da Caravaggio — am content and satisfied with — the picture I painted at the — Compagnia di S.ta Ana." The work by Caravaggio was to substitute the *Saint Anne* brought from the altar of the old church, which was too small. But the new work had no better luck, as it re-mained on the altar only until April 16. Already by June 16, at a profit of twenty-five scudi, the work's sale to cardinal Borghese was approved, as it "was no damage to the company, but was rather useful, as the Cardinal Borghese had it for a sum of 100 scudi." Spezzaferro investigated the reasons behind the work's rejection, which were linked to the recent refusal of the *Death of the Virgin*, painted by the artist for the church of Santa Maria della Scala in Trastevere, but linked also to Caravaggio's discredit following his murder of Tomassoni on May 28, 1606. Above all, as Marini observes, this grave incident "placed the painter in an all but desperate situation, preventing him from defending his owns works, and even from replacing them." External reasons, then, rather than iconographic contradictions, were what impeded the work from going to its originally assigned place, in favour of cardinal Borghese, who in this way was able to secure for himself the last painting by Caravaggio before his condemnation to being banned from the capital. Bellori preferred to see a more scandalous motive behind the painting's rejection, as "within the work were vilely portrayed the Virgin with a naked young Jesus." Moir and Hibbard also focus on the iconographic question — the former observing the humanisation of the abstract doctrinal theme of good's victory over evil, the latter recognising an interpretation of the immaculate conception that is just too extreme, even for the Counter-Reformation's perfect orthodoxy. Calvesi's interpretation is unacceptable, as it insinuates a pro-Protestant interpretative deviation with little proof. A few interpreters claim that Scipione Borghese created obstacles in order to make the painting's successful placement more difficult, thereby guaranteeing that the work — probably the last one painted in Rome — would become his.

V.S.

Bibliography: Marini 2001, pp. 500–503.

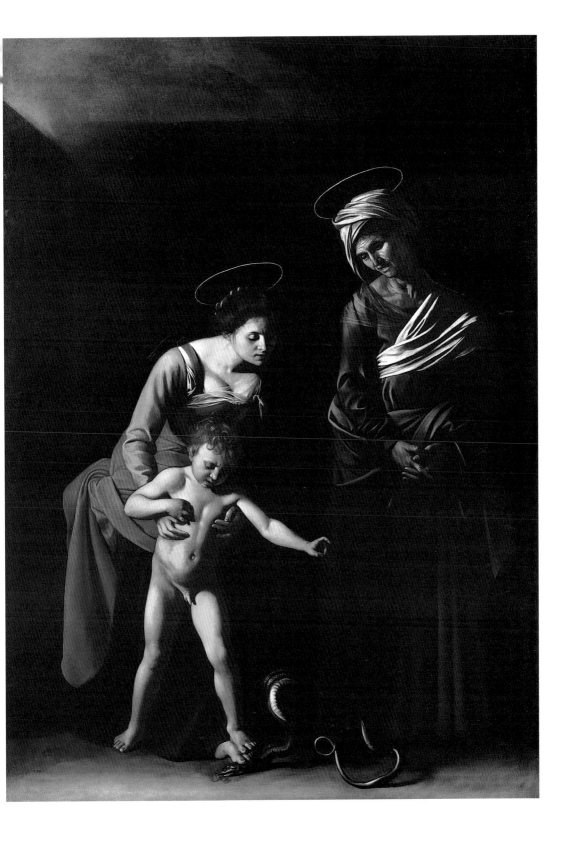

44
Death of the Virgin

Oil on canvas, 369 × 245 cm
Paris, Musée du Louvre

Intended for the Cherubini chapel in Santa Maria della Scala, this altarpiece was actually painted by Caravaggio shortly before his dramatic flight from Rome after having murdered Ranuccio Tomassoni. The document of contract between painter and patron, jurist Laerzio Cherubini, is dated June 14, 1601 (Parks 1985, p. 414). From the document we learn that the price was set by Marquis Vincenzo Giustiniani, and that at the time Merisi was living in the palazzo of cardinal Girolamo Mattei, brother of Ciriaco, who was also one of the painter's patrons (Macioce 2003, p. 105). This painting constitutes departure from iconographic tradition, to such a point that it was rejected by the cleric "of S.M. della Scala." The motive reported by Mancini (1619–1621) and made explicit by Baglione (1642, p. 138) and Bellori (1672, p. 213) for the scandal created by the work and its subsequent refusal (Spezzaferro 2001, pp. 23–33) was that it had used a meretricious woman as a model, "dead, swollen, and with uncovered legs." The Discalced Carmelite Fathers, to whom the church belonged, refused it without offering Caravaggio a new commission. The painting reappears in a letter dated January 12, 1607, when the biographer Giulio Mancini writes from Rome to his brother Deifebo in Siena. Mancini expresses a desire to buy the painting, but, after almost a year of negotiations, everything is interrupted. Vincenzo I Gonzaga, Duke of Mantua, buys the work, following Rubens' suggestion. The agreed upon price was 280 scudi. Rubens declared the work a masterpiece. Before it entered the collections in Mantua, it was exhibited to the public for a week at the end of April 1607 (Cinotti, Dell'Acqua 1983, p. 482). From the Duke of Mantua's collection it then passed to the Royal Collections in 1627, and after a few other transfers it is recorded in 1671 at Versailles, and subsequently in the Louvre. While Caravaggio painted the *Death of the Virgin*, presumably between April and May 1606 (a date almost all historians agree upon), the nun Caterina Vannini — whose biography was written by Borromeo — died of hydropsy. As is recorded in a letter by Borromeo (Calvesi 1990, p. 341), "among the other illnesses that ailed Caterina, one was that most grave one [...] hydropsy." Borromeo also owned a portrait of Vannini, dated 1605. Caterina had been a prostitute, was expelled from Rome in 1575 because of her scandalous life (Cecchini 1933, p. 10), and the episode may have influenced this singular iconographic composition (Calvesi 1990, pp. 331–345). Vice versa, Spezzaferro (1974, pp. 134–135) notes a total absence of saving values in the painting, and reads this as the reason for its rejection. In this enormous canvas, the largest of all his Roman altarpieces, Merisi treats the theme of a divine creature's death uniquely. The Virgin is surrounded by crying apostles, under a red drapery that lends theatricality to the scene with respect to the dark, humble environment in which she is laid out on an unadorned catafalque. Zuccari (1996, p. 22) maintains that Caravaggio pushed the assumption of a few Counter-Reformationist principles to their extreme, and is supported by Paleotti regarding representations of the Virgin "in adherence to the sacred texts as a woman living in a poor house in Nazareth." According to Marini (1980, p. 50) the artist interpreted the conceptual and religious themes of a canvas intended for a memorial altar, and the copper basin in the foreground, filled with a vinegar solution for washing the cadaver, is the crude proof of a distrust in the resurrection. Once again here we see the insidious intertwining of art and the all-too-human events of Merisi's life as his dramatic flight draws near.

A.L.

Bibliography: Mancini 1619–1625; Baglione 1642; Bellori 1672; Cecchini 1933, IV, p. 22; Arslan 1959; Calvesi 1971; Dell'Acqua, Cinotti 1971, p. 160; Spezzaferro 1974; Marini 1980; Cinotti, Dell'Acqua 1983; Parks 1985; Marini 1987; Askew 1990; Calvesi 1990; Zuccari 1996; Maccherini 1997; Marini 2001, *passim*; Spezzaferro 2001; Macioce 2003.

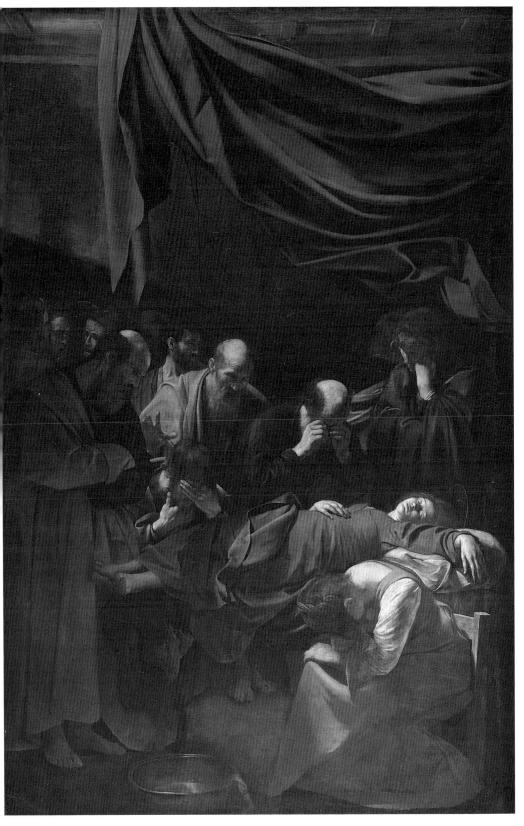

45

Supper in Emmaus

Oil on canvas, 141 × 175 cm
Milan, Pinacoteca di Brera

This work is probably the painting of
on the Way to Emmaus" recorded by
ni as painted in Zagarolo and purcha
Rome by Ottavio Costa. Yet in 1664, Bellc
scribes a "most beautiful Supper of the
in Emmaus with two disciples by Miche
Caravaggio" in the palazzo dei Patrizi, ar
1672 he writes of a "Christ in Emmaus betwee
the two apostles" painted "in Zagarolo." These
must be two different paintings. One, pur-
chased by the Pinacoteca di Brera in 1939 from
Marquis Patrizio Patrizi, corresponds to the one
described by Bellori in "nota delli Musei, Li-
brerie, Galleria ecc. di Roma": "Christ is in the
middle and blesses the bread; one of the seat-
ed apostles, upon recognising him, spreads his
arms, while the other holds his hands to the
table and looks at him in wonder. Behind is the
innkeeper with a cap on his head, and an old
woman who brings the food [...] quite differ-
ent [...] more coloured." This is certainly the
one recorded in the Patrizi inventory of 1624,
and is probably the one executed in Zagarolo
after Caravaggio's flight from Rome in 1606. It
was more recently recognised by Lionello Ven-
turi in the Patrizi collection, following hints by
Ricci and Cantalamessa, and correctly published
as authentic. Marangoni and Voss doubt its au-
thenticity, while Pevsner (1928), Longhi (1951),
Berenson (1951), Mahon (1952), and Hinks
correctly deem it an authentic work from the
final period in Rome. Jullian agrees, and
places it in relationship with the Montserrat
Saint Jerome, as do Bottari, Ottino della
Chiesa, Cinotti, Marini, Moir, Hibbard, and
Gregori. Modern historiography (Vannugli
2000) is inclined to believe that Costa, who had
commissioned works in the past and was grave-
ly ill in 1606, here played a merely intermedi-
ary role. This hypothesis could be confirmed
by some of the evidence; in 1606 Costa ceded
possession of two works that, though no painter
is specified, allude to two Caravaggesque sub-
jects: a *Martha and Magdalene* to his business
partner Juan Enríquez de Herrera, and a *Saint
Francis* to his friend Ruggiero Tritonio of Udine,
both executors of his will. Vannugli (2000)

o ...ially, while the vast majority
of copies are of the 1601 Mattei *Supper*, the copy
owned by the Costa could be associated with
two other versions; the Aldobrandini invento-
ry of 1606 to 1638 records a painting of "the
miracle that Our Lord performed in Emaus for
the two disciples by Michelagnolo da Carava-
gio." Finally, in the version of the Palatine codex
made from Mancini's manuscript the author af-
firms that from Zagarolo, where he painted
"Christ on the Way to Emaus," Caravaggio
"sent it to be sold in Rome."
Compared with the London version, so poly-
chromatic and painted a few years earlier
(1602), still in the spirit of the Cerasi chapel,
the Brera canvas shows the draining that occurs
at the height of his maturity, in a reduction of
virtuoso effects and chromatic plasticism in
favour of a mystical, humble, interpretation of
the subject. And if it is true that, as is betrayed
by the face of the woman so similar to the one
of Saint Anne in the *Madonna dei Palafrenieri*,
working from life has been replaced by 'gener-
ic types,' repeated models, and the extreme es-
sentiality of the composition with respect to
density; this version, in comparison to the Lon-
don *Supper*, reveals a new, more spiritual vision.
It is to these exercises that the young Velázquez
later looks.
V.S.

Bibliography: Spezzaferro 1974, pp. 579–586; idem
1975, pp. 103–118; Cappelletti, Testa 1990, pp.
234–244; Cappelletti in *Storia dell'Arte*, 1993–1994,
pp. 341–347; Pedrocchi 2000; Spezzaferro in Rome
2000, pp. 280–281; Vannugli 2000, pp. 55–83; Mari-
ni 2001, *passim*.

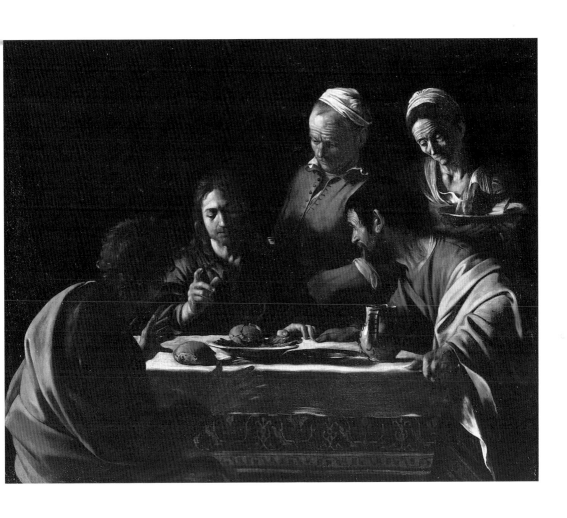

137

46
Saint Jerome in Meditation

Oil on canvas, 110 × 81 cm
Montserrat (Barcelona), monastery of Santa Maria, Pinacoteca

This canvas is mentioned in an epigram by Silos (1673, ed. 1979, I, p. 89, no. CLX), which says it was in the Giustiniani collection. The list of goods in the inventory of Marquis Vincenzo Giustiniani, dated February 9, 1638 (Salerno 1960, pp. 135–136), confirms that fact; Giustiniani had inherited the painting from his brother, cardinal Benedetto, who died in 1621 (Macioce 2003, p. 352). With the exception of Silos, the painting isn't recorded in any other literary source.

It entered into the present collection in 1917 from the Magni collection in Rome; Longhi published it as an authentic Caravaggio (1943, p. 16), but the attribution wasn't met by unanimous consent. Critics recognised its authenticity only much more recently, not least by virtue of its connection to the Giustiniani inventory (Marini 1987, p. 477). In reality its relation to the Borghese *Saint Jerome*, which features the same model, exposes a degree of weariness in the modelling of this painting, upon which several doubts regarding its authenticity were based, including that of Voss (1951, p. 168), Friedländer (1955, p. 204), and Nicco Fasola (1951). According to Longhi it was completed before the Borghese *Saint Jerome* (1606), and is a preparatory work. Gregori (1985, pp. 298–300), underlining the theme of meditation, dates the work to Caravaggio's last years in Rome. Cinotti (1983, p. 418) believes the work was done during "the same time as the Brera Emmaus [...] probably along with the other St Francis in the Pinacoteca of Cremona — all paintings linked to the moment of meditation and the mythic ascent as if from a tenuous yet solid umbilical cord descending from the two St Jerome paintings of 1606, in Montserrat and in the Galleria Borghese." According to Marini (1987, p. 478) the concentration of the figure in a compressed space and its solemn immobility recall the second version of *Saint Matthew and the Angel*. The saint is an ascetic figure, rapt in an exasperated mysticism and silent conversation with death, symbolised by the skull. Conversely, Gregori (1985, p. 298) sees the saint's position — in a precarious balance, with chest leaning forward, arms in diagonal, and legs ready to move — as a stylistic analogy to the Corsini and Kansas City versions of *Saint John the Baptist*. Caravaggio also eliminates the lion, the traditional iconographic attribute, from the composition, in order to extinguish any element that might distract the viewer's focus from the painting's central motif — the saint's moment of reflection and prayer.

A.L.

Bibliography: Longhi 1943; Nicco Fasola 1951; Vos 1951; Hinks 1953; Friedländer 1955; Wagner 1958; Della Pergola 1959; Salerno 1960; Jullian 1961; Dell'Acqua, Cinotti 1971; Marini 1974; Moir 1976; Cinotti 1983; Gregori 1985; Marini 1987; Gregori (ed.) 1992; Gregori 1994; Marini 2001, *passim*; Macioce 2003.

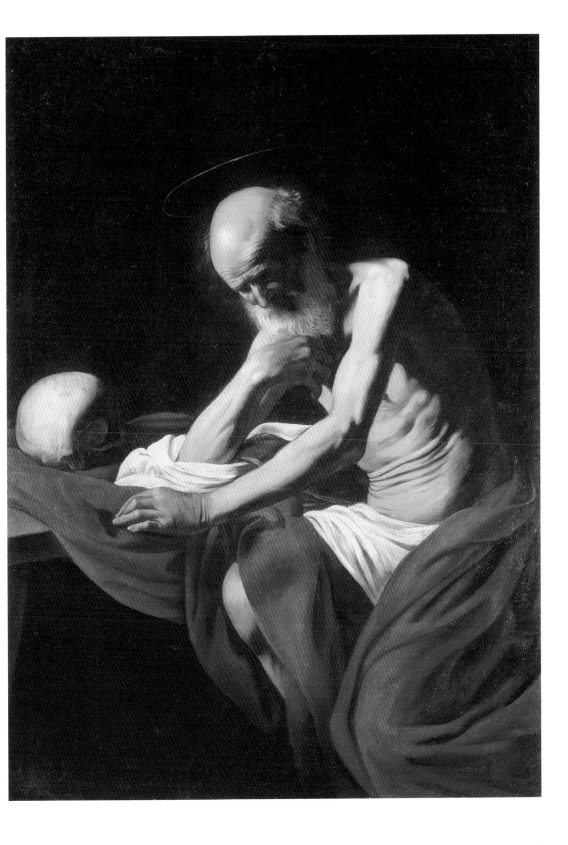

47
Saint John the Baptist

Oil on canvas, 94 × 131 cm
Rome, Galleria Nazionale d'Arte Antica, Palazzo Corsini

"Caravaggio returned to a subject he held particularly dear […] Saint John the Baptist […]. In the version at the National Gallery in Rome, the rascally young companion, who had often acted as the artist's model, sits in a rather agitated fashion in the forest amid roughly textured tree trunks, with his hand on a bark-stripped branch and, right next to it, a vessel hollowed out by the whirling, infallible brush as if by a Velázquez merely twenty years later." These are the words Longhi uses when recalling the dramatic effects of shadow and the vigour of luminously cut composition (Longhi 1927, p. 32).

This work belongs to Caravaggio's period of artistic maturity. There are no known documents that cite the work or identify it with any certainty. The painting is catalogued as an original Caravaggio in the Corsini collection in Rome, after the State acquired it for the Palazzo alla Lungara in 1883. Supposedly it went to the Corsini in 1758 following the marriage of Bartolomeo and lady Felice Barberini. In the inventory of goods owned by Prince Tommaso Corsini (1808) four canvases attributed to Caravaggio are mentioned, of which the only one found is this *Saint John the Baptist* (Macioce 2003, p. 384).

Longhi (1927) claimed this work's authenticity, which was almost unanimously agreed upon by art historians.

As for the work's date, Longhi (1927) sets it between the lateral paintings and the second version of *Saint Matthew and the Angel* in the Contarelli chapel. According to Jullian (1961, pp. 151–153), it is probably the oldest of all his works on this subject. Marini (1973–1974, p. 411) emphasises the effects in the landscape immersed in late crepuscular shadow. Cinotti (1983, p. 518) dates it to approximately 1605, next to or just before the "Madonna of the Snake" or *Madonna dei Palafrenieri*, given the prevalence of dark tones, a vigorously abbreviated mode of working, and the distribution of light.

From radiographic examination, in addition to the duct of quick, long brushstrokes, it became clear that in an earlier stage the reed cross had been in his left hand, resting on his right knee. The reddish underpainting, according to Mahon (1951, p. 226; 1952, p. 28), is typical of the artist's late Roman period.
A.L.

Bibliography: Longhi 1927 (1928, reissued 1967); Arslan 1951; Longhi 1951; Mahon 1951; Jullian 1961; Cinotti 1971; Marini 1974; Magnanimi 1980; Cinotti, Dell'Acqua 1983; Gregori (ed.) 1992; Marini 2001, *passim*; Macioce 2003.

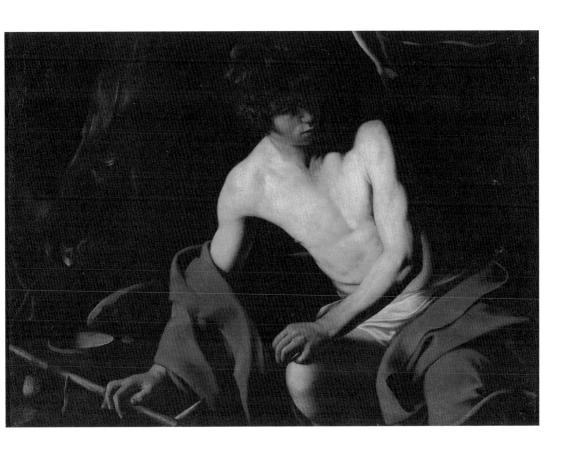

48
Saint Jerome Writing

Oil on canvas, 112 × 157 cm
Rome, Galleria Borghese

The first mention of this work is in Manilli's 1650 description of Villa Borghese outside Porta Pinciana: "The Saint Jerome who is writing is by Caravaggio." Bellori, later on, records a "Saint Jerome who, attentively writing, extends his hand and pen to the inkwell," painted for cardinal Scipione Borghese. With the correct attribution to Merisi the work is then recorded in the second room, as number 43 in Borghese's 1693 inventory: "A large work on canvas with Saint Jerome who writes, with death's head, numbered 316, gilt frame, by Caravaggi" (Della Pergola 1964). The attribution remains until the end of the seventeenth century; in the eighteenth-century Borghese inventories the Lombard painter's name was substituted with that of Spagnoletto. A long time passed before Caravaggio's name reappeared at the beginning of the twentieth century, with Kallab, Modigliani, and Lionello Venturi. All critics and art historians soon followed, indicating an approximate date of 1605–1606. Berenson conceded that that painting is "probably authentic," while Marangoni disagrees, though recognises the "thought" of Caravaggio within it, as do Pevsner and Wagner. There is no doubt among later critics, from Cinotti to Marini, Moir, Hibbard, Gregori, and Spike. The work's commission, if Bellori's affirmation stands, could be directly traced to Scipione Borghese, who was elected cardinal on July 18, 1605. Or, as Calvesi suggests, the painter could have donated the canvas to the newly elected cardinal for having interceded on his behalf in the events following the wounding of Mariano Pasqualone. This may also clear up the objection raised by Hibbard (1983), based on Francucci, regarding the Roman cardinal's initial ownership of the canvas. Indeed, as Coliva noted (2000), while Francucci doesn't mention the *San Gerolamo ne La Galleria dell'Illustrissimo e Reverendissimo Signor Scipione Cardinale Borghese* sung in verse, written in 1613, there were numerous copies of the works belonging to the collection at the time that are not mentioned in the celebra-

tory volume. No copies are known of this work. There could perhaps be a reference in the passage mentioning a "painting over the doorway, measuring an *imperatore* in length — Saint Jerome — Michelangelo da Caravaggio" registered in the 1783 inventory of Filippo III Colonna (Safarik 1996).

The painting, of an extreme simplification, was done toward the end of his Roman period, fairly close to the *Madonna dei Palafrenieri* and is rather more mature than the more dramatic and emotional composition of the earlier *Saint Jerome in Meditation* in the monastery of Santa Maria in Monserrat, with the expressionistic emphasis of the signs of old age in the hand and the insistent folds of the stomach, while the head seems almost a prototype of the Borghese version. Here the saint is pictured in a closed environment, with books on a simple table and his arm reaching out in suspension from writing, waiting for his thought to ripen in order to comment and annotate the text he is reading with such extraordinary concentration. The skull set atop the book seems to contrast — as a monition within a natural *vanitas* — his head, so silently rapt in reading. The iconography of Saint Jerome, enveloped in his red mantle, certainly paves the way for Ribera's exercises, adding value to the ascetic, composed nature of the saint and his distance from worldly things. Ribera preferred to take him out of the act of reading in order to underline his condition of penitence and ascendance, thereby showing his favour for the Montserrat version's interpretation. In the Borghese painting Caravaggio means to make Saint Jerome into a studious reader. According to Marini, who seems to underestimate the urgency of painting quickly in order to follow a thought, the painting is "apparently unfinished."
V.S.

Bibliography: Della Pergola 1964, no. 26, pp. 219–230, no. 28, pp. 451–467; Calvesi 1994, pp. 274–286; Safarik 1996; Coliva in Madrid-Bilbao 1999; Marini 2001, *passim*.

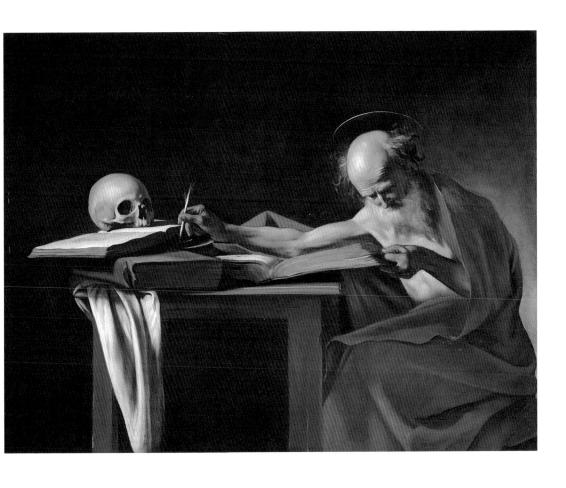

49
Saint Francis

Oil on canvas, 128 × 90 cm
Cremona, Pinacoteca Ala Ponzone

This is an ascetic, disarmed work that aggrandises nothing. *Saint Francis*, now in Cremona, was first recognised by Spezzaferro (1984) as the painting recorded in Ottavio Costa's inventory compiled in Rome from January 18 to 24, 1639: "And another painting of Saint Francis made by the selfsame Caravaggio, with its own frame." After the definitive identification of the Costa canvas with the Hartford *Saint Francis* (Vannugli 2000; Costa Restagno 2004), another hypothesis proposed by Marini (2001) becomes very interesting, as it suggests a direct link of the work in the Museo Ala Ponzone in Cremona with monsignor Benedetto Ala. Ala, who had family roots in Cremona, was appointed governor of Rome from June 16, 1604 to May 5, 1610. A hypothetical relationship with Merisi would seem to be confirmed by a declaration made by the painter on May 28, 1605: "I have no license whatever to bear sword and dagger in this city, except for the word of the governor of Rome, who ordered the commander of the local militia and his corporals to let me be; other license I have not" (Marini 2001). If a direct relationship between Merisi and Benedetto Ala were demonstrable, the work would then be dated between 1604 and 1606, before Caravaggio's flight from Rome. Thus all the hypotheses that set the painting's completion to after his departure from Rome — which are in the vast majority — would be disproved. The sole exception is Marini, who suggests the very early date of 1603, because he links the work's execution to the time that Orazio Gentileschi lent Caravaggio a Capuchin robe for a few days in September of that year. Such an episode is usually set in relation to the Cappuccini-Carpineto *Saint Francis* in Rome. For now it remains difficult to provide inventory proof of this, and, if the *Saint Francis of Assisi in Ecstasy* now in Hartford is excluded, the remaining traces lead to the Mattei di Giove family ("Caravaggi San Francesco," post-1802, in Cappelletti, Testa 1994), or to Christoph Sebastian, Baron of Remshingen ("a painting of St Francis of As-

sisi painted by Caravaggio," 1756, in Azzopardi 1995). A copy of the work, noted by Gregori (1987) is in the Museo della Collegiata di Castell'Arquato.

After the 1951 Caravaggio exhibition in Milan, where the work was shown as a copy, Mahon claimed it was an authentic Caravaggio from the early Neapolitan period, around 1607. In 1952 Longhi also agreed with this hypothesis. And, after Wagner and Friedländer's doubts, Gregori again strongly asserted the work's authenticity, setting it "between the period immediately following his flight from Rome, during his stay at the Colonna feudal grounds in the summer months of 1606 [...] and the beginning of the first Neapolitan period." Hinks indicates the same chronology, while Baumgart believes it is a later work. Moir continues to think it is a copy, while Cinotti's judgement varies. According to Christiansen it is a key work of exceptional quality: "In the Cremona Saint Francis Caravaggio's technique hasn't yet arrived to that 'staccato' style, to that 'sketchy' brushstroke that characterises his last paintings." As in all Caravaggio's other late works, the style seems more and more to gush out of the psychological and expressive atmosphere of the painting. The particular iconography, with the meditation on Christ, in an intensely introspective and melancholic position, legitimises the hypothesis that this is an idealised self-portrait with a "tragically autobiographical thought" (Longhi 1943). Caravaggio seems to "see himself in the saint, silent and concentrated in meditation, almost as though he wanted to confer on it his own sense of guilt and his own desire of penitence and expiation" (Gregori).
V.S.

Bibliography: Spezzaferro 1975, pp. 103–118; Gregori in Cremona 1987, pp. 19–25; Cappelletti, Testa 1994; Azzopardi 1995; Vannugli 2000, pp. 55–83; Marini 2001, *passim*; Christiansen in Naples 2004, pp. 104–106; Costa Restagno 2004.

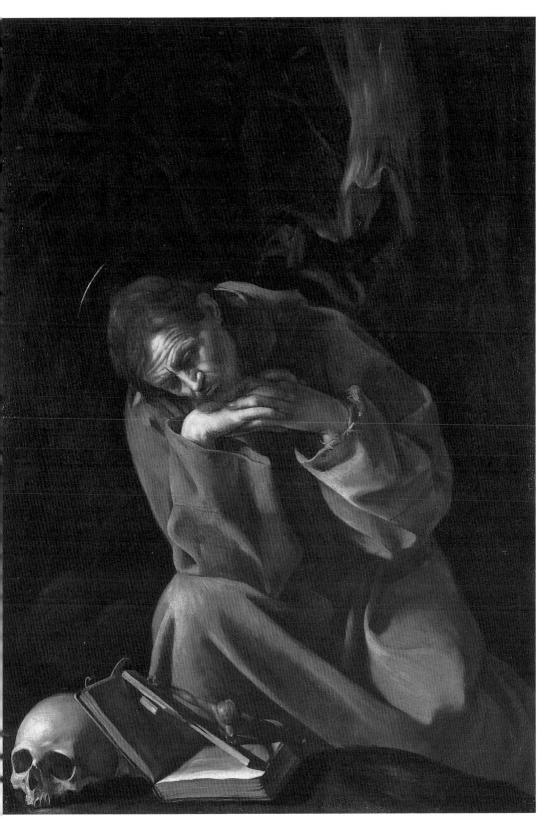

Saint Francis in Meditation

Oil on canvas, 125 × 93 cm
Carpineto Romano (Rome), church of San Pietro
on long-term loan to the Galleria Nazionale d'Arte Antica,
Palazzo Barberini

This is one of the most debated paintings with regard to attribution, not least because there are so few documents that mention it. The work has often been seen in relation to the other Saint Francis, in the Capuchin convent of Santa Maria della Concezione in Rome, and published as an authentic Caravaggio by Cantalamessa in 1908 (pp. 401–402). Until 1968 the critical debate had centred around this version, believed to be the original. After the 1969 restoration, Brugnoli (1970, pp. 23–24) proposed the Carpineto painting as the original Caravaggio, in which the prepared ground with an oily brown under-painting, typical of the artist's later works, suggests a later date. Before restoration the critics and art historians proposed 1603 as a possible date of the painting's completion, and only Mahon (1951, p. 234) proposed 1605, based on a September 14, 1603 document in which Orazio Gentileschi admits not having seen Caravaggio since "he lent him a Capuchin robe that was returned to him ten days before" (Macioce 2003, p. 132). Other more recent proof has come from the restoration carried out in 2000 under Vodret's direction. Before this latest restoration the most credible attributions were divided into two main groups: Gregori, Andersen, and other art historians maintained the Capuchin canvas was the original, while Maurizio Marini, Calvesi, and Zuccari maintained the authenticity of the Carpineto canvas (Vodret 2004, p. 46). The restoration recovered the rock at the bottom of the scene and the longitudinal section of the cross, and brought the works dimensions back to what they were originally. Between the two versions there are clear differences in both the structuring of the light-to-dark relationship — which only in the Carpineto version recalls Caravaggio's *modus operandi* (Macioce 2003, p. 5) — and the application of colour and spatial relationships of the entire scene. The historical events surrounding the work and its dating remain quite complex.

Brugnoli, also in light of a *pentimento* in the monk's hood, had proposed that the work could have been a commission for cardinal Pietro Aldobrandini, nephew of Clement VIII, a gentleman from Carpineto and founder of the convent and church entrusted to the Padri Minori Riformati. Cinotti (1971, p. 128) observes the unlikelihood of such a commission three years prior to the church's foundation, and maintains that the painting was completed in 1606, during Caravaggio's time on the Colonna feudal grounds. Spezzaferro (1975, p. 113), on the other hand, proposed that the indication of a painting of Saint Francis in the 1639 inventory taken upon Ottavio Costa's death could refer to the Carpineto painting. Marini (1974, pp. 56–57) agrees regarding the practical impossibility of an Aldobrandini commission, since the cardinal wasn't in Rome from 1606 to 1610. Marini sets the painting in Caravaggio's Sicilian period, proposing a later date, toward 1609. Recent studies conducted by Testa (2002, p. 129) attest to how Caravaggio continued, even in his absence, to have contact with cardinal Aldobrandini through his sister Olimpia, such that a long-distance commission could be considered.

According to Strinati (1982) the mood of the painting is connected to the *Ars moriendi* in an assimilation of the humanistic theme of melancholy. In including the act of contemplating the skull the painter could have been influenced by a 1585 engraving by Annibale Carracci (Gregori 1985), and such a work may also have inspired the 1603 Cremona *Saint Francis in Meditation*.

A.L.

Bibliography: Cantalamessa 1908; Brugnoli 1968, pp. 11–15; Longhi 1968; Salerno 1970; Cinotti 1971; Marini 1974; Spezzaferro 1974 (1975 edition); Cinotti 1975; Marini 1980; Strinati 1982; Gregori 1985; Strinati, Vodret 1999; Marini 2001, *passim*; Treffers 2001; Vodret 2001; Testa 2002; Macioce 2003; Morello (ed.) 2003; Vodret 2004.

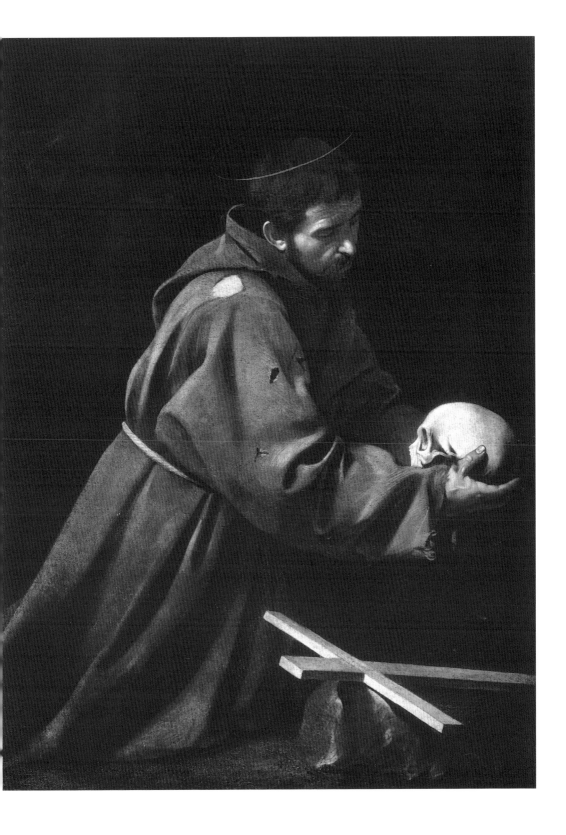

51

Seven Acts of Mercy (Our Lady of Mercy)

Oil on canvas, 390 × 260 cm
Naples, church of the Pio Monte della Misericordia

This scene is set in a dark, narrow, sinister alley, permeated with humidity, odours, and moods, and delimited by high, grey, seemingly endless walls, swarming with a rather diverse humanity — noble and destitute, suffering and hopeful ("a famous crossing of rich and poor, misery and nobility [...] remade in the naked truth of the Neapolitan neighbourhoods of Forcella or Pizzofalcone" wrote Roberto Longhi in 1951). "This is the Naples of the early seventeenth century, the ancient, overflowing city — a little Greek, a little Latin, and a little Spanish, as chaotic and unliveable now as it was then — that welcomed Caravaggio as he fled Rome. This is where the painter learned how to perceive, with heart as well as with eyes and mind, to what an extreme degree of exasperating frustration, widespread marginalisation, and saddening desolation the human condition could reduce itself," adds Nicola Spinosa (2004). Precisely there, in that "famous crossing" imagined by Longhi, where you least expect it, the Acts of Mercy described in the Gospel of Matthew materialise all together, simultaneously (according to the principle of unity of time, place, and action justly addressed by Mina Gregori in 1985, as will also happen later with the *Martyrdom of Saint Ursula*), in a synthesis of extremely high spiritual, religious, and evocative strength, but also didactic strength, because everyday naturalism and the palpable and true 'life experience' are a language accessible to even the most illiterate of viewers. What is happening this night is a miracle, because everyone has suddenly decided to do good; and suddenly even the Madonna and Child appear, high up, seemingly just any regular young woman looking out a window to find out what all the fuss is about, if it weren't for the large-winged street urchin-angels holding her up. On the lower right is a classical scene of Pero nursing her father Cimon in prison (give food to the hungry and visit prisoners), right next to it is the powerful image of a cadaver being carried away (bury the dead); in the centre an elegant Saint Martin in plumed

hat, favoured son from a well-heeled family, gives his mantle to a poor man sitting on the ground (clothe the naked), who could also represent a sick man (visit the ailing); next to him Saint James the pilgrim (recognisable by the seashell on his hat) is led by an innkeeper, vigorously portrayed, to his inn (house pilgrims); behind those two a classic Sampson drinks from a donkey-hide canteen (give drink to those who thirst). Here Caravaggio chose to "represent the 'practice' of 'acts' and not just 'faith' [...] But it seemed even more necessary to him to represent above all else corporeal acts of mercy, not just idealistically spiritual ones [...] and hence [he chose] to radically transform the representation of the 'Acts of Mercy' from abstracting and canonically symbolic situations that responded to exemplary and typified concepts into masses of painful life experience — bona fide *tranches de vie* [slices of life] caught in the making" (Bologna 2004). The large altarpiece, which is one of the most complex sacred creations of the seventeenth century in Italy, was executed for the Pio Monte della Misericordia at the beginning of Caravaggio's Neapolitan period, toward the end of 1606 (a document dated January 9, 1607 cites the painting as already "painted"), and therefore just a few months after the murder of Ranuccio Tomassoni, May 28, 1606, and the precipitous flight from Rome that followed. Nor is this work devoid of autobiographical implications (the jail, but above all the themes of death and salvation will become ever more central to the painter's thoughts). It also had a very strong impact on a squadron of young Neapolitan painters and was the start of a true 'Caravaggesque school' in the city.

A.C.

Bibliography: Marini 1987, pp. 494–497 (with bibliography); idem 2001, *passim* (with bibliography); Bologna 2004, pp. 23–24, 106; Spinosa 2004, pp. 13–14.

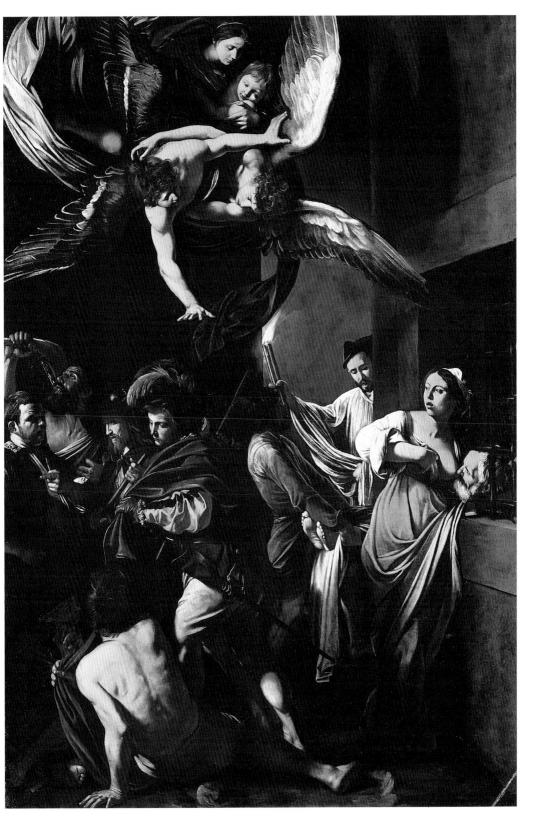

52

David with the Head of Goliath

Oil on poplar panel, 90.5 × 116.5 cm
Vienna, Kunsthistorisches Museum, Gemäldegalerie

There are three noted works published on the theme of *David and Goliath*: in 1910 Lionello Venturi (pp. 269–270) connected this painting to the half-length figure of David that Bellori (1672, p. 214) wrote was the count of Villamediana, who lived in Naples from 1611 to 1617 and was murdered in Madrid in 1622. His painting collection was dispersed, and part of it was purchased by the Prince of Wales, who was later crowned King Charles I of England. The *David* was sold in 1649, a year after the king's death, and went to Amsterdam. Of the many engraved copies of Caravaggio's work it is worth mentioning the mezzotint done in Amsterdam by Wallarant Vaillants after 1662 (Garas 1981, pp. 397–401). In 1675 the painting belonged to archbishop Karl von Liechtenstein up until its arrival, through sale or donation, in the Austrian Emperor's collection (Garas 1981).

According to Gregori (1985, p. 338) the three paintings inspired by the biblical episode of David defeating Goliath are deeply different from one another, and their sequence is indicative of not only stylistic change, but also a psychological change that occurred in Caravaggio's not-so-long life. The work in Vienna is the second version, but a long and articulated critical debate has developed regarding its authenticity and date. The Vienna *David* has been confused with a painting from the Caravaggesque school in the castle of Prague. Kallab (1906–1907, p. 289) and Venturi (1910, pp. 269–270) are responsible for having first recognised it, but even afterwards many critics initially expressed negative judgements of it (Cinotti 1971, p. 169) only to later confirm its authenticity (Cinotti 1973, p. 189) based on stylistic comparison. "That manner of devouring the flesh with shadow (see the left forearm extended to hold Goliath's severed head) is entirely Caravag-

gio, and is also found in the bare-backed figure seen from behind in the *Seven Acts of Mercy* and in the Madrid *Salome*." According to Terzaghi (2001, p. 330) "Merisi brings back the image of a young shepherd who proudly returns with the giant's head, using the disproportion between the large sword and the more minute figure of the boy as a narrative expedient, emphasising the gesture of the left hand that, stretching out, holds the giant's head at a distance — a detail that Gregori's research (2000, p. 154) has traced back to the Apollo Belvedere model."

The date of this work has fluctuated from the last decade of the sixteenth century (Schudt 1942, p. 27) to the end of Caravaggio's Roman period (Voss 1924, p. 440), to the beginning of the Neapolitan period in 1606–1607, in relation to the *Seven Acts of Mercy* and the *Madonna of the Rosary* (Gregori 1982, p. 38). From radiographic research (Klauner 1953) it has also been discovered that underneath Caravaggio's composition is another one, with *Venus, Mars, and Cupid*, by a mannerist painter.

A.L.

Bibliography: Bellori 1672, p. 214; Kallab 1906–1907, p. 289; Venturi 1910, pp. 269–270; Voss 1924, p. 440; Schudt 1942; Mahon 1951, p. 234 (marginalia); Longhi 1952; Cinotti 1971; Marini 1974; Bologna 1980; Garas 1981; Gregori 1982; Cinotti, Dell'Acqua 1983; Gregori 1985; Calvesi 1990; Gregori 1994; Gregori 2000; Marini 2001, *passim*; Terzaghi 2001; Pacelli 2002; Puglisi 2003.

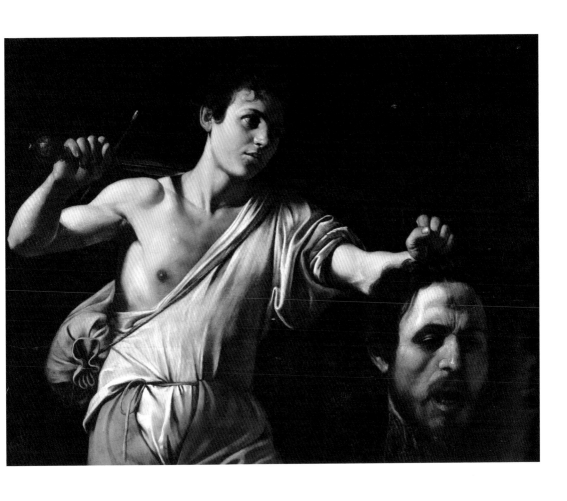

53
Flagellation of Christ

Oil on canvas, 134.5 × 174.5 cm
Rouen, Musée des Beaux Arts

This painting, while not mentioned in the historic sources, is certainly an authentic work from the early Neapolitan period. The composition must be seen in direct relationship with the *Flagellation of Christ* executed in Naples for the de Franchis family in 1607, and it is quite likely that the commission for the Rouen *Flagellation of Christ* was the result of the success that the de Franchis version enjoyed. This work's history prior to the mid-twentieth century, however, is unknown.

The composition of this *Flagellation of Christ* recalls Caravaggio's Roman works in the models' poses and narrative setup. Christ and the two executioners are represented in three-quarter-length, in a scene that develops from the viewer's right to left. Christ isn't in the centre, but to the side, in order to leave space to the two thugs. The scene isn't represented in its entirety, and a sole column emerges from the darkness of the scene's shadowy void. The broad gesture of the executioner in the centre, as he opens his arms in a very theatrical way, is exquisite, and extends over nearly the entire length of the painting. In reality this figure is holding Christ by the hair with his right hand, while he is about to whip him with the left. This is also, essentially, the action that one of the executioners in the de Franchis *Flagellation* is carrying out, but with different gestures and greater realism. The other thug has almost finished binding Christ's hands, and again here one of the motifs of the de Franchis *Flagellation* is repeated. Christ is seen in profile looking outward, to the left, toward the light that dramatically illuminates his figure and brings out the gestures of the two executioners. It is a light that is also invested with a spiritual meaning — it is the light of salvation. The painting is of a uniform yet softer execution with respect to the rapid technique used in the paintings done in the same for-

mat after 1608. The attention to the modulation of Christ's figure is equal to that of the de Franchis altarpiece. The light's animation is typical of this period, as are the brushstrokes that suggest a landscape in the shadows.

The painting was purchased by the Musée des Beaux-Arts of Rouen in 1955 as a work by Mattia Preti, and was recognised as a Caravaggio, amid various controversies, by Longhi in 1960. In fact, the work confirmed the art historian's intuitions, as in 1951 he had proposed another work, in Lucca at the time, as a copy from a lost original (the Rouen painting wasn't known at the time). The controversy regarding the originality of the Rouen painting lasted more than twenty years, complicated by another version in Switzerland at the time, published by Mahon in 1956. It was Mahon himself, however, that correctly proposed a date between 1605 and 1607 for this work, correcting Longhi's indications that it was from the Roman period.

K.S.

Bibliography: Longhi 1960, p. 26; Jullian 1961, pp. 174, 181, nos. 31, 32; Paris 1965, no. 61; Rosenberg in Paris 1965, no. 61; Longhi 1968; Kitson 1969, no. 75; Cleveland 1971, no. 18; Causa 1972, p. 963; Volpe 1972, pp. 61, 62; Gregori 1974, p. 599; Marini 1974, pp. 426–428, no. 65; Röttgen 1974, p. 201; Nicolson 1979, p. 32; Cinotti 1983, no. 65; Hibbard 1983, pp. 325–326; Gregori 1985, no. 91; Christiansen 1986, pp. 442, 445; Bejon de Lavergné, Volle 1988, p. 73; Marini 1989, pp. 506–508, no. 72; Papi in Florence-Rome 1991, no. 18; Bologna 1992, pp. 343–344; Gregori 1994, pp. 130, 152, no. 62; Pacelli 1994, pp. 54–62; Lapucci in *Come dipingeva* 1996, pp. 31–50; Finaldi in London 1998; Puglisi 1998, no. 64; Madrid-Bilbao 1999, pp. 136–137; Marini 2001, no. 81; Spike 2001, no. 56; Bologna in Naples-London 2004, p. 37.

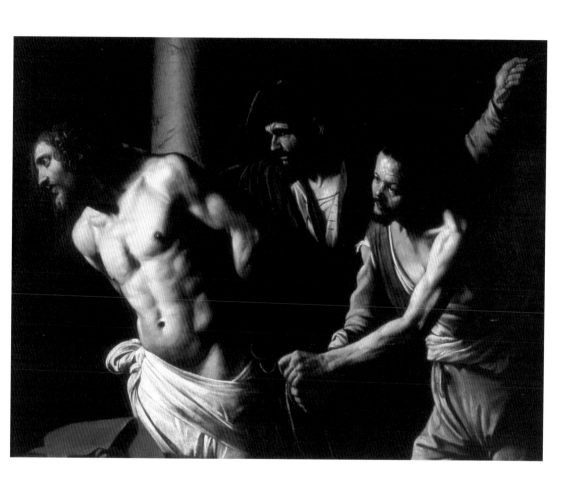

54

Salome with the Head of Saint John the Baptist

Oil on canvas, 116 × 140 cm
Madrid, Palacio Real, Patrimonio Nacional

While this work isn't cited in the early biographies, it can be dated — although without universal agreement among critics — to Caravaggio's initial period in Naples, between the end of 1606 and the first months of 1607. The work must be seen in relation to the other two interpretations of the martyrdom of Saint John the Baptist, namely the monumental *Beheading* in Malta and *Salome with the Head of the Baptist* in London. And it is precisely these two works that give us the stylistic and technical reference points by which to date the Madrid painting. Painted in a 'solid' manner, it differs from the more rapid, abbreviated way in which Caravaggio painted the London work (dated to his very last period). The Malta canvas, where Caravaggio 'proudly' applies himself in the use of a preparatory ground, can be dated between these two canvases.

In this work Caravaggio presents an incredibly intrepid composition: the figures of Salome, the executioner, and the elderly woman are grouped into an elliptical composition that is dramatically shifted to the right-hand side of the canvas. Thus a void remains to the left, a space that contrasts with the solidity of the figures. The three characters are physically close, but psychologically quite separated; the attention to their gestures is focussed on the movement of their heads. Salome is in the centre, with a red mantle, in a pose that can also keep her isolated from the other figures. The intensity of her stare, almost an enigma suspended between satisfaction and repentance, leaves various possibilities open to interpretation. The executioner, seen from behind, is represented as though he were turning to catch one last glimpse of the head of the Baptist before leaving the scene. The elderly woman, as in the repertory the artist had used in the past, plays the harmonic role: visibly tried and sad, she looks at the Baptist's head. This is a magnificent interpretation, a composition that pushes the inventive capabilities of the artist to the limit. In addition, there are very few

154

works by Caravaggio in which the light is so audacious, and so powerful in defining the figures' modulation. It is an intense work — a masterpiece of his later years.

Longhi first brought the work to the attention of the critics in 1927, and linked the painting to Bellori's citation that spoke of a "half-length figure of Herodiade with the head of Saint John on a platter" that Caravaggio sent to Grand Master Wignacourt to placate his ire after the flight from Malta. Longhi set the work to the period following his time in Malta. The identification of the work through Bellori's citation is not, as far as I can tell, correct. After the initial controversies it gained attention from critics following the 1951 exhibition. The central debate regarding its date of completion remains. Though it isn't accompanied by any documentation, this painting is cited in the royal collection of the Alcázar in Madrid in 1666 (even if a similar one, by an unidentified artist, is cited in 1636). It was moved to the Royal Palace after 1734, and to the Prince's Casita, El Escorial, by 1849. In 1970 it was moved to the Royal Palace of Madrid.
K.S.

Bibliography: Longhi 1927 [1967], p. 124; Longhi 1943, pp. 8, 19; Ainaud 1947, pp. 392–393; Mahon 1951, p. 234, no. 122; *Caravaggio e i Caravaggeschi* 1951, no. 44 bis; Venturi 1951, no. 40; Mahon 1952, p. 19; Hinks 1953, no. 55; Wagner 1958, pp. 119–121, 133–134, 212–213; Longhi 1959, pp. 24–25, 28; Jullian 1961, pp. 173–174, 177–178; Guttuso, Ottino della Chiesa 1967, no. 92; Kitson 1969, no. 91; Causa 1972, p. 963, no. 5; Seville 1973, no. 1; Harris 1974, p. 236; Marini 1974, pp. 52, 268, 449, 450, no. 84; Moir 1976; Nicolson 1979, p. 33; Gregori 1982, p. 133; Cinotti 1983, no. 28; Gregori 1985, p. 335, no. 96; Marini 1989, pp. 540–543, no. 91; Bologna 1992, p. 341; Gregori 1994, p. 153, no. 81; Pacelli 1994, pp. 97–99; Keith 1998, pp. 47–49; Puglisi 1998, no. 84; Milicua in Madrid, Bilbao 1999, pp. 138–141; Marini 2001, no. 99; Spike 2001, no. 69; Carr in Naples-London 2004, no. 13.

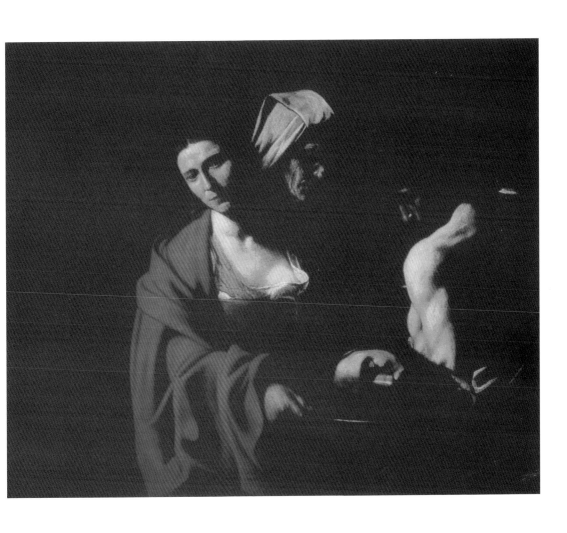

55
Madonna of the Rosary

Oil on canvas, 364.5 × 249.5 cm
Vienna, Kunsthistorisches Museum

This is a monumental scene of complex construction played out over several different levels: there is a diagonal line of figures seen from behind gravitating toward Saint Dominic to the left; and Saint Dominic and the group around the Virgin, from left to right, are on a single plain, which also underlines the spatial depth of the scene. To the right Saint Peter Martyr looks out from the scene portrayed here, it seems, into the apse of the church with a large fluted column, and points to the divine group for the viewer. A large red curtain is theatrically raised above, just like a stage curtain or baldachin (and recalls the one in the Louvre's *Death of the Virgin*), closing the space high up. The complexity and intelligence of the setup don't preclude the subtle psychological tension that animates the figures; we see the restlessness of Saint Dominic, whose forehead is wrinkled as he tries to intercede on behalf of such pained, desolate humanity, dusty-footed poor, and children with uncertain futures, but also nobles; all hold their hands out seeking protection, help, and something to hope for. It is precisely these hands that elevate the level of pathos, creating a memorable passage that dramatises and updates in one quick flash the centuries-old, classic iconography of the *Sacra Conversazione* that recalls Titian (echoes of the Pesaro Altarpiece surface here). It is an instantaneous reflection, but at the same time also a universal and very elevated meditation on the troubled human condition.

From a letter by the painter Frans Pourbus dated September 25, 1607 we know that this large canvas ("a rosary, made to be an altarpiece") was up for sale in Naples, though the reasons such an altarpiece wasn't placed in the spot it was made for (or was immediately removed) are unknown, as are the exact circumstances in which it was realised. Some specialists, most recently Ferdinando Bologna (2004), set its date of completion to the last phase of Caravaggio's Roman period, which ended with the precipitous flight after the dramatic Tomassoni affair (May 28, 1606), almost contemporaneous with the *Death of the Virgin* and the other large canvases from that period; others, such as Maurizio Marini (1987; 2001) believe it was a commission from the very beginning of his Neapolitan period, contemporaneous with *Our Lady of Mercy*, suggesting a rich merchant from Ragusa, Niccolò Radolovich (or Radulovich) was the patron, based on documents recording advance payments made to Merisi at the end of 1606. The extraordinary portrait of the old man seen from behind, who turns toward the viewer, would seem to be a likeness of either Niccolò or a member of his family. According to Denunzio (2004), on the other hand, the commission came from Juan Alfonso Pimentel Enriquez VIII, count of Benavente, who would also be the man portrayed from behind on the lower left. In any case, the canvas was purchased by the painter Louis Finson (who made a copy of it that was then sold in Amsterdam in 1630 and later lost), sent to the Netherlands, and after Finson's death was passed down to Abraham Vinck, who sent it to the church of Saint Paul in Antwerp around 1619, thanks to the good offices of a group of artists presided over by Pieter Paul Rubens. The work remained there until 1786, when it was ceded to Josef II of Austria and sent to the royal collections; since 1891 it has been in the present collection (Marini 1987).
A.C.

Bibliography: Marini 1987, pp. 497–503 (with bibliography); idem 2001, pp. 516–517 (with bibliography); Bologna in Naples 2004, p. 27; Denunzio ibidem, pp. 52–55.

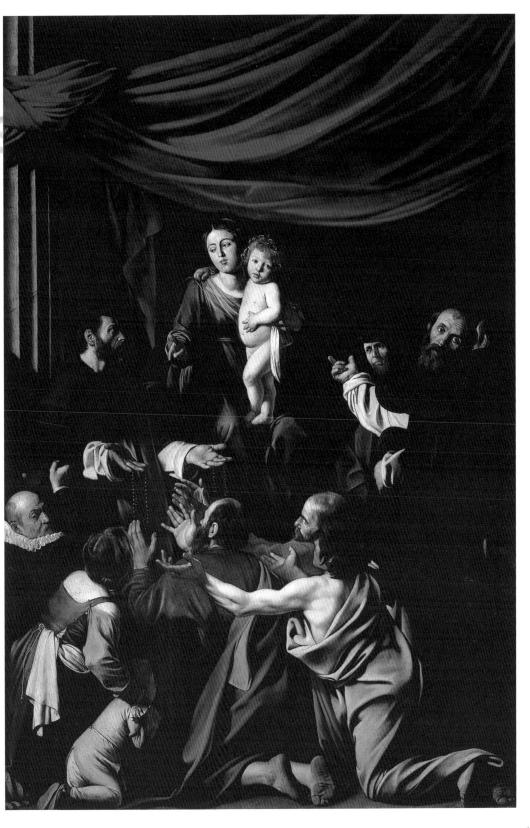

56
Crucifixion of Saint Andrew

Oil on canvas, 202.5 × 152.7 cm
Cleveland, The Cleveland Museum of Art

According to Bellori, "The count of Benavente, Viceroy of Naples, brought the Crucifixion of Saint Andrew back to Spain." The research carried out thus far on this painting, which reappeared only in 1977, is based on this reference to a painting from Don Juan Alonso Pimentel y Herrera, eighth count of Benavente and Viceroy of Naples from 1603 to 1610. This is certainly a painting from the Neapolitan period, but critics are still divided on its date, seen during either the first (1606–1607) or second (1609–1610) stay in Naples. Stylistically, comparison with the altarpiece of the *Seven Acts of Mercy* and the *Flagellation* would suggest a date toward the first months of 1607. It would be impossible to date this work to the period after the Malta *Beheading* and the Sicilian paintings — the *Burial of Saint Lucy* and the *Raising of Lazarus*. Despite the success in identifying the painting, the background of its commission is still unknown, as is whether or not the painting was realised as an altarpiece, as the format would suggest. In Spain the painting was kept in the count's mansion in Valladolid.

The painting's iconography, with the saint crucified on a Latin cross instead of the traditional X-shaped cross, is unusual but not absolutely unique, and was perhaps painted like this upon the patron's request. The painting doesn't show the bona fide act of crucifixion, but instead portrays the moment of death during an attempt to free the saint; fixed to the cross, Andrew continued to preach, instigating the crowd's call to free him. The attempt failed because the apostle prayed to God to grant him martyrdom. The man who has climbed up to free him, portrayed in the act of untying the saint's right arm, remains frozen with his arms immobilised.

Caravaggio approaches this narrative with an admirable and decisive simplicity. Returning to the process of his last Roman altarpieces, he offers a humble, more realistic naturalism in a composition designed to draw the viewer into an involvement with the work. The crucified saint extends for almost the entire height and width of the composition; his liberator, who has climbed up on a step, is portrayed next to him in full length, while the scene takes place in the foreground, at minimal distance from the viewer. Four characters portrayed in half-length — one of whom is a poor elderly woman painted with a penetrating realism — encircle the cross and look upward at the old, exhausted apostle. The saint is about to pass away, and the viewer, just like the four people under the cross, has to raise his head up to catch the crucial moment of martyrdom.

The light dramatises the scene with a powerful chiaroscuro that partially illuminates the figures and leaves in shadow the open countryside in which the martyrdom takes place. The solid execution of the background, striking spots of light, brushstrokes of the draped clothing, and colours are typical of the artist's early Neapolitan period. At the same time, especially in the figure of the saint, there is a pictorial brevity and essentiality in the execution that foreshadow the techniques the artist would use in the altarpieces after 1607.

Purchased in 1976 by the Cleveland Museum of Art, the painting was previously known only through copies. Its attribution to Caravaggio — proposed by Mahon and Tzeutschler Lurie in 1977 — was immediately and favourably welcomed by the critics. The painting was rediscovered at a very important time, a period in which new paintings and documents were permitting more accurate delineation of controversial aspects such as the date and chronology of his works.
K.S.

Bibliography: Pérez Sánchez 1973, no. 4; Marini 1974, pp. 235, 433–435; Nicolson 1974, pp. 604–608; Gregori 1975, pp. 43–44; Tzeutschler Lurie, Mahon 1977, pp. 1–24; Nicolson 1979, p. 32; Bologna 1980, p. 42; Gregori in London-Washington 1982, no. 17; Cinotti 1983, no. 8; Hibbard 1983, pp. 219–223; Gregori 1985, no. 99; Christiansen 1986, p. 436; Calvesi 1990; Bologna 1992, pp. 333–334; Gregori 1994, no. 69; Pacelli 1994, pp. 39–41; Puglisi 1998, no. 82; Marini 2001, no. 88; Spike 2001, no. 55; Christiansen in Naples-London 2004, no. 5.

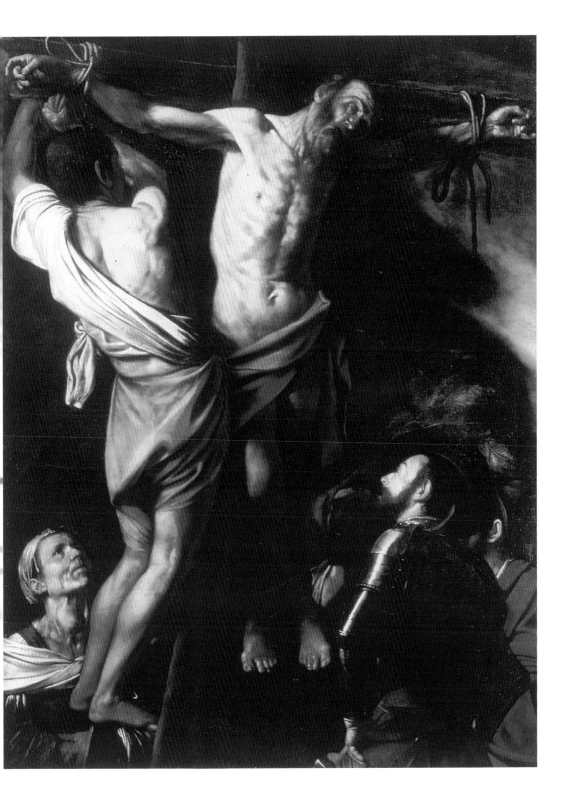

57
Flagellation

Oil on canvas, 286 × 213 cm (formerly 286 × 217 cm)
Naples, church of San Domenico Maggiore,
on long-term loan to the Museo Nazionale di Capodimonte

Thanks to Bellori's records, which are the first to mention this canvas, Pacelli (1977) related this Dominican work to a May 1607 note of payment: "To Tomase di Franco, one hundred Ducats, and for him to said Michelangelo Caravaccio, upon completion of the work two-hundred fifty are to be paid, awaiting the other 150 ducats received in banknotes, and these are to be accounted for on a [receipt?] that he will need to submit. To him 100 ducats." The history surrounding this work is well summed up in the recent studies of Pagano (2004) and Marini (2001), which are suggested reading. It is difficult to agree (Bologna, Pagano) that the document described above constitutes an advance or deposit rather than simply a payment upon completion of the work. According to Cinotti, if it is true that for the altarpiece with the *Seven Acts of Mercy* Caravaggio received a sum of 400 scudi, it is also true that the *Flagellation* is of a significantly smaller size and, above all, includes fewer characters. It is worth repeating that this altarpiece, interestingly, isn't mentioned in any of the biographical sources of periegetic literature prior to 1672. This curious omission could be justified by the continuous renovation the de Franchis chapel underwent between 1632 and 1652, when the works were finished and the chapel was renamed "chapel of the Flagellation of the Lord." Doubts remain regarding whether or not this canvas was always kept in the church, above the altar or elsewhere, since it was repeatedly moved until its final removal for security reasons. In 1972 it was placed on long-term loan to the Museo di Capodimonte. Among the sources written after 1672 it is worth mentioning the De Domenicis testimony, according to which the *Flagellation*, "exhibited to the public, attracted all the viewers' eyes, because the figure of Christ was shown with an ignoble naturalness, not gentle, as was necessary for representing the figure of a God made man for us; in any case, the new manner of that terrible way of shadowing, the verity of those nudes, and the somewhat humiliated illustration without many reflections caused not only dilettantes, but also a good number of Professors to remain surprised, and Caravaggio's fame was made audible where the dilettantes desired to compete for his works." The *Flagellation* is a classical work unlike any other, even in its almost didactic naturalism. Modern critics, from Berenson to Bologna (Naples 2004), have observed the sixteenth-century influences of Sebastiano del Piombo and the "impressive plasticity" and "tendency toward gigantesque proportions" of Buonarroti — who did Piombo's preparatory sketches — as well as the precedents in Titian, Peterzano, Campi, and Federico Zuccari. Longhi sees connections with copies of a lost Flagellation from the Pinacoteca Civica of Macerata and the Museo Civico of Catania, while Marini sees echoes of a small work on copper in the sacristy of San Pietro in Perugia. The compositional and pictorial debts to seventeenth-century Neapolitan painting are numerous, from Caracciolo to Luca Giordano. There is a copy of this work in San Domenico Maggiore, probably the one recorded by De Domenicis in the church of the SS. Trinità degli Spagnoli, attributed to Vaccaro. The paintings mentioned in the following inventories are hypothetically copies, but they may also have roots in some other original work: Carlo de Cardenas, count of Acerra, Marquis of Laino, December 23, 1699 (Labrot 1992); Nepita Bonaventura, November 24, 1704; Carlo Carafa, Prince of Belvedere, January 10, 1707. The date of the work's ranges from 1607 to a possible later intervention on the canvas during Caravaggio's second stay in Naples in 1609. Although recent restoration brought out evidence that the painting was done in a process of rethought and additions to the support, it seems hard to believe that Merisi could have left Naples leaving the work incomplete.
V.S.

Bibliography: Pacelli 1977, pp. 819–829; Labrot 1992; Marini 2001, *passim*; Bologna in Naples 2004, pp. 16–47; Pagano 2004.

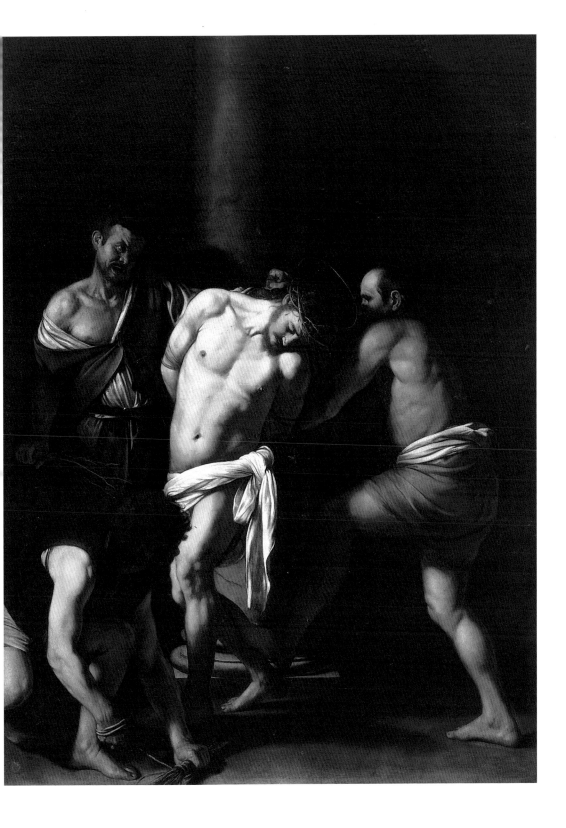

58

Portrait of Grand Master Wignacourt in armour
[with a Page]

Oil on canvas, 195 × 134 cm
Paris, Musée du Louvre

It was probably with this work that Caravaggio was able to secure himself the interest of the Knights of Malta. The painting must have made a great impact on the Maltese court, as the artistic scene on the island wasn't accustomed to portraits of this sort and of this quality. Therefore Wignacourt, the Frenchman from Picardy elected Grand Master in 1601, requested a papal dispensation at the end of that same year, in hopes of "not losing" Caravaggio. Clearly the artist had already proven himself, and this is probably one of the very first paintings he executed in Malta. His stay lasted little more than fifteen months, and was the longest period he would stay in any one place after his flight from Rome. This is the only full-length portrait painted after he left Rome, and is also the only one with the subject portrayed standing up. In the painting, accompanied by a young page, the Grand Master is represented in an austere room, yet dressed as warrior and commander-in-chief. Portrayed in armour as he firmly holds a club with both hands and turns his face to the upper right to avoid any dialogue with the viewer, Wignacourt emanates a determined aura of military stoicism; there is no explicit religious reference. The page enters the scene from the right, holding the Grand Master's helmet and overcoat, and directly looks at the viewer. The two characters are portrayed against a plain wall, with a calibrated use of gesture that allows the artist to play with shadow and bring out the armour. Wignacourt is painted in a solid manner and the execution is notably elaborate, with brushstrokes that carefully modulate his face and armour. A naturalistic precision becomes clear in directly comparing the painting with the real armour, which is fortunately still conserved in the National Armoury in Valletta. This armour, perhaps made in Milan and datable to approximately 1565–1680, ironically wasn't Wignacourt's own personal, modern armour. Why the Grand Master chose to be portrayed in this isn't known; it is worth noting that it is also a size larger than the one he wore. It was, however, an important piece in the Order's Armoury, and others after him also had their portraits done in the same suit. The less-than-optimal conditions of the work inspired some controversy regarding its attribution, which Longhi was vigorously opposed to for several years. The authenticity of this work mustn't, however, be doubted. Baglione refers to the fact that "introduced to revere the Grand Master, he painted his portrait," while Bellori notes that "he portrayed him standing, in armour, and sitting disarmed in the clothing of Grand Master; the first portrait is in the Armoury of Malta." Here, however, Bellori (or his Maltese informer) is mistaken, and refers to the "official" painting of the Grand Master, which was not painted by Caravaggio. It is also improbable that Caravaggio painted, as Bellori claims, another portrait in which the Grand Master is portrayed without arms and seated, as a portrait with those features was done in an oval format by Francesco dell'Antella.

Regardless of the importance of this painting, it is debatable whether or not this is really "the official portrait" from which many copies for the various palaces of the Knights of Malta must have been made. Indeed, the "official" portrait is a different one, painted shortly after this one by Caravaggio, and portrays Wignacourt with his armour. It is possible that Caravaggio's work left Malta not long after it was painted; it is mentioned in Paris for the first time in 1644, in the palace of Duke de la Rocheguyon et de Liancourt, and was in the collection of Louis XIV in 1670.

K.S.

Bibliography: Guttuso, Ottino della Chiesa 1967, no. 84; Longhi 1968, p. 42; Kitson 1969, no. 83; Cinotti 1971, pp. 83, 136–137; Gregori 1974, pp. 594–602; Marini 1974, pp. 435–438, no. 74; Moir 1976, pp. 67, 101, nos. 40, 133, 220; Nicolson 1979, p. 33; Cinotti 1983, no. 43; Hibbard 1983, pp. 227–228, 326–327; Gregori 1985, no. 94; Marini 1989, pp. 525–527, no. 82; Gregori 1994, p. 153, no. 70; Pacelli 1994, pp. 69–74; Gregori 1998, p. 3; Langdon 1998, pp. 350–351; Puglisi 1998, no. 71; Marini 2001, no. 90; Spike 2001, no. 59; Sciberras, Stone in Naples-London 2004, pp. 64, 67–70; Sciberras, Stone (to be published 2006).

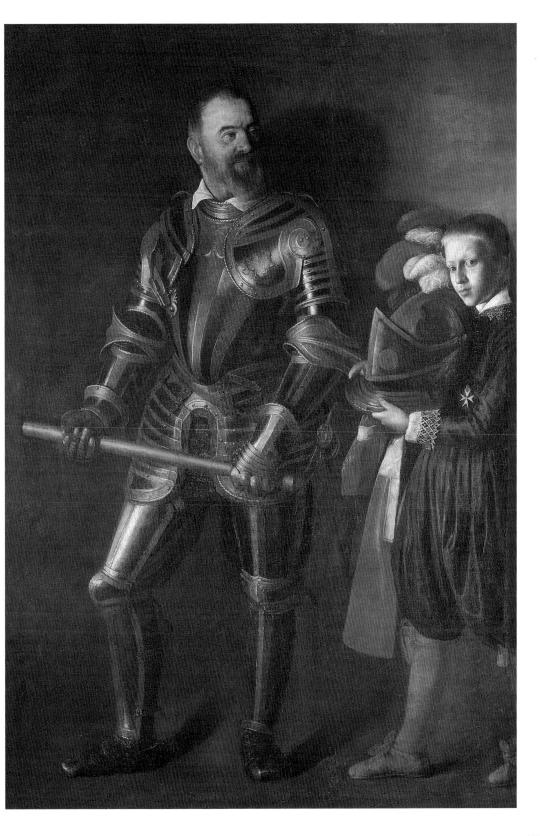

59
Beheading of Saint John the Baptist

Oil on canvas, 361 × 520 cm
Valletta (Malta), co-cathedral of San Giovanni Battista

Painted for the oratory of San Giovanni Decollato in Valletta, this solemn altarpiece is the masterpiece of Caravaggio's Maltese period. It perfectly reflects the artist's temperament in Malta, and he decides to sign it as 'F'[ra] 'Michela'[ngelo] (Sir Michelangelo) right in the centre of the composition, symbolically done in the blood that gushes from the severed neck of the Baptist. This painting is the manifestation of his rise to knighthood, on July 14, 1608. Completed (or at least signed) after that date, the work was probably also part of the artist's 'passage' into the Order of Saint John.

The oratory, connected to the convent and church of San Giovanni (now co-cathedral), had just been completed, and the need to decorate it with a titular painting arose just when the artist arrived in Malta. This was the perfect commission — to represent the martyrdom of the patron saint of the Knights of Malta. The large format was probably chosen by the artist himself; this extraordinary extension, more common for a mural, was a size that the artist had never before attempted. In many ways it extends the space of the oratory toward the East and sets the scene up on a theatrical stage in which architecture dominates the background. The vastness of space and audacious composition paved the way for the Sicilian altarpieces soon after.

The saint, partially covered by his intense red mantle, is laid out on the ground at the centre, with his throat sliced open. The executioner, with a brutal realism, changes sword for knife and holds the Baptist's head to complete the beheading; the act was swift, and the arm wasn't stained with blood. Caravaggio distributes his characters in a semi-circular composition set slightly to the left, and calculates with intensity their gestures. In addition to the saint and executioner, there are the prison guard and two women — one old, one young, bent over with a basin, ready to receive the saint's head. This composition, so very geometric, has an explicitly classical character, and its technical realisation sums up the artist's most extreme years. On this monumental scale, clearly carried out with no assistants, the artist worked with "pride," speed, and great self-assurance, making the most of the reddish-brown preparatory ground. In some passages, aside from simply creating transparency, Caravaggio laid the ground down directly as a pictorial film. This use of the ground, evident in some expressive indentations on the surface, becomes a characteristic of the works done after his stay in Malta.

It is possible that, dramatically, Caravaggio wasn't present at the opening party held for the work's unveiling, likely held on August 29, 1608, the feast day of the martyrdom of Saint John the Baptist. On August 27, in fact, he had been arrested for a tumult in Valletta in mid-August. After his escape he was stripped of the Knight's rank right in the oratory of San Giovanni Decollato, in front of the *Beheading* and his own signature in the Baptist's blood. The scent of oil and pigment probably still permeated the oratory air when the artist was exiled *in absentia*, "tanquam membrum putridum et foetidum."

K.S.

Bibliography: Bellori 1672; Von Sandrart 1675; Marangoni in Florence 1922, no. XLI; Mahon 1951, p. 234; Venturi 1951, no. 42; Longhi 1952, p. 43; Mahon 1952, p. 19; Hinks 1953, no. 59; Friedländer 1955, p. 211, no. 36; Scicluna 1955, pp. 138–139, 141; Carità 1957, pp. 41–68; Hess 1958, p. 146; Cauchi 1962, p. 169; Bottari 1966; Guttuso, Ottino della Chiesa 1967, no. 83; Moit 1967, I, pp. 12, 313; Kitson 1969, no. 82; Gregori 1974, pp. 598, 600; Marini 1974, p. 43, no. 75; Röttgen 1974, pp. 208–212; Moir 1976, p. 101, no. 39; Sammut 1978, pp. 21–27; Cinotti 1983, no. 23; Hibbard 1983, pp. 228–234; Gregori 1985, p. 44; Pacelli 1987, pp. 81–103; Marini 1989, pp. 527–528, no. 83; Gregori 1994, pp. 135, 153, no. 72; Macioce 1994, pp. 212–213; Pacelli 1994, pp. 76–78; Azzopardi 1996, pp. 204–205; Stone 1997, p. 165; Langdon 1998, pp. 356–363; Puglisi 1998, no. 72; *Caravaggio al Carmine…* 1999; Marini 2001, no. 91; Spike 2001, no. 63; Sciberras 2002, pp. 229–232; Sciberras, Stone in Naples-London 2004, pp. 64, 71–74; Sciberras, Stone (to be published 2006).

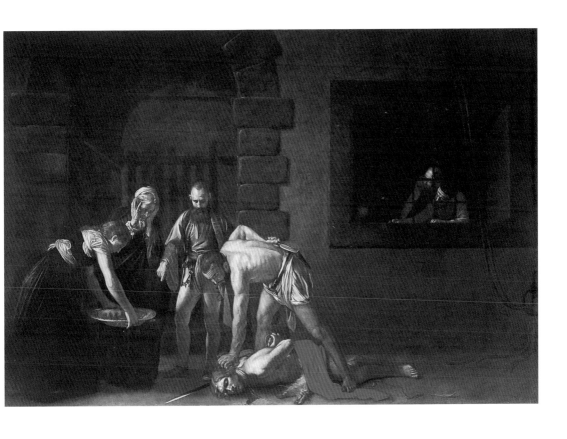

60
Saint Jerome Writing

Oil on canvas, 117 × 157 cm
Valletta (Malta), co-cathedral of San Giovanni Battista,
Museo di San Giovanni

Painted for brother Ippolito Malaspina, Marquis of Fosdinovo and prior of Naples for the Knights of Malta, this work is an eloquent expression of the high naturalism Caravaggio reached in his most extreme years. This *Saint Jerome* was painted in a period of tranquillity for the artist who, "taking refuge" in Malta, finally found a serene environment in which an attempt to elevate him to knight was carried out in hopes of giving him back the dignity compromised by the Tomassoni murder. In Malta he saw a true possibility of papal pardon, and Malaspina was a key person in this newfound tranquillity. In this work he doesn't choose to amaze Malaspina with a controversial creation, but instead strategically offers a composed, naturalistic, rigorously decorous representation.

Intense, humble, and dignified, Saint Jerome is portrayed in his cell, intent on writing in a small book. The numerous books and their precarious balance atop a tiny table in the Borghese *Saint Jerome* are absent here, and there is just one small volume, almost a mere post-it note, on which all the concentration of the old saint is focused. The saint dominates the composition, and is portrayed squarely in the centre, seated as if he had just risen from bed to continue writing. The cell is austere (the original depth of the background is no longer visible due to abrasion), with a simple table and the symbols associated with the saint — an extinguished candle, a bed, the cardinal's hat — as well as a vertical strip on the right, perhaps a door. An intense light comes from the left and imbues the work with a spiritual dimension. The chiaroscuro is quite strong and the light slides along the saint's right arm, drawing attention to his act of writing, accentuated by a decisive spotlight on the page he is writing on. The contrast between the red of his mantle and his flesh is energetic and very beautiful, as is their contrast with the reddish-brown surroundings.

The modulation is solid and 'complete,' just as in his great Neapolitan pictures; it is quite similar to the Madrid *Salome* which preceded this by a few months. After Malta, even in medium-sized paintings, Caravaggio applies himself with greater "pride" to his works, making the most of the preparatory ground almost as a sketch, as in the New York *Denial of Saint Peter*. It is significant, however, that in Malta he uses the same rapid techniques as he did for the monumental *Beheading*.

Malaspina, patron of this work, is identified by a coat of arms on the lower right (this is the only time, perhaps because of the patron's insistence, that Caravaggio uses a family crest in this manner). Marquis Malaspina returned to Malta aboard the same fleet Caravaggio boarded upon leaving Naples. From 1603 to 1605 Malaspina had lived in Rome as General of the Pontifical Jail. As he was related to Ottavio Costa, Caravaggio's patron in Rome, he certainly knew of the artist's fame before his arrival in Malta, and was probably one of his first protectors on the island.

Saint Jerome Writing was a private commission for Malaspina's house in Valletta, and was then brought to the chapel of the Italians in the church of San Giovanni in the same city as a gift in his will. Described in Bellori, it was brought to the attention of critics by Bonello and published for the first time in 1922 by Marangoni. In 1956 it was restored in Rome by the ICR (Istituto Centrale per il Restauro, or Central Restoration Institute), and was cut from its frame, rolled up, and stolen from the museum of the church of San Giovanni in 1985. Rediscovered in 1987, it was again restored by the ICR. Despite the grave incident, some abrasions, and a loss of some colour, the painting is now in good condition.
K.S.

Bibliography: Bellori 1672; Marangoni 1922, p. 41; Hess 1958; Cinotti 1983; Macioce 1987; Gash 1997; Marini 2001, no. 92; Spike 2001, no. 60; Sciberras, Stone in Naples-London 2004, no. 7; Sciberras, Stone 2005, pp. 3–17; Sciberras, Stone (to be published 2006).

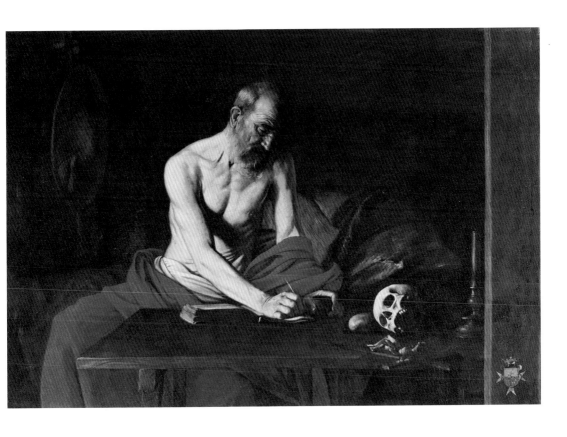

61

Sleeping Cupid

Oil on canvas, 72 × 105 cm
Florence, Palazzo Pitti, Galleria Palatina

Painted in Malta, this is the only mythological work attributed to Caravaggio's final period. A very trustworthy inscription on the reverse indicates the date of 1608, and contemporary documents identify it as a commission by the Florentine knight brother Francesco dell'Antella (1567–1624), one of the literati and a confidante of the Grand Master. Dell'Antella became a knight in 1587, was a powerful man, and as one of Wignacourt's beloved acted as his Italian-language Secretary, working to obtain a papal dispensation to grant Caravaggio the title of knight; the dispensation was arranged by Paul V in February 1608. This painting was perhaps a gift from Caravaggio as recognition. *Sleeping Cupid* expresses dell'Antella's marked aesthetic taste. The small work is a typical "palazzo painting," done for a connoisseur and intended for a private room. Cupid is portrayed as a nude child sleeping on the ground and occupies the entire length of the painting; the pose may derive from a 1538 engraving by Giovan Battista Scultori. The child emerges from the dark with a strong chiaroscuro that illuminates the few symbols of Cupid, painted as if in a still life: his wings, a quiver upon which he rests his head, an arrow, and a bow with its untied cord in his left hand. Strangely, the darts peek out of the quiver. The bow is significantly rendered inoffensive; it cannot launch the arrows that animate passion. The attributes, perhaps for reasons of modesty and decorum, are hidden in dark shadow. Sleeping Love is represented with a crude naturalism; the child certainly isn't beautiful — he appears ugly and swollen. In his final phase Caravaggio's idea of beauty undergoes a metamorphosis with respect to the Roman years. Painted on a solid, thick ground, the colours are sober — only tones of brown and ochre — with touches of red in the arrows and on his lips, and a few spots of light in lead white. The brushstrokes are decisive, long, and laden with oil. A few small *pentimenti* have been revealed; originally the right wing was more evident, and today only a dramatic line of light in the dark is visible. This was the second time Caravaggio worked with this theme; the first painting, where "Languidly he sleeps," painted in Rome and now lost, was the subject of a madrigal by Gaspare Murtola published in 1604. On the theme of love Caravaggio had also painted the celebrated *Amor Victorious* now in Berlin. The difference in concept and technique, between the 'morbid' *Sleeping Cupid* done in Malta and the immodest *Amor Victorious* painted in Rome, is vast. The contrast between the two is emblematic of two different periods. In 1609, after the artist's flight from Malta, this painting was already in Florence. Object of lauds and sonnets, dell'Antella considered it "a delight." Whose idea is behind the painting is debatable; maybe dell'Antella wanted "a delight" with complex meaning upon which to base poetic compositions; perhaps the intent was to represent sleeping, blind (and inoffensive) Love as a symbol for the vow of chastity the knights were sworn to, or an example of spiritual tranquillity after overcoming all passions. This painting isn't cited by the biographers; only Baldinucci mentions it in the context of a fresco in Florence's piazza Santa Croce. From dell'Antella's family it went to cardinal Leopoldo de' Medici's collection before March 1667, then to the Grand Duke's collection (1675), and there are many copies and derivations made from it. *K.S.*

Bibliography: Meloni Trkulja 1977, pp. 46–50; Mosco 1982, p. 77; Cinotti 1983, pp. 433–434; Pizzorusso 1983, pp. 50–59; Marini 1987, pp. 530–532; Pacelli 1994, pp. 78–80; Gregori in Florence 1996, pp. 20–21, 40–41; Stone 1997, pp. 165–177; Puglisi 1998, pp. 294–297; Sebregondi in Venice 2000, p. 163; Marini 2001, no. 93; Spike 2001, no. 64; Chiarini 2003, p. 110; Macioce 2003, pp. 253–254; Sciberras, Stone in Naples-London 2004, no. 8; Sebregondi in Naples-London 2004, pp. 116–118; Sciberras, Stone (to be published 2006).

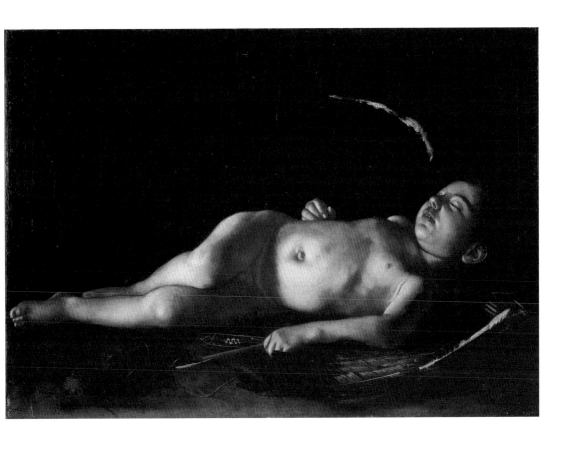

Portrait of a Knight of Malta

Oil on canvas, 72 × 105 cm
Florence, Palazzo Pitti, Galleria Palatina

With rosary in one hand, sword in the other, and the eight-pointed cross, this portrait admirably captures the spirit of the religious and military men in the Order of Saint John. Painted in Malta, this is the second portrait done during Caravaggio's stay, which lasted just under fifteen months. Significantly the only two portraits unanimously attributed to the artist's final period (this and the *Portrait of Grand Master Wignacourt*) were painted in Malta. The technical differences are nevertheless noteworthy: the *Portrait of Wignacourt* has the air of a "palazzo painting" about it, and is solidly concluded, while the *Portrait of a Knight* is more intimate and fluid, almost a portrait meant for a house, rather than a palazzo. Austere and without adulation, the latter is fruit of a direct naturalism.

Old, with a long face, short hair, and brown goateed beard — with no signs of grey from age — the knight turns his head to the right with a slight inclination downward, avoiding looking at the viewer. Positioned at the centre and portrayed at almost three-quarter length, he wears the black suit with large white cross, in dramatic contrast with the dark tones of his suit and the empty background. Since the centrality of the cross was a prerogative of the Knights Grand Cross the knight portrayed here is one of the more prominent members of the Maltese Order.

Not cited by any of the biographers, this painting was only identified and attributed to Caravaggio in 1966. Following the first proposal of attribution to Caravaggio by Gregori, the painting met with controversy regarding both the attribution and the identity of the subject. The initial identification of the sitter as Wignacourt is, however, dismissible. A note in the inventory of Palazzo Pitti from the late seventeenth century (1666–1670) instead indicates the more probably identity of the man as brother Antonio Martelli (Chiarini 1989; Gash 1997).

An illustrious, distinct man, the Florentine Martelli was born in 1534 and joined the Order of Saint John in 1558. A courageous knight, he distinguished himself with honours in numerous battles, military assaults and campaigns of the Order, along with the Venetians, and in the service of the grand Duke of Tuscany. He was promoted to Knight Grand Cross and occupied important priory positions, including Admiral (*Piliere*) of the Italian Language. When Caravaggio arrived in Malta, Martelli was 'in convent' on the island as the prior of Messina. Because of the respect he enjoyed he was very close to the Grand Master, and was active in diplomacy with the Grand Duke of Tuscany.

Here the knight is portrayed as a distinct man who, despite his age, grips his sword with great firmness, in a gesture that inspires authority and makes an explicit reference to his military career. Caravaggio catches his personality at a moment of rest, and his expression is severe yet benevolent. This painting was executed in a very fluid, fast manner, with a slightly 'unfinished' air in some portions. The artist plays with very beautiful spots of light and uses the ground as a finished colour, especially in the eight-pointed cross worn with honour and dignity. The painting is also severe in its colour, but, as in the *Sleeping Cupid*, the palette is restricted to brown and ochre tones, with a powerful use of black and white. The knight wears a long-sleeved white shirt under his monastic robe, which suggests the painting wasn't done in the heat of summer. A date between the end of 1607 and the early months of 1608 is, therefore, the most plausible.

K.S.

Bibliography: Fogolari 1927, p. 118; Borea in Florence 1970; Gregori 1974; Cinotti 1983; Gregori in Naples-New York 1985, no. 95; Chiarini 1989; Gregori in Florence-Rome 1991, no. 20, pp. 318–324; Gregori, Bonsanti in Florence 1996, p. 36; Gash 1997; Papi in Venice 2000, no. 49, pp. 197–199; Marini 2001, no. 95; Spike 2001, no. 62; Chiarini in *La Galleria Palatina* 2003, no. 156, pp. 110–111; Sciberras, Stone in Naples-London 2004, no. 9; Sciberras, Stone (to be published 2006).

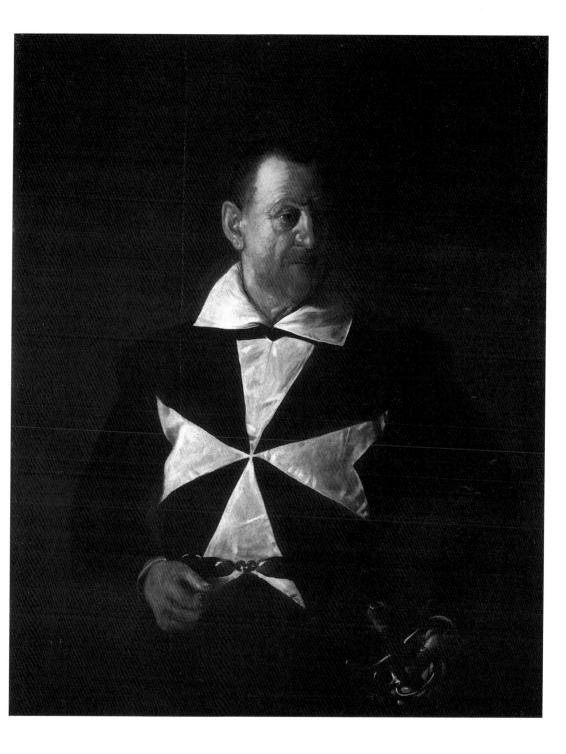

63

Annunciation

Oil on canvas, 285 × 205 cm
Nancy, Musée des Beaux-Arts

Caravaggio likely painted the *Annunciation* in Malta in 1608; it was painted for the principal altar of the primatial church of Nancy and given as a gift by Henri II, Duke of Lorraine. Regardless of its stylistic affinity to the works done in the Maltese-Sicilian period, there are precise circumstances that support the fact that it was executed in Malta. This work is undocumented, but is certainly connected to the Lorraine family, and probably also to their contact with the Knights of Malta. Charles of Lorraine, count of Brie, was in Malta in 1608, when his father Henri II assumed the title of Duke of Lorraine after the death of Charles II. As his biological son, de Brie was officially recognised in 1605, just before the marriage of Henri II to Margherita Gonzaga. Given that he had the insignia of the Lorraine family's political power, de Brie was immediately sent to the Order of Malta. In July 1608 Prince François of Lorraine, brother of Henri, was also on the island for a brief period, creating an opportunity for the Lorraine family to receive Caravaggio's *Annunciation* altarpiece. De Brie had great interest to act as a middleman for his father, considering that the primatial church was opened to the religious group in 1609.

Here Caravaggio expresses a humble, powerful, but also quiet, peaceful spirituality. There is real humility in the Virgin's gesture and the simplicity of the scene. There is also strength in the high figure of the angel atop a cloud; its spiritual strength also grows by virtue of the fact that his face remains unseen. The lily is an important symbol that the angel holds in his left hand and in shadow, almost so as not to distract attention from the emphatic gesture of his right hand. The Virgin doesn't look upward, but lowers her head and kneels to the right, silent and collected. The angel is dramatic, illuminated by a light from above — divine light. His arm captures the viewer's attention and the light slides down his shoulder, toward his hand, to then rest upon the Virgin. The contrast between the angel's white and ochre swaths of cloth-

ing and his shadowy wings is noteworthy, as is the compactness of the Virgin's form, enveloped in a blue mantle and ochre veil. The painting is constructed like a geometric exercise, with spaces and figures positioned along a diagonal line.

The work is in a poor state of conservation, with many abrasions and gaps, especially in the background, which has lost much of its original depth. There are precise technical aspects that are also in the other Maltese works, especially the *Beheading*, in the use of the preparatory ground. The Virgin's profile is similar to that of the girl who leans forward to receive the Baptist's head in the *Beheading*, and it is more likely a creation of the artist rather than a posed girl painted from life. The solidity of the angel's arm, on the other hand, recalls *Saint Jerome Writing*.

In 1742 the *Annunciation* (although ignored) was installed in the new cathedral built on the area where the primatial church had been, and was later moved to the museum in the des Visitandines convent. In 1814 it was moved to the museum in the Pavillion de la Comedie, and in 1829 it was permanently moved to the Musée des Beaux-Arts of Nancy. In 1948 Pariset rediscovered the work, brought it to the critics' attention, and reattributed it to Caravaggio, but it was Longhi who in 1959 definitively reinforced this attribution.

K.S.

Bibliography: Pariset 1948, pp. 108–111; Longhi 1959, p. 29; Guttuso, Ottino della Chiesa 1967, no. 95; Fagiolo dell'Arco 1968, p. 59, no. 40; Longhi 1968; Marini 1974, pp. 53, 270–271, 451–453; Nicolson 1979, p. 32; Gregori 1982, pp. 37, 40, 132; Cinotti 1983, no. 34; Hibbard 1983, p. 338, no. 190; Campagna Cicala in Syracuse 1984, p. 103; Brejon de Lavergnée, Volle 1988, pp. 72–73; Marini 1989, pp. 544–546, no. 93; Calvesi 1990, pp. 375, 378; Bologna 1992, p. 345; Gregori 1994, p. 155, no. 82; Macioce 1994, pp. 209–210, 220, no. 22; Pacelli 1994, pp. 80–83; Marini 2001, no. 101; Spike 2001, no. 71; Brejon de Lavergnée in Naples-London 2004, no. 15; Sciberras 2005, pp. 38–39; Sciberras, Stone (to be published 2006).

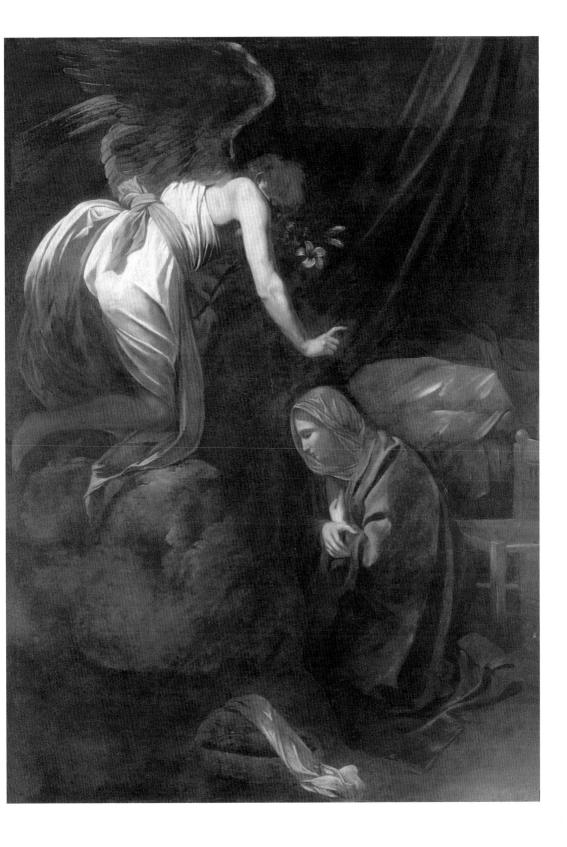

Burial of Saint Lucy

Oil on canvas, 408 × 300 cm
Syracuse, church of Santa Lucia al Sepolcro,
on long-term loan to the Galleria Regionale, Palazzo Bellomo

The information that has been handed down to us about this canvas to date is all from the historiographic testimonies of Bellori, Baldinucci, and Susinno, as there are no references to the work in other documents. It was the first work Caravaggio painted in Sicily, and was completed during his brief stay in Syracuse from October 6, 1608, just after he fled Malta, and the early months of 1609. The commission for the Crociferi altarpiece in Messina dates back to December 6, 1608, but the artist's name doesn't appear in the document. The *Raising of Lazarus*, recorded this time as the work of "brother Michelangelo Caravagio militis Gerosolimitanus," was completed and delivered only on the 16 June 1609, a date that provides the earliest limit for the period in which the Messina piece, and consequentially also the Syracuse work, was painted.

While Bellori offers us a precise yet succinct description of the Roman works, Susinno describes the [Sicilian] works in great detail and also documents their success. Susinno also informs us that in Syracuse Caravaggio was introduced by Mario Minniti — who he definitely frequented in Rome and perhaps also in Malta — and that Minniti also proposed him to the Senate as the artist for the altarpiece. Even if recent historiography doubts the real possibilities Minniti might have had to offer Merisi protection and help, it is necessary to emphasise how quickly the artist assumed a dominant role among Sicilian painters, as well as how, wherever he found himself, he managed to obtain the help and protection of more than one person at the same time.

This work's authenticity is indubitable, even if the modest quality of some sections — due mostly to Giuseppe Politi's nineteenth-century repainting — caused some suspicion that other hands were involved in its completion (a doubt which lasted up until just before the most recent restoration). Regarding the subject, Barbera recently observed, "the theme of burial, which is quite rare in the iconography of this saint from Syracuse, is perhaps tied to the location in which the large altarpiece was set. According to traditional local historiography, the church of Santa Lucia al Sepolcro, also called Santa Lucia *extra moenia*, in the eastern section of the city (ancient Acravina) would have originally been built atop the catacombs, which were said to be the site of the saint's martyrdom and sepulchre." The setting of this episode is certainly very "local," as it takes place in the stone quarries of Syracuse; the high wall against which the action takes place strongly resembles the Grotta dei Cordari. On the other hand, we know that Caravaggio visited the quarries in the erudite company of Vincenzo Mirabella, who by 1608 was already at work on one of his most noted works, *Dichiarazioni della pianta delle Antiche Siracuse* (1613), for which he made many elevations and did extensive research. It was Mirabella who credited Caravaggio with the invention of the toponym "Orecchio di Dionisio" ("Ear of Dionysus") for the most famous grotto, also called "Prigione di Dionigi" ("Dionysus's Prison") and "Grotta della Favella" ("Grotto of Words"), whose form allowed the tyrant to listen to every word of the prisoners held there. Erudite Mirabella must have admired the painter, "moved by that unique genius of his for imitating the things of nature." Within Caravaggio's mind, however, the suggestiveness of those places, evoked (even in a synthesis of differing elements) in the vast, naked wall that bears down on the characters, almost compressing them, a most original invention that was immediately brought out by Longhi. The work's success is documented by the many copies made from it — in San Giuseppe in Syracuse, in a private collection in Malta, in Sant'Antonio Abate in Palestrina, and in private collections in Rome and Scicli. An 1835 etching in *Siracusa per i viaggiatori* by Giuseppe Politi, is also dedicated to this canvas.

V.S.

Bibliography: Marini 2001, *passim*; Barbera in Naples 2004, pp. 122–124.

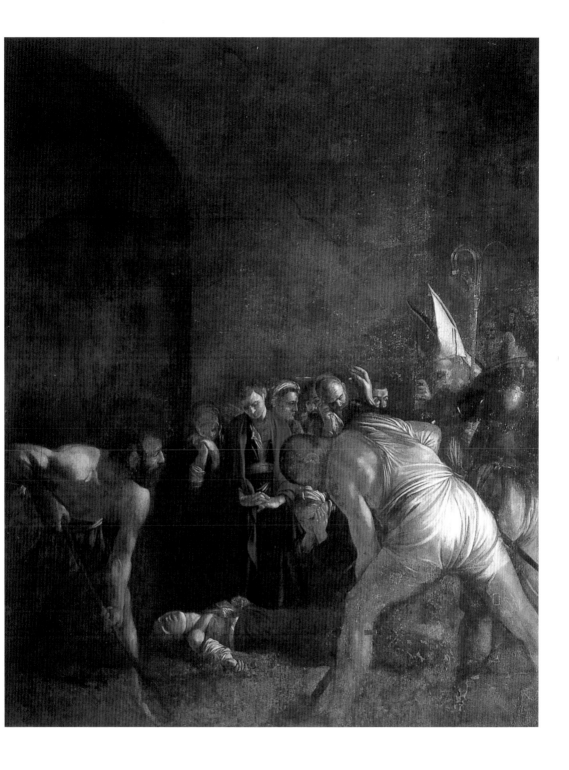

175

Raising of Lazarus

Oil on canvas, 380 × 275 cm
Messina, Museo Regionale
(formerly in the church of the Padri Crociferi)

This painting is announced in a contract dated December 6, 1608 regarding merchant Giovanni Battista de' Lazzari's intention to build the main chapel of the church of the Padri Crociferi and decorate it with a painting, all with his own funds. The canvas was to represent the Madonna, Saint John the Baptist, and other saints. The receipt of delivery dated June 10, 1609, however, refers to it as a *Raising of Lazarus* by the hand of "brother Michelangelo Caravagio militis Gerosolimitanus." The first citation of the work dates back to 1613, in a work of monsignor D. Silvestro Maurolico of Messina. Samperi (pre-1654) follows, and in 1672 Bellori describes the work in great detail. In 1724 Susinno faithfully repeats Bellori and the other documents, correctly omitting details about a man plugging his nose because of the stench, which was added by Bellori and never existed in the painting.

Commissioned by the Lazzari family, which was originally Milanese but Genoese by adoption, the canvas remained on the altar until 1866, and by 1670 had already been subjected to a rather mysterious — and equally disastrous — cleaning. Following the suppression of religious factions, it appeared in Messina at the Museo Civico in 1879, and from there, shortly after the 1908 earthquake, it was placed in the current collection. The motives that inspired the Lazzari family to opt for the rather unusual iconography of the work are unclear. As Susinno confirms, the possibility that Caravaggio could have suggested the theme of resurrection cannot be ruled out, and it's certainly more interesting than the more traditional Madonna with saints. The rediscovery of documents attesting to the 1608 death of Tommaso de' Lazzari, Giovan Battista's brother, however, would make the choice of subject appear to be a decision made within the family, whose name also alludes to Lazarus. Pupillo's assertions must also be added to these considerations: the clear reference to the activities of the Padri Crociferi, who were also known as ministers to the sick, must have made the change a particularly welcome one to the religious fathers themselves. Certainly by this time Caravaggio's reputation must have preceded him by a long shot. It is also worth noting that in Messina Antonio Martelli — knight of the Order of Saint John within the Knights of Malta — was acting prior; Caravaggio had met and frequented him in Malta, and painted the portrait of him that is now at Palazzo Pitti. Brother Orazio Torriglia received Martelli in Messina and, Genoese just like the Lazzari, had a solid friendship with them. As Sciberras and Stone (Naples 2004) note, Torriglia "was actively involved in procuring the armour given to Grand Master Wignacourt in Malta in 1602."

The execution of this canvas, therefore, very closely followed the *Burial of Saint Lucy*. In a flash of memory, Caravaggio projects the vision of Christ as he points to the subject of his miracle in the same paired-down scene as the Syracuse altarpiece, with an indistinct, rocky background. After Röttgen's indication of a possible reflection of the engraving by Diana Ghisi of the fresco with the *Battle Around the Cadaver of Patroclus* by Giulio Romano, Hibbard links this composition to the earlier canvases portraying *The Calling of Saint Matthew* and the *Burial of Saint Lucy*. There is a clear repetition of Christ's gesture in *The Calling of Saint Matthew*, as he points to the young Lazarus to bring him back to life, and the irreparable pain of the people gathered round, who hold Lazarus and seem not to realise the miraculous presence in their midst. Between the two groups some heads are visible as though called by the light coming from behind them. The absolutely physical light coincides with a supernatural light, the same light that flows from the front of the group to the body of Lazarus brought back to life. The painting aims to fix the decisive moment of the current of energy transmitted from Christ's hand to that of Lazarus.
V.S.

Bibliography: Marini 2001, *passim*; Pupillo in Palermo 2001, pp. 109–111; Sciberras, Stone in Naples 2004, pp. 61–79.

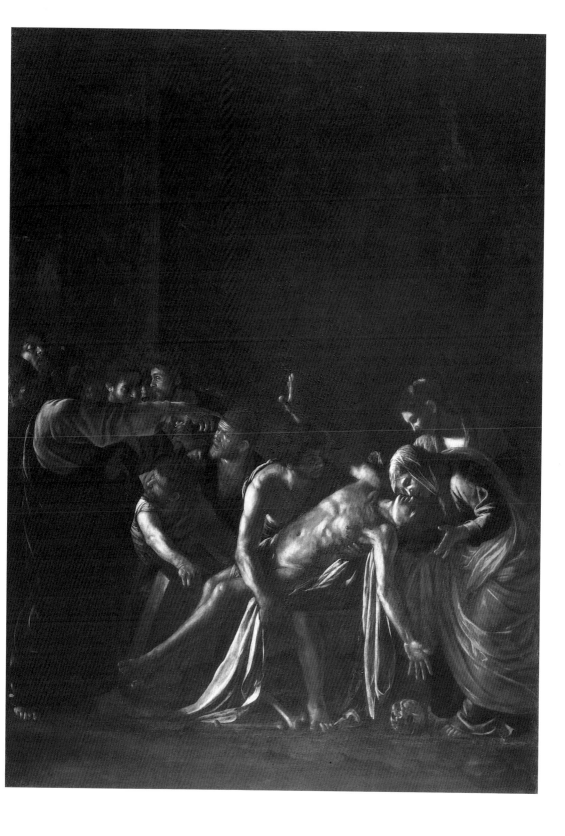

Oil on canvas, 314 × 211 cm
Messina, Museo Regionale

The *Adoration of the Shepherds* was painted for the main altar of the church of Santa Maria la Concezione in the Verza *contrada*, destroyed in the 1908 earthquake. The *Burial of Saint Lucy, Raising of Lazarus*, and *Nativity* in the oratory of San Lorenzo in Palermo — all the Sicilian works produced for public places — were intended to hang above the main altar (see Spezzaferro's catalogue essay). First cited by Samperi (1644), this canvas enjoyed the privilege of being reproduced in an engraving, albeit a rather rough one, by Placido Donia. Bellori (1672) underlines the "hut of planks and architraves, which is broken and in poor shape," without passing judgement on its merits. Only in 1724 did Susinno offer a detailed description, referring to its commission by the Senate of Messina. The unrecoverable documents, in an irreparable state even before the earthquake, preclude verification of this point. Nevertheless, the Senate of Messina was the most active patron of the city, and its involvement in such a major commission wouldn't be surprising. Abbate (1984) in light of the markedly pauperised iconography, proposes Girolamo Errante as a possible mediator; Errante had been a general of the Order and lived in Messina between 1605 and 1611. Spadaro (1987) points out that in those same years, from 1605 to 1609, Bonaventura Secusio became the city bishop, and is therefore another possible intermediary. The theme of evangelical humility and poverty — in the iconography with the Virgin reclining on the ground, yet posed in a classical position that recalls an ancient sarcophagus or a Byzantine mosaic — would indicate a "poor" patronage. It is in this spirit that the space within the hut can be understood, with the heat of the animals, and the pastors who kneel above the divine group, taking light from it in an unprecedented compositional essentiality. This work enjoyed very high praise, beginning with Susinno who, comparing it with the *Raising of Lazarus*, judged it "the sole, most masterful of all Caravaggio's works, because in these [natural figures] this great naturalist escaped from that stain-like, cunning colouring,

and yet showed things naturally again, without that fierceness of shadow." While the two altarpieces display pictorial and compositional differences, it is difficult to see the "redemption" announced by Susinno. While he established a faint pretext within which Merisi's change is linked to the improbable influence of Antonio Catalano the Elder's work (Catalano was a painter from Messina still tied to mannerist modules and close to Barocci's style), one can also justly believe that the state of the *Raising*, which in 1670 was subjected to a ruinous cleaning, was already quite altered. A testimony of the "essential" similarities of the two works is provided in Longhi's unsurpassed description (1952): "For the Capuchins of Messina he managed to finish the extremely humble 'Crèche with the [Three] Shepherds;' and again here he attempted, more humanely, a new branching-out relationship between figures and space. The Madonna with the tiny baby under the shepherds' apprehensive stare, almost poured in bronze, appears lost on that little bit of pungent straw, in the closed space with animals immobile as objects, of planks and stubbly grass that only a diffuse light on the horizon seems to interrupt, in order to meet with the rumbling of the invisible sea; while a sort of 'still life of the poor' slides towards us in the foreground — napkin, breadbasket, and carpenter's plane in three tones of white, brown, and black — condensing down to a desperate essence." Although some continue to claim this work was completed before the Crociferi altarpiece, it is preferable to think of a more opportune date, just after the *Raising of Lazarus*, in the second half of 1609. After remaining *in situ* until the suppression of religious orders, it was moved to the Museo Civico of Messina in 1887, and from there to its current location.

V.S.

Bibliography: Spadaro in Syracuse, 1987, pp. 289–292; Marini 2001, *passim*; Abbate in Palermo 2004, pp. 43–76.

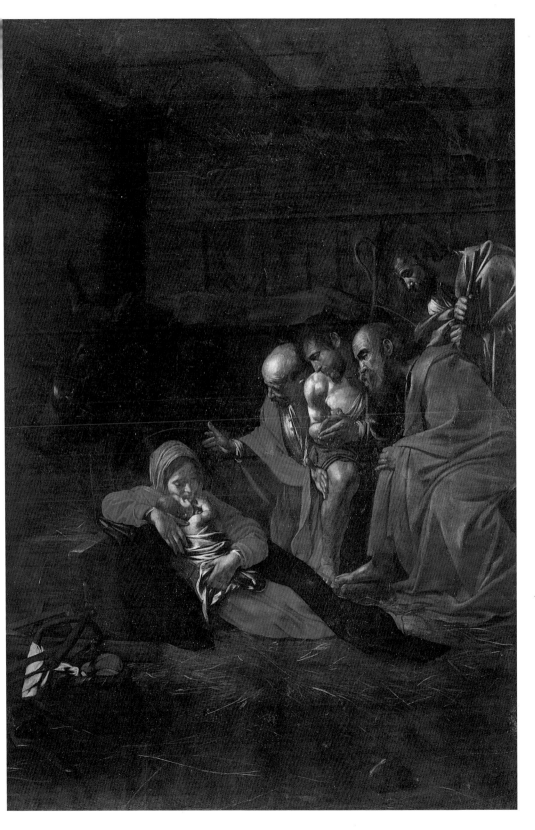

179

Nativity with Saint Lawrence and Saint Francis

Oil on canvas, 268 × 197 cm
Present location unknown, formerly in Palermo,
oratory of the Compagnia di San Lorenzo

This painting was almost certainly complet-
ed in Palermo between August and October
1609 for the Compagnia di San Francesco
d'Assisi, which was located within the orato-
ry of San Lorenzo (Marini 1987) during Car-
avaggio's forced stay in Sicily. Universally
recognised as authentic by the critics, the work
— after a generic mention in Baglioni (1642)
about Caravaggio's activity in Palermo — is
exclusively described by Bellori (1672, re-
published in 1976).
According to Cinotti the iconography is less
unusual than that of the Messina *Adoration of
the Shepherds*: appearing among the witness-
es are a shepherd, in which Marini (1974) sees
a representation of brother Leo; Saint
Lawrence and Saint Francis of Assisi, whose
presence is "conditioned by the Franciscan-
Laurentian setting in which the work is
meant to be displayed."
Cinotti also suggests that in order to under-
stand the work it isn't essential to discover
whether the "more triumphant" tone of the
Palermo *Nativity* was dictated by the patrons
or not, since "it's unclear why the Franciscans
of Palermo would have been any more con-
servative and rigorous than the Senate and Ca-
puchins of Messina."
On the other hand, Caravaggio always re-
sponded to precise requests in his public al-
tarpieces, but this fact never prevents him
from realising his own ideas. Cinotti sees noth-
ing conventional, but a lot of Caravaggio, in
the innovation of this *Nativity* in which
"colour regains its height" (Longhi 1952; Jul-
lian 1961; Marini 1974) and the characters
once again occupy all the available space (Jul-
lian 1961) in the favoured choice of "fore-
grounds," where "the centred vortex structure
is renewed in a calm, elliptical flow," while the
light "shines with vivacity." Brandi
(1972–1973) also finds this painting com-
pletely congruous with the one in Messina. Re-
garding the work's commission, Calvesi
(1990) underlines how this work fits into the
realm of the "typical institutions of the pau-
perised sphere of Catholic reform."

On these same lines Abbate (1999) underlines
how the Palermo *Nativity* closely adheres to
the basic text of the most particular Minorite-
Capuchin Rule. As already pointed out by
Friedländer, the two Sicilian Nativity scenes
(a theme that is consistently dear to Francis-
can ideology) have the same iconography of
the "Vergine del parto" (birthing Virgin)
Madonna, which is evidently connected to
more ancient portrayals. Abbate (1999) also
underlines the hypothesis of a "Genoese link"
regarding the commission given to Caravag-
gio in Palermo — a point also made by Calvesi
(1990) and emphasised by Malignaggi (1987).
Given such a hypothesis, don Gaspare Orieles
and Orazio Giancardo's close ties with the
Genoese colony would also seem sympto-
matic; in 1627 they asked the painter Paolo
Geraci to make a copy of the Palermo *Nativity*
(Meli 1929; Moir 1976). The well-preserved
canvas underwent restoration in 1951, was
stolen in 1969, and hasn't been found since.
G.D.

Bibliography: Bellori 1672 in Borea 1976, p. 228, no.
2; Baldinucci 1702, p. 687; Amico 1757 in Di Mar-
zo 1856, p. 276; Lanza 1859, p. 17; Saccà 1906, p.
45; 1907, p. 46; Witting 1916, p. 45; Rouches 1920,
pp. 110–112; Dell'Acqua, Cinotti 1971, pp. 52,
85–86; Mariani 1971, p. 138; "Commando Gen-
erale" 1972, p. 79; Brandi 1972–1973, p. 108; Cinot-
ti 1973, pp. 106, 190; Mariani 1973, p. 133; Rossi
1973, p. 107, no. 68; Carandente 1974, p. 258, tab.
314; Marini 1974, pp. 55–58; Cinotti 1975, p. 230;
Moir 1976, p. 103, no. 460; Bardon 1978, pp.
189–190, tab. LIII; Marini 1980, p. 72, no. 82; Mari-
ni 1981, p. 424; Cinotti 1983, pp. 284, 481–482, fig.
628; Campagna Cicala 1984, p. 101; Ciolino
Maugeri 1984, p. 162; *la Repubblica* 18 January 1984,
p. 16; Malignaggi 1987, p. 287; Spadaro 1987, p. 292;
Calvesi 1990, pp. 132, 331–332, 374, 387–388; Ab-
bate 1999, pp. 32–39; Marini 2001, *passim*.

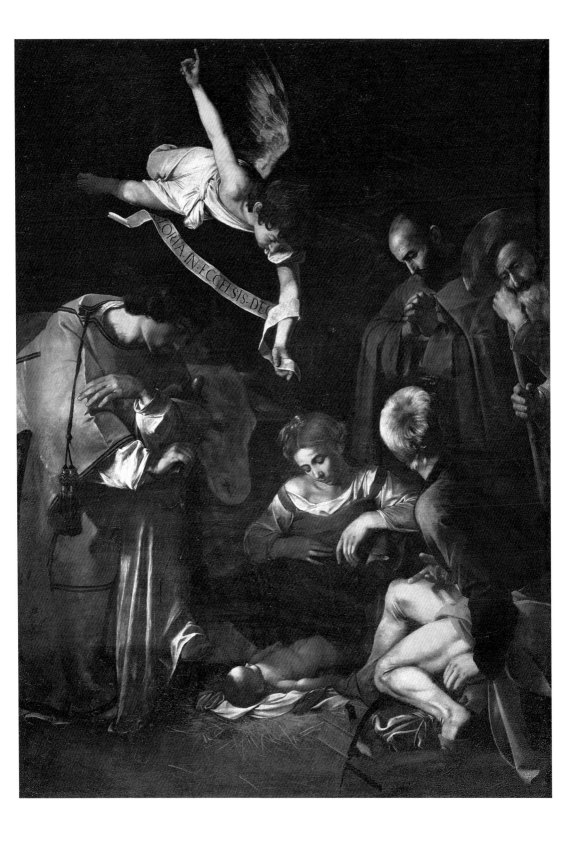

68
Salome with the Head of Saint John the Baptist

Oil on canvas, 91.5 × 107 cm
London, National Gallery

This painting isn't explicitly recorded in any of the old sources that have been found to date. Marini (2001) proposes the suggestive hypothesis of recognising the work as "un quadro de la degollación de San Juan con la mujer que recive la caveza del Santo el Bergudo y una vieja al lado de seis palmos con marco negro" ("a painting of the beheading of Saint John with the woman who receives the Saint's head, the executioner, and an old woman, [measuring] six palms, with a black frame") recorded in the 1657 inventory of García Avellaneda y Haro, second count of Castrillo, Viceroy of Naples from 1653 to 1659. This document was made famous by Milicua (Madrid, Bilbao 1999), and because of a coincidence in conservation was related to the Madrid *Salome with the Head of Saint John the Baptist*, registered in the royal inventories since 1666. Marini's observation, however, seems most opportune, as it reveals how in the Spanish canvas the Baptist's head is already set on the platter, while in the English version Salome is seen while receiving the severed head. Carr (Naples 2004) hypothesises that the Spanish canvas can be recognised in the painting described, although without any attribution, in the 1636 inventory of the Alcázar in Madrid. In this case the connection between the Spanish *Salome* and the Avellaneda y Haro inventory becomes even more improbable.

The only description of a painting with this same subject that has been passed down to us is provided by Bellori: "In Naples [...] seeking to placate the Grand Master, he sent as a gift a half-length figure of Herodiade with the head of Saint John on a platter." The gift was certainly suited to Wignacourt, Grand Master of the Order of Saint John, for whom Caravaggio had already composed the spectacular *Beheading*. And even though no documentary or iconographic sources able to attest to this work's presence in Malta have yet been found there, a large part of the historiography is inclined to give credit to Bellori's account, tying it to the English version. Marini is an exception; stating how in the Spanish canvas Salome dominates the composition both chromatically and physically, as she is set at the centre of the painting, he prefers to recognise that version in the "literary" recollection of the Roman biographer. The date of this work's completion is still far from certain. Longhi, who made the work famous in 1959 and immediately referred to it as a Caravaggio, dates it to his second Neapolitan period. For Marini and Cinotti it dates back to the first Neapolitan period. According to Campagna Cicala it is a Sicilian-period work, and she points out its iconographic debts to the work of Minniti and Paladini. Gregori and Mahon agree with its dating to the second Neapolitan period. As a dramatic variation on the Madrid *Salome*, the London canvas is characterised by the irreverence of the executioner's brutal figure, as he dramatically exits the shadow with an energetic expressionism. This is quite probably one of Caravaggio's last works, not far from the *Denial of Peter* in its essentiality, with a clearly renewed principle of psychological realism. Salome seems distracted, disquieted — as if she'd like to be somewhere else — with the shadow of a thought and the torment of a self-inflicted guilt. Even the executioner, brutal as a boxing-ring champion, seems pierced by doubt and uncertain in his ineluctable gesture; even more so the servant, who already displays a penitent behaviour. While Caravaggio's life is coming to a close one notices the signs of what could have been his future artistic development.

This painting appeared in a sale at the Hôtel Drouot, and was purchased in 1970 by the National Gallery in London following the indications of Sir Denis Mahon. Levey, Kitson, and Moir raised reservations regarding its attribution.

V.S.

Bibliography: Milicua in Madrid, Bilbao 1999, pp. 138–141; Marini 2001, *passim*; Carr in Naples 2004, pp. 132–133.

182

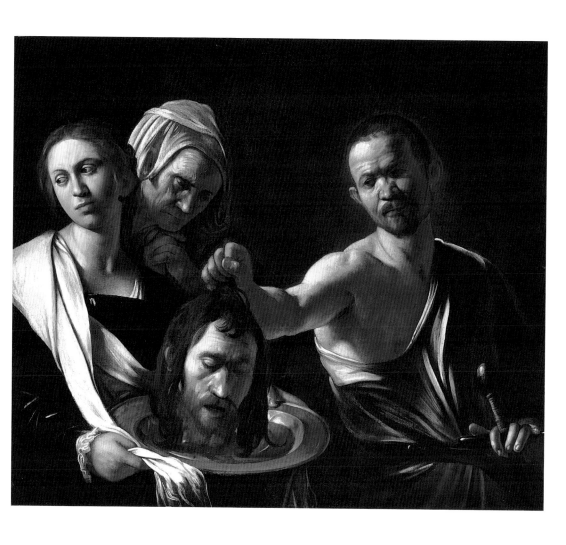

Denial of Saint Peter

Oil on canvas, 94 × 125.5 cm
New York, The Metropolitan Museum of Art

This work isn't precisely documented in the sources, with the exception of a 1650 mention in the Savelli inventories, and is from Caravaggio's last period in Naples. Very similar to the *Martyrdom of Saint Ursula* in its technical realisation and the intensity of the gestures, it probably dates back to the artist's last weeks of life. Here Caravaggio expresses all his intensity and ability in the brushstrokes, used sparingly to place lights and shadows dramatically charged with energy. This quickened freedom in execution, which self-assuredly makes the most of the reddish-brown preparatory ground, became a characteristic of his last works. The *Denial of Saint Peter* is a painting of great immediacy and composition, in which the narrative is told through a remarkable rhetoric of gestures. The dialogue, or better yet confrontation, between the three characters portrayed in half-length is very beautiful and intense; the intention to create a relationship between this rhetoric and naturalism is quite clear. Face to face, on either side of the composition, the soldier confronts Peter with an explicitly accusatory gesture; the saint has been pointed out to the soldier by a servant woman, who Caravaggio places in the centre of the composition, but set slightly behind. The three protagonists are extremely close to one another, and Caravaggio narrates the story with the gestures of their hands and their facial expressions. The hands point to Peter, while the saint's hands are turned toward his own chest, almost making the composition flow from left to right. Caravaggio balances this movement with the counterpoint of the servant's turned head, struck by a dramatic ray of light on her forehead and veil. In the darkness of hands and faces (the soldier's face and hands are in shadow) there is a crescendo toward the light in Peter's direction. In the background, using the preparatory ground, Caravaggio introduces a fireplace with a hastily painted flame.

Light plays a very important role here. The soldier, in shadow, is almost a silhouette against the strong chiaroscuro that models the maidservant's head. Peter, conscious of his denial, is saddened, and illuminated by a warm, intense light. His mouth is open and clearly intent on denying the accusations. His hands and head are lit by the same light, which might symbolically represent an illumination leading up to penitence. In a compositional reading, Caravaggio introduces a strong spot of long, vertical light on the extreme left-hand side, which makes the soldier's armour scintillate in a way quite like the light in the *Martyrdom of Saint Ursula*. As has happened elsewhere in Caravaggio's œuvre, the soldier is wearing a contemporary helmet.

The *Denial of Saint Peter* was purchased by the Metropolitan Museum of Art in 1997. Through the mid-twentieth century it had been in the collection of princess Elena Imparato Caracciolo, but it is also possible to try and connect it to "a maidservant with a denying St Peter, and another figure across from him" documented as early as 1624 in the palazzo of cardinal Paolo Savelli in Ariccia. The history of the work after 1650, however, is unclear.

K.S.

Bibliography: Roseberg 1970, p. 104; Marini 1974, pp. 428–429; Gregori in Whitfield, Martineau 1982, pp. 40, 130; Cinotti 1983, no. 67, pp. 548–549; Gregori in New York-Naples 1985, p. 350; Christiansen 1986, pp. 430–431, 445; Marini 1987, pp. 61, 508–509; Pacelli 1994, pp. 99–100; Bona Castellotti 1998 (published 2001), p. 135; Puglisi 1998; Testa 1998, pp. 348–349; Marini 2001, no. 82; Spike 2001, no. 57; Christiansen in Naples-London 2004, pp. 140–142.

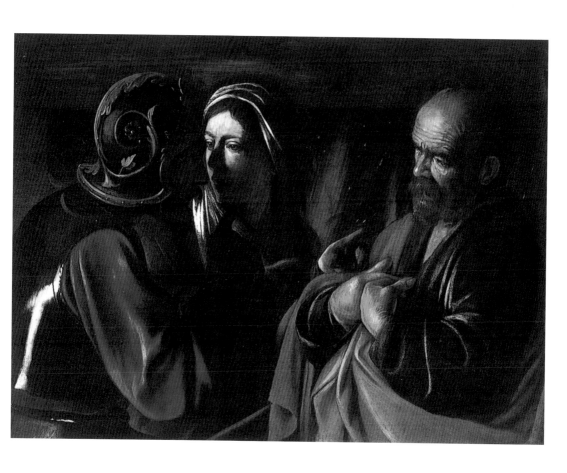

Oil on canvas, 143 × 180 cm
Naples, Banca Intesa collection

This is certainly one of Caravaggio's last works, and sums up his life's extreme anguish. It is a powerful, tragic, and very human painting.

In the traditional iconography of her martyrdom, Saint Ursula is portrayed with her martyred companions. She was murdered by a barbarian king who planned to take her as his wife. Caravaggio chooses to focus on the moment in which the saint is shot by the tyrant's arrow. The narration is direct and concise, set in a darkness cut through with contrasting points of light; five characters depicted in two-thirds length act out the tragic scene in front of the viewer. The sovereign, wearing a contemporary cuirass, has shot the arrow that has already pierced the young saint's chest. Between them, a man tries to protect her with a dramatically raised arm, while a soldier in armour holds her from behind. The artist is also present at the martyrdom, and just as in the Dublin *Taking of Christ* he portrays himself in profile, trying to raise his glance above the crowd's shoulders.

The *Martyrdom of Saint Ursula* is a masterpiece that expresses all the power of the gestures' rhetorical language. In the sovereign's theatrical gesticulations, the saint's dignified gesture as she brings her hands to her chest, the hand that emerges from the diagonal movement of the sovereign's arm, the paleness of the saint's face, and the blood spurting from her chest, Caravaggio accentuates the contrast between the victim and the persecutor, the faithful and the infidel. More than anything else, the painting underlines the physical acceptance of martyrdom.

Despite the fact that it is in a regrettably abraded condition, the painting suggests some important considerations regarding the technical execution of Caravaggio's late work, including the brevity and speed of execution, the use of the preparatory ground for the shadowed sections, the light distributed in irregular spots and with dramatic accents, the rapid representation of clothing's folds, and the modulation of flesh with very few tones and synthetic brushstrokes. The painting's history is complex, but it is also one of the most documented works of his final period. It was painted for prince Marcantonio Doria in Genoa, shortly before Caravaggio left Naples to embark on his last unlucky journey. On May 11, 1610 Lanfranco Massa, Marcantonio Doria's Neapolitan procurator, wrote to the prince: "I had thought to send you the painting of Saint Ursula this week, but, to be sure of sending it well dried, I set it yesterday in the sun, which most rapidly made the paint become dry; I want once again to go to said Caravaggio to get his opinion of how one must do in order that it doesn't spoil" (Pacelli, Bologna 1980). Perhaps Massa's impatience in wanting to send it to his master had negative consequences for the painted layers and the work's state of conservation. The painting was sent "excellently conditioned" on May 27, 1610 and was received in Genoa on June 18. The *Martyrdom of Saint Ursula* was made famous in the fifties (as an early seventeenth-century allegorical painting), but was only definitively attributed to Caravaggio in the seventies thanks to the research of Gregori, Pacelli, and Bologna. Its provenance is from the Romano-Avezzano collection, where it went from the Doria d'Angri family, and the Banca Commerciale Italiana (now Banca Intesa) acquired it in 1973. The 2004 restoration revealed important elements that had been hidden under repainted layers, as well as *pentimenti* that are now clearly visible on the painting's abraded surface.

K.S.

Bibliography: Scavizzi in Naples 1963, p. 53, no. 50; Gregori 1974, pp. 44–48; Bologna 1980, pp. 30–45; Pacelli 1980, pp. 24–30; Gregori in London-Washington 1982, pp. 131–133, no. 19; Cinotti 1983, no. 37; Hibbard 1983, pp. 252–254, 331; Calvesi 1985, pp. 84–85; Gregori 1985, no. 101; Christiansen 1986, p. 441; Pacelli in *L'ultimo Caravaggio...* 1987, pp. 81–103; Marini 1989, pp. 557–561, no. 102; Bologna 1992, pp. 263–280, 344; Gregori 1994, p. 155, no. 87; Pacelli 1994, pp. 100–117; Puglisi 1998, no. 88; Bona Castellotti in Bergamo 2000, p. 222; Marini 2001, no. 110; Spike 2001, no. 74; Bologna in Naples-London 2004, no. 18; *L'ultimo Caravaggio...* 2004.

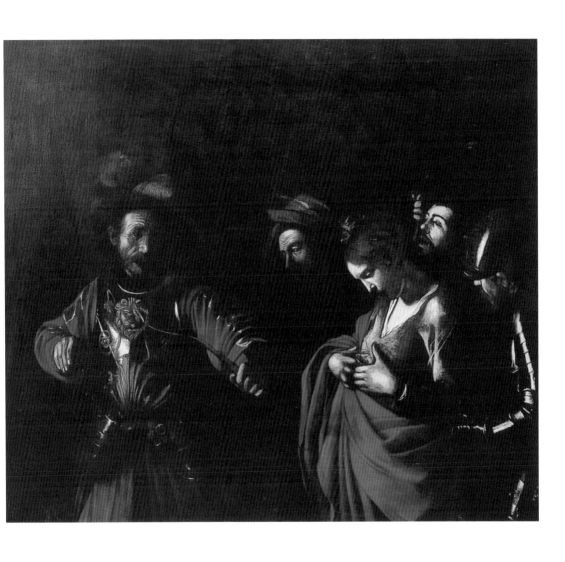

187

71
Saint John

Oil on canvas, 159 × 124 cm
Rome, Galleria Borghese

On his way back to Rome, which he'd fled in 1606 after Ranuccio Tomassoni's murder, Caravaggio brought with him three works, two paintings of *Saint John the Baptist* and a *Magdalene*; the date is confirmed by recent research and the sources (Pacelli 1994, p. 121; Macioce 2003, p. 265). A document dated July 29, 1610 casts new light on the painter's dramatic final days; he had arrived in Palo with his felucca, and from there, after being imprisoned, he managed to escape and continue on foot toward his final destination (Baglione 1642, p. 136). With him aboard the felucca were also *Saint John* and *Magdalene*, the paintings completed in Naples that were certainly to be delivered to cardinal Borghese, in hopes that he would intercede for the painter's pardon. The second *Saint John* remains unidentified. Only two days later, on July 31, 1610, Deodato Gentile, bishop of Caserta, addresses a letter to cardinal Scipione Borghese in which he refers to the fact that the paintings in question had returned to Naples and were with Costanza Colonna, Caravaggio's protector, and had then been sequestered by the Prior of Capua, member of the Order of the Knights of Malta. Deodato Gentile promises he will do everything necessary to recover the paintings for Borghese, and the correspondence between the two carries on (Macioce 2003, p. 268). The *Saint John the Baptist* will be sent to its recipient, but only after a delay of several days because the Viceroy of Naples, don Pedro Fernandez de Castro, count of Lemos, had a copy painted for himself, as is recorded in a document dated December 10, 1610 (Pacelli 1991, p. 169). Among the literary sources Scannelli (1657, pp. 198–199) cites the painting among those in Palazzo Borghese in Ripetta. In the Borghese inventories the work is always attributed to Caravaggio with the exception of one document, dated 1790, which attributes the work to Valentin de Boulogne. Lionello Venturi (1909, 1910, p. 39) is credited with reinserting this work into Caravaggio's œuvre, based on Francucci's 1613 poem in which another painting by Merisi, the *David* (Coliva 2004, p. 148) is cited. Cinotti sees one of the "recurring Caravaggesque motifs" in the theme of the young nude male figure (1983, p. 502). After a few oscillations in the work's chronology it is now unequivocally set within the last phase of Caravaggio's second stay in Naples (the spring of 1610). Marini (1974, pp. 459–460) was the first to propose this date, and the documents rediscovered by Pacelli confirm it.

A.L.

Bibliography: Francucci 1613; Baglione 1642; Scannelli 1657; Venturi 1893; Marangoni 1922; Voss 1924; Arslan 1951; Della Pergola 1959; Causa 1966; Longhi 1968; Cinotti 1973; Marini 1980; Cinotti, Dell'Acqua 1983; Pacelli 1991, p. 169; Corradini 1993, p. 108; Pacelli 1994, pp. 127–128; Marini 2001, p. 569; Macioce 2003; Coliva in Naples 2004.

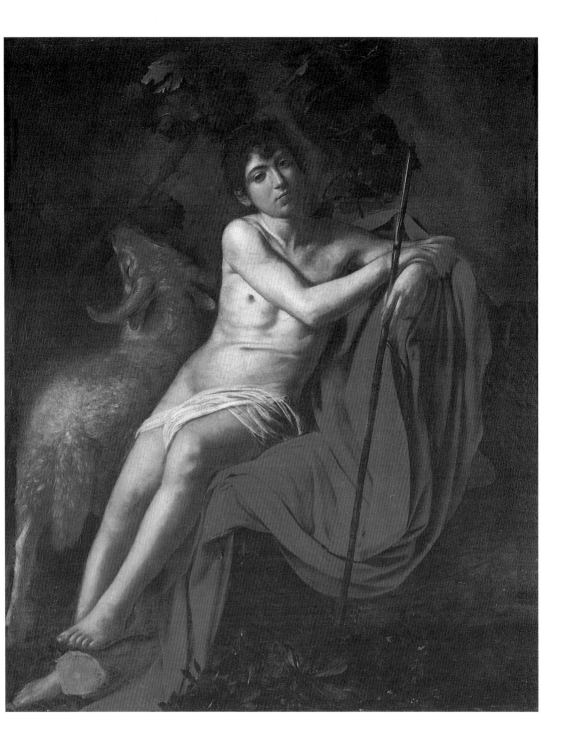

David with the Head of Goliath

Oil on canvas, 125 × 101 cm
Rome, Galleria Borghese

Traditionally considered Caravaggio's last painting, done as he reached the end of his life, *David with the Head of Goliath* sums up the entire character of the artist's most extreme years. This work was probably painted for cardinal Scipione Borghese, a key man in obtaining the papal pardon Caravaggio so greatly desired. The painting is documented in the Borghese collection (in a record of payment for the frame) as early as 1613, and enjoyed particular success, considering the numerous copies made from it.

Because of the direct connection to cardinal Borghese, for a long time critics placed the painting to Caravaggio's last year in Rome. In 1959 Longhi moved it to the final Neapolitan period, comparing it with paintings like the London *Salome*. The 1610 date now agreed upon by the majority of critics, however, cannot be held for certain; the figure of David, the brush handling, the youth's face, and the modelling of his pants have the spirit of the paintings done around 1606 and 1607, while Goliath's head contains all the intensity and anguish of the final episodes of Caravaggio's life. In comparison with the Vienna *David with the Head of Goliath*, however, it is difficult to believe that the Borghese one was painted before the Viennese one, dated to the first Neapolitan period and which has nothing of the emotional drama and intensity of the Borghese work. In a much more romantic rather than reasonable vision, the Borghese *David* is considered by many to be the conclusion of Caravaggio's tragic life.

Caravaggio expresses great power and character in this quite brutal and immediate scene. In two-thirds figure length the young David emerges from the dark, sword held low in his right hand, and shows off the severed head of Goliath with his left hand stretched out toward the viewer. A curtain is hastily painted high up, barely visible in the dark background. The light models the face, torso, and extended arm of David, also isolating Goliath from the dark *vacuum* of obscurity. The diagonal movement of the extended arm is reinforced lower down by the sword that follows the same direction. The brutality of Goliath's face, the blood gushing from the fresh wound, his mouth opened in a scream, his eyebrows furrowed and his open eyes are all in clear contrast with David's expression. The hero isn't triumphant — his look is sad, intense, and expresses great pity for the victim. This look might even reflect the psychological conditions and many difficulties the artist faced in his final years, in an autobiographical interpretation of the famous subject that had already been prominently painted earlier in the seventeenth century.

Manilli and Bellori refer to the fact that Caravaggio portrayed himself in Goliath, almost an explicit reference to his repentance, while in David Manilli saw the young man Caravaggio had painted several times during his Roman period. Whether or not Caravaggio really portrayed himself in Goliath's head is uncertain, but this point is agreed upon by the majority of critics, who then go on to provide various interpretations of this self-portrait. In the dramatic context of his final years, it isn't entirely strange to think that Caravaggio would represent himself as the victim, and this may also be an extreme attempt at asking for forgiveness.

An inscription on the sword, which isn't clearly legible, has inspired various interpretations.
K.S.

Bibliography: Manilli 1650; Bellori 1672; Venturi 1893, p. 209; Venturi 1921, 1951 edition, pp. 27, 55; Pevsner 1927–1928; Longhi 1951, p. 25; *Caravaggio e i Caravaggeschi* 1951, pp. XVII, 28; Mahon 1952, p. 19; Wagner 1958; Longhi 1959; Röttgen 1974; Calvesi 1985; Marini 1987; Papi, Lapucci in Florence-Rome 1991; Preimesberger 1998; Marini 2001, no. 108; Spike 2001, no. 77; Pacelli 2002; Stone 2002; Coliva in Naples-London 2004, pp. 137–138.

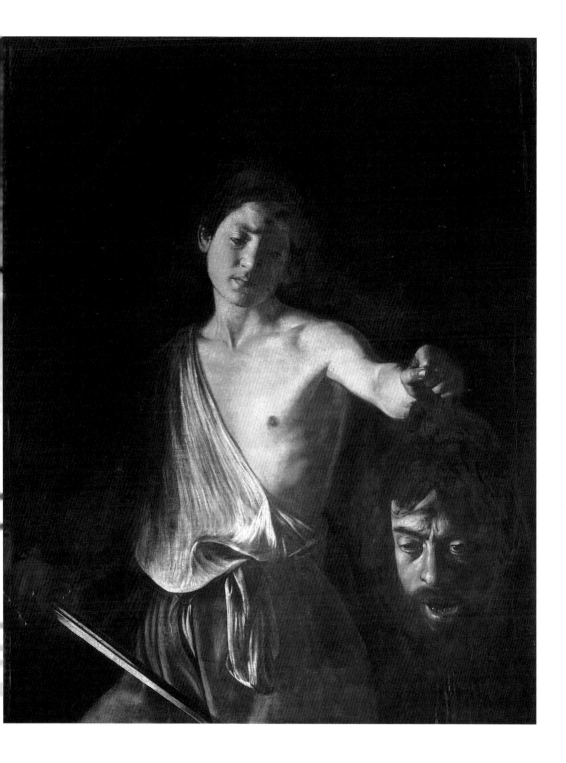

Bibliography

1603

Murtola, G. *Rime, Cioè gli occhi d'Argo. Le lacrime. I baci. I pallori. Le Veneri. I nei. Gl'Amori.* (Dedicated to the "Most Illustrious and Most Revered Monsignor Alessandro Centurione, Archbishop of Genoa, Deacon of the Camera," with a dedication dated "Venice, the 16 of Jul. 1603"), Venice; third edition, Venice, 1604.

Van Mander, K. *Het Lewen Der Moderne oft dees-tijsche doorluchtige Italiensche Schilders,* Haarlem.

1606

Bizoni, B. *Relazione in forma di diario del viaggio che corse per diverse provincie di Europa il signor Vincenzo Giustiniano Marchese di Bassano l'anno 1606.* (Abridged edition by E. Rodocanachi, titled *Adventures d'un grand seigneur italien à travers l'Europe,* undated, Paris; critical edition by A. Banti, titled *Europa milleseicentosei,* Rome, 1942, p. 200).

1619–1621

Mancini, G. *Considerazioni sulla Pittura.* Critical edition by A. Marucchi with commentary by L. Salerno, 1956–1957, I–II, Rome: I, part one (various news on Caravaggio), pp. 108–109, 120, 132, 136, 140, 146; part two (life of Caravaggio and autographed annotations of the Marciano Codex in Venice, variations and anonymous annotations of the Palatino Codex in the Biblioteca Nazionale, Florence), pp. 223–227, 340; II (commentary), pp. 109–126, notes 877–905. See also "Viaggio per Roma" (republished in 1923, edited by L. Schudt, Leipzig), I, pp. 281–283; II, pp. 196–199, notes 1480–1488, 1505. See also the earlier edition of "Vita del Caravaggio" from the Marciano Codex ms. it. IV, 47, 5571, edited by L. Venturi, 1910, pp. 279–280; from the Palatino Codex 597, J. Clark (ed.), in Longhi 1951, pp. 46–49.

1620

Celio, G. *Memoria Fatta dal Signor Gaspare Celio dell'habito di Cristo. Delli nomi del-l'Artefici delle Pitture, che sono in alcune Chiese, Facciate, e Palazzi di Roma* (1638 edition, Naples; the manuscript carries a dedication to G. V. De' Rossi dated 11 April 1620, a name discovered in the facsimile edition with an introduction and critical commentary by E. Zocca, Milan, 1967).

1620–1630

Giustiniani, V. "Lettera sulla pittura a Teodoro Amideni," *Raccolta di lettere sulla pittura, scultura ed architettura,* vol. VI; G. Bottari and S. Ticozzi (eds.), Milan, 1822.

1642

Baglione, G. *Le vite de' Pittori, Scultori et Architetti. Dal Pontificato di Gregorio XIII del 1572 in fino a' tempi di Papa Urbano Ottavo nel 1642.* J. Hess and H. Röttgen (eds.), Vatican City, 1995.

1644

Samperi, P. *Iconologia della gloriosa Vergine Maria,* Messina.

1647

Francucci, S. *Galleria dell'Ill.mo e Rev.mo Signor Scipione Cardinale Borghese cantata in versi da S. F.,* Arezzo.

1650

Manilli, J. *Villa Borghese fuori di Porta Pinciana descritta da Jacomo Manilli Romano guardaroba di detta villa,* Rome.

1657

Scannelli, F. *Il microcosmo della pittura,* Cesena, pp. 51, 197, 277; republished in R. Longhi 1951, no. 17, pp. 52–54.

1672

Bellori, G. P. *Le vite de' pittori, scultori e architetti moderni,* Rome.

1675

Von Sandrart, J. *Academia Todesca del architettura, scultura, e pittura,* Nuremberg.

1678
Malvasia, C.C. *Felina pittrice, vite de' pittori bolognesi*, I, pp. 244–253; II, pp. 9, 14–16, Bologna; republished in R. Longhi 1951, no. 17, pp. 57–58.

1681–1728
Baldinucci, F. *Notizie de' professori del disegno da Cimabue in qua*, 6 vols., Florence.

1724
Susinno, F. *Le vite de' pittori messinesi e di altri che fiorirono in Messina*, V. Martinelli (ed.), Florence, 1960.

1846
Baldinucci, F. *Notizie de' professori del disegno da Cimabue in qua*, Florence 1681–1728, F. Ranalli (ed.), IV, Florence.

1855
Amico, V. *Dizionario topografico della Sicilia*, Palermo.

1870
Campori, G. *Raccolta di cataloghi ed inventari inediti*, Modena.

1893
Venturi, A. *Il Museo e la Galleria Borghese*, Rome.

1906–1907
Kallab, W. "Caravaggio," in *Jahrbuch der Kunsthistorischen Sammlungen des allerhöchsten Kaiserhauses*, 26, 1906–1907, pp. 272–292.
Saccà, V. "Michelangelo da Caravaggio pittore. Studi e ricerche," in *Archivio Storico Messinese*, VII, 1906, pp. 40–69; VIII, 1907, pp. 41–79.

1908
Cantalamessa, G. "Un quadro di Michelangelo da Caravaggio," in *Bollettino d'Arte*, pp. 401–402.
Maindron, M. "Le Portrait du Grand-Maître Alof de Wignacourt au Musée du Louvre. Son Portrait et ses armes à l'Arsenal de Malte," in *Revue de l'Art ancien et moderne*, 24, pp. 241–254, 339–352.

1909
Giglioli, O.H. "Notiziario: R. Galleria Pitti," in *Rivista d'Arte*, VI, pp. 150–156.
Venturi, L. "Note sulla Galleria Borghese," in *L'Arte*, XII, 1, pp. 31–50.

1910
Venturi, L. "Studi su Michelangelo da Caravaggio," in *L'Arte*, XIII, 3, 25, pp. 191–201; 3, 35, pp. 268–284.

1912
Venturi, L. "Opere inedite di Michelangelo da Caravaggio," in *Bollettino d'Arte*, VI, pp. 1–18.

1916
Witting, F. *Michelangelo da Caravaggio*, Strasbourg.

1920
Rouchès, G. *Le Caravage*, Paris.
Venturi, A. "Un Caravaggio a Basilea," in *L'Arte*, XXIII, fascicle VI, no. 35, November–December, p. 282.

1921
Venturi, L. *Il Caravaggio*, Rome.

1922
Mostra della pittura italiana del Sei e Settecento (Florence, Palazzo Pitti), Rome.
Marangoni, M. *Il Caravaggio*, Florence.
Marangoni, M. "Note sul Caravaggio alla Mostra del Sei e Settecento," in *Bollettino dell'Arte*, II, series II, pp. 217–229; republished in M. Marangoni 1927, 1953, 1973.
Voss H. "Caravaggio 'Amor als sieger' und Baglione 'Himmlische und irdische Liebe'," in *Berliner Museen*, 43, pp. 60–64.

1923
Voss, H. "Caravaggio Frühzeit. Beiträge zur Kritik seiner Werke und seiner Entwicklung," in *Jahrbuch der preussischen Kunstsammlungen*, 44, pp. 73–98.

1924
Voss, H. *Die Malerei des Barok in Rom*, pp. 435–446, 493. Berlin, no date (introduction dated autumn 1924; occasionally cited in bibliographies on Caravaggio as "Voss 1925").

1925
Von Sandrart, J. Abridgement of the 1675 edition with commentaries by A. Peltzer, Munich (see Von Sandrart pre-1658).

1927
Longhi, R. "Un S. Tommaso del Velázquez e le congiunture italo-spagnole tra il '500 e il '600," in *Vita Artistica*, II, 1927, 2, pp. 4–12, now in *Opere complete*, II, *Saggi e ricerche*

1925–1928, Florence, 1967, pp. 300–306.
Marangoni, M. *Arte Barocca: revisioni critiche*, Florence.

1927–1928
Pevsner, N. "Eine Revision der Caravaggio-Daten," in *Zeitschrift für Bildende Kunst*, LXI, pp. 386–392.

1928
Longhi, R. *Precisazioni nelle Gallerie italiane*, I, *R. Galleria Borghese,* Rome.
Zahn, L. *Caravaggio*, Berlin.

1928–1929
Longhi, R. "Quesiti caravaggeschi," I, "Registro dei tempi;" II, "I precedenti," in *Pinacoteca*, I, no. 1, July-August, 1928, pp. 17–33; II, 1929, nos. 5–6, pp. 258–320; republished in *Opere complete*, IV, Florence, 1968.

1930
Venturi, L. "Caravaggio," entry in *Enciclopedia italiana*, VIII, 1930, pp. 942–944.

1932–1933
Hess, J. "Nuovo contributo alla vita del Caravaggio," in *Bollettino dell'Arte*, XXVI, series III, no. 1, July 1932, pp. 42–44.

1935
Isarlov, G. *Caravage et le caravagisme européen*, Aix-en-Provence.

1942
Schudt, L. *Caravaggio*, Vienna.

1943
Argan, G.C. "Un'ipotesi caravaggesca," in *Parallelo*, 2.
Longhi, R. "Ultimissime sul Caravaggio," in *Proporzioni*, I, pp. 99–102.

1945
Friedländer, W. "The 'Crucifixion of St. Peter', Caravaggio and Reni," in *Journal of the Warburg and Courtauld Institutes*, VIII, pp. 152–160.

1947
Ainaud de Lasarte, J. "Ribalta y Caravaggio," in *Anales y Boletin de los Museos de Arte de Barcelona*, 3–4, pp. 345–413.

1948
Argan, G.C. "Notes sur le Caravage," in *Arts plastiques*, 1–2, pp. 74–76.

Friedländer, W. "The Academician and the Bohemian Zuccari and Caravaggio," in *Gazette des Beaux-Arts*, XC, no. 33, January, pp. 27–36.
Pariset, F. *Georges La Tour*, Paris.

1951
Arslan, E. "Appunto su Caravaggio," in *Aut Aut*, 5, pp. 414–451.
Berenson, B. *Del Caravaggio, delle sue incongruenze, e della sua fama*, Florence (second edition, Milan).
Caravaggio e i Caravaggeschi, exhibition catalogue (Milan, Palazzo Reale, 1951), Florence.
Hess, J. "The Chronology of the Contarelli Chapel," in *The Burlington Magazine*, XCII, no. 579, June, pp. 186–201.
Longhi, R. "Il Caravaggio e i suoi dipinti a S. Luigi dei Francesi," in *Paragone*, II, no. 17, May, pp. 3–13.
Longhi, R. "Sui margini caravaggeschi," in *Paragone*, II, 21, pp. 20–34.
Mahon, D. "Egregius in Urbe Pictor: Caravaggio Revised," in *The Burlington Magazine*, XCIII, 580, pp. 223–234.
Nicco Fasola, G. *Caravaggio anticaravaggesco*, Florence.
Venturi, L. *Caravaggio*, preface by B. Croce, Novara (second edition, Novara, 1963).
Voss, H. "Die Caravaggio Ausstellung in Mailand," in *Kunstchronik*, pp. 165–169.

1952
Longhi, R. *Il Caravaggio*, Milan.
Mahon, D. "Addenda to Caravaggio," in *The Burlington Magazine*, XCIV, 586, pp. 3–23.
Norris, C. "The Disaster at Flaktum Friedrichschain, a Chronicle and List of Paintings," in *The Burlington Magazine*, 94, pp. 337–347.
Venturi, L. *La peinture italienne du Caravage à Modigliani. Études critiques de Lionello Venturi*, Geneva.

1953
Hinks, R. *Michelangelo Merisi da Caravaggio: His Life, His Legend, His Works*, London.
Mahon, D. "Die Dokumente über die Contarelli-Kapelle und ihre Verhältnis zue Chronologie Caravaggios," in *Zeitschrift für Kunstwissenschaft*, pp. 183–208.
Marangoni, M. *Arte Barocca*, Florence.

1954
Friedländer, W. Review of R. Hinks' "Michelangelo Merisi da Caravaggio," in *Art Bulletin*, 36, pp. 149–152.

1955

Ainaud de Lasarte, J. "Le Caravagisme en Espagne," in *Cahiers de Bordeaux*, II, pp. 21–25.

Battisti, E. "Alcuni documenti su opere del Caravaggio," in *Commentari*, VI, fascicle III, July–September, pp. 173–185.

Baumgart, F. *Caravaggio. Kunst und Wirklichkeit*, Berlin.

Friedländer, W. *Caravaggio Studies*, Princeton (bound reprints, New York, 1969, 1972).

Hinks, R. "Caravaggio the Romantic," in *Actes du XVIII Congrès International d'histoire de l'art* (1952 congress held in Amsterdam), pp. 59–69, Den Haag.

Jullian, R. "Caravage à Naples," in *Revue des Arts*, V, no. 2, June, pp. 79–90.

Scicluna, H.P. *The Church of St. John in Valletta*, Rome.

1957

Carità, R. "Il restauro dei dipinti caravaggeschi della cattedrale di Malta," in *Bollettino dell'Istituto Centrale del Restauro*, fascicle 29/30, pp. 41–82.

Della Pergola, P. "Per la storia della Galleria Borghese," in *Critica d'Arte*, IV, no. 20, March–April, pp. 135–142 (Caravaggio, pp. 16–39).

1958

Della Pergola, P. "Una testimonianza per Caravaggio," in *Paragone*, IX, no. 105, September, pp. 71–75 (see also Longhi 1958).

Hess, J. "Caravaggio's Paintings in Malta: Some Notes," in *The Connoisseur*, CXLII, pp. 142–147.

Wagner, H. *Michelangelo da Caravaggio*, Bern.

Wittkower, R. *Art and Architecture in Italy, 1600–1750*, London.

1959

Arslan, E. "Nota caravaggesca," in *Arte Antica e Moderna*, II, 6, pp. 191–218.

Berne-Joffroy, A. *Le dossier Caravage*, Paris (new edition, Paris, 2000).

Della Pergola, P. *Galleria Borghese*, vol. 2, Rome.

Longhi, R. "Un'opera estrema del Caravaggio," in *Paragone*, X, 121, pp. 21–32.

1960

Longhi, R. "Un originale del Caravaggio a Rouen e il problema delle copie caravaggesche," in *Paragone*, XI, 121, pp. 23–36.

Salerno, L. "The Picture Gallery of Vincenzo Giustiniani: Introduction and Inventory," in *The Burlington Magazine*, 102, pp. 21–28, 93–104, 135–148.

1961

Jullian, R. *Caravage*, Lyon-Paris.

Longhi, R. *Opere complete*, I, *Scritti giovanili 1912–1922*, I–II, Florence; reissued 1913, 1914, 1915, 1916, 1917, 1950 (1922); first edition, 1922.

1963

Caravaggio e i caravaggeschi, Naples.

1964

Della Pergola, P. "L'inventario Borghese del 1693," I–II, in *Arte Antica e Moderna*, VII, no. 26, April–June, pp. 219–230; no. 28, October–December, pp. 451–467 (III, no. 30, pp. 202–217, not concerning Caravaggio).

Della Pergola, P. "Nota per Caravaggio," in *Bollettino d'Arte*, XLIX, series IV, no. 3, July–September, pp. 252–256.

D'Onofrio, C. "Inventario dei dipinti del cardinal Pietro Aldobrandini compilato da G. B. Agucchi nel 1603" (III), in *Palatino*, 9–10, pp. 202–211 (Caravaggio p. 204, no. 202).

Levey, M. *The later Italian pictures in the Collection of Her Majesty the Queen*, London.

1965

Casanova, M.L. (ed.) *Le seizième siècle européen. Peintures et dessins dans les collections publiques françaises*, Paris.

1966

Bottari, S. *Caravaggio*, Florence.

Causa, R. *Caravaggio*, Milan.

Salerno, L., Kinkead, D.T. and Wilson, W.H. "Poesia e simboli nel Caravaggio," in *Palatino*, 2, pp. 106–117.

1967

Aronberg Lavin, M. "Caravaggio Documents from the Barberini Archive," in *The Burlington Magazine*, 109, pp. 470–473.

Longhi, R. "Un San Tommaso del Velázquez e le congiunture italo-spagnole tra il Cinque e il Seicento," in *Opere complete*, II, *Saggi e ricerche 1925–1928*, Florence, pp. 300–306.

Moir, A. *The Italian followers of Caravaggio*, Cambridge (Massachusetts).

Ottino Della Chiesa, A. *L'opera completa di Caravaggio*, preface by R. Guttuso, Milan.

1968

Fagiolo Dell'Arco, M. "Le opere di Miseri-

cordia: contributo alla poetica del Caravaggio," in *L'Arte*, March, pp. 37–61.

Longhi, R. *Caravaggio*, Rome.

Longhi, R. *Opere complete, IV, 'Me pinxit' e 'Quesiti caravaggeschi', 1928–34*, Florence (contains a reissue of the essays from 1928–1929, 1930).

Panofsky, E. and Soergel, G. "Zur Geschichte des Palazzo Mattei di Giove," in *Römisches Jahrbuch für Kunstgeschichte*, XI, pp. 111–188.

1969

Kitson, M. *The Complete Paintings of Caravaggio*, Harmondsworth.

Röttgen, H. "Caravaggio Probleme," in *Münchner Jahrbuch der bildenden Kunst*, tab. 20, pp. 143–170.

Zandri, C. "Un probabile dipinto murale del Caravaggio per il cardinal Del Monte," in *Storia dell'Arte*, I, no. 3, July–September, pp. 338–343.

1970

Bodart, D. *Louis Finson*, Brussels.

Borea, E. ed. *Caravaggio e Caravaggeschi nelle Gallerie di Firenze*, Florence.

Marini, M. "Due ipotesi caravaggeschi: la Susanna per il cavalier Marino e la Cortigiana con una rosa," in *Arte illustrata*, III, nos. 34–36, October–December, pp. 74–79.

Pérez Sánchez, A.E. *Pintura italiana del siglo XVII*, exhibition catalogue, Madrid, pp. 117–124.

Rosenberg, P. *Le siècle de Rembrandt. Tableaux hollandaise des collections publiques français*, Paris.

Salerno, L. "Caravaggio e i Caravaggeschi," in *Storia dell'Arte*, no. 8, pp. 234–248.

1971

Brugnoli, M.V. "Un 'San Francesco' da attribuire al Caravaggio e la sua copia," in *Bollettino d'Arte*, 53, 1968 (1971), 1, pp. 11–15.

Calvesi, M. "Caravaggio o la ricerca della salvazione," in *Storia dell'Arte*, 9–10.

Dell'Acqua, G.A. and Cinotti, M. *Il Caravaggio e le sue grandi opere da San Luigi dei Francesi*, Milan.

Frommel, Ch. L. "Caravaggios Frühwerk und der Kardinal Francesco Maria del Monte," in *Storia dell'Arte*, III, 9–10, pp. 53–56.

Kirwin, W.C. "Addendum to Cardinal Francesco Maria Del Monte's Inventory," in *Storia dell'Arte*, IX–X, pp. 53–56.

Levey, M. *The Seventeenth and Eighteenth Century Italian Schools*, National Gallery, London.

Pérez Sánchez, A.E. "Caravaggio e i Caravaggeschi a Firenze," in *Arte illustrata*, IV, 37/38, pp. 85–89.

Schleier, E. "Caravaggio e i caravaggeschi nelle Gallerie di Firenze. Zur Austellung in Palazzo Pitti, Sommer 1970," in *Kunstchronik*, XXIV, 4, pp. 85–102.

Spear, R. *Caravaggio and his Followers*, exhibition catalogue, Cleveland.

1971 (1972 edition)

Calvesi, M. "Caravaggio o la ricerca della salvazione," in *Storia dell'Arte*, III, 9–10, January–June, pp. 93–141.

Dell'Acqua, G.A. *Il Caravaggio e le sue grandi opere da San Luigi dei Francesi*, Rizzoli, Milan.

Spezzaferro, L. "La cultura del cardinal Del Monte e il primo tempo del Caravaggio," in *Storia dell'Arte*, 9–10, pp. 57–92.

1972

Baldini, U. and Dal Poggetto, P. (eds.). *Firenze restaura. Il laboratorio nel suo quarantennio. Guida alla mostra,* exhibition catalogue, Florence.

Causa, R. "La pittura del Seicento a Napoli dal naturalismo al Barocco," in *Storia di Napoli*, V, 2, Naples, pp. 915–994.

Volpe, C. "Annotazioni sulla mostra caravaggesca di Cleveland," in *Paragone*, XXII, 263, pp. 50–76.

1973

Caravaggio y el naturalismo español, exhibition catalogue, Madrid (1972).

Cinotti, M., in *Immagine del Caravaggio*, pp. 23–27, 113–211.

Marini, M. "Caravaggio 1607: la Negazione di Pietro," in *Napoli Nobilissima*, XII, pp. 189–194.

Marini, M. *Io, Michelangelo da Caravaggio*, Rome.

Pérez Sánchez, A.E., in *Caravaggio y el naturalismo español* (exhibition catalogue, Madrid, 1972), Madrid.

1973–1974

Brandi, C. *La diffusione dell'arte di Caravaggio in Italia e in Europa*, publication of the Università La Sapienza, Facoltà di Lettere e Filosofia, Istituto di Storia dell'arte medievale e moderna, Rome.

1974

Borea, E. "Caravaggio e la Spagna. Osservazioni su una mostra a Siviglia," in *Bollet-*

tino d'Arte, LIX, 1–2, pp. 43–52.

Cummings, F. "Detroit's Conversion of the Magdalen (The Alzaga Caravaggio), The Meaning of Caravaggio's Conversion of the Magdalen," in *The Burlington Magazine*, CXVI, 859, October, pp. 563–564, 572–578.

Gregori, M. "A New Painting and Some Observations on Caravaggio's Journey to Malta," in *The Burlington Magazine*, CXVI, 859, pp. 594–603.

Harris, E. "Caravaggio e il naturalismo spagnolo," in *Arte illustrata*, 58, pp. 235–239.

Lavin, I. "Divine Inspiration in Caravaggio's Two St. Matthews," in *Art Bulletin*, 56, pp. 59–81.

Marini, M. *Michelangelo da Caravaggio*, Rome.

Nicolson, B. "Recent Caravaggio Studies," in *The Burlington Magazine*, CXVI, 859, pp. 624–625.

Pérez Sánchez, A.E. *Caravaggio y los caravaggistias en la pintura española*, pp. 57–85.

Röttgen, H. *Il Caravaggio. Ricerche e interpretazioni,* Rome; reissued 1964, 1965, 1966, 1969; edition of *Riflessioni sul rapporto tra la personalità del Caravaggio e la sua opera*, pp. 145–240; (pp. 213–227 in the edition modified at the Convegno di Bergamo, Röttgen 1974, 1975).

Spezzaferro, L. *Caravaggio e i caravaggeschi*, colloquium held in Rome, 12–14 February 1973; issued by the Accademia Nazionale dei Lincei ("Problemi attuali di Scienza e di Cultura", notebook no. 205) Rome; contributions by J. Ainaud de La Sarte, G.C. Argan, F. Bologna, C. Brandi, A.E. Pérez Sánchez, X. de Salas, H. Schulte Nordholt, L. Spezzaferro).

Spezzaferro L. "Detroit's Conversion of the Magdalen (The Alzaga Caravaggio), 4. The Documentary Finding: Ottavio Costa as a Patron of Caravaggio," in *The Burliongton Magazine*, CXVI, 859, pp. 579–586.

Spezzaferro, L. "La pala dei Palafrenieri," in *Atti del colloquio sul tema Caravaggio e i caravaggeschi*, Rome, pp. 125–138.

1974–1975

Wallach, C. "An Iconographic Interpretation of a Ceiling Painting Attributed to Caravaggio," in *Marsyas. Studies in the History of Art*, XVII, pp. 101–102.

1975

Aronberg Lavin, M. *Seventeenth-Century Barberini Documents and Inventories of Art,* New York (Caravaggio index entry, pp. 473–474).

Calvesi, M. "Lettere iconologiche del Car-

avaggio" (from the acts of the January 1974 meeting in Bergamo), in *Novità sul Caravaggio,* Milan, pp. 75–102.

Cinotti, M. *Caravaggio*, Bergamo.

Cinotti, M. "Il contributo della mostra didattica itinerante 'Immagine del Caravaggio': La mostra," in *Novità sul Caravaggio,* Milan, pp. 217–250.

Cummings, F.J. "Letters. The Alzaga Caravaggio," in *The Burlington Magazine*, CXVII, no. 866, May, p. 303.

Gregori, M. "Significato delle mostre caravaggesche dal 1951 ad oggi" (from the acts of the January 1974 meeting in Bergamo; text dated Bergamo, December 1973–October 1974), in *Novità sul Caravaggio*, Milan, pp. 27–60.

Novità sul Caravaggio. Saggi e contributi, M. Cinotti (ed.); coordinated by Carlo Nitto, Regione Lombardia, Milan.

Salerno, L. "Caravaggio e la cultura del suo tempo" (from the acts of the January 1974 meeting in Bergamo), in *Novità sul Caravaggio*, Milan, pp. 17–26.

Spear, R.E. *Caravaggio and His Followers*, New York.

Spezzaferro, L. "Ottavio Costa e Caravaggio: certezze e problemi" (from the acts of the January 1974 meeting in Bergamo), in *Novità sul Caravaggio*, Milan, pp. 103–108.

1976

Causa, R. *Caravaggio*, I (from the series *I Maestri del Colore*, 49), Milan.

Dell'Acqua, G.A. *Il Caravaggio e le sue grandi opere da San Luigi dei Francesi, con un'appendice di Mia Cinotti* (from the series *Grandi monografie d'arte*), Milan.

Gregori, M. "Caravaggio," in *Enciclopedia Europea*, Milan, II, pp. 868–871.

Moir, A. *Caravaggio and His Copyists*, New York University Press (*Monographs on Archaeology and the Fine Arts*, 31), New York.

1977

Meloni Trkulja, S. "Per l'amore dormiente di Caravaggio," in *Paragone*, XXVIII, 331, pp. 46–50.

Pacelli, S. "New Documents Concerning Caravaggio in Naples," in *The Burlington Magazine*, CXIX, 897, pp. 819–829.

Tzeutschler Lurie, A. and Mahon, D. "Caravaggio's Crucifixion of Saint Andrew from Valladolid," in *The Bulletin of the Cleveland Museum of Arts*, LXIV, pp. 3–24.

1978

Azzopardi, J. *The Church of St. John in Val-*

letta 1578–1978. An Exhibition Commemorating the Fourth Centenary of its Consecration, exhibition catalogue, Malta.

Marini, M. *"Michel Angelus Caravaggio Romanus". Rassegna degli studi e proposte*, Rome.

Pacelli, V. "Nuovi documenti sull'attività del Caravaggio a Napoli," in *Napoli nobilissima*, XVII, II, March–April, pp. 57–67.

Sammut, E. "The Trial of Caravaggio," in *The Church of St. John in Valletta 1578–1978. An Exhibition Commemorating the Fourth Centenary of its Consecration,* exhibition catalogue, J. Azzopardi (ed.), Malta, pp. 21–27.

1979

Fulco, G. "Il sogno di una 'Galeria': nuovi documenti sul Marino collezionista," in *Antologia di Belle Arti*, III, no. 9–12, pp. 84–99 (Caravaggio p. 90).

Marini, M. "'Michel Angelus Carvaggio Romanus'. Rassegna degli studi e proposte," in *Studi barocchi*, I, Rome (the cover is dated 1979, the frontispiece is dated 1978).

Nicolson, B. *The International Caravaggesque Movement. Lists of Pictures by Caravaggio and his Followers throughout Europe from 1590-1630*, posthumous edition, L. Vertova (ed.), Oxford.

Spear, R.E. "The International Carvaggesque Movement," in *The Burlington Magazine*, CXXI, 914, pp. 317–322.

1980

Bologna, F. "L'identificazione del dipinto (e i rapporti artistici fra Genova e Napoli nei primi decenni del Seicento)," in F. Bologna and V. Pacelli, "Caravaggio 1610: la Sant'Orsola confitta dal tiranno per Marcantonio Doria," in *Prospettiva*, XXXIII, 23, pp. 30–45.

Fulco, G. "'Ammirate l'altissimo pittore': Caravaggio nelle rime inedite di Marzio Milesi," in *Ricerche di Storia dell'Arte*, 10, "Roma nell'anno 1600", pp. 65–89.

Gash, J. *Caravaggio*, London.

Lavin, I. "A Further Note on the Ancestry of Caravaggio's First 'Saint Matthew'," in *The Art Bulletin*, LXII, I, March, pp. 113–114.

Spezzaferro, L. "Caravaggio rifiutato? 1. Il problema della prima versione del 'San Matteo'," in *Ricerche di Storia dell'Arte*, 10, pp. 49–64.

Spezzaferro, L. "Il testamento di Marzio Milesi: tracce per un perduto Caravaggio," in *Ricerche di Storia dell'Arte*, 10, "Roma nell'anno 1600", pp. 90–99.

1981

Garas, K. "Ergänzungen zur Caravaggio-Forschung," in *Ars auro prior*, pp. 397–401.

Marini, M. "Caravaggio e il naturalismo internazionale," in *Storia dell'arte italiana*; VI, second part, "Dal Medioevo al Novecento;" II, "Dal Cinquecento all'Ottocento;" I, "Cinquecento e Seicento," Turin, pp. 347–445.

1982

La città degli Uffizi, Florence.

Gregori, M., in *Painting in Naples 1606–1705: from Caravaggio to Giordano* (exhibition catalogue, London-Washington 1982–1983), C. Whitfield and J. Martineau (eds.), London.

Moir, A. *Caravaggio* (from the series *I grandi pittori*, 9), New York-Milan.

Sebregondi Fiorentini, L. "Francesco dell'Antella, Caravaggio, Paladini e altri," in *Paragone*, XXXIII, no. 383–385, pp. 107–122.

Strinati, C., in *L'immagine di S. Francesco nella Controriforma* (exhibition catalogue, Rome, Palazzo Venezia, 1982), Rome, pp. 91–92, cat. nos. 82–83.

Whitfield, C. and Martineau, J. (eds.). *Painting in Naples 1606–1705: from Caravaggio to Giordano* (exhibition catalogue, London-Washington 1982–1983), London.

Zuccari, A. *Arte e committenza nella Roma di Caravaggio*, Rome.

1983

Cinotti, M. "Michelangelo Merisi detto il Caravaggio. Tutte le opere," in *I pittori bergamaschi dal XII al XIX secolo. Il Seicento,* I, Bergamo, pp. 203–641.

Hibbard, H. *Caravaggio*, London.

Pizzorusso, C. "'Un tranquillo dio' Giovanni da San Giovanni e Caravaggio," in *Paragone*, 405, pp. 50–59.

Trinchieri Camiz, F. and Ziino, A. "Caravaggio: aspetti musicali e committenza," in *Studi musicali*, XII, 1, pp. 67–90.

1983–1984

Bologna, F. "Sul passaggio a Eboli della Sant'Orsola del 1610 e una Strage degli innocenti di Giovan Battista Paggi," in F. Bologna, "Tre note caravaggesche," in *Prospettiva*, nos. 33–36, April 1983–January 1984; special issue, "Studi in onore di Luigi Grassi," pp. 202–211.

1984

Abbate, V. "I tempi del Caravaggio. Situazione della pittura in Sicilia (1580–1625)," in *Caravaggio in Sicilia, il suo tempo, il suo influsso* (exhibition catalogue, Syracuse

1984–1985), Palermo, pp. 43–76.

Caravaggio in Sicilia, il suo tempo, il suo influsso (exhibition catalogue, Syracuse 1984–1985), Palermo, pp. 43–76.

Civiltà del Seicento a Napoli, exhibition catalogue, Naples.

Pacelli, V. *Caravaggio. Le Sette Opere di Misericordia*, Salerno.

Spinosa, N. ed. *Il patrimonio artistico del Banco di Napoli. Catalogo delle opere*, Naples.

1986

Christiansen, K. "Caravaggio and 'L'esempio davanti del naturale'," in *The Art Bulletin*, LXVIII, 3, pp. 421–445.

Segrebondi Fiorentini, L. "Francesco Buonarroti, cavaliere gerolosimitano e architetto dilettante," in *Rivista d'Arte*, XXXVIII, series IV, II, pp. 49–86.

1987

Brown, J. and Kagan, R. "The Duke of Alcalá: His Collection and Its Evolution," in *Art Bulletin*, LXIX, 2, pp. 231–255.

Calvesi, M. (ed.) "L'ultimo Caravaggio e la cultura artistica a Napoli," in *Sicilia e Malta*, acts of the April 1985 Syracuse-Malta convention, Syracuse (Sicily).

Gregori, M. "Dal Caravaggio al Manfredi," in *Dopo Caravaggio. Bartolomeo Manfredi e la Manfrediana Methodus* (exhibition catalogue, Cremona), Milan, pp. 19–25.

Marini, M. *Caravaggio. Michelangelo Merisi da Caravaggio "Pictor Praestantissimus". La tragica esistenza, la raffinata cultura, il mondo sanguigno del primo Seicento nell'iter pittorico completo di uno dei massimi rivoluzionari dell'arte di tutti i tempi,* Rome.

Pacelli, V. "Dalla Sant'Orsola alle Sette opere, un percorso all'inverso ricordando i dipinti maltesi e siciliani," in "L'ultimo Caravaggio e la cultura artistica a Napoli," in *Sicilia e Malta*, acts of the April 1985 Syracuse-Malta convention, M. Calvesi (ed.), Syracuse (Sicily), pp. 81–103.

Posèq, A.W.G. "A Note on Caravaggio's Sleeping Amor," in *Source. Notes on the History of Art*, VI, no. 4, pp. 27–31.

König, E. *Caravaggio*, Cologne.

1988

Brejon de Lavergnée, A. and Volle, N. *Musées de France. Répertoires des peintures italiennes du XVIIe siècle*, Paris.

1989

Azzopardi, J. "Caravaggio's Admission into the Order: Papal Dispensation for the Crime of Murder," in *Caravaggio in Malta*, Ph. Farrugia Randon (ed.), Malta, pp. 45–56.

Azzopardi, J. "Documentary Sources on Caravaggio's Stay in Malta," in *Caravaggio in Malta*, Ph. Farrugia Randon (ed.), Malta, pp. 19–44.

Chiarini, M. *La probabile identità del "cavaliere di Malta" di Pitti*, in "Antichità viva", 28, no. 4, pp. 15–16.

Farrugia Randon, Ph. (ed.) *Caravaggio in Malta*, Malta.

Marini, M. *Caravaggio. Michelangelo Merisi da Caravaggio "Pictor Praestantissimus",* second edition, Rome.

Nicolson, B. *Caravaggism in Europe*, second edition edited by L. Vertova, 3 vol., Turin.

Spinosa, N. (ed.) *Capolavori dalle collezioni d'arte del Banco di Napoli*, Naples.

1989–1990

Pacelli, V. "Strumenti in posa: novità sull'Amore vincitore del Caravaggio," in *Prospettiva*, LVII–LX, "Scritti in ricordo di Giovanni Previtali," pp. 156–162.

1990

Askew, P. *Caravaggio's Death of the Virgin* (Princeton University Press, "Princeton Essays on the Arts"), Princeton-Oxford.

Bologna, F. *L'incredulità del Caravaggio e l'esperienza delle cose naturali*, Turin.

Calvesi, M. *Le realtà del Caravaggio*, Turin.

Camiz, F. "Death and Rebirth in Caravaggio's Martyrdom of St. Matthew," in *Artibus et historie*, XI, 22, pp. 89–105.

Cappelletti, F. and Testa, L. "E per me pagate a Michelangelo da Caravaggio. Nuove date per i dipinti Mattei," in *Art e Dossier*, V, 42, pp. 4–7.

Cappelletti, F. and Testa, L. "I quadri di Caravaggio nella collezione Mattei. I nuovi documenti e i riscontri con le fonti," in *Storia dell'Arte*, LXIX, pp. 234–244.

Cappelletti, F. and Testa, L. "Ricerche documentarie sul 'san Giovanni Battista' dei Musei Capitolini e sul 'san Guiovanni Battista' della Galleria Doria-Pamphilj," with a documentary appendix, in *Identificazione di un Caravaggio. Nuove technologie per una rilettura del San Giovanni Battista*, Venice, pp. 75–101.

Correale, G. (ed.) *Identificazione di un Caravaggio. Nuove technologie per una rilettura del San Giovanni Battista*, Venice.

Spike, J.T. "Caravaggio," in *The Burlington Magazine*, CXXXIV, 1069, pp. 275–277.

Spike, J.T. "Problemi di autografia: e se il Caravaggio avesse avuto una bottega?," in *Il giornale dell'arte*, 99, p. 5.

Vodret, R. "Inventario di Palazzo Mattei, ms. 2147, Roma, Bibliot. Angelica," in *Invisibilia. Rivedere i capolavori, vedere i progetti* (exhibition catalogue, Rome), M.E. Tittoni and S. Guarino (ed.), Rome, p. 63.

1991

Bologna, F. "Battistello e gli altri. Il primo tempo della pittura caravaggesca a Napoli," in *Batistello Caracciolo e il primo naturalismo a Napoli* (exhibition catalogue, Naples), F. Bologna (ed.), Naples, pp. 15–180.

Cinotti, M. *Caravaggio. La vita e l'opera*, Bergamo.

Lapucci, R. Analytical texts in *Michelangelo Merisi da Caravaggio, Come nascono i capolavori*, Milan.

Michelangelo Merisi da Caravaggio. Come nascono i capolavori (exhibition catalogue, Florence-Rome, 1991–1992), M. Gregori (ed.), Milan; second edition, Milan, 1992.

Pacelli, V. "La morte di Caravaggio e alcuni suoi dipinti da documenti inediti," in *Studi di Storia dell'Arte*, pp. 167–188.

Il San Girolamo da Caravaggio a Malta. Dal furto al restauro. Istituto Centrale del Restauro, Rome.

1992

Bologna, F. *L'incredulità del Caravaggio e l'esperienza delle "cose naturali,"* Turin.

Labrot, G. *Collections of Paintings in Naples 1600–1780. The Provenance Index of the Getty Art History Information Program*, Munich.

Pesenti, F.R. "Il primo momento del caravaggismo a Genova," in *Genova nell'età barocca*, Bologna.

La pintura holandese del siglo de oro: la escuela de Utrecht (exhibition catalogue, Madrid-Bilbao-Barcelona, 1992–1993), Madrid.

1993

Corradini, S. *Caravaggio. Materiali per un processo*, Alma Roma (from the *Monografie romane* series), Rome.

1994

Calvesi, M. "Uno sbozzo del Caravaggio e la Deposizione di Santa Maria in Vallicella," in *Studi in onore di Mina Gregori*, Milan, pp. 148–197.

Cappelletti, F. and Testa, L. *Il trattenimento di Virtuosi. Le collezioni seicentesche di quadri nel Palazzo Mattei di Roma,* Rome.

Caravaggio, with an essay by Mina Gregori (from the series *I Maestri*, no. 9), Electa, Milan.

Espinel, C.H. "Caravaggio's 'L'Amore dormiente': a Sleeping Cupid with Juvenile Rheumatoid Arthritis," in *The Lancet*, 344, pp. 1750–1752.

Fumagalli, E. "Precoci citazioni di opere del Caravaggio in alcuni documenti inediti," in *Paragone*, XLV, 535/537, pp. 101–116; republished in *Come dipingeva il Caravaggio* (acts from the 28 January 1992 meeting in Florence), edited by M. Gregori, in collaboration with E. Acanfora, R. Lapucci, G. Papi, Milan, pp. 143–148.

Gregori, M. *Caravaggio*. Milan.

Lapucci, R. "Documentazione tecnica sulle opere messinesi del Caravaggio," in *Come dipingeva il Caravaggio. Le opere messinesi* (*Quaderni dell'attività didattica del Museo Regionale di Messina*, no. 4), Messina, pp. 17–67.

Macioce, S. "Caravaggio a Malta e i suoi referenti: notizie d'archivio," in *Storia dell'Arte*, 81, pp. 207–228.

Pacelli, V. *L'ultimo Caravaggio: dalla Maddalena a mezza figura ai due san Giovanni (1606–1610)*, Todi.

Wazbinski, Z. *Il cardinale Francesco Maria del Monte 1549–1626*, Florence.

1995

Caravaggio e la collezione Mattei (exhibition catalogue, Rome, Galleria Nazionale d'Arte Antica di Palazzo Barberini), Milan.

Cottino, A. (ed.) *La natura morta ai tempi del Caravaggio* (exhibition catalogue, Rome, Musei Capitolini), Naples.

Gilbert, C. *Caravaggio and His Two Cardinals*, University Park (Pennsylvania).

1996

Azzopardi, J. "Un 'San Francesco' di Caravaggio a Malta nel secolo XVIII: commenti sul periodo maltese del Merisi," in *Michelangelo Merisi da Caravaggio: la vita e le opere attraverso i documenti*, *Atti del Convegno internazionale di studi*, edited by S. Macioce, with research and editorial collaboration by M. Gallo and M. Pupillo; editing and coordination by Malena B. McGrath, Logart, Rome, pp. 195–211.

Balsamo, J. "Les Caravage de Malte: le témoignage des voyageurs français (1616–1678)," in *Come dipingeva il Caravaggio* (acts from the 28 January 1992 meeting in Florence), edited by M. Gregori, in collaboration with E. Acanfora, R. Lapucci, G. Papi, Milan, pp. 151–153.

Belloni, C. "Cesare Crispolti: documenti per una biografia," in *Michelangelo Merisi da Caravaggio: la vita e le opere attraverso i documenti, Atti del Convegno internazionale di studi,* edited by S. Macioce, with research and editorial collaboration by M. Gallo and M. Pupillo; editing and coordination by Malena B. McGrath, Logart, Rome.

Bonsanti, G. and Gregori, M. (eds.). *Caravaggio da Malta a Firenze,* Milan.

Come dipingeva il Caravaggio (acts from the 28 January 1992 meeting in Florence), edited by M. Gregori, in collaboration with E. Acanfora, R. Lapucci, G. Papi, Electa, Milan.

Danesi Squarzina, S. "Caravaggio e i Giustiniani," in *Michelangelo Merisi da Caravaggio: la vita e le opere attraverso i documenti, Atti del Convegno internazionale di studi,* edited by S. Macioce, with research and editorial collaboration by M. Gallo and M. Pupillo; editing and coordination by Malena B. McGrath, Logart, Rome, pp. 94–122.

Frommel Ch.L. "Caravaggio, Minniti e il Cardinal Francesco Maria del Monte," in *Michelangelo Merisi da Caravaggio: la vita e le opere attraverso i documenti, Atti del Convegno internazionale di studi,* edited by S. Macioce, with research and editorial collaboration by M. Gallo and M. Pupillo; editing and coordination by Malena B. McGrath, Logart, Rome, pp. 18–41.

Gregori, M. "Contributi alla lettura del murale per il cardinale Del Monte," in *Come dipingeva il Caravaggio* (acts from the 28 January 1992 meeting in Florence), edited by M. Gregori, in collaboration with E. Acanfora, R. Lapucci, G. Papi, Electa, Milan, pp. 106–120.

Marini, M. "Un contributo all'iconografia del 'David e Golia' del Prado," in *Come dipingeva il Caravaggio* (acts from the 28 January 1992 meeting in Florence), edited by M. Gregori, in collaboration with E. Acanfora, R. Lapucci, G. Papi, Electa, Milan, pp. 135–142.

Michelangelo Merisi da Caravaggio: la vita e le opere attraverso i documenti, Atti del Convegno internazionale di studi, edited by S. Macioce, with research and editorial collaboration by M. Gallo and M. Pupillo; editing and coordination by Malena B. McGrath, Logart, Rome.

Puija, C. Entry in *Domenico Fetti 1588/1589–1623* (exhibition catalogue, Mantua 1996), E. Safarik (ed.), Milan, pp. 79–80.

Pupillo, M. "I Crescenzi, Francesco Contarelli e Michelangelo da Caravaggio: contesti e documenti per la commissione in S. Luigi dei Francesi," in *Michelangelo Merisi da Caravaggio: la vita e le opere attraverso i documenti, Atti del Convegno internazionale di studi,* edited by S. Macioce, with research and editorial collaboration by M. Gallo and M. Pupillo; editing and coordination by Malena B. McGrath, Logart, Rome, pp. 148–166.

Safarik, E. *Collezione dei dipinti Colonna: inventari 1611–1795,* Munich.

Treffers, B. "'In agris itinerans': l'esempio della Madonna di Loreto del Caravaggio," *Mededelingen van hat Nederlands Institut te Rome, Historical Studies,* 55, pp. 274–292.

Wazbinski, Z. "Il viaggio del Cardinale Francesco Maria del Monte a Napoli negli anni 1607–1608," in *Michelangelo Merisi da Caravaggio: la vita e le opere attraverso i documenti, Atti del Convegno internazionale di studi,* edited by S. Macioce, with research and editorial collaboration by M. Gallo and M. Pupillo; editing and coordination by Malena B. McGrath, Logart, Rome, pp. 42–62.

1997

Danesi Squarzina, S. "The Collection of Cardinal Benedetto Giustiniani," in *The Burlington Magazine,* CXXXIX, pp. 766–769, CXL, pp. 102–118.

Di Fabio, C. in *Van Dyck a Genova. Grande pittura e collezionismo* (exhibition catalogue, Genoa), Milan.

Gash, J. "The Identity of Caravaggio's Knight of Malta," in *The Burlington Magazine,* CXXXIX, 1128, pp. 156–160.

Maccherini, M. "Caravaggio nel carteggio familiare di Giulio Mancini," in *Prospettiva,* LXXXVI, pp. 71–92.

Stone, D.M. "In Praise of Caravaggio's Sleeping Cupid: New Documents for Francesco dell'Antella in Malta and Florence," in *Melita Historica,* XII, no. 2, pp. 165–177.

Stone. D.M. "The Context of Caravaggio's Beheading of St. John in Malta," in *The Burlington Magazine,* CXXXIX, 1128, pp. 161–170.

1998

Bona Castellotti, M. *Il paradosso di Caravaggio,* Milan.

Chiarini, M. (ed.) La *natura morta a palazzo e in villa* (exhibition catalogue, Florence, 1997), Livorno.

Cinotti, M. *Caravaggio. La vita e l'opera,* Bergamo.

Corradini, S. and Marini, M. "The Earliest Account of Caravaggio in Rome," in *The Burlington Magazine,* 140, pp. 25–28.

Finaldi, G. (ed.) *Caravaggio: The Flagellation of Christ, a Loan from the Musée des Beaux-Arts, Rouen, at the National Gallery of London*, London.

Keith, L. "Three Paintings by Caravaggio," in *National Gallery Technical Bulletin*, XIX, pp. 37–51.

Langdon, H. *Caravaggio: A Life*, London.

La Madonna dei Palafrenieri del Caravaggio. Vicende, interpretazioni, restauro, Venice.

Marini, M. "Luce su Caravaggio," in *Quadri & Sculture*, VI, 29, p. 38.

Preimesberger, R. "Golia e Davide," in *Docere delectare movere. Affetti, devozione e retorica nel linguaggio del primo barocco romano* (acts of the convention held in Rome, 19–20 January 1996), Rome, pp. 61–69.

Puglisi, C. *Caravaggio*. London.

Spezzaferro, L. "Nuove riflessioni sulla pala dei Palafrenieri," in *La Madonna dei Palafrenieri del Caravaggio. Vicende, interpretazioni, restauro*, Venice, pp. 51–60.

Testa, L. "Presenze caravaggesche nella collezione Savelli," in *Storia dell'Arte*, 93/94, pp. 348–352.

1998–1999

Macioce, S. "Mario Minniti bello spoglio di un cavaliere maltese," in *Storia dell'Arte*, XCII-XCIV, pp. 337–340.

1999

Calvesi, M. "Sobre algunas pinturas de Caravaggio" la Buenaventura, el San Francisco de Hartford, el David y Goliat de la Borghese u las dos Natividades sicilianas," in *Caravaggio* (exhibition catalogue, Madrid-Bilbao, 1999–2000), Madrid, pp. 10–17.

Caravaggio (exhibition catalogue, Madrid-Bilbao, 1999–2000), Madrid.

Ciatti, M. and Silla, C. (eds.). *Caravaggio al Carmine. Il restauro della 'Decollazione del Battista' di Malta* (exhibition catalogue, Florence), Milan.

La Flagellazione del Caravaggio. Il restauro, edited by D.M. Pagano, Naples.

Gregori, M. "Decollazione del Battista," in *Caravaggio al Carmine. Il restauro della 'Decollazione del Battista' di Malta* (exhibition catalogue, Florence), Milan, pp. 33–38.

Langdon, H. *Caravaggio: A Life*, New York.

Longhi, R. (ed.) *Studi caravaggeschi*, I, 1943–1968, edition of the complete works of Roberto Longhi, XI, Sansoni, Florence.

Maccherini, M. "Ritratto di Giulio Mancini," presentation at the convention *Bernini dai Borghesi ai Barberini. La cultura a Roma intorno agli anni Venti*, 17–19 February, Villa Medici, Rome.

Pacelli, V. "Reconsideraciones sobre la vicissitudes artisticas y biográficas del ultimo Caravaggio," in *Caravaggio* (exhibition catalogue, Madrid-Bilbao, 1999–2000), Madrid, pp. 49–62.

Spezzaferro, L. "All'alba del Seicento. Caravaggio e Annibale Carracci," in *La Storia dei giubilei*, A. Zuccari (ed.), Florence, III, pp. 180–195.

Vodret, R. in *Caravaggio e i suoi. Percorsi caravaggeschi in Palazzo Barberini* (exhibition catalogue, 18 February–9 May), C. Strinati and R. Vodret (eds.), Naples, pp. 30–32.

2000

Caravaggio. La luce nella pittura Lombarda (exhibition catalogue, Bergamo, Accademia Carrara di Belle Arti, 2000), F. Rossi (ed.), Milan.

Caroli, F. "Le radici della rivoluzione," in *Il Cinquecento lombardo: da Leonardo a Caravaggio* (exhibition conceived and curated by Flavio Caroli, Milan, Palazzo Reale, 4 October–25 February 2001), Milan, pp. 23–31.

Il Cinquecento lombardo: da Leonardo a Caravaggio (exhibition conceived and curated by Flavio Caroli, Milan, Palazzo Reale, 4 October–25 February 2001), Milan.

Corti, L. (ed.) *Lungo il tragitto crociato della vita*, Venice.

Galleria Borghese, Touring Club Italiano, Milan.

Gallo, N. "Lo stemma dei Malaspina di Fosdinovo sulla tela del San Girolamo del Caravaggio a Malta: Note e osservazioni," in *Atti e Memorie della Deputazione di Storia patria per le antiche provincie modenesi*, 22, series XI, pp. 255–262.

Gregori, M. "Un nuovo Davide e Golia del Caravaggio," in *Paragone*, LI, 31, pp. 11–22.

Lavin, I. *Caravaggio e La Tour: la luce occulta di Dio*, Rome.

La luce del vero: Caravaggio, La Tour, Rembrandt, Zurbarán, Cinisello Balsamo.

Pedrocchi, A.M. *Le stanze del tesoriere: la quadreria Patrizi; cultura senese nella storia del collezionismo romano del Seicento*, Milan.

Roma, la città del papa. Vita civile e religiosa dal giubileo di Bonifacio VIII al giubileo di papa Wojtyla, L. Fiorani and A. Prosperi (ed.), annal 16 in the *Storia d'Italia* series, Turin.

Rossi, F. *Caravaggio e le armi. Immagine descrittiva, valore segnico e valenza simbolica, in Caravaggio. La luce nella pittura lombarda* (exhibition catalogue, Bergamo, Accademia Car-

rara di Belle Arti), F. Rossi (ed.), Milan, pp. 77–88.

Spezzaferro, L. *Caravaggio*, in *L'idea del bello, viaggio per Roma nel Seicento con Giovan Pietro Bellori*, brief exhibition guide, E. Borea and L. de Lachenal (eds.), De Luca, Rome, series II, pp. 271–274.

Vannugli, A. "Enigmi caravaggeschi: i quadri di Ottavio Costa," in *Storia dell'Arte*, 99, pp. 55–83.

Vodret, R. "I primi anni romani di Caravaggio: nuovi documenti su Lorenzo Siciliano, alias 'fratello Lorenzo pittore', alias Lorenzo Carlo," in *Studi di storia dell'arte in onore di Dennis Mahon*, M.G. Berardini, S. Danesi Squarzina, and C. Strinati (eds.), Milan, pp. 53–56.

2001

Abbate, V. "Contesti e momenti del primo caravggismo a Palermo," in *Sulle orme di Caravaggio fra Roma e la Sicilia* (exhibition catalogue, Palermo), V. Abbate, G. Barbera, C. Strinati, and R. Vodret (eds.), Venice, pp. 77–97.

Caravaggio e i Giustiniani, toccar con mano una collezione del Seicento (exhibition catalogue, Rome, Palazzo Giustiniani, 26 January–15 May 2000; Berlin, Altes Museum, 15 June–9 September 2001), "Senato della Repubblica Italiana, Comitato nazionale per le celebrazioni del IV centenario della Cappella Contarelli in San Luigi dei Francesi, Università degli studi di Roma 'La Sapienza' (et al.)," S. Danesi Squarzina (ed.), Milan.

Caravaggio e il genio di Roma (exhibition catalogue, London-Rome), B.L. Brown (ed.), Rome.

Chiarini, M. *La Galleria Palatina e gli appartamenti reali di Palazzo Pitti*, Florence.

Cirenei, A. "Conflitti artistici, rivalità cardinalizie e patronage a Roma fra Cinquecento e Seicento. Il caso del processo criminale contro Cavalier d'Arpino," in *La nobiltà romana in età moderna. Profili istituzionali e pratiche sociali*, M.A. Visceglia (ed.), Rome, pp. 255–306.

Il genio di Roma (exhibition catalogue, London-Rome), B.L. Brown (ed.), Rome.

Gregori, M. "Un nuovo 'Davide e Golia' del Caravaggio," in *Paragone, Arte*, LI, pp. 11–22.

Lambert, G. *Caravaggio (1571–1610)*, Cologne.

Langdon, G. "Bari, zingare e venditori ambulanti," in *Il genio di Roma, 1592–1623*, pp. 42–65.

Laureati, L. "Natura morta: frutta, fiori e ortaggi," in *Il genio di Roma, 1592–1623*, pp. 66–89.

Macioce, S. "Precisazioni sulla biografia del Caravaggio a Malta," in *Sulle orme del Caravaggio tra Roma e la Sicilia* (exhibition catalogue, Palermo), V. Abbate, G. Barbera, C. Strinati, and R. Vodret (eds.), Venice, pp. 25–37.

Marini, M. *Caravaggio pictor praestantissimus*, third edition, Rome.

Prohaska, W. in *Caravaggio e i Giustiniani. Toccar con mano una collezione del Seeicento* (exhibition catalogue), S. Danesi Squarzina (ed.), Rome, pp. 288–293.

Robb, P. *L'enigma Caravaggio*, Milan.

I segreti di un Collezionista. Le straordinarie raccolte di Cassiano dal Pozzo 1588–1657 (exhibition catalogue, Biella), F. Solinas (ed.), Rome.

Sickel, L. "Remarks on the Patronage of Caravaggio's Entombment of Christ," in *The Burlington Magazine*, 143, pp. 426–429.

Sulle orme del Caravaggio: tra Roma e la Sicilia (exhibition catalogue, Palermo, Palazzo Ziino), V. Abbate and G. Barbera (eds.), Venice.

Spezzaferro, L. "La cappella Cerasi e il Caravaggio," in *Caravaggio, Carracci, Maderno. La Cappella Cerasi in S. Maria del Popolo a Roma*, L. Spezzaferro, M.G. Bernardini, C. Strinati, and A.M. Tantillo (eds.), Milan, pp. 9–34.

Spike, J.T. *Caravaggio*, New York-London.

Treffers, B. in *Caravaggio e il genio di Roma* (exhibition catalogue, London-Rome), B.L. Brown (ed.), Rome.

Vodret, R. and Strinati, C. "Le nuove rappresentazioni della musica: con alcune osservazioni sul Discorso di Vincenzo Giustiniani," in *Il genio di Roma, 1592–1623*, pp. 90–115.

Volpi, C. in *I segreti di un Collezionista. Le straordinarie raccolte di Cassiano dal Pozzo 1588–1657* (exhibition catalogue, Biella), F. Solinas (ed.), Rome.

2002

Berra, G. "Il giovane Michelangelo Merisi da Caravaggio: la sua famiglia e la scelta dell''ars pingendi," in *Paragone*, 53, nos. 41–42, pp. 40–128.

Caravaggio nel IV centenario della Cappella Contarelli (international study convention held in Rome, 24–26 May), texts by A. Antinori et al., acts of the convention edited by C. Volpi, Città di Castello.

Corrain, L. "Cristo nell'orto di Caravaggio, un esempio di narrazione prodomica," in *Car-*

avaggio nel IV centenario della Cappella Contarelli (international study convention held in Rome, 24–26 May), texts by A. Antinori et al., acts of the convention edited by C. Volpi, Città di Castello, pp. 221–231.

Ebert-Schifferer, S. "Caravaggio, 'Früchtekorb'—das früheste Stilleben?," in Zeitschrift für Kunstgeschichte, 65, 1, 2002, pp. 1–23.

Farina, V. Giovan Carlo Doria promotore delle arti a Genova nel primo Seicento, Florence.

Floridi, G. "La morte e la sepoltura di Caravaggio a Porto Ercole e la sua appartenenza all'Ordine di Malta," in Strenna dei Romanisti, 63, pp. 245–253.

Gregori, M. "Un amico di Simone Peterzano a Venezia," in Paragone, 41–42, p. 23.

Maccherini, M. "Novità sulle considerazioni di Giulio Mancini," in Caravaggio nel IV centenario della Cappella Contarelli (international study convention held in Rome, 24–26 May), texts by A. Antinori et al., acts of the convention edited by C. Volpi, Città di Castello, pp. 123–128.

Macioce, S. "Caravaggio a Malta: precisazioni documentarie," in Caravaggio nel IV centenario della Cappella Contarelli (international study convention held in Rome, 24–26 May), texts by A. Antinori et al., acts of the convention edited by C. Volpi, Città di Castello, pp. 155–169.

Moffitt, J.F. "Caravaggio and the Gypsies," in Paragone, 41–42, pp. 129–156.

La natura morta italiana tra Cinquecento e Settecento (exhibition catalogue, Florence-Munich, 2002–2003), M. Gregori (ed.), Munich.

Pacelli, V. L'ultimo Caravaggio, 1606–1610; il giallo della morte, un omicidio di Stato?, Todi.

Pacelli, V. L'ultimo Caravaggio, Naples.

Röttgen, H. Il Cavalier Giuseppe Cesari D'Arpino: un grande pittore nello splendore della fama e nell'incostanza della fortuna, Rome.

Sciberras, K. "Frater Michel Angelus in Tumultu: The Cause of Caravaggio's Imprisonment in Malta," in The Burlington Magazine, CXLIV, 1189, pp. 229–232.

Sciberras, K. "Riflessioni su Malta al tempo del Caravaggio," in Paragone, LIII, third series, no. 44, pp. 3–20.

Sohn, P. "Caravaggio's Death," in The Art Bulletin, 84, pp. 449–468.

Spezzaferro, L. "Caravaggio accettato, dal rifiuto al mercato," in Caravaggio nel IV centenario della Cappella Contarelli (international study convention held in Rome, 24–26 May), texts by A. Antinori et al., acts of the convention edited by C. Volpi, Città di Castello, pp. 197–208.

Stone, D.M. "In Figura Diaboli: Self and Myth in Caravaggio's David and Goliath," in From Rome to Eternity: Catholicism and the Arts in Italy, ca. 1550–1650, P.M. Jones and T. Worcester (eds.), Leiden, pp. 19–42.

2003

Bonavera, C. and Di Fabio, C. Die Restaurierung von Caravaggios Ecce Homo, in Contini 2003.

Bozzi, U. La natura morta italiana dal Caravaggio al Settecento (exhibition catalogue, Florence), M. Gregori (ed.), Florence.

Capecelatro, G. Tutti i miei peccati sono mortali. Vita e amori di Caravaggio, Milan.

Contini, R. Pracht und Pathos: Meisterwerke der Barockmalerei aus dem Palazzo Bianco in Genua, Cinisello Balsamo.

Danesi Squarzina S. La collezione Giustiniani, Turin.

Macioce, S. Michelangelo Merisi da Caravaggio: fonti e documenti, 1532–1724; with research collaboration by A. Lippo, Rome.

Masetti Zannini, G.L. "Hermes Cavalletti bolognese, ragioniere generale della Chiesa e la sua cappella con il quadro del Caravaggio," in Atti e memorie. Deputazione di Storia Patria per le Provincie di Romagna, no. 54, pp. 153–166.

Puglisi, C. Caravaggio, London.

Sickel, L. Caravaggios Rom. Annäherungen an ein dissonantes Milieu, Berlin.

Vodret, R. in Visioni ed estasi. Capolavori dell'arte fra Seicento e Settecento (exhibition catalogue, Vatican City, 14 October 2003–18 January 2004), G. Morello (ed.), Milan, pp. 194–195.

2004

Acts of the international colloquium Caravaggio e il suo ambiente (Rome, Biblioteca Herziana, 30–31 January).

Bologna, F. in Caravaggio. L'ultimo tempo. 1606–1610 (exhibition catalogue, Naples), N. Spinosa (ed.), Naples.

Caravaggio: la Medusa. Lo splendore degli scudi da parata del Cinquecento (exhibition catalogue, Milan, Museo Bagatti Valsecchi), Cinisello Balsamo, p. 19 and following pages.

Caravaggio. L'ultimo tempo. 1606–1610 (exhibition catalogue, Naples), N. Spinosa (ed.), Naples.

Costa Restagno, J. "Ottavio Costa (1554–1639)," in L'età di Rubens: dimore, committenti e collezionisti genovesi (exhibition catalogue, Genoa, Palazzo Ducale), P. Boccardo (ed.), pp. 424–429.

Costa Restagno, J. Ottavio Costa (1554–1639): 205

le sue case e i suoi quadri; ricerche d'archivio, XXXI (from the "collana storico-archeologica della Liguria occidentale"), issued by the Istituto Internazionale di Studi Liguri, Bordighera-Albenga.

Denunzio, in *Caravaggio. L'ultimo tempo. 1606–1610* (exhibition catalogue, Naples), N. Spinosa (ed.), Naples.

L'età di Rubens: dimore, committenti e collezionisti genovesi (exhibition catalogue, Genoa, Palazzo Ducale), P. Boccardo (ed.), Milan.

Gregori, M. and Bayer, A. (eds.). *Pittori della realtà: le ragioni di una Rivoluzione da Foppa e Leonardo a Caravaggio e Ceruti*, Milan.

L'ultimo Caravaggio: il "Martitio di Sant'Orsola" restaurato (exhibition catalogue, Milan-Rome-Vicenza), Milan.

Sciberras, K. and Stone, D.M. *Caravaggio in bianco e nero: arte, cavalierato e l'ordine di Malta (1607–1608)*, Naples-London, pp. 61–79.

Sgarbi, V., in *Le ceneri violette di Giorgione*, V. Sgarbi (ed.), Milan.

Spezzaferro, L. "La Medusa del Caravaggio," in *Caravaggio: la Medusa. Lo splendore degli scudi da parata del Cinquecento* (exhibition catalogue, Milan, Museo Bagatti Valsecchi), Cinisello Balsamo, p. 19 and following pages.

Vodret, R. "I 'doppi' di Caravaggio: le due versioni del S. Francesco in meditazione," in *Storia dell'Arte*, 8, 2004, no. 108, pp. 45–78.

2005

Berne-Joffroy, A. *Dossier Caravaggio. Psicologia della attribuzioni e psicologia dell'arte*, Milan.

Berra, G. *Il giovane Caravaggio in Lombardia: ricerche documentarie sui Merisi, gli Aratori e i Marchesi di Caravaggio*, published by the Fondazione di Studi di Storia dell'Arte, R. Longhi, Florence.

Caravaggio e l'Europa. Il movimento caravaggesco internazionale da Caravaggio a Mattia Preti (exhibition catalogue, Milan, Palazzo Reale), Milan.

Sciberras, K. "Due persone," in *The Burlington Magazine*, 147, January 2005, pp. 38–39.

Sciberras, K. and Stone, D.M. "Malaspina, Malta, and Caravaggio's St. Jerome," in *Paragone*, LXI, third series, no. 60, March 2005, pp. 3–17.